Stanford White

Wayne Craven

COLUMBIA UNIVERSITY PRESS NEW YORK

DECORATOR

IN OPULENCE

Stanford White

AND DEALER

IN ANTIQUITIES

Columbia University Press
Publishers Since 1893
New York Chichester, West Sussex

Library of Congress Cataloging-in-Publication Data
Craven, Wayne.
Stanford White : decorator in opulence and dealer
in antiquities / Wayne Craven.
p. cm.
Includes bibliographical references and index.
ISBN 0-231-13344-8 (cloth : alk. paper)
1. White, Stanford, 1853-1906.
2. Interior decorators—United States—Biography.
3. Antique dealers—United States—Biography. I. Title.
NK2004.3 W48C73 2005
747'.092—dc22 2004055271

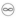

Columbia University Press books are printed on
permanent and durable acid-free paper.

Printed in the United States of America
c 10 9 8 7 6 5 4 3 2 1

To Lorna
This was your idea

Contents

Illustrations

PLATES

IN THE NINTH CENTURY, THE VIKINGS WERE THE SCOURGE OF MUCH OF Europe, raiding monasteries, churches, and castles, wherever precious treasures were to be found, and carrying off their plunder to their homeland, where they held revelries to flaunt their newly gained symbols of wealth and conquest. A thousand years later, not much had changed, except the direction from which the insatiably predacious invaders now came; the new warriors came from the New World and, instead of brandishing the sword and the torch, were armed with the vast financial resources and economic might of the Industrial Revolution, which had finally come to a belated fulfillment in the United States. These parvenus saw themselves as a new aristocracy—an aristocracy based on wealth such as the United States had never before known.

But unlike their Norse predecessors, the Americans carried off coffered ceilings, carved fireplaces, paneled walls, stained-glass windows, stone portals, and iron gates, as well as smaller trophies such as suits of armor, coats of arms, paintings, sculptures, altarpieces, Oriental carpets, Gobelins tapestries, gilded furniture of every description (as long as its style included the name "Louis" or "Henri"), and anything else that would set this high-riding new aristocracy apart from the sedate old Knickerbocker society and from the dowdy American middle class. For their new man-

sions, these wealthy Americans demanded interiors appropriate to their elevated social status, and many turned to Stanford White to create those settings for them.

The European aristocracy seemed powerless to resist the expropriation of its ancient treasures as they disappeared to such places as New York; Newport, Rhode Island; Philadelphia; Miami; and Old Westbury, Long Island. One must ask why the American millionaire raiders and their minions braved the North Atlantic crossings to bring back the cultural symbols of other nations and other families for decorating their newly risen pleasure domes. Within their gilded mansions, what social events required an ambience that connoted Old World gentility and aristocratic position? While the stories of numerous American nouveaux riches could tell the tale, those of the Whitneys, Paynes, Poors, and Mackays offer excellent and somewhat unfamiliar examples. The story becomes one of society itself and the rise of great interrelated families, not simply a tale of what happened to certain interiors, decorative arts, paintings, and sculptures.

The common denominator was Stanford White, who has long been known as an architect but is less well known as a collector of and dealer in Old World antiquities, and as a creative genius whose special talents defined the new profession of interior decorator at its highest level.

Acknowledgments

I AM PARTICULARLY GRATEFUL TO THE PROFESSIONAL STAFFS OF THE three institutions that are the main repositories of the Stanford White Papers and the McKim, Mead & White Papers. The curators, keepers, and librarians who assisted me were excellent in their knowledge and care of those invaluable materials. Many were helpful there, but I should like to thank, especially, Mary Beth Kavanagh, Wendy Kaplan, Valerie Komor, and Donna Davey of the New-York Historical Society; Angela Giral, director, and Janet Parks, curator of drawings, at Avery Architectural and Fine Arts Library, Columbia University; and Eileen K. Morales and Faye Haun at the Museum of the City of New York. Mary Doherty of the Photograph Library at the Metropolitan Museum of Art has been especially helpful in obtaining photographs of objects in the Met's collection. Neville Thompson at the Winterthur Museum was always ready to provide assistance.

Anyone who writes about Stanford White—even when writing about his work as a decorator, dealer, and collector rather than as an architect—is indebted to the several scholars who have long studied the works of McKim, Mead & White, specifically, Paul Baker, David Lowe, Leland Roth, Samuel White, Richard Guy Wilson, and Lawrence Wodehouse. This book is intended to add to what they have already accomplished. Also,

the publications of Robert A. M. Stern have been an inspiration for the scholarly and sensitive way they have treated the era of the Gilded Age.

I also would like to acknowledge Nancy Anderson, Franklin Kelly, and Lynn Russell of the National Gallery of Art, who provided a boost just when I needed it most. Paul Miller of the Preservation Society of Newport County and James Yarnall of Salve Regina University in Newport, Rhode Island, reminded me that I did indeed have colleagues who were seriously interested in La Belle Epoque.

At the University of Delaware, I want to thank President David Roselle, Provost Daniel Rich, and Director of Libraries Susan Brynteson for encouraging my research and writing, even long after I retired, and for providing me with that wonderful little faculty study in Morris Library that looks out on the campus mall. To my former graduate students, who seemed never to tire of asking when this book was going to come out, I say, "Here it is, at last."

My family members now all realize that when I start to write a book, they will hear little else from me for five to ten years. Thank you for your forbearance and for being good listeners.

This book came about when my wife, Lorna, and I were talking about my work, one evening, as I was writing another book, on the architecture and interiors of the Gilded Age. I complained that I had accumulated so much primary material on Stanford White that it was getting out of control in its abundance and complexity. She said, quite simply, "Then why don't you write a book on Stanford White's interiors?" And the next morning, I began doing just that.

Stanford White

\mathcal{I}NTRODUCTION

ON 20 APRIL 1898 JOEL DUVEEN OF BOND STREET, LONDON, INFORMED
Stanford White:

> We have bought a most wonderful Louis Seize room, complete,
> carving by [Jean Charles] de la Fosse, and as fine in its way as the
> Louis Quatorze Room you bought for Mr. Whitney['s house]. We
> have also bought the contents of this room consisting of the finest
> tapestry chairs, tapestry curtains, and [Pierre] Gouthiere pieces of
> furniture. . . . Are you interested? . . . We want to get as many fine
> things together as possible for the season especially as you and a great
> many of your friends are coming over to look for special things.[1]

White bought many such rooms out of Old World palazzos, châteaux, vil-
las, nunneries, and country houses. And when they did not come com-
pletely furnished, he bought at random to fill these rooms as he reinstalled
them in the Fifth Avenue mansions or Long Island estates that the firm of
McKim, Mead & White was then designing. White moved like a whirl-
wind through Europe's antique shops on annual foraging trips, acquiring
assorted bibelots left and right; photographs of his own home in New York
City attest to his eclectic buying habits (see figures 56–63 and plate 5).

Stanford White (1853–1906) has long been known and often studied as an

architect and a partner in the firm of McKim, Mead & White, and his life has been the subject of several biographies.[2] But scholars have concentrated on the designs of the exteriors and the floor plans of his buildings while giving much less attention to his activities as a dealer in both the fine and decorative arts or to the role he played as an interior decorator and the extent to which he helped establish that new profession.[3] In truth, White devoted much of his time and seemingly boundless energy, as well as a large portion of his personal resources (which proved not to be boundless), to those pursuits.

The study of those activities provides an insight into the international infrastructure of the European decorative arts market at the turn of the twentieth century. An enormous corps of dealers catered to the demands of the Gilded Age. A Fifth Avenue mansion or Long Island château would need, say, a sixteenth-century gilt coffered ceiling from Venice, an Henri II ornamented fireplace from France, carved wood paneling from an English country house, or Gobelins tapestries when the walls were not adorned with British ancestral portraits in the grand manner by Sir Joshua Reynolds. Here is the story of the broad web of business dealings in antiquities, mostly legal but not always, as American money brought American industrialists and financiers into the burgeoning European art market, of which Americans previously had been barely cognizant.[4]

Important sociological factors were involved in the dramatic shift in taste among the wealthiest citizens of the United States after the Civil War and through the decades of the Gilded Age—that is, roughly from 1865 to 1918. Rejecting the nationalist, isolationist, and self-absorbed attitudes of the antebellum era, the American glitterati became internationalist, intercontinentalist, and cosmopolitan in their outlook. They turned their backs on the nationalism that had prevailed in regard to the fine and decorative arts before the Civil War, seeing such attitudes as homey and insular and gladly left to the middle class. For example, the nouveaux riches rejected the paintings by Hudson River School artists as quaintly chauvinistic, and the wealthy began to collect Raphaels and Rembrandts; well-heeled Americans were less interested in a teapot by Paul Revere than they were in a silver tea service that had once belonged to King George III.

The Astors, Vanderbilts, Morgans, Whitneys, Mackays, Belmonts, and hundreds more of the newly rich perceived themselves as a new and discrete sector of American society: an industrial and financial aristocracy stationed well above the moderately comfortable middle class and separated from it by the sheer magnitude of its enormous wealth. That wealth permitted a high-flying lifestyle divested of most lingering vestiges of Puritan

restraint. These wealthy Americans criss-crossed the Atlantic on their private steam yachts or aboard the first great steamships, in search of everything that Europe had to offer, from fashionable Parisian gowns by Worth to titled husbands for their daughters, from rare Botticelli Madonnas to whole rooms from noble palazzos or hoary castles. In their zeal to establish themselves as an American aristocracy, they aligned themselves with European aristocracy, as much as the latter would allow. American wealth could, and did, buy almost anything it wanted from the great noble families of Europe. Henry James often took such acquisitiveness as the theme for his novels, as in *The American* (1877).

From the end of the Civil War to the end of World War I, wealth and property changed hands on an enormous scale as power passed from an often impoverished Old World nobility to the suddenly rich American beneficiaries of the Industrial Revolution. This new element in American society tended to be brash and crusty, raw and unpolished, and sought an instant mantle of culture from its association with European aristocracy and antiquities. While a few clarion voices in the United States—Louis Sullivan, for example—called for an art and architecture that expressed the new technologies and new materials of the age, American millionaires, as a group, preferred to find in Europe's antiquity the forms that would conceal their brazen newness and promote their position as an aristocracy. Stanford White knew precisely how to satisfy this wish insofar as splendid architectural interiors were concerned.

The newly wealthy industrialists of the nineteenth century also succumbed to escapism to some degree. Because the society in which they lived tended to be rather crass and coarse, they turned to earlier eras for tranquility and gentility. Even Europeans resorted to such escapist tactics, as when the late-nineteenth-century French novelist Edmond de Goncourt decorated his bedroom in Paris in a Rococo manner and surrounded himself with an assemblage of objects that "when I open my eyes in the morning, give me the impression that I have awakened, not in my own age which I do not love, but in the time which has been the object of my studies, in some chamber of a castle . . . of the time of Louis XV."[5]

Europeans who visited the United States recognized at once the appeal that Old World culture held for newly wealthy Americans. Paul Bourget, a Parisian poet, critic, and novelist, rebuked an American who was critical of his countrymen for their desire to surround themselves with the refined relics of Europe's past: "In my opinion, he does not recognize the sincerity, almost the pathos, of this love of Americans for surrounding

themselves with things around which there is an idea of time and stability. It is almost a physical satisfaction of the eyes to meet here the faded colors of an ancient painting, the blurred stamp of an antique coin, the softened shades of a medieval tapestry. In this country, where everything is of yesterday, they hunger and thirst for the long ago."[6]

And so one of the many ways in which the American nouveaux riches enveloped themselves in a veneer of Old World culture was by commissioning domestic interiors from architects such as Stanford White, Richard Morris Hunt, George B. Post, and a host of others. In satisfying this demand, White was unsurpassed as an interior decorator, for he moved well beyond the mere designing of empty architectural spaces to the filling of them with the trappings of European aristocracy. The discovery, purchase, and installation of Old World artifacts became a business for him, on a scale that has not heretofore been adequately considered.

The art market, as one historian has observed, became "truly international because art was regarded as the prerogative of the rich individual rather than part of any one nation's patrimony."[7] Europeans, driven by necessity to sell their personal and national treasures, resented the arrival of American buyers, their pockets stuffed with the dollars of the Whitneys or the Vanderbilts. Count Boni de Castellane, who once sold his family title, if not his affection, in a marriage to the daughter of Jay Gould, expressed this discontent in his autobiography:

> The fact that so many treasures of the Old World are captured by America causes me positive physical and mental distress, for the simple reason that American collectors have not the remotest idea how to arrange objects of art. They are in urgent need of a guiding hand and an unerring brain to assist them. These two qualifications they will never possess, for taste in such matters springs from knowledge founded in part on tradition and in part on a passion for beauty. Americans are, above all things, men of business, and value, not beauty, is the first consideration with them.[8]

RISE OF THE INTERIOR DECORATOR IN THE GILDED AGE

Stanford White became the foremost agent of taste in interior decor, supplying that element for clients who, according to Count Boni, knew more about making money than about appreciating tradition or beauty. For men such as William Collins Whitney, Clarence Mackay, and Frederick Vanderbilt,

White plunged himself into the international network of trade in fine and decorative arts that extended from London to Cairo, Rome to Istanbul, and Paris to Madrid. And then, having successfully commandeered the requisite relics, he stepped easily into the role of interior decorator by installing the treasures he had brought back to the United States, sometimes in loads of forty or fifty crates from a single European dealer.

The interior decorator was virtually unknown before the Civil War. Architects created rooms, which they left empty as they departed the site, to be filled by the owners, usually piece by piece with whatever style of furniture was then in vogue. Then, after the war, the great wealth of the new American millionaires retained people who were familiar with Louis XVI ensembles, Japanese aesthetics, Tiffany glass, Renaissance tapestries, and Brussels carpets.

When Stanford White began his career as an architect in the mid-1870s, professional standards for interior decorators had yet to be established.[9] The earliest decorators, all of whom were men, tended to emerge from the ranks of furniture makers—that is, artisan craftsmen—who expanded beyond mere cabinetmaking by adding upholstery to their list of skills; they, too, formed international contacts that turned their showrooms into bazaars of imported delights from faraway places, especially after the Philadelphia Centennial Exhibition of 1876 made Americans much more aware of the world as a vast emporium.[10]

The profession slowly emerged and defined itself, thanks in part to the publication of a number of books on the tasteful interior. The essence of High Victorian, especially in the neo-Gothic and Renaissance Revival traditions, was defined in *Hints on Household Taste* (1868) by the Englishman Charles Locke Eastlake and popularized in the United States by Clarence Cook's *House Beautiful* (1877). For those who desired a treatise on Japanese aesthetics for a room decorated in that manner, Edward W. Godwin's *Art Furniture* became available in 1877. Numerous new periodicals catered to the thirst for information by making features on the tasteful decoration of interiors one of their main components—for example, the *Art Amateur,* which began publication in 1879; *Decorator and Furnisher,* which first appeared in 1882; and *Art and Decoration,* which was first printed in 1885.

WOMEN AS INTERIOR DECORATORS

Although women did not at first practice interior decorating, they played an important role by writing about it, preparing the way for those who actually entered the profession. Harriet Prescott Spofford published *Art*

Decoration Applied to Furniture in 1878, and three years later came Constance Cary Harrison's *Woman's Handiwork in Modern Homes.* Louise Forsslund's article "Woman's Influence in House Decoration," which appeared in the May 1906 issue of *Good Housekeeping,* is an example of writing on the subject that was aimed at the middle class.

The most important essay to address the matter was undoubtedly Edith Wharton's *The Decoration of Houses,* coauthored by Ogden Codman and published in 1897; it stressed the architectonic character of rooms, declaring architectural qualities to be as important to any chamber within as they were to the design of the exterior. In a statement that reflected the role that Stanford White had assumed, Wharton and Codman asserted that instead of the architect or builder's simply erecting bare rooms that were then decorated "superficially," the architect should design more of the decor as an integral part of the total ensemble. "Rooms may be decorated in two ways," they stated, "by a superficial application of ornament totally independent of structure, or by means of those architectural features which are part of the organism of every house, inside and out."[11]

Wharton and Codman's book authoritatively decreed that the only acceptable styles were those invented in Italy after about 1400 or those established in France after 1500, and—in an attack on all that Louis Sullivan and the young Frank Lloyd Wright advocated—that any effort to create a modern style expressive of modern times was utter folly. In *Kindergarten Chats,* Sullivan had sarcastically chided American architects who, instead of taking up the banner of modernism, were doggedly devoted to styles that originated in ancient Rome: "I am going to insist that the banker wear a toga, sandals, and conduct his business in the venerated Latin tongue. . . . I do not relish Roman-temple banks."[12] But the "modern" styles of the 1890s in Europe—Art Nouveau and Jungendstil—were unacceptable to Stanford White and his crowd "because Americans instinctively felt that what they needed decoratively was the good safe thing and not the latest innovations."[13] Wharton's aesthetic code was, in fact, expressed even earlier by a Mr. Dyer of Boston, who wrote in 1883 that "Louis XVI and Renaissance are the styles we have been principally using during the past ten years. . . . Instead of introducing new ideas, the tendency is to go back to the old schools. . . . You cannot produce anything that will surpass in elegance or style the furnishings and decorations of the Louis XVI period, and all efforts to formulate new departures end in a reproduction of what has already been done."[14]

Candace Wheeler (1828–1923), a sometime collaborator with Louis Comfort Tiffany and in 1877 the founder of the Society of Decorative Arts,

was perhaps the first American woman to become an interior decorator, although she did so as an extension of her work as an artisan.[15] Elsie de Wolfe, however, was a protégé of Stanford White, who arranged for the actress-turned-socialite-turned-decorator to do the interiors of the Colony Club in New York City. She eventually worked with Joseph Duveen on decorating the Henry Clay Frick mansion on Fifth Avenue, selecting and coordinating furnishings that paralleled the quality of the paintings that Frick was collecting. De Wolfe's book *The House in Good Taste* (1913) was essentially a paraphrase of Wharton and Codman's *The Decoration of Houses*.

EXECUTING THE ARCHITECT'S INTERIORS

A number of firms were established to execute that which architect and decorator devised: Herter Brothers of New York, A. H. Davenport of Boston, Allard and Sons of Paris and New York, Henry Watson of New York and Paris, Stefano Bardini of Florence, and Duveen Brothers of London and New York were among the most prominent. One contemporary commentator observed that those who had the requisite wealth and the willingness to spend it on furnishing a grand house would find that the materials were readily available:

> At Watson's or Duveen's may be obtained tables and cabinets of Boulle, consoles, screens, even old sedan-chairs. . . . At Allard's, there are tapestries after Boucher, with Chinese landscapes as they were imagined to look in the days of the Regency . . . and chairs and sofas in old Beauvais, which would convert any room into a flower-garden. . . . Old bronzes, old lustres, crystals, Sevres . . . among which the eighteenth-century dames and petits maîtres ate, drank, danced and chattered are also to be bought, at prices that would astonish them. And as for the framing and setting off of them with modern wood-work, painting and gilding when necessary, the dealers understand that business to a nicety. Given a Louis XVI vase, it is easy for them to supply a Louis XVI room to put it in.[16]

These establishments employed highly skilled craftsmen who could either duplicate the ancient paneled interiors of the Old World or adapt and install originals that had been dismantled and shipped to the United States. When a decorator required period-style furniture or furnishings and the original antique pieces were either unavailable or undesirable, the same shops could provide excellent reproductions, whether the order was for a

giant Francis I fireplace carved of Caen stone or a set of twenty-four elegant Louis XV side chairs.

An article titled "The Collection and Designing of Furniture" appeared in 1902, when Stanford White was at his peak as a designer of interiors. The anonymous author noted that procuring original period pieces could be difficult and expensive but added that some firms were "prepared, not only to copy such pieces with the utmost fidelity and skill, but they make a specialty of designing and manufacturing furniture, which are as good as the old pieces in outline and proportions, and which are more precisely adapted to modern needs."[17] The author then specifically addressed interior designs by noting that those establishments were prepared to "carry out the designs of architects, to interpret the ideas of customers, and to assume the responsibility themselves for the entire furnishing and decoration of the most elaborate houses." The writer concluded,

> They have in their draughting rooms designers who have devoted their lives to the study of the forms and proportions of good furniture. They have in their shops workmen, who have been in their employ for years, and who are in sympathy with their methods. They can control the pieces of furniture they turn out to the smallest detail of their design. . . . They are prepared, in addition to supplying furniture, to do all kinds of architectural cabinet work, and if desired, the decorative painting and drapery of a house. Such organization cannot be put together in a few months; it must be the growth of many years, and the product of good taste, labor, study and experience.[18]

Stanford White worked closely with all the aforementioned firms, and with many others, as their craftsmen executed his artistic conceptions of interiors. Those artisans and their handiwork appear many times throughout the book as I discuss the installation of White's interiors. To be sure, for each major project undertaken by McKim, Mead & White, some member of the staff—a sort of project foreman—handled the routine business in day-to-day dealings with those firms. But considerable correspondence exists directly between White and, say, the houses of Allard, Duveen, and Davenport, demonstrating that White was directly involved in a collaborative effort to achieve the desired results. Letters to and from those distinguished houses of decoration, along with such informative documents as estimates for work to be done and bills for services, abound in the McKim, Mead & White Papers. Scholars have studied extensively

the craftsmen of earlier periods of American art, but here is a whole new division of labor and talent that was integral to the creation of interiors expressive of an age of wealth, exuberance, dynamism, and culture consciousness. Those talented craftsmen toiled at the whim of the architect's clients, as when Helen Hay Whitney decided that she wanted an armchair of Louis XIV design adapted to serve as a toilet seat in her grand bathroom in the town house that Stanford White designed for her and her husband, Payne Whitney. We may smile at this quirky display of affluence, but we must remember that at the time a standard form of porcelain toilet fixture did not yet exist, and when a client rejected a design or came up with one of her own, architects and craftsmen had to adapt. The same was true with respect to that new marvel, electricity, which necessitated the reworking of candle sconces and gas jets to accommodate it. The electric lamp made its appearance in 1879, but its incandescent bulb was glaring and harsh; in response, the studios of Louis Comfort Tiffany created their famous leaded-glass shades to tone down the illuminating power of the bare bulb.

THE GREAT EUROPEAN HOUSES OF DECORATION SET UP SHOP IN THE UNITED STATES

Several great European houses of decoration sent designers and workers to this country to establish branches, primarily in New York City. Stanford White's career became intimately interwoven with the European system, once that system was transplanted into the United States.

In France, the rise of the decorators began rather modestly at midcentury, with an *antiquaire,* a French term for a dealer who bought and sold everything from old carved paneling (boiserie) to ancient stonework, from antique furniture to portieres (drapes hung in doorways). The *ebeniste* was an artisan who made fine furniture, mostly in a recognized historic style, whereas the *tapissier* was an upholsterer who also dealt in tapestries or rare fabrics. Many of these workers enlarged their realms to become decorators, but they did not begin to refer to themselves as *decorateurs* until around 1900.

In 1878 the young Stanford White, then just beginning his career as an architect and a decorator, went to Paris, where he saw the great exposition at the Palais de l'Industrie—a fair so wondrous that people discussed it for many years after. In 1882 the art critic and journalist Theodore Child wrote of what he had observed there:

> All the exhibits [in the French section] were either copies or reminiscences. . . . The styles of Henry II, Louis XIII, Louis Quatorze . . . were in vogue next to the Renaissance. . . . The French cabinet makers, with their fine wood, fine carving, and fine workmanship, continue to imitate the models of the past. Many of the first Parisian houses devote themselves purely . . . to reproduction. One house has a specialty of Louis XIV, XV, [and] XVI and reproduces the incrustations of Boulle and the chiselled bronzes of Gouthiere with such exactitude, that a hundred years hence it will be impossible to tell the original from the copy; another house makes a specialty of reproducing the Gothic and Renaissance models preserved in the Cluny Museum. . . . No praise is too high for these reproductions.[19]

Many major decorator houses of France began operations in the 1850s and 1860s and prospered as a result of the extensive ornamentation of Paris undertaken by Napoleon III and Eugénie during the Second Empire. At that time, their royal highnesses wished to affirm their regal lineage by endowing themselves and their capital with the architectural and domestic trappings of the great Bourbon kings of France—Louis XIV, Louis XV, and Louis XVI, whose fashions and furnishings became the stylistic rage of Paris. In short, Napoleon III and his empress were using historic Bourbon styles for sociopolitical purposes, as much as the American millionaires later used these styles to promote their claim to aristocracy.

In Paris the foremost firm was that of Jules Allard and his sons, which executed rooms for Stanford White in, say, the Payne Whitney mansion, and for Richard Morris Hunt at the Breakers in Newport. By 1885 Allard's had so much business in the United States that it established a branch in New York to handle it all. But there were many others in Paris as well—Carlhian & Beaumetz, for example, which executed the reception room for Hunt's Fifth Avenue mansion for Elbridge Gerry, and Henri Dasson, who created the furniture for the library at Marble House in Newport. Jansen et Compagnie of Paris was well known for its period-style furniture. Leon Marcotte actually packed up his affairs and moved to New York City, where he served for a time as a partner of the architect Detlauf Lienau. Later Marcotte established his own factory to produce unique, exquisite furniture for the homes of the very wealthy; around 1884, for example, Marcotte provided some furniture for the Henry Villard Houses on Madison Avenue, the interiors of which were designed by Stanford White.

Should one desire the finest woodcarving then available—for ornate staircases or overmantels or headboards of beds—architects and decorators often turned to the talented Italian Luigi Frullini (1839–1897) of Florence, and his handiwork appeared in many great Gilded Age houses built in the United States.[20] In London, Graham and Jackson was the most important firm of cabinetmakers; it worked in a French mode, copying Parisian pieces and even hiring French designers such as Eugene Prignot and Alfred Lorimer. Sir Charles Allom, of the London house of White Allom, frequently collaborated with Joseph Duveen, as in the interiors of the Frick mansion in New York. Allom also worked on William Randolph Hearst's California castle, in San Simeon, and on Whitemarsh Hall, outside Philadelphia; White Allom opened a New York City branch in 1905. Daniel Cottier, a skillful glassworker of London, became a decorator and in 1870 formed Cottier and Company, makers of art furniture, glass, and ornamental tiles; three years later, he moved to the United States, where he collaborated with American architects in much the same way that Louis Comfort Tiffany and his studio partners did.

All this inevitably led to the creation of similar houses of decoration in the United States. I have already mentioned the Herter Brothers; although both Gustav and Christian had retired by the time Stanford White began designing his millionaires' mansions, White often turned to the brothers' foreman, William Baumgarten, who took over the house of Herter and continued operating it well into the twentieth century. Davenport's of Boston also provided some furnishings for the Villard Houses and for Clarence Mackay's Harbor Hill on Long Island. Duveen Brothers—first under the direction of Joel and old Uncle Henry, who were succeeded by Joel's son, Joseph—was also involved in completing a number of White's interior commissions. Eugene Glaenzer's name appears frequently in the papers that deal with White's interiors, for Glaenzer's firm not only dealt in fine paintings and decorative arts in New York City but also served as White's importing agent, attending to everything from packing special items for shipment to receiving crates of items that White had sent over from Europe.

Many studios, shops, and factories specialized in everything from the production of small side tables to the installation of huge window assemblages to the creation of whole rooms, demonstrating that White could call on an abundance of talent as he designed various rooms.

THE AESTHETIC MOVEMENT AND THE PERIOD ROOM

Two of the most important phenomena of the late nineteenth century, insofar as the decoration of houses was concerned, were the Aesthetic Movement and the rise of the period room. The basic premise of the former was that every item put into a room should be a thing of beauty, a work of art of its kind, and that the more such objects there were, the greater aesthetic effect the whole ensemble would have.[21] This sometimes involved historic pieces—everything from Asian ceramics to Renaissance tapestries—mixed with modern works such as stained-glass windows by John La Farge, lamp shades by Tiffany Studios, embroidered portieres by Candace Wheeler, or a richly inlaid cabinet in various woods by Herter Brothers, with a clutter of curios such as peacock feathers or Turkish armaments thrown in. No one particular style had to dominate. The primary issue was the aesthetic excellence of all the parts, which contributed to the aesthetic diversity of the entire room. Such perfection not only declared the owners' high level of cultivation but also made them better people, through the osmosis of perfection, as it were. Henry James was fascinated with this notion and made it the theme of one of his finest novels, *The Spoils of Poynton* (1897). Harry Desmond and Herbert Croly noted: "The whole motive of the book is derived from the passionate devotion to a beautiful house, which is aroused in the woman who planned it, by the danger of it falling into the hands of people who will impair its perfection."[22]

Examples of pure Aesthetic Movement interiors include the rooms of the William Henry Vanderbilt house (1879), on Fifth Avenue, and Louis Comfort Tiffany's Veterans' Room of the Seventh Regiment Armory (ca. 1885) in New York City. By the mid-1880s, the interiors of McKim, Mead & White's Villard Houses were a composite of Aesthetic Movement touches—such as the zodiacal signs on which Stanford White and Augustus Saint-Gaudens collaborated—or of period-style rooms done in the Renaissance manner.

The period room first appeared during the Gilded Age, in two venues: museums and private homes. Museums and historic houses undertook the systematic re-creation of rooms of a given period or style in the aftermath of the Philadelphia Centennial Exhibition, which made Americans aware, and proud, of their colonial past. That great exposition of 1876, with its many displays of early American artifacts, led to the creation of innumerable Colonial and Federal rooms at such places as the New-York

Historical Society and the Metropolitan Museum of Art. Architects and curators also re-created ancient European rooms. An early example was the bedroom (antechamber and bed alcove, ca. 1718) from the Palazzo Sagredo in Venice (plate 1). By the late 1880s, the homes of the very wealthy were beginning to have period rooms as well—rooms that bore stylistic names such as the Gothic library, the Francis I salon, the Louis XIV dining room, and the Louis XVI music room. While the cultural institutions installed American period rooms—a Queen Anne parlor, for instance, or a Federal dining room—the parvenus of the Gilded Age more often opted for rooms of European origin that displayed aristocratic elegance. By then, White was devising quasi-period rooms for clients such as William C. Whitney, to which one or another of the "Louis" epithets was proudly applied.

But White was a creative decorator at heart and, while working in the context of both the Aesthetic Movement and the period room, refused to be restricted to one of those modes or any other mode. His intention was never a scholarly, archaeological re-creation of a period room, for he was indifferent to the correctness and purist objectives of the antiquarian who attempted, in museums or historic houses, to restore a period room exactly as it would have been originally: a polar bear rug on the floor of a Louis XVI salon presented neither an aesthetic nor a cultural conflict, to White's way of thinking.

This book, then, concerns the integration of all these various facets of the creation of interiors that were expressive of a new industrial and financial aristocracy in the United States, with Stanford White as a pivotal figure in the acquisition, adaptation, and installation of Old World aristocratic paraphernalia in the grand residences of the first millionaire society in the United States.

STANFORD WHITE'S EARLY LIFE

As Stanford White's life has been chronicled many times,[23] I will recount here only a brief general biography that concentrates on those early traits and events that contributed to the personality, aesthetic concerns, and social characteristics of the man as a collector, dealer, and decorator.

Stanford was the son of Richard Grant White, a well-known journalist, critic, and cultural man-about-town who was prominent in the art and music circles of New York City. In the year that Stanford was born, 1853, the elder White was asked to write the catalogue for the art section of the

Crystal Palace Exhibition in New York. We may perceive in the cultured home life, pleasure taken in social prominence, and interest in art certain factors that shaped the life of young Stanford.

There was another matter as well. Stanford's paternal grandfather had been a successful businessman in New York, the owner of several clipper ships engaged in transoceanic trade and a manager of an ironworks; however, that shipping and industrial empire collapsed in the mid-1840s, leaving the family destitute. Forever after, Richard Grant White sulked about the loss of a lifestyle that he believed should have been his—that is, he was born to wealth but then deprived of it and its privileges. Richard Grant White was a descendant of John White, who had come to Massachusetts from England in 1632, and Richard Grant White considered himself a member of the Yankee aristocracy. But he always lamented that he was never accorded the aristocratic status due him and that in general the United States suffered from the absence of an aristocracy to direct its cultural affairs and stimulate its intellectual life. These attitudes, discussed openly in the little family circle of White, his two sons—Richard Mansfield and Stanford—and his wife, Nina, instilled in Stanford a certain feeling that he should live the life of nobility, as resplendently as anyone in the country, even members of its emerging industrial aristocracy, with whom he would regularly associate in later years.

Richard Grant White was perhaps an influence on Stanford in another way, for the senior White is believed to have kept a mistress, and the son's later penchant for philandering is well known. As Paul Baker has stated, the elder White's superior self-image made him feel that "some of the accepted standards of the time just did not apply to him," and his son must have absorbed something of this notion.[24]

Stanny, as he was known from childhood, grew up on East Tenth Street and attended a nearby public school. His parents encouraged his early artistic interests. By the time he was sixteen, he had determined to become a painter, so Richard Grant White took his son to talk with a friend, the artist John La Farge. Embittered by what he considered a lack of respect and patronage for artistic talent in the United States, La Farge suggested that Stanford consider architecture instead. Another friend of the family, Frederick Law Olmsted, agreed and introduced Stanny to Henry Hobson Richardson, who hired him at once, and the course of Stanny's career was set. Richardson's office immediately recognized Stanny's extraordinary ability as a draftsman, and the head draftsman of the firm, a young man named Charles Follen McKim, immediately put it to use.

Two years later, in 1872, Richardson won the competition for a large Romanesque church on Boston's Copley Square—Trinity Church. After McKim left the firm to begin his own architectural practice, Stan became chief draftsman on that important project. Traveling frequently to Boston by train with Richardson, he began to indulge joyfully in his employer's love of food and drink, again establishing a pattern for later life. The interiors of Trinity were to be like those of no other church in the United States—an extravaganza of murals, stained-glass windows, and polychroming and gilding that dazzled the eyes of Episcopalian parishioners. As construction neared completion, a small army of artists and artisans went to work on its interior decoration, among them, John La Farge, Augustus Saint-Gaudens, Kenyon Cox, Frank Millet, and Francis Lathrop—all artists with whom Stan would work again years later in connection with interiors for the great mansions that he would design.

Someone in Richardson's office had to coordinate all this varied artistic activity, a job that fell to Stanford White, giving him valuable experience—by the time he was twenty-three—in the integration of multiple art media for the creation of grand interiors. When Richardson received the commission for the William Watts Sherman house in Newport, Rhode Island, the senior architect again called on Stanford's talent. With the increasing success of Henry Hobson Richardson, involving numerous important commissions in the late 1870s, Stanford's fortunes rose, too, as did his reputation as both a masterful articulator of architectural details and an innovative coordinator of brilliant multimedia interiors. Insofar as beauty was concerned, he was totally committed to nothing less than perfection of design, color, and form.

White continued to live with his parents on East Tenth Street in New York, not far from the studio of his friend Augustus Saint-Gaudens. White became a member of an intimate circle of the art world when he joined the Tile Club, a group of artists who met regularly but informally to sketch on tiles.[25] But he was eager to see Europe, and so on 3 July 1878 he sailed aboard the *Pierre*, joined at the last moment by his friend Charles Follen McKim. The duo became a trio in Paris, where they teamed up with Saint-Gaudens. The sculptor, who was then working on a statue of Admiral David Farragut, asked White's advice on the design of a base for it. Thus began a series of collaborations that lasted until the early twentieth century and that revolutionized the concept of design for the bases of statues.

After seeing the sights of Paris, the three men departed on a walking tour of the Romanesque country of France, for—thanks mainly to Richardson—

Romanesque Revival was then quite the hot ticket architecturally. Back in Paris, White shared rooms with Saint-Gaudens, cementing a friendship with drinking, joking, and wenching to a degree that surpassed the more staid Charlie McKim's level of indulgence. White remained in Europe for just over a year, visiting Rome, Venice, and Verona before returning to New York in 1879. At this point, let me note three important factors that would affect Stanford White's later career. First, he had initially wanted to be a painter, suggesting an innate predilection toward painterly things as opposed to architectural/mathematical/engineering inclinations. Second, he had no formal schooling whatsoever as an architect and/or engineer; that is, he was not exposed to the rigorous training of, say, the Ecole des Beaux-Arts in Paris the way that Richard Morris Hunt and Charles Follen McKim had been. Third, at the very commencement of his life's work, he was thrust into a large multimedia interior-decorating project at Trinity Church and given the task of coordinating color, murals, mosaics, stained glass, and various decorative arts. The last greatly appealed to him and established the course of his specialization a few years later with the firm of McKim, Mead & White. The first two points tell us that, by his nature, he did not entirely think like an architect. All this helps explain the delight that he took in devoting much of his time to the decorative aspects of his firm's commissions. At the same time, I should hasten to add, this assessment is not meant to demean in the least White's proven ability as an architect in the mature years of his career.

THE FIRM OF McKIM, MEAD & WHITE

Charles Follen McKim (1847–1909) came from a good Philadelphia family and gained New England connections when his sister married a son of William Lloyd Garrison.[26] Upon graduation from Harvard, McKim, like Richard Morris Hunt a few years earlier, went to Paris to study architecture at the Ecole des Beaux-Arts. But he found the architecture of France rather frivolous and much preferred that of ancient Rome and brought to its study a scholarly archaeological devotion that deepened throughout his life, renewed by his almost annual visits to Italy. Margaret Terry Chanler remembered him as "a charming man of exquisitely fastidious taste and ardent classical convictions."[27]

In personality and temperament, McKim could hardly have been more different from his eventual partner. Pensive, prudent, reserved, always keeping the steady course, McKim was often the anchor to the impetuous

Stan. McKim's two chief contributions to the firm, once it was established, were his celebration of the city as the very center of civilization and his ability to organize large projects—such as the Boston Public Library and New York's Pennsylvania Station—into beautifully logical plans. Upon his return from Europe, Stanford White entered the architectural office that McKim and William Rutherford Mead (1846–1928) had recently established. In the division of labor within the firm, Mead emerged as the highly efficient office manager who kept all the projects moving along, supervised what became a legion of draftsmen, and kept an eye on accounting and other paperwork.

With all three members on board by 1879, the firm received a number of important commissions in the early 1880s: the Casino, the Isaac Bell House, and the remodeling of the Gothic Revival cottage called Kingscote, all in Newport. But the commission that established the office's reputation as designer and decorator of monumental mansions was that for the Villard Houses (1882–1885), a six-house project that occupied a full block on Madison Avenue between Fiftieth and Fifty-first Streets. Breaking with the grid of row upon row of undistinguished brownstones that had dominated New York architecture for more than forty years, the Villard Houses were of a classical Roman palazzo style that found favor among the new American millionaires as expressive of great wealth, aristocratic position relative to the middle class, and triumph in the economic and social Darwinism of the day. Here was a mode of architecture that duly represented the ambitions and bravado of that new stratum of American society, an aristocracy based on enormous wealth.

Together with Richard Morris Hunt's Petit Château (1882), erected only a block away on Fifth Avenue for Alva and William Kissam Vanderbilt, the Villard Houses defiantly denounced the ubiquitous, monotonous brownstone as the domicile of a comfortable but dowdy middle class. From then on, the firm of McKim, Mead & White joined that of Richard Morris Hunt (until his death in 1895) as the preeminent architects in service to the Gilded Age.

Although McKim, Mead & White occasionally experimented with the Château and Colonial American Revival forms, the Roman or Renaissance palazzo style tended to dominate its designs, as in New York City's Metropolitan Club (1893) and the several buildings for the new campus of Columbia University (beginning in 1893). It was probably Charles Follen McKim, and perhaps the firm's talented draftsman Joseph Wells, who came up with the idea of countering runaway urban sprawl

with this classical style, for it was sufficiently monumental and dignified to stand up to the urban environment, even dominate it, and it was elegant enough for the aesthetic purposes of the City Beautiful Movement, which arose in the last years of the nineteenth century. Although the firm worked in other styles as well, it often turned to the Roman Renaissance for inspiration in the design of exteriors. Some critics said that Hunt's Château style of mansion was based on a rural architectural form and was therefore inappropriate for the urban setting; McKim, Mead & White used a style that was, in its origins, an urban type and therefore more suited to the modern cityscape.

However, when Stanford White was designing interiors, his primary sources of inspiration were the styles of the French Renaissance, Baroque, and Rococo eras—of Francis I, Henri II, Louis XIV, Louis XV, and Louis XVI. And if Charlie McKim's noble, restrained classicism determined the overall design of a given commission, Stanford White's details were what gave an exquisite aesthetic finish to the building. White became one of the foremost designers in the Beaux-Arts mode in his era. His was truly a natural gift, which he exploited to maximum advantage. More than a pedantic reciter of academic clichés, he had a flair for innovative decoration, which the enormous wealth of his clients permitted him to explore. While his self-taught knowledge of Renaissance, Baroque, and Rococo architectural details may have been his inspiration and his starting point, from there White was engaged in reinvention rather than imitation. In the houses that I discuss in the chapters that follow, we will see those special gifts at work.

\mathscr{S} TANFORD WHITE AS DEALER IN ANTIQUITIES

DURING THE DECADES BETWEEN THE CIVIL WAR AND WORLD WAR I, American millionaires or their agents bought up Europe's treasured antiquities in enormous quantities and shipped them back to the United States. Many noble families on the Continent and in England had little else to sell—other than their titles and themselves. One by one, they were becoming an impoverished caste and seemed helpless to stop the transfer of power to the parvenus, with their bushels of profits from shoe polish, celluloid shirt collars, a new process for manufacturing barbed wire, or a lucky strike at a gold field in the West. The nouveaux riches of the Industrial Revolution came not only from the United States, for England, France, Germany, and other countries also had newly wealthy social climbers who were storming the gates of the old order. But members of the European aristocracy found it especially distasteful that so many of their treasures were being carted off to the United States to be fondled by people who may once have worked as blackened coal miners, hog butchers, or greasy-fingered mechanics. In fact, Cornelius Vanderbilt's father had been a ne'er-do-well farmer on Staten Island, and John D. Rockefeller's forebears were impecunious. John William Mackay had arrived in this country from Ireland as a penniless youth but then struck it rich with the Comstock Lode. America's first millionaire society was filled

with stories of rags to riches, of fabulous wealth suddenly materializing in the hands of men and women of humble origins. American millionaires now numbered in the thousands, and they were determined to assert their place at the peak of the social pyramid, nationally and internationally, through the ostentatious display of their wealth.

In the United States art, architecture, and the decorative arts were called into service to encase this crass new social creature in the paraphernalia of the Old World. That was where Stanford White came in, for he was an avid collector of exquisite bibelots and rare antiquities, sometimes for himself, sometimes as agent for one of his wealthy clients, sometimes on speculation with an eye to turning a profit when he could sell a piece or a room to someone for whom he was then designing a grand house. His clients respected his taste, and they eagerly purchased items that he collected, for they were unable to do for themselves what he could do for them so brilliantly.

White felt no qualms about voraciously raiding the Old World aristocracy's treasures and carrying them back to the United States, for he believed in "the right of all dominant nations, as exercised throughout history, to plunder the art from earlier generations."[1] Ironically, governments often contributed to the forced sale of national treasures. In the nineteenth century, for example, the British Parliament continually passed higher death and inheritance taxes to pay for the social programs that it instituted. The law had long forbidden the aristocracy, heirs to magnificent castles or country houses with splendid collections, to break up such holdings by selling portions of them, yet the nobility had to pay enormous inheritance taxes when properties passed from one generation to the next. But in 1882 Parliament passed the Settled Lands Act, which made it relatively easy to sell both land and goods that had been entailed, or held in trust, for generations. This brought about a dealers' field day, with no thought to whether the choicest pieces went where the money and power were—that is, across the Atlantic to that upstart nation that had almost no history, had never possessed an aristocracy, and had never produced an aristocratic art of its own. In this rampant redistribution of wealth and patrimony, dealers—the house of Duveen, for example—made a fortune selling to collectors such as Henry Clay Frick and the Henry Huntingtons and Stanford White in his capacity as architect-decorator.

White's activities from about 1885 to 1906 involved not only the designing or remodeling of numerous great mansions but also the interior decorating of their more important rooms. A partial list would include (all New York City unless otherwise indicated):

1882–1885	Villard Houses, 451–457 Madison Avenue
1889–1890	William C. Whitney residence, 2 West Fifty-seventh Street
1892+	Stanford White residence, Twenty-first Street and Lexington Avenue
1894	Colonel Oliver Payne residence, 852 Fifth Avenue
1896–1899	Frederick Vanderbilt residence, Hyde Park, New York
1897–1902	William C. Whitney residence, 871 Fifth Avenue
1897–1900	Stuyvesant Fish residence, 25 East Seventy-eighth Street
1899–1901	Henry W. Poor residence, 1 Lexington Avenue
1897–1902	Tessie Oelrichs's Rosecliff, Newport, Rhode Island
1899–1902	Clarence Mackay residence, Roslyn, Long Island
1898–1906	James Breese's Orchard, Southampton, Long Island
1900–1902	William C. Whitney estate, Westbury, Long Island
1902–1906	Payne Whitney residence, 972 Fifth Avenue
1904–1906	W. K. Vanderbilt, Jr., residence, 666 Fifth Avenue
1905–1906	Harry Payne Whitney residence, Westbury, Long Island

Because White, on his almost annual buying trips through Europe, was often acquiring objects and furnishings for two or three clients as well as for himself, it is difficult to tell, from the surviving records, exactly what was destined for which splendid residence. These trips were normally financed in advance by his clients, who made large sums available for him to draw on as he made his rounds of antique shops, sometimes rendezvousing with his patrons at one or another of them. His excursions often lasted for several months, taking him to England, France, Italy, Spain, Germany, Belgium, or even Egypt and other parts of the Near East, where he often could not resist the treasures of the bazaars.

The European trips were a combination of sightseeing and business. On a trip to Paris in 1889, Stanford and Bessie, his wife, saw the newly erected Eiffel Tower and visited the International Exposition of that year, one of the greatest international displays of industrial goods and art. On the same trip, White toured the Parisian antique shops on behalf of William C. Whitney, whose New York City house White was then remodeling; Whitney had specifically asked White to look for things for his new residence. In Florence, Stanford and Bessie visited Arthur Acton, the antiques

dealer who was to become White's agent in Tuscany. On another trip several years later, in 1893, Stan and Bessie went to Egypt, where they climbed to the top of the Great Pyramid of Cheops. The prominent author Richard Harding Davis joined them as they sailed up the Nile to Aswan in a rented *dahabeyah*. From Paris, the Whites and Davis went out to see Versailles.

All the while, Stan was acquiring bric-a-brac and bibelots by the score, and the dealers were only too happy to arrange for their crating and shipment back to New York. His annual trips brought him into contact with an enormous number and array of dealers, agents, and collectors.

ON THE TRAIL OF ROOMS

The interiors that White created in Fifth Avenue palazzos, Long Island châteaux, and elsewhere consisted of a ceiling, four walls, a floor, enframements for doors and windows, cornices, moldings, and fireplaces—the interior architecture, to distinguish it from the furnishings of carpets, draperies, tables, chairs, sofas, desks, beds, and so forth. White obtained these architectural assemblages in two ways: by ordering them from decorating firms renowned for their exquisite craftsmanship, which produced them in various styles (French Renaissance, Louis XV, seventeenth-century Venetian, or whatever the client and architect desired), or by literally buying a room out of the castle of a down-and-out Italian nobleman or from the country house of some English gentleman of aristocratic lineage or from the chapel of a French monastery, or some such place.

An 1898 letter from Duveen Brothers, London, to Stanford White reveals that whole rooms—of splendid artistry and ancient vintage—were available:

> In reference to the Italian carved Boiserie in Genoa, we beg to say that this is sold, but we are sending you by this mail, photographs of a room which is offered to us—It is belonging to an Italian nobleman near Turin and it consists of: 7 doors, with upper doors, beautifully painted; 7 door frames with the upper part painted; 5 fine Consoles with mirrors (marble tops); 10 window frames; 4 mantel mirrors; (about) 900 feet of woodwork (wainscoting), 3 feet wide; 200 feet of molding; 8 room corners finely carved; 14 paintings above the door and door frames. All this is very richly carved and gilded and genuine of the period. Please let us know if it is anything in your way—the price they ask is £2500.[2]

This letter was sent while White was remodeling the interior of William C. Whitney's house at 871 Fifth Avenue, where White eventually installed in several major rooms the carved boiserie and ornate ceilings from a number of Old World mansions.

Stefano Bardini of Florence could supply White with venerable partial- or whole-room assemblages, with antique furnishings and paintings. The extensive inventory, such as that offered to White in Bardini's galleries, appears in figure 1, and tapestries, ceilings, sculptures, furniture, and carpets of the kinds observed in this photograph regularly found their way into the interiors that White was executing in the United States. Paintings were also among the prized trophies that touring Americans like White or his patrons regularly purchased from Bardini's establishment, where the works of Botticelli, Uccello, Signorelli, Filippino Lippi, and other renowned Italian Renaissance artists were for sale (figure 2). In a letter, also from 1898, Bardini informed the American architect: "The ceiling [number] 1005 was sent from Genoa the 8th inst. . . . By the next steamer I will send you another ceiling, reduced to the dimensions of [your] room."[3] Bardini had earlier written to White, "Yesterday I shipped to Genoa the ceiling No. 122. . . . It is all numbered. . . . As for the other ceilings, I will push the work as much as possible and will ship them when finished."[4] On another occasion he wrote to say, "On Saturday I shipped to you the second ceiling, No. 128, by steamer. . . . In the house where I bought this ceiling there was under the cornice the frieze, decorated with frescoes, that you bought from me and which was at my Salon."[5]

Ancient rooms were available from many sources and for many reasons. I have already mentioned the necessity of a destitute aristocracy to part with its patrimony. But in Paris at least, a market in whole rooms was thriving because hundreds of old houses were being demolished to make way for Georges-Eugene Haussmann's grand new plan for Napoleon III's capital city. Before the demolition crews attacked those houses, any room of distinction had its paneling, ceiling, fireplaces, door and window frames, chandeliers, and so on dismantled and carried away to the storage warehouses of architects or art dealers.[6]

Georges Hoentschel was one such French architect who was largely involved with the restoration and reconstruction of antique interiors that dated from the late Middle Ages to the eighteenth century. He amassed an enormous collection of Gothic and Rococo decorative arts that included "all kinds of woodwork, garlands, festoons, brackets, balustrades, panels, overdoors, cabinets, chairs, tables, frames, pedestals, doors and ormolu

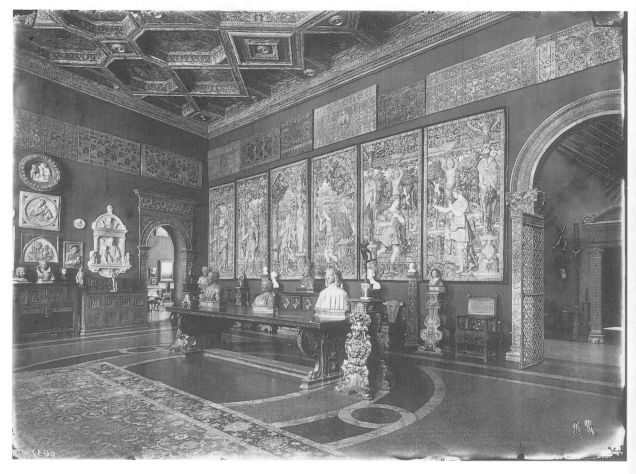

FIGURE 1. Tapestry gallery, Museo Bardini, Florence. Stefano Bardini was one of the most important antiquities dealers of the late nineteenth and early twentieth centuries. Beginning around 1895, Stanford White bought many items from him to furnish the grand rooms that he was decorating for his clients. His purchases were as large as an entire room or as small as a majolica vase. (With permission of Fototeca dei Musei Comunale di Firenze)

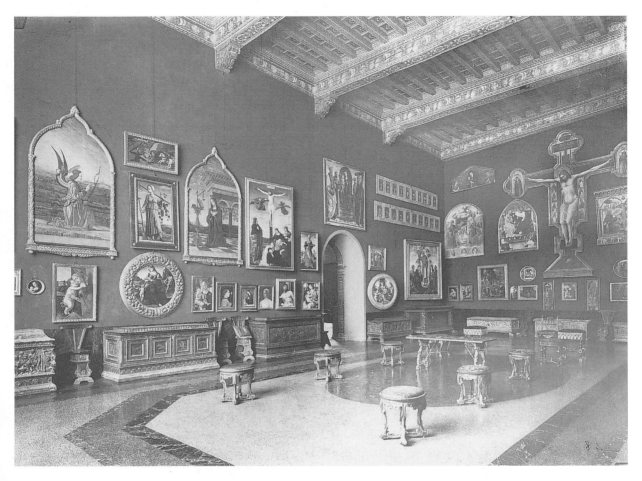

FIGURE 2. Paintings gallery, Museo Bardini, Florence. White often purchased paintings from Bardini on behalf of clients or for himself on speculation, with the intention to sell them to patrons at a later date. The photograph reveals the extraordinary inventory that Bardini maintained. Bernard Berenson, the well-known connoisseur of Renaissance art, regularly frequented Bardini's galleries, informing such contacts as Isabella Stewart Gardner and Duveen Brothers of London of things that he had seen there. (With permission of Fototeca dei Musei Comunale di Firenze)

decorations," which he kept in a two-story private gallery in Paris—that is, he kept it there until J. Pierpont Morgan saw it, bought it, and presented much of it to the Metropolitan Museum of Art.[7] At Hoentschel's gallery in the boulevard Flandrin (figures 3 and 4), the walls were lined with boiseries "of every size and description characteristic of the reigns of Louis XV and Louis XVI, many with their original colors and gilding still fresh upon them. . . . Many of these wood-carvings have an added interest from the fact that they come from historical buildings."[8] By the late 1880s, men such as Hoentschel were well aware that American millionaires were creating an expanded market for such things because architects like Stanford White were designing "period rooms" for the millionaires' new mansions.

REASSEMBLING ANCIENT ROOMS

When White bought the paneling, ceiling, floor, fireplace, and windows of a period room, its parts would be carefully dismantled, the pieces coded by number, and shipped to one of the great decorator houses such as Duveen's in London or Allard's in Paris. There, artisans would reassemble the parts in a warehouse so a client could view the room or a photographer could capture it so White could show it to a prospective buyer.

Because a room taken out of an Italian palazzo or a French château was inevitably of dimensions different from those of the room in the American mansion that was to receive it, a certain amount of reworking was necessary to make it fit in its new home. The correspondence of several of White's contacts, such as Bardini and the Duveens, mentions such remodeling, which was usually done before the panels, fireplace, door frames, or whatever were shipped to the United States. For instance, Duveen's of London once informed White that its artisans were working on an old room to reshape it to his architectural specifications: "In reference to the Louis XIV room, we intend starting alterations at once. . . . We conclude that you want the room altered according to [your] drawings." The letter then stressed that "although we have a ground plan which you gave us, we do not feel satisfied with this, [and] we want sizes of every wall and of every recess in the walls, in fact we want a perfect architect's plan."[9]

Once White had provided a plan and an elevation of his patron's room, the craftsmen at Duveen's, Allard's, or Bardini's would adapt the period room to the new dimensions, repositioning doors, windows, niches, fireplaces, and so on according to the plan. Bardini, for example, wrote to

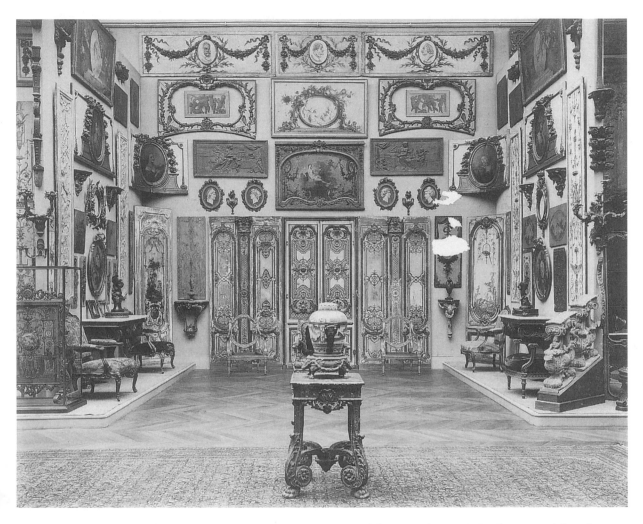

FIGURE 3. Georges Hoentschel apartment, Paris, 1900–1905. Georges Hoentschel was an architect in Paris who scavenged through an-
cient buildings that were destined for destruction as part of the city's many renewal projects. He filled his own apartment, on the boulevard
Flandrin, with architectural fragments that he would sell to decorators such as Stanford White. (Courtesy Madame Nicole Hoentschel)

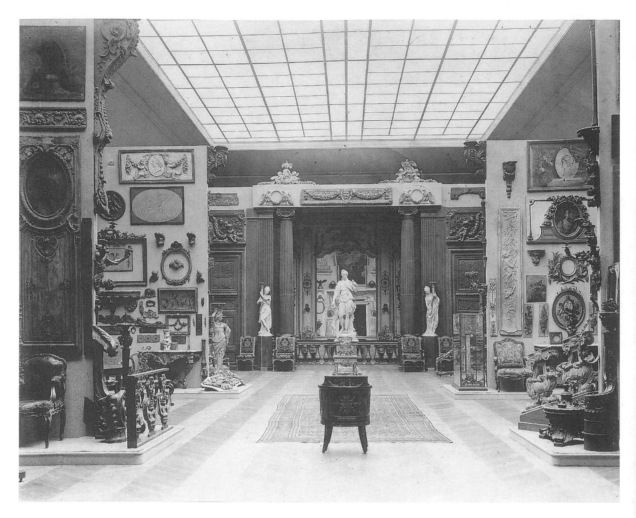

FIGURE 4. Georges Hoentschel apartment, Paris, 1900–1905. The Hoentschel Collection became known to Americans when J. Pierpont Morgan purchased more than three hundred pieces of it and presented them to the Metropolitan Museum of Art. The *Bulletin of the Metropolitan Museum of Art* of March 1908 described the gift, noting that it included "brackets, frames, screens, pedestals, balustrades, newel-posts, chairs, tables, cabinets, doors, overdoors, and panels. Many of the wood carvings have an added interest from the fact that they come from historical buildings." Stanford White would have been able to choose from just such an assortment at the turn of the century. (Courtesy Madame Nicole Hoentschel)

White in July 1898 regarding a ceiling that the Italian dealer had bought out of an ancient palazzo and installed in his own villa, where White had seen it: "I was obliged to take apart a great part of it in order to reduce it to the irregular shape . . . [of my] salon. Now, I have had to make it true again, and to do this work according to your dimensions I have had to take it to pieces, even down to the smallest part. I have then put it together again . . . [and] I have made what repairs I thought necessary. . . . I have used the old cornice but I have suppressed the frieze and architrave. . . . Moreover it is all numbered [for reassembly] and think it will go all right."[10]

In some cases the craftsmen who had worked on the room, in a crew of three or four, would accompany it when it was shipped to its new home in the United States, there to attend to its installation.

CREATING NEW "OLD" ROOMS: JULES ALLARD ET FILS

Sometimes the better approach was to create a period room anew—that is, made in a period style but wrought entirely by craftsmen in the employment of, say, Allard's. Paris was the hub of the decorative arts business in the late nineteenth century, mainly because of the grand remodeling plans—for palaces, train stations, civic and state buildings—instituted by Napoleon III during the Second Empire (1852–1870), and Allard's was one of the most important decorators in the French capital. Spectacular Gilded Age interiors such as the music room and the state dining room at the Breakers (1895), the Newport "cottage" that Richard Morris Hunt designed for Alice and Cornelius Vanderbilt II, were actually created in the Paris workshops of Jules Allard et Fils and then transported to the United States (plate 2).[11]

Allard's artisans were unexcelled at paneling, carving for furniture or architecture, gilding, decorative painting, furniture making, upholstering, glassworking (including mirrors)—in short, the whole range of skills necessary to produce a total period room. The house of Allard could also provide a wide range of fabrics, from ancient velvets for furniture to French Renaissance tapestries to rich brocade (old and new) for draperies, as well as embroidered portieres. In the several houses that I discuss in the pages that follow, Allard's services will be a recurring theme.

Nor were White and Hunt the only architects to make use of the house of Allard's many talents. Ogden Codman (1863–1951), a slightly younger architect-decorator who was a contemporary of Stanford White, spent many months each year in France for the very reason that the furnishings, old or new, for his clients' houses were most obtainable in Paris. To him,

FIGURE 5. Allard et Fils, presentation drawing for the salon of Alice Drexel, New York, ca. 1900. After consulting with White, one of Allard's draftsmen would prepare a sketch, such as this watercolor and ink on paper (24¾ × 15 inches [64.1 × 38.3 cm]), for the architect to show to his client. Allard's worked for a number of American architects of the turn of the twentieth century—George B. Post and Horace Trumbauer, for example, as well as Hunt and White (Preservation Society of Newport County)

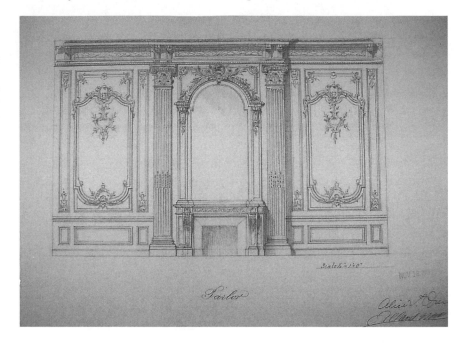

"France offered both the best quality and the best price, especially for the exact copies of Louis XV and Louis XVI furniture that were made to order for clients. In addition . . . there were the requisite curtains, trimmings, carpets, hardware, statuary, and bric-a-brac."[12] All the furniture, mantelpieces, and paneling for the Ethel Rhinelander King house (1900) in New York "were made to measure in France and shipped over, along with a *contremaître* or foreman who stayed for six weeks . . . while the installation was being carried out and everything carefully fitted into its place."[13]

A presentation sketch prepared by Allard's draftsmen for a New York City mansion is one of several similar studies now in the collection of the Preservation Society of Newport County, Rhode Island (figure 5). Ogden Codman also made presentation sketches of this sort, such as that for the bedroom of Louise Vanderbilt at her Hyde Park mansion (figure 6).

That Stanford White had established a close working relationship with the house of Allard is evident in the correspondence. In October 1897, Jules Allard, the head of the firm, wrote to White, who was then visiting Paris: "My son, Georges Allard, duly informed me that he has taken an appointment with you for tomorrow . . . morning at our show-rooms, Rue de Chateaudun. I am very pleased to hear this as I have several new things

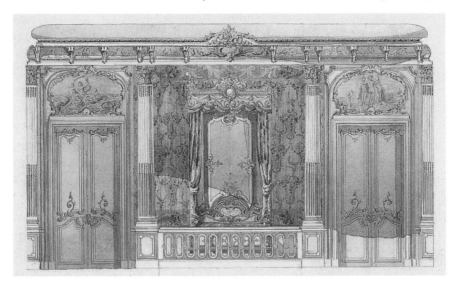

FIGURE 6. Ogden Codman, presentation drawing for the bedroom of Louise Vanderbilt, Vanderbilt mansion, Hyde Park, New York, ca. 1899. Ogden Codman, who was slightly younger than Stanford White, was an architect who, like White, had a special gift for interior decoration, and Codman's activities in that area increased as his career progressed. He is also known as the co-author, with Edith Wharton, of an influential thesis on interior decorating, *The Decoration of Houses* (1897). Codman did this sketch with watercolors and ink on paper (26⅛ × 14 inches [66.6 × 35.8 cm]). (The Metropolitan Museum of Art. Gift of the Codman Estate, 1951 [51.644.80 (2)])

of interest to show you and if you will kindly let me know at what time I may expect you I will arrange to be present."[14] Jules Allard and White sometimes went about Paris together, as when, on the same visit, they went to see the Senate and the Bank of France, two of the city's grandest showplaces of Second Empire effulgence, insofar as interior decoration was concerned. Allard's had also worked on White's own house at Gramercy Park in New York City: "We beg to send you herein enclosed bill folio #1345 . . . for all the work done at your residence during the year 1900, also bill folio 1342 for one large Fontainebleau bracket modelled especially for the Ball Room of Mr. Whitney's residence."[15]

Allard's sent and reissued a steady stream of bills to the office of McKim, Mead & White, begging for White's approval of them so they could be paid. For example, the Paris decorator sent an itemized bill for work on the house of Stuyvesant Fish, noting that it—like some others—was three years overdue, as was the bill for "one model done for the rooms of Hon. W. C. Whitney."[16] Duveen's, too, sometimes had trouble collecting for its services, as reflected in a letter of 1903: "The London account . . . has been standing since 1897, which is 6 years ago. The New York purchases acct . . . has been running since 1899, and the special acct . . . has been running since 1900. . . . I think the better plan would be for you to give us notes of acceptance for the amounts, spread over 24 months and then no doubt you would not feel it so much."[17]

The American branch of the house of Duveen had been doing business in Boston and New York ever since Uncle Henry Duveen had come over from London in the mid-1870s. Edward Fowles, the Duveens' senior associate, recalled that Henry soon had an impressive list of clients that included J. Pierpont Morgan, Benjamin Altman, and P. A. B. Widener and that Henry formed an "association with Stanford White . . . who at the time was converting many of the old brownstone houses on Fifth Avenue into mansions in the style of the French chateau."[18] Uncle Henry assisted several American architects and decorators in the refurbishing of fine mansions, supplying tapestries, porcelains, carpets, furniture, or whatever was needed: should a client desire a certain style of antique furniture and the originals were not available, "Uncle Henry ordered copies to be made according to precise requirements; or if the client had purchased . . . a set of antique chairs, and later discovered that the number was insufficient, Duveen's would endeavor to supply near-perfect copies to supplement the originals." Fowles then added that "the demand for furnishings and panelings became so great in the last decade of the century that the New York house contracted to place with the Parisian firm of Carlhian & Beaumetz annual orders worth not less than $500,000 in order to ensure first call on its artisans."[19]

FURNISHING ROOMS WITH "NEW" AND OLD ANTIQUES

Once interiors were created architecturally—either recycled ancient chambers or newly created period rooms—they had to be furnished appropriately. Again, the choice was between actual antiques or reproductions, for both were readily available. Regarding the latter, Ogden Codman believed that French workmanship was superior to any other and obtainable at a better price. French establishments would send him drawings or photographs of furniture of the Louis XIV through Louis XVI styles (roughly 1660–1789), from which he would choose what he wanted. "Although there was certainly no difficulty in purchasing antiques at the time," Pauline Metcalf has noted, "Codman found it far more expedient to have copies made that exactly fitted his clients' needs."[20]

The house of Duveen was also ever ready to accommodate clients with exquisitely made reproductions. Fowles remembered the case of a Major Saville of Rufford Abbey who had a fine set of two sofas and six chairs, all eighteenth-century French, that were covered in Beauvais tapestry. The suite was brought down to London to Duveen's and then sent to Paris to be restored: "At the same time, excellent copies were made by Carlhian

and Beaumetz. Both the originals and the copies were eventually shipped back to England. The copies were returned to Rufford Abbey, and Major Saville received $50,000 for the original suite."[21]

Paul Carlhian (d. 1914) and Anatole Beaumetz (d. 1904), creators of reproduction furniture and interior architecture since about 1870, enjoyed an international reputation. Beaumetz's brother-in-law was the French minister for the arts, who allowed Beaumetz to "borrow" from museums, historic houses, or government properties almost any piece that the firm wished to copy. The house of Carlhian & Beaumetz was so respected that it was asked to produce the six throne chairs needed for the celebration of the coronation of King Edward VII of England. One or the other of the partners crossed the Channel frequently to provide some service for Duveen Brothers, a house with which they worked for more than thirty years. The Paris art dealer René Gimpel had recommended Carlhian & Beaumetz to make some furnishings for the Fifth Avenue mansion that Richard Morris Hunt had designed for Elbridge Gerry, and Collis P. Huntington had commissioned Carlhian & Beaumetz to produce much of the furniture for his Romanesque stone castle, also on Fifth Avenue.[22] Fowles recalled his first meeting with Beaumetz when he came to London one time "to organize the scheme of decoration for the houses which Stanford White was building on Fifth Avenue."[23]

Before the turn of the twentieth century, several firms in the United States could produce period furniture with great exactitude and handsome finish. For example, Stanford White frequently called on the Boston house of A. H. Davenport to execute interior designs and provide reproduction furniture of high quality. Also, the house of Herter Brothers continued operations long after Gustav and Christian had retired, under the directorship of their former foreman, William Baumgarten; the craftsmen there—who had excelled in making decorative arts of the Aesthetic Movement—now made period reproduction furniture.

White's patrons relied on his taste and his international network of contacts for furnishing their new mansions. Word soon spread that he would arrive in Paris, London, Rome, Florence, Berlin, Brussels, or wherever with his pockets filled with the near limitless wealth of the richest families in the United States. The Vanderbilts, Whitneys, and others sent White off on gathering expeditions, virtually giving him carte blanche in using both his own taste in objects and the money to exercise it on their behalf.

Frederick Vanderbilt, grandson of the old commodore, wrote to the firm of McKim, Mead & White regarding a European buying excursion

that White had planned; Vanderbilt was eager to furnish his new mansion in Hyde Park on the banks of the Hudson River with Old World objects of virtu (figure 7), and he enlisted White's aid in doing so. "Dear Sirs," he wrote, "Mr. White is to use his own discretion in the selection of furnishings, but to be guided somewhat by the list and description of articles required, to be given him by McKim. . . . Old Italian mantels and furniture especially desired."[24] A few days later, a functionary of the firm drew up a memorandum addressed to Vanderbilt as a kind of contract, so there would be no misunderstanding regarding White's mission. It was agreed that Frederick Vanderbilt would arrange a line of credit with a bank in Paris on which White could draw for purchases, up to the then-sizable sum of $50,000; in time, that figure grew to $150,000. It was understood, the document stated, that White was "to exercise his own judgment" in making purchases, which, however, are "to conform, as far as possible, to the selection of such furniture, hangings, floor rugs, mantels and objects of a decorative character, in wood, metal, stone or marble, of Italian workmanship, as may, in his judgment, be appropriate for use in your [Hyde Park] house." It was further agreed that White should acquire "certain more important pieces, on which the interior of your house will depend for its chief adornment."[25]

The same day, Charles Follen McKim addressed to White a "wish list" memorandum for his pending European trip: "I suggest as desirable treatment of [Vanderbilt's] hall: Large central table; long divan or sofa, opposite fireplace backing against table, with important chairs flanking the fireplace. . . . Fine chimney piece for this hall. . . . Staircase Hall: Trousseau just under stairs with chair on each side; also small table with mirror at foot of stairs." McKim then continued with things he wanted for the reception room:

> Look up old room in Paris, but Style Louis XVI. . . . The woodwork being mahogany, and consisting of a wainscot not higher than 4 ft., the rest of the trim being also of mahogany, very simple; walls to be covered with damask, or leather; ceiling of stucco. The columns indicated at the entrance of this room are also desirable. Two mantel pieces are needed, and one, two or three rugs; a table and 24 chairs, or a type to be hereafter copied. . . . One or more sideboards, and at least two side tables. [Library] Walls to be covered with paneling in English oak, floor ditto. . . . Chimney pieces and columns at entrance in stone or marble. . . .

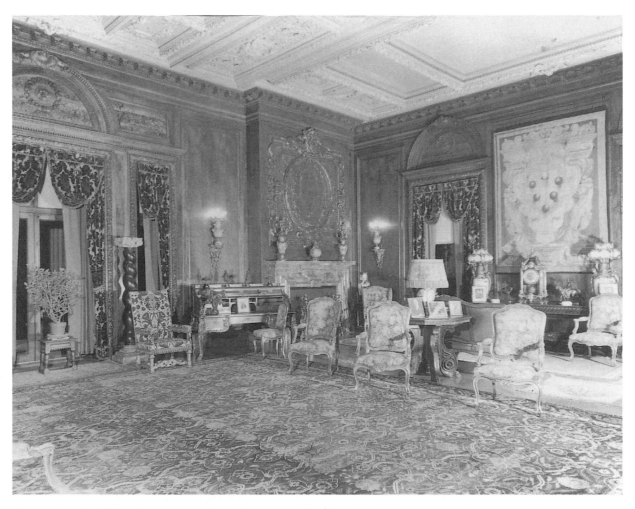

FIGURE 7. Stanford White, drawing room, Vanderbilt mansion, Hyde Park, New York, 1897–1898. In 1895 Frederick and Louise Vanderbilt purchased a 600-acre estate overlooking the Hudson River as a summer retreat. When the existing house on the property proved to be unsound, it was demolished and McKim, Mead & White was asked to design a new mansion. As the construction of the shell of the new house neared completion, Stanford White was sent to Europe to search for ancient furnishings for the interiors, and the results of his efforts are seen in this illustration. In addition to the antique furniture, a number of pieces were made—in imitation of seventeenth- and eighteenth-century styles—by the contemporary craftsman Paul Sormani of Paris. (National Park Service, Roosevelt–Vanderbilt National Historic Site, Hyde Park, N.Y.)

Old Florentine or Roman mirrors. . . . Any antique or finely wrought designs in metal work, such as fire-irons, candelabra, standing lamps, hanging lamps, etc. . . . Jardinieres: Stone or marble, for hall.[26]

Vanderbilt was, however, but one client whom White was to represent on his annual travels abroad. On 2 June 1898 (the following summer), White wrote to Colonel Oliver Payne: "I have a balance of 51,500 francs to account to you for, of the 125,000 you sent over to me in Paris. Against this are things which I bought as per the enclosed list. "[27] Also, on 14 October 1897 Harry Payne Whitney, son of William C. Whitney and nephew of Oliver Payne, deposited more than $280,000 with a European banking house for White to draw on while he was touring the Continent and buying things on Harry's behalf. The discord and rivalry within the Whitney–Payne family is revealed in a letter that Harry Payne Whitney wrote to White just before he was to depart on a European buying spree: "We do not want more than three pictures. Would really rather have two splendid ones. . . . So don't get crazy & buy the first thing you come across. Sir Joshua, Gainsborough or Van Dyck. . . . They must be better than the Col.'s [his uncle, Oliver Payne]."[28] In June 1898 White wrote to the younger Whitney to give him a partial accounting of those funds: "I have paid out for you as follows: Louis XIV tapestries, $42,775; [a portrait by Sir Joshua] Reynolds; [a portrait by Sir Thomas] Lawrence, $15,000."[29]

That White's patrons relied on his final judgment in matters of taste is seen in a note that he received in the fall of 1897 from someone at the house of Lowengard, fashionable Parisian dealers located on the Champs-Elysées: "I am sorry not to have had the pleasure of your visit today as you promised. Mr. and Mrs. Whitney have been a week ago at my place & they saw I think several things they liked & wished me to draw your attention to. They said they left everything in your hands—therefore they took no decision."[30]

White did considerable business with Lowengard's. The firm had been established by Maurice Lowengard, who worked closely with Duveen Brothers of London while developing his own clientele. Joel Duveen's daughter Esther (sister of Joseph Duveen) married Lowengard's son, Jules (d. 1908). Duveen's obtained many of its fine French antique furnishings through the Lowengards. By the time White was doing business with Lowengard's, Jules was running it; his son, Armand, succeeded him, but Armand eventually joined the firm of Duveen Brothers of London.

Lowengard's could supply White with antiquities of the highest quality. Jules once offered him two fine paintings by Jean-Baptiste Greuze, some bronze Renaissance statuettes, and "a set of very fine Louis Seize tapestry chairs & sofa which would go very well in a drawing & dancing room especially with some Boucher tapestry! And a set of embroidered Louis Seize chairs . . . [that] belonged to Prince Demidoff once of San Donato, Florence."[31] In 1899 Lowengard contacted White, who was then in Paris, to say that he had a number of very fine items that he thought would be right for the Whitney or Vanderbilt mansions—four extraordinary French Regency tapestries from around 1714 that had been woven at Gobelins and commissioned by the regent himself.[32] White's American clients were fascinated with the idea of owning objets d'art with royal pedigrees.

GODFREY KOPP: IVORY, EBONY, AND FOUR HUNDRED PAINTINGS

Godfrey Kopp, a fascinating scalawag, maintained an establishment in the Palazzo Caprara in Rome. Like Jules Lowengard, Kopp could come up with truly choice pieces with which to furnish mansions being built in the United States, as when he wrote to White in February 1898 regarding White's offer to purchase six large windows and two door pieces from a certain viscountess. In an earlier letter he had told White that the windows were made by Jean de Caumont around 1614 "for the Flemish Monastery Premontre" and that they represented "the life of St. Norbert surrounded by noblemen and the Coats of Arms of France, Hungary and Holland."[33] The following spring, Kopp offered White two exceptional pieces—if, indeed, they were what he claimed—stating in his letter that an old Italian family "has entrusted me with the private sale of the two most extraordinary silversmith pieces ever made by the celebrated Benvenato [*sic*] Cellini, viz., a large vase and its basin, beautifully chased and representing the interesting history of the Genoese patrician Lercaro."[34]

The range of Kopp's contacts is demonstrated in a letter in which he offers White his choice from an ancient collection: "I have been entrusted with the sale of a old English castle dating back from 1060 containing in over hundert Rooms most beautiful and unknown things, over 400 Paintings by Italians, Van Dyck, Rembrandt, Romney, Gibson, Lawrence; mostly portraits of the family. Early furniture, tapestry (14), China, panellings, etc."[35] A few weeks later, Kopp wrote to White of a most exotic room that had become available in Cairo: "In an ex-Khedival

Palace there is a very large Renaissance room of Oriental style made at the beginning of this century for the then Khedive. . . . The whole panelling and furniture is made exclusively of Ivory and Ebony, very finely carved, with ceiling to match the decoration, and I was charged with the sale of it last year."[36]

The grand salons being created or re-created in American mansions frequently included ancient fireplaces from noble European houses. White's contacts regularly offered him a selection, as when Kopp notified him that he had for sale "one very good wood carved [chimney], Louis XIII and one fine marble Renaissance one."[37] Several years later, Kopp wrote that he could provide White with a "Grand Boiseries Louis XVI, with Clodion chimney [and Etienne-Maurice] Falconet garniture, ceilings, etc."[38]

The fireplaces, usually huge and, if stone, extremely heavy, were carefully dismantled, crated, and shipped to New York, where White had a network of local craftsmen who would reconstruct the fireplaces in their new homes. For work of that type, he frequently called on Robert Fisher & Company, whose letterhead announced the firm's range of services: "Importers of and Workers in Fine Marbles & Onyx, Marble Mosaics, Granite and Marble, Monumental Work, Special Attention given to Architectural & Monumental Work, Established 1830." Fisher & Company did, in fact, bill McKim, Mead & White for work done "in House of Col. Oliver Payne, 852 5th Avenue."[39] On other occasions, White arranged for William H. Jackson & Company, of 860 Broadway, to install the fireplaces, as it did in the entrance hall of the William C. Whitney residence.

THE SALE OF THE ARCH OF CONSTANTINE

Mischief and fraud at times came to play in this international network of dealers, as I discuss in chapter 2, and Godfrey Kopp was involved in his share. In June 1898 Henry Duveen wrote a cautionary note to Stanford White: "[A] certain party in Rome whose name is Kopff [*sic*] is capable of almost anything and we warn you herewith to have nothing to do with him. . . . This man Kopff is a very dangerous person and you should be very careful to keep away from him."[40]

Kopp was, to be sure, a scoundrel.[41] He passed himself off as a Hungarian baron who had been forced to flee his native land because of a dalliance with a young woman of the royal family. In truth, he was the son of a Swiss pastry chef and began his career as a hotel errand boy. But he was impeccably dressed, charming, and suave, and was for several years

a correspondent of the connoisseur Bernard Berenson, whom Kopp had met in St. Moritz. Kopp became involved with a Paris art dealer who sold forgeries produced by Gaston Duchamp-Villon, the elder brother of the Dada artist Marcel Duchamp.

Kopp sold one such painting, supposedly a Constable called *Flatford Mill,* to John R. Thompson, a touring American who owned a number of restaurants in Chicago. Not one to miss an opportunity for a potentially enormous scam, Kopp offered to accompany Thompson on his tour of Italy. In Rome, Thompson became infatuated with the Arch of Constantine (erected in the early fourth century A.D.), which Thompson ardently wished he could re-erect as the entrance to one of his finest restaurants back in Chicago. What good fortune, Kopp whispered to his gullible American mark, for the Italian government, then in desperate need of funds, was willing to sell the great Roman arch. Such things had to be handled delicately and secretly, with Kopp as the go-between, but here was the deal: the government would sell the Arch of Constantine for a reasonable $500,000, if Thompson would give Kopp a $100,000 down payment, the balance due when the celebrated monument arrived in Chicago. Eventually, Thompson realized that he had been duped, but by then he was back in the Windy City, and, although he brought suit, Kopp had disappeared for the time being.

Another dealer reportedly pulled a similar ruse on Charles T. Yerkes, a traveling American millionaire, who became enamored of the Column of Trajan, which he could have at the bargain price of $250,000. J. Pierpont Morgan was similarly taken in when he thought he was buying the ancient bronze doors from the Cathedral of Bologna. Morgan and Yerkes asked the Duveens to look into these unscrupulous characters, which they did by sending Edward Fowles to make inquiries, and that is how Henry Duveen came to warn Stanford White to have nothing to do with Kopp. All that aside, White made numerous purchases from Kopp and even received the goods he bought.

Count Boni de Castellane recalled another story of an American's falling prey to her own acquisitiveness. "Americans imagine that American dollars can buy anything or anybody," he wrote, "and I shall never forget the laughable impudence of a *nouveau riche* who, upon seeing the Arc de Triomphe for the first time, thought that she would like to ship it to New York, and actually imagined it was for sale, provided the offer was high enough."[42]

From our historical vantage point, and a time when national treasures are carefully protected, we may smile at the prospect—the foolishness of the idea—of an American's buying the great Arch of Constantine or the Column of Trajan. But Kopp's ability to pull off such a scam is testimony to two things: first, that Europeans—nations as well as individuals—were often in financial straits that necessitated the sale of their national treasures, and, second, that American millionaires truly believed that their money could buy almost anything, which could then be carted off to New York, Chicago, St. Louis, or wherever.

Moreover, such was by no means an impossibility. A notice that appeared in the June 1891 issue of an architects' professional journal informed its readers, perhaps with tongue in cheek, that a syndicate had been formed to purchase the Colosseum in Rome and re-erect it in Chicago's Jackson Park as part of the show for the World's Columbian Exposition of 1893. That syndicate was to "negotiate with the present Finance Ministers of Italy, who, finding difficulty in 'making ends meet . . . are not in a position to ignore a fair offer.'"[43]

While the aforementioned deals fell through, others did not. John D. Rockefeller bought portions of several European monasteries and had them re-erected at the Cloisters (which opened in 1938) in Fort Tryon Park, New York City, as a part of the Metropolitan Museum of Art. William Randolph Hearst similarly acquired entire ancient European buildings or parts thereof for his Hearst Castle at San Simeon in California. Agecroft Manor was taken apart stone by stone, transported from its original location in Lancashire, England, and put together again outside Richmond, Virginia. And perhaps the most audacious of all was the acquisition by an American of London Bridge and its resettlement in Arizona in the 1960s. To be sure, the money of America's millionaire society could buy almost anything it wanted.

VITALL BENGUIAT: EXOTIC FABRICS, OLD AND NEW

The grand interiors that were being created in American mansions consumed an enormous amount of fabric that was ancient—of Renaissance through eighteenth-century vintage—as well as its modern imitations. Antique material was used not only for the draperies at the huge windows and for upholstery for, say, dining room chairs that were sometimes purchased in sets of twenty-four and for matching sofas, but also for lining the walls of whole rooms.

The leading supplier of rare and exotic fabrics was Vitall Benguiat of London, "Importer of Antique Embroideries, Brocades, Laces, Velvets, Fine Carpets, Jewellery, China, Works of Art, Etc.," according to his stationery, which gave Bond Street as his fashionable address.[44] White and Benguiat had been doing business since the mid-1890s, often with the house of Duveen as intermediary to handle crating, shipping, paying duty taxes and insurance, and so forth.

In November 1897, Benguiat wrote to White and extended an invitation to call at his shop when White next visited London. White evidently did so, for later that month Benguiat informed the architect that he was sending four crates of goods to New York in White's name.[45] The following spring, in anticipation of White's annual buying trip, Benguiat again wrote, saying, "I beg to inform you that I have received a large lot of Renaissance velvet, sets of cushions, and borders, also rich vestments."[46] A month later, he sent word that "I have received 50 yards of rich red Genoese velvet, red ground with raised design in red, also 500 yards of crimson Damas[k]. I could send you small samples of these if you wish."[47]

In what appears to be a final listing of objects bought from European dealers on behalf of William C. Whitney for the remodeling of the Stuart mansion (discussed in chapter 3), the following list appears under the name of Benguiat and gives some idea of the richness and age of the materials in which he dealt:

> Antique rug. In main hall.
> Portieres—red and gold.
> Two hundred yards Renaissance figured velvet. Parlor.
> Seven hundred yards Louis XIV red and white velvet.
> Eighty-six yards old velvet.
> Sixty yards old velvet.
> One hundred yards similar pattern red velvet on silver
> ground.[48]

The demand for antique fabrics became so great in the United States that several European merchants began making annual trips, usually to New York, bearing rare and enticing goods of trade. Benguiat, for example, once notified Stanford White that "I am coming to New York next week with a very fine collection of goods, and hope to see you. . . . Will you kindly mention to your friends that you are expecting someone with a fine collection of velvets, brocades, and carpets."[49] The market had clearly changed

from only a decade or two earlier, when Jacques Seligmann found that it was not worth his while to cross the Atlantic to cater to the American market.[50]

Vitall Benguiat (1865–1937) was one of five brothers who traded in ancient fabrics and Oriental carpets. Ephraim, the oldest, was the first to establish himself in the United States, followed by Vitall and then Benjamin, the youngest. David Benguiat maintained the London business after Vitall left, and Leopold (Vitall's quarter-partner in V. & L. Benguiat) had his establishment in Paris. The family had been Spanish Jews before wandering about the Near East for many generations, primarily in Smyrna and Alexandria, and the Benguiats had special talents both for coming up with extraordinary examples of Renaissance embroideries or Persian carpets of the rarest beauty, and for transforming modern rugs into antiques: with the help of pumice stones and saffron dye, garish new rugs could be given the harmonious mellow tones of antiquity. The Benguiats sometimes neglected to mention to buyers the true provenance of these "antique" rugs.

But the Benguiats were doomed to sibling warfare, and they spent nearly as much time fighting in the law courts as they did selling their wares, and nearly as much on lawyers' fees as any of them took in. Benjamin soon left the partnership to establish his own business, and Stanford White occasionally bought from him as well as from Vitall. An invoice from Benjamin, dated 1905, shows that White purchased from him a fragment of a Gothic tapestry, a Renaissance panel, seven tapestry coats of arms, a large yellow tapestry, and an embroidered panel representing the Crucifixion.[51]

TAPESTRIES AND CARPETS

Tapestries and Oriental carpets,[52] which came into great demand during the Gilded Age, were constantly offered to White, as when Joel Duveen wrote to him in 1898 to inform him that he had just "bought a very wonderful late 15th century carpet with figures and animals, 22 feet wide. Much finer than any you bought last season."[53] Tiffany Studios, too, was sometimes involved in White's search for carpets that were of a scale appropriate to the large rooms he was decorating—at the Clarence Mackays' Harbor Hill, for example. In 1903 someone at Tiffany's contacted White to describe the international scope of the market available to the architect through the firm: "We know of a rug now being held in Russia, which is 27 × 42 feet. It belongs to the Mesched family, and is similar in character and color to the [one for] $6,500 which you saw in our studio the other day. The one abroad, however, is finer in weave, and much heav-

ier in texture, and is a very rare specimen of its kind; because of its extraordinary value as a piece of fine workmanship and beauty and its unusual size, the cost to Mr. Clarence Mackay would probably be $12,000 to $15,000."[54]

Joel Duveen was astute enough to acquire ancient tapestries in large numbers, and he convinced American clients that they added a luster and the timeless charm of aristocratic ambience to any room. Moreover, the nouveaux riches of the Gilded Age wished also to insulate themselves from the crass world that they had created in the United States, as the decorative arts critic Oliver Bell Bunce, writing of tapestries and draperies, observed: "A room liberally hung with curtains and portieres seems to my imagination to have shut out the disagreeable conditions of the world, and to have inclosed within itself the peaceful serenities of home."[55] Edith Wharton and Ogden Codman held tapestries in high aesthetic regard, declaring that "the three noblest forms of wall decoration are fresco-painting, panelling and tapestry hangings."[56] Also, tapestries had a certain social standing, for while members of the middle class were then applying that new decorator commodity, wallpaper, to their walls, the wealthy could afford the beautiful woven fabrics of the Renaissance, Baroque, and Rococo periods.[57]

So great was the demand for tapestries, a demand that exceeded supply, that William Baumgarten established his own looms in New York City in 1893—the Gobelins Tapestry Works—where his weavers created reproductions of Brussels, Beauvais, and Gobelins tapestries. In so doing, Baumgarten was following the precedent of William Morris (1834–1896), the great master of the Arts and Crafts Movement, who in 1881 had established a tapestry factory at Merton Abbey in Surrey, England. Morris declared tapestry to be the "noblest of the weaving arts" and led the tapestry revival in England, in many ways imitating French and Flemish medieval models, including researching the weaving methods and dyeing techniques of the fifteenth and sixteenth centuries. When touring Americans were presented at court, they would have seen his tapestries at St. James's Palace in London—in the Armoury and Tapestry Rooms, for instance, and in the Throne Room and Reception Room.[58] Others in the United States who set up looms for the weaving of tapestries in the medieval and Renaissance manner were Candace Wheeler and Albert Herter; the latter created works that imitated antique tapestries, such as *Gothic Tapestry* (figure 8).

But dealers in England and on the Continent were White's best sources for tapestries, and they were quick to contact him when they had choice

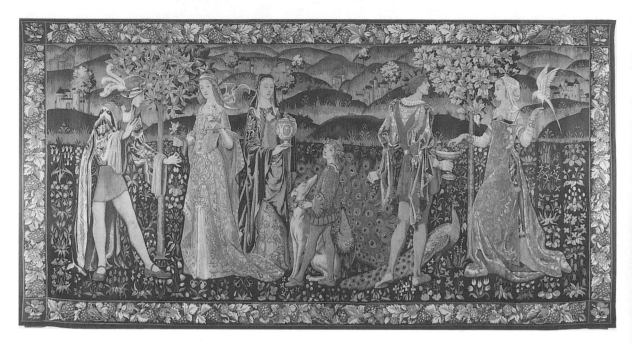

FIGURE 8. Herter Looms, *Gothic Tapestry*, ca. 1910. Albert Herter, the son of Christian Herter of Herter Brothers, operated tapestry looms in New York City from 1908 until 1934. Pieces such as *Gothic Tapestry* (11½ × 6 feet [3.48 × 1.82 m]) took their inspiration directly from such late Gothic and early Renaissance prototypes as *The Lady of the Unicorn* tapestry, now at the Metropolitan Museum of Art, and they were prized for their beautifully muted colors and the aura of culture that they added to interiors of the Gilded Age. Candace Wheeler, one of the most talented craftspersons of that era, also experimented with weaving tapestry, as in her *Miraculous Draught of Fishes,* copied from Raphael's famous tapestry in the Vatican and illustrated in her book *The Development of Embroidery in America* (1921). (Collection of Cranbrook Academy, Museum of Art, Bloomfield Hills, Mich.)

pieces to offer. Jules Lowengard of Paris, for example, notified White that among the things he had recently bought was

> the finest set of 4 tapestries, Regency 1714, which were ever made. . . . The former director of the Gobelins knew the cartoons of this set and . . . said the Gobelins works never turned out a better set. These tapestries were only made once and never reproduced—like the Bouchers. . . . It is a series only made for & by order of the Regent de France for Madame la Duchesse d'Orleans. It was once in the Palais Royal in Paris & sold by one of the members of the Orleans family. The tapestries were made according to the design conceived by the Regent himself [with] the assistance of Oudry and other artists. . . . They represent as subjects the Pastoral history of Daphnis & Chloe.[59]

Lowengard then informed White that he was sending photographs of the tapestries, gave him the size of each, and told him that the price was 900,000 francs, or about $160,000, an extraordinary sum. The dealer concluded his letter by saying that he had also bought some very fine Russian tapestries and had "sold the fine Boucher tapestry you would have liked to buy for Mr. Whitney."[60]

White also heard from another Parisian dealer, Emile Gavet, who sent him photographs of the three tapestries "of Raphaelesque design of which we spoke when you were last here. The tapestries have been made from designs attributed to Raphael, for the Palace of Duke Doria, at Genoa, the Duke's arms being on the tapestries. . . . I ask 125,000 francs for them."[61] Gavet was a prominent dealer who, in the last quarter of the nineteenth century, formed an extraordinary collection of Gothic art and decorative arts. Richard Morris Hunt, the William Kissam Vanderbilts, and the Stanford Whites were in Paris in the summer of 1889 to see the great International Exposition, and they undoubtedly visited the Gavet collection. Gavet formed several collections and regularly placed them on the auction block, providing Americans such as White with a steady supply of late medieval and early Renaissance artifacts.[62] Emile Molinier's 1889 catalogue of the collection is beautifully illustrated with views of Gavet's apartment, showing rooms filled with extraordinary treasures—fireplaces, ceilings, sculptures, furniture, paintings, and large tapestries hanging on the walls (figures 9 and 10).

About the time that White was decorating the Payne Whitney rooms, he received a letter from the London dealer George Donaldson, who wrote about the availability of some especially handsome tapestries: "In a fine Elizabethan house in the country is a set of six tapestries [from the time of] Francis I, in fine state. I enclose photograph of one. [There are] 4 about 11 feet by 9 feet high—two 11 ft. × 4 or 5 feet—charming subject—the history of the courtship and crowning of some queen. Charming in color."[63]

White was not the only architect who assisted his patrons in obtaining such things. Catharine Hunt's unpublished biography of Richard Morris Hunt tells of a journey to Europe that she and her husband made in the company of George W. Vanderbilt, for whom Hunt was then designing Biltmore, near Asheville, North Carolina:

> We sailed for Europe on the 15th of May [ca. 1892]. G.W.V. was
> insatiable in his desire to see beautiful interiors and pictures, and I
> can see him now as he surreptitiously paced historic rooms and an-
> nounced with glee that the long gallery at Biltmore was a few feet

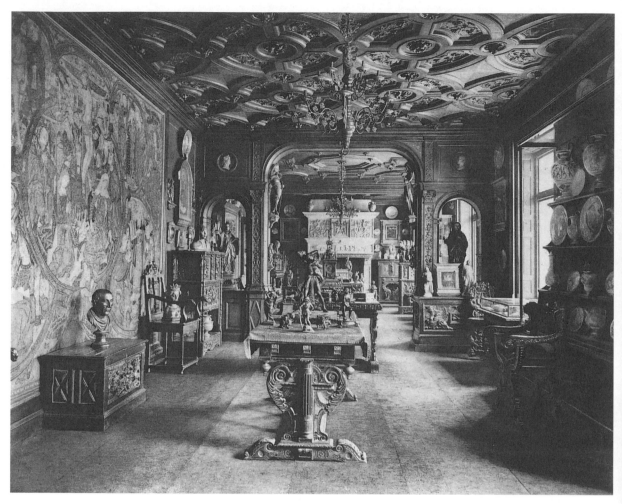

FIGURE 9. Emile Gavet apartment, Paris, ca. 1888. When Stanford White made his annual visits to Paris, Emile Gavet offered him an exhilarating bazaar of antiquities. All the items in this photograph were for sale. White bought many objects from the Parisian dealer, who arranged their transportation to the United States, where they would be installed in their new homes. Gavet once wrote to White, "Permit me . . . to remind you of the good promise you made me to place my wood work and the large chimney of the Renaissance, which are in my gallery, in one of your buildings" (Emile Gavet to SW, 28 October 1899, SW Papers, Avery). (From Emile Molinier, *Collection Emile Gavet,* courtesy of The John and Mable Ringling Museum of Art, the State Art Museum of Florida, Sarasota)

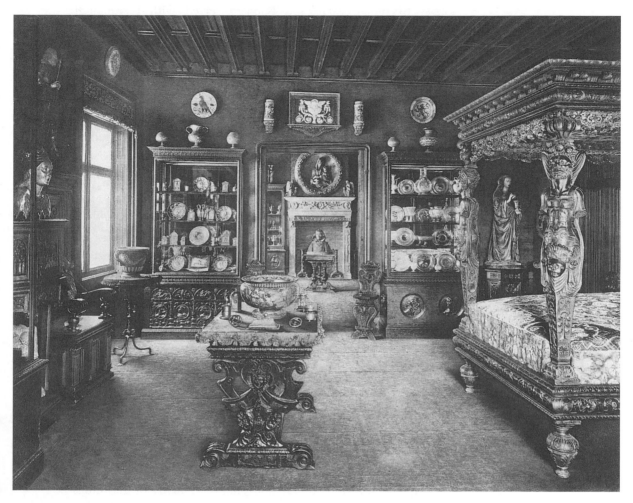

FIGURE 10. Emile Gavet apartment, Paris, ca. 1888. Although most objects in this photograph date from the Renaissance or Baroque period—the elaborately carved bed, for example, with its caryatid posts that support the carved cornice—Gavet also had a collection of medieval decorative arts. That is, he had it until Alva Vanderbilt saw it one spring when she was in Paris and purchased it in toto for the Gothic Room, which Richard Morris Hunt had designed for her Marble House in Newport. Gavet himself went to Rhode Island to supervise its installation. The collection is still largely together, for it was purchased in 1928 by John Ringling for the museum he was developing in Florida, where it is on display today. (From Emile Molinier, *Collection Emile Gavet,* courtesy of The John and Mable Museum of Art, the State Art Museum of Florida, Sarasota)

longer or broader. He and Richard stayed with [Ferdinand] Rothschild, his house [Waddesdon Manor] being said to be the handsomest country place in England. . . . One morning we spent at the great oriental carpet warehouse of Robinson, where G.W.V. selected three hundred rugs for the house yet to be built. When RMH was called to Paris by the William Kissam Vanderbilts who were clamoring for his presence to arrive at certain decisions for the interiors for Marble House [at Newport], I stayed behind in London with G.W.V. while he terminated various negotiations.[64]

Vanderbilt continued the buying binge on the Continent, with Catharine Hunt noting that "RMH and G.W.V. went to Brussels for a Sunday to look at tapestries."[65] On the same trip, the Hunts, George W. Vanderbilt, and the William Kissam Vanderbilts, whom they joined in Paris, were invited to Chantilly by the duc d'Aumale, who had restored the great château regally before presenting the estate to the French nation; its interiors must have encouraged the builders of Biltmore and Marble House to furnish their grand houses similarly.[66] Hunt designed the architectural interiors of the mansions of a number of his wealthy clients and assisted them in obtaining appropriately grand furnishings, as seen in photographs of the drawing room and library of the John Jacob Astor IV residence that once stood on the corner of Fifth Avenue and Sixty-fifth Street (figures 11 and 12).

A SAMPLING OF WHITE'S PURCHASES

Stanford White often bought in large quantities, as when he made an offer to Stefano Bardini of Florence that sought a discount on the total price because of the large size of the purchase, pleading that "many of the things I am buying at my own risk" and adding that "whereas before we had no duty on antiquities, we have now to pay from 30 to 60% and this will increase to me enormously the cost of things landed in America." Writing from Paris in October 1897, he concluded: "I offer you, therefore, according to the list of 52 affairs comprising 88 single objects at your Palace and 5 at your villa the sum of . . . 260,000 francs in gold."[67] Bardini accepted the offer and in his reply gave a long list of the items that White had purchased, including the woodwork from the Château de la Bastie d'Urfe on the Loire, four Beauvais tapestries representing scenes from the *Iliad*, and "the magnificent Italian Renaissance furniture."[68] On 24 February 1898, the Florentine dealer notified White that forty-nine cases of such goods had been shipped to him in New York.

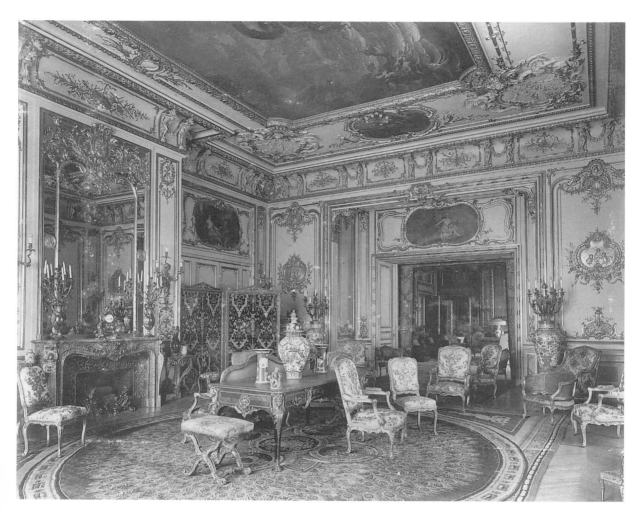

FIGURE II. Richard Morris Hunt, drawing room, John Jacob Astor IV residence, 840 Fifth Avenue, ca. 1895. Richard Morris Hunt, like Stanford White, assisted his clients in decorating the major rooms of the houses that he designed for them—such as this grand salon, with its elegant Louis XV– and Louis XVI–style furniture, all of which was produced in France. Hunt, too, had numerous contacts with Continental European artists and artisans, and his wife, Catharine, recalled that when he was in Paris, he particularly enjoyed attending the Beaux-Arts dinners where his companions included the painters Paul Baudry, William Bouguereau, and Jean-Léon Gérôme; the sculptor Jean-Alexandre Falguiere; Baron Georges-Eugène Haussmann, the great redesigner of the city of Paris; and patrons such as Alfonse Roth-schild and the duc d'Aumale, as well as the preeminent decorator Jules Allard. (Museum of the City of New York)

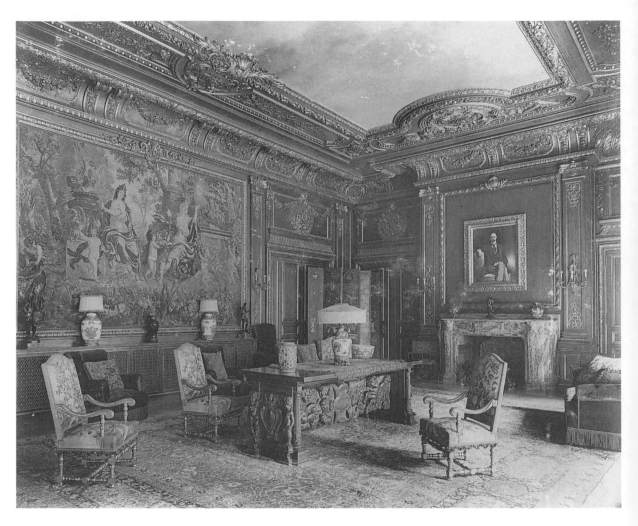

FIGURE 12. Richard Morris Hunt, library, 840 Fifth Avenue, ca. 1895 and 1910. This room originally was the dining room in the portion of the Astor mansion that had belonged to Caroline Astor—*the* Mrs. Astor—the mother of John Jacob Astor IV. After her death, he converted it into his library, retaining the original paneling and ceiling decorations; they probably were produced by Allard and Sons of New York, for Hunt used that firm extensively for his interiors after he had them execute Alva Vanderbilt's bedroom at her Petit Château on Fifth Avenue in 1879 and 1880. (Museum of the City of New York)

White did business with many other dealers; some were specialists in one sort of object or another, and others were fairly small operators from whom he bought only a few pieces. Altogether he had about fifty dealers who composed a web of contacts throughout the Continent and England. Among these was Henry Watson of Paris and New York, from whom White had purchased, in 1895, a great many items, including two Italian Renaissance doorways that were destined for White's own home in New York City. The Galleries Heilbronner of Paris dealt in "Objets d'Art Anciens" and in 1900 sold to White three fireplaces (presumably ancient), a fountain, and a statue. Two undated but related lists detail the things that White had bought from Heilbronner; among the itemized purchases—in what numbered at least thirty-eight cases, packed and ready for shipment to New York—were a Renaissance chest, a gilded wooden altar top, thirteen pieces of gilded woodwork, a gilded ceiling with a painted central panel, some Henri II carved paneling, and two Spanish cabinets; also included in that shipment were a pair of large gilded wooden candlesticks and two gilded wooden birds, three terra-cotta statues, and six gilded pilasters.

In the final accounting of items acquired for the William C. Whitney mansion, White listed the following, also obtained from Raoul Heilbronner: a large forged- and wrought-iron gate from the Palazzo Doria, Genoa, installed in the entrance hall; an Italian wrought-iron balcony in the ballroom; a carved and painted Renaissance frieze in the main hall; three gold Venetian lanterns in the vestibule; and a large vase in the ballroom passage, among other things. Heilbronner obviously had contacts in Italy through whom he was able to maintain a store of Italian antiquities.[69]

The same list for the Whitney interiors identifies several other European dealers who were a part of the network that White called on during his visits abroad. Emile Peyre of Paris, for example, sold him the following items, which were placed in Whitney's residence:

> Old carved panelling, Henry II paneled wainscoting from La
> Chapelle de Beti. Ball room passage.
> Italian Renaissance cabinet of the 16th century, in ebony, inlaid
> with ivory. Main Hall.
> Henry II Cabinet, French walnut. In parlor.
> Henry III cabinet in French walnut in main hall.
> Small consul, Henry II, Italian walnut. In dining room.
> Italian marriage chest in library.

> Eight gold Louis XIV X chairs, Two in main hall, balance in rug room.
>
> Two long Renaissance tapestries, designed by Germain Pilon for Diane de Poitiers. Staircase landing main hall.[70]

The list of dealers further mentions Carrere and the Venetian Art Company, both of Venice, as well as San Giorgi and Simonetti in Rome; other references are to the houses or galleries of Salvadori and Elia Volpi of Florence, Durlacher Brothers of London's New Bond Street, Fernand Robert of Paris, Dirkan "The Khan" Kelekian, and Vincent Robinson & Company. In Rome, one of White's agents was Waldo Story, son of the famous American expatriate sculptor William Wetmore Story. The younger Story wrote to White in November 1905:

> All your business with Simonetti has been finally settled, and the fountain and mantel are yours, and will be forwarded as soon as they can be packed up and the necessary permissions procured. I am forwarding you today the drawings for the foundation of the fountain together with photographs. . . . I have also secured for you from [the dealer] San Giorgi, according to your telegram, another column of Cippolino [marble] similar to the one you saw when you were here and I got for you. . . . This will be sent off to you at once. I have also ordered for you, according to your telegram, a replica in marble of the candelabra from [the dealer] Iandolo.[71]

An invoice for the transaction with Simonetti to which Story referred survives and shows that, among other things, White purchased from him a Roman terra-cotta jar with travertine base, two columns with capitals and bases with their architrave, a high-relief marble sculpture, a "sarcophagus with two cupids and coat-of-arms, also small marble figure," and a large portrait of a lady plus two more paintings representing a magistrate and his wife; also mentioned were two pulpits from the fifteenth century, which White probably intended to reassemble as decorative portions of some grand room.[72]

From F. Schutz of 18 rue Bonaparte, Paris, White bought more than two hundred pieces on one trip alone, in 1905, acquiring furniture, portraits, and incidental items as well as fabrics, carpets, and tapestries. The inventory lists nine portraits, unfortunately with no attribution of artist and no identification of subject other than that they represented a man, a woman, or children. The lists include several carved tables, gilded chairs,

one "piece of Spanish furniture 16th cent.," four carved and gilded columns, two carved alabaster columns, a bronze dome supported by four columns, thirteen flags and standards, a carved and gilded harp, a mandolin, two decorated chests, an ivory door knocker, a marble torso, a small stone statue of the Virgin Mary, and assorted candlesticks, vases, fire dogs, carved and gilded small figures, blue faience bottles, and the like.[73]

Each of these items could have found a home in a Payne Whitney salon or in Henry Poor's drawing room, in Harry Payne Whitney's library, in Katherine Mackay's dining room, or in Tessie Oelrichs's ballroom. In such spaces, a cardinal's red velvet cape might be thrown casually over the back of a settee or an embroidered chasuble might be displayed, spread out, on a paneled wall or a particularly fine tapestry might be draped over the railing of a stairway. An Italian blue faience vase, a Chinese pot, an armadillo-hide mandolin from South America, and a small statue of the Virgin Mary might be placed side by side on a Turkish carpet of Islamic design atop a Spanish table that stood in front of a sixteenth-century tapestry depicting the Greek myth of Bacchus or before a portrait of a lady of the court of Louis XVI in its great carved and gilded frame. Photographs of the rooms, as Stanford White decorated them according to his "clutter aesthetic," demonstrate the possibility of just such a culturally mixed arrangement.

DEALERS, AGENTS, FORGERS, EXPORT LAWS, AND STANFORD WHITE

STANFORD WHITE'S CORRESPONDENCE REVEALS THE GREAT VARIETY of sources from which he could obtain the Old World antiquities with which to fill the rooms of the mansions placed in his charge. From 1900 to 1906, he was especially aggressive in his acquisitions, gladly assisted by his large network of agents and dealers, especially in Italy and France. White had a good working relationship with many of his correspondents, who often addressed him as "Dear Old Stan" or joked with him even while doing business. Charles Loeser, for example, wrote about a statue that he was about to ship to White and closed his letter by saying that "it would be jolly" to have White visit him in Florence: "Can you not induce some of your American clients to let you build them American country houses here, to go with their Italian houses in America?"[1]

CHARLES COLEMAN: WHITE'S AGENT IN NAPLES AND CAPRI

Charles Coleman (1840–1928), an American painter who, at the turn of the twentieth century, was completing the restoration of his Villa Narcissus on the isle of Capri, frequently journeyed to Naples, Rome, Sicily, and elsewhere on White's behalf, tracking down an ancient ceiling or some stained glass or reporting on the amount of restoration in a sculp-

tured fountain that a dealer was trying to sell to the architect-decorator. Coleman asked White to remember him to all the good fellows at the Players, a club that White frequented, and Coleman often mentioned his friend Henry Poor, whose house White was then redecorating.

Also among their mutual friends was Charles Freer, a Detroit industrialist whose name appears frequently in the correspondence regarding ancient walnut paneling or other items that he had bought for the villa he was building on Capri. In October 1900, Coleman told White that Freer had purchased six antique columns in Rome for a small temple near his villa, adding, "I believe he intends to have you make the architectural design for same. Freer is bitten strong with the fever for antiquities, and will in time . . . make Villa Castello a Paradise. . . . I suppose you are having a good time as usual with the girls and have been too busy to write me sooner." The painter then recalled a time when he and White had visited Taormina, on the island of Sicily: "I never will forget the day at Taormina and the way grand old Mt. Etna seemed a thousand miles high."[2]

But Coleman's letters are filled with matters of business, too, as when he wrote to White about a ceiling that he had been to see in Naples, enclosing photographs and noting that it was in perfect condition, without restorations, and removable by sections: "The exact size . . . is 5M × 4M 66c. The pictures in panels do not amount to very much as works of art, but are decorative in the sense of being in harmony of color with the rest. I would judge the wood carvings and moldings to be of walnut and they are against a gold ground perfectly ripping in tone." The same letter mentions two dealers—Innocenti and Iandolo—from whom White had purchased objets d'art, evidently in large numbers, for Coleman states that "most of the Naples purchases are already packed and will be sent off, probably by next Friday steamer." There were other dealers as well, such as Apollino, the Romanos, and Cannoima. The final item of business in Coleman's letter about the ceiling concerned an enormous walnut and gold frame that dated from around 1600: "It could be used for a fine piece of tapestry or a decorative piece could be painted for it, to be placed, say, in the N.Y. [Public] Library. Possibly [Thomas] Hastings would like it? . . . It is [in] an old monastery which is being demolished. I bought some old glass and a fountain out of the place for almost nothing."[3]

In September 1900, Coleman wrote to White about some tapestries that he had gone to see in Veterbo at a house owned by someone named Puertz: "But they would not let me see them. I think they had an idea that we were spies for the Italian government. The tapestries were probably

stolen church property."[4] Later that month, he again wrote to White that he had located an "ancient mosaic pavement from Prima Porta and [a] statuette in basalt," obtainable through the dealer Iandolo, and Coleman added in great excitement: "In a few days I hope to be able to give you the opportunity of your life in the way of statuary . . . Greek, Roman and 15th century work—All the restorations of the antique statuary in this lot were made in the 15th century and are from [the halls and stairway of the Palazzo Guistermani, Rome]. There never has been anything like it or to equal it in the market before and probably never will be again. . . . Iandolo has the refusal of the entire collection . . . and as soon as . . . he will be able to guarantee its exportation he will doubtless make the purchase."[5]

Coleman wrote again to White in November to say that he had received a photograph of a tabernacle that was available in Naples, through a dealer-friend named Roselli, who specifically mentioned Stanford White as a possible buyer for it; it seemed "just the thing you were looking for when we were in Florence together. . . . The columns are beautifully worked—all around the background is of color celeste. . . . It is greatly superior to the one of which I sent you a photo in my last [letter]."[6] Coleman was occasionally able to offer White old paintings and sculptures as well as boiserie and furnishings. Coleman once wrote that he was sending photographs of a fourteenth-century Madonna, carved in marble, that he owned; he asked $600 for it and declared it to be "a stunning work of art and beautifully modeled, creamy in color. St. Gaudens would love it. How is the dear fellow? Say all sweet things to him for me."[7]

As word got around that Coleman was buying on behalf of rich Americans or their decorator, people increasingly brought things to him, as did Emma Richards, who lived in Rome. Coleman informed White that he had received a letter from the woman, who was "at one time . . . supposed to be very rich and her son [was] quite a collector of art objects—now she is evidently very much reduced in circumstances and anxious to sell. I have promised to call and inspect the collection on my next visit to Rome."[8] One can sense a tone of near desperation in Richards's letter to Coleman: "Now I ask you, do you really wish to be polite to me? Do you want to make things a little bit easier for me after my disastrous financial troubles? Don't you want to buy some really superior objects which still remain in my possession, and which were in my son's collection? We have a column of Verde Antique that Mr. Guillaume, Director of the French Academy in Rome, calls a rare piece of marble. I have also four [Frans] Snyders which are surprising. I can also recommend a num-

ber of decorative marbles . . . and painted whole figure portraits in interesting costumes."[9]

THE ANTIQUITIES OF ROME AND FLORENCE . . . FOR SALE

Stanford White bought prodigiously in Rome, which seems to have had an unending supply of furnishings, fabrics, paintings, sculptures, and assorted bibelots. I have already noted his dealings with Godfrey Kopp, but White had many other Roman connections. In December 1905, when he was back in New York City, White received word from Ramponi & Cremonesi, a shipping agent, that it had "sent 29 cases of antique objects which left Naples the 15th inst per SS Francisco."[10] The items therein had been purchased from G. Giaccomini, and accompanying documents show that among those many cases were a marble fountain, a small cipolino marble column, four china vases, eight oil paintings, eighteen armchairs, six additional chairs, a small china tiger, a quantity of lace, and 19 feet of embroidery.[11]

One additional example discloses the rich array of goods that White bought during the summer of 1905. A bill from Antonio and Alessandro Iandolo lists a fifteenth-century portrait of a young girl on canvas, an Egyptian deity in basalt, a Greek head of an athlete "from excavation," a marble "archaic" Hermes, a "Drunk Hercules (Little marble statue from excavation)," a small draped marble statue of Vanity dated about 1700 with accompanying base, two large terra-cotta pots "(excavation)," two capitals carved with the coat of arms of Alexander Borgia, a large walnut table dated about 1500, and an armchair "with gold stamped leather."[12]

Arthur Mario Acton (1879–1952) was for many years White's principal agent in Florence. A connoisseur who formed a fine collection at his Villa La Pietra, he supported himself in part by buying and selling antiquities and looking after affairs for Americans such as White. Bernard Berenson once wrote to the art collector Isabella Stewart Gardner to introduce Acton, who was visiting the United States: "We are sending you a Florentine acquaintance named Arthur Acton, who collects and sells. He was Stanford White's agent here, but since then he has married a very rich Chicago woman. He is a 'bounder,' but he has a flair for good things, and would appreciate yours."[13] Just as Bernard Berenson devoted a portion of his life to I Tatti, his villa in Florence, and ultimately bequeathed it to Harvard University, so Acton worked on restoring the Villa La Pietra, which dated from the fifteenth century; Acton's son, Sir Harold Acton, gave the villa to New York University to be used by scholars as a study center.

Acton knew what was secretly available from one or another of the great noble families of Italy, and he kept White informed. When White was in Italy, he and Acton sometimes traveled together, touring the countryside, visiting great houses, or calling on dealers. White would often write to Acton to ask him to look into the availability of some special treasure; on one occasion, for example, when White was decorating William C. Whitney's ballroom, the architect informed his patron: "I have sent Acton to Aquila . . . [near] Rome . . . where I heard there was a beautiful ceiling 42 × 25 feet & I am awaiting photographs & a report from him."[14] A typical invoice of items that White bought on a visit to Florence in 1905 lists a tapestry, a small dresser, the cornice and tiles of a ceiling, an East Indian cane divan, two marble mortars, a portrait of a woman, and several pieces of fringe—all of which Acton packed in thirteen cases and arranged to ship to New York.

White's trip to Italy in the summer of 1905 was especially rewarding for Giuseppe Salvadori of Florence, from whom the American bought such items as four armchairs in red velvet, two wooden pilasters and an ornamental architrave, a polychromed and gilded plaster bas-relief, a woolen carpet, two majolica vases, and two little carved wooden lions.[15] Another invoice shows that White purchased additional items from Salvadori: a large walnut table, two marriage chests, eight miscellaneous pieces of carved stone, fifteen large tiles, and two gilded wooden lanterns on poles.[16]

From the Manifattura di Signa of Florence, White bought three cases of terra-cotta sculptures, including a gilded bust and a gilded Cupid; a bronze statue of Venus about 50 inches high; and a bronze Cupid.[17] From Giuseppe Santoni came an invoice that itemized quite a variety of items, including a pair of andirons and six brass candlesticks, a gilded and painted altarpiece, a Spanish wooden tabernacle and a piece of Spanish velvet, and a Louis XV armchair.[18] The next month, Gabriele Egidi of Florence shipped nine cases of goods to Stanford White; their contents included two gilded wooden doors, an antique painting in oil of a Madonna and Child, a marble console, a marble fountain, a felt cardinal's hat, two gilded tabernacles, and a gilded wooden console.[19]

One of the most fascinating personalities among the Florentine dealers was Professor Elia Volpi (1858–1941), a protégé of Stefano Bardini. Volpi's villa in Florence—called the Palazzo Davanzati—was crammed full of treasures that he enjoyed, but some that he would gladly sell. He had lovingly restored the late Gothic–early Renaissance sections of the palazzo and during his lifetime turned it into an amazing bazaar, financ-

ing his restoration work by dealing in antiquities (figures 13 and 14).[20] Among those who purchased items from his famous villa were J. Pierpont Morgan, Benjamin Altman, William Randolph Hearst, P. A. B. Widener, and Thomas Fortune Ryan. Bernard Berenson frequently advised Isabella Stewart Gardner of paintings that Volpi had turned up or of his activities in the art world of Tuscany; in fact, Gardner did buy from him a bas-relief portrait of a woman by Mino da Fiesole. Stanford White occasionally acquired things from the professor, such as the old carved and inlaid seat of Italian workmanship that he placed in the house of William C. Whitney.

By 1915, when nearly all of Europe was torn apart by World War I and the annual parade of Americans to Italy had ceased, Volpi decided to liquidate and chose New York City as his marketplace. Loading a boat with his treasures, he braved the terror of the U-boat–infested Atlantic and made a killing at auction.[21] So great was his success that he brought over another load the next year, with similar results. As Gardner informed the Berensons: "Volpi is selling out in New York."[22] Volpi returned to New York and Thomas Kirby's auction rooms at the American Art Association in 1917 for the third time, and in 1918 he convinced his Florentine compatriot, Stefano Bardini, to join him in the business venture.[23]

STEFANO BARDINI AND THE TAORMINA AFFAIR

The dealer in Florence from whom Stanford White made the most purchases was Stefano Bardini (1837–1922). In February 1898, the Italian dealer notified his American friend that he had shipped to him forty-nine cases of goods selected from Bardini's palazzo and villa. A shipping manifest of 1906 shows that White was about to receive a stone fountain, a pair of gilded chairs with leather cushions, a walnut table, a marble mantelpiece, "two pieces Della Robbia," a column, a plaster bust and a plaster Cupid, a portrait in oil, and some cut-leather portieres, among other things.[24]

Bardini's establishment was housed in a palazzo that was filled with a rich assortment of fine and decorative arts from the late Middle Ages, the Renaissance, and the Baroque period; it is located on the Piazza Mozzi, just where the Ponte alle Grazie crosses the River Arno. In its large rooms, the dealer had installed the ceilings, wall paneling, fireplaces, and so forth that he had purchased from other Italian palaces, making them easily visible to potential buyers such as Stanford White. After Bardini's death in 1922, his house became a museum that displays all the unsold items (see figures 1 and 2).[25]

FIGURE 13. An interior, Palazzo Davanzati, Florence, 1900–1916. Stanford White purchased many objets d'art on behalf of his clients from Professor Elia Volpi. Tables similar to the one seen here, for instance, appear in old photographs of the dining rooms of the William C. Whitney and Payne Whitney residences (figures 25, 38, and 39). (Courtesy University of Delaware Library, Newark)

FIGURE 14.
Armchairs, Italian,
1590–1630. The
photograph of these
chairs was made in
connection with a
large sale of his an-
tiquities from the
Palazzo Davanzati
that Volpi arranged
in 1916 in New York
City, where the de-
mand for such things
ensured its success.
(Courtesy University
of Delaware Library,
Newark)

Bardini carried high-quality pieces, such as *St. George and the Dragon* by Uccello, an attribution questioned by Bernard Berenson, who frequently visited the dealer's palazzo. There, too, one could chance upon a della Robbia altarpiece, a collection of weapons, handsome Oriental carpets and Italian tapestries, ancient Roman sarcophagi, Romanesque and Gothic sculptures, a carved pulpit, bronzes by the foremost Renaissance masters, a painting by Antonio Pollaiuolo, fifteenth-century wedding chests, an assortment of sixteenth-century chairs, and so on—all for sale.

In 1898 and 1899, White was on the trail of a large amount of old boiserie for William C. Whitney's ballroom. The boiserie was then owned by Prince Cerami of Taormina, Sicily, and Bardini was making every effort to acquire it on White's behalf; indeed, the prince was quite eager to sell it, but Bardini needed the permission of the Italian government to export it. White had seen the boiserie on his visit to Europe in 1897, but he later received word from Bardini that a problem had arisen: "I sent you yesterday by my cable the measurements of the choir and sacristy of Taormina, in regard to the leaving of which the Director of the Gallery of Beaux-Arts of Palermo, Sicily, caused us some trouble."[26] In the spring of 1898 came a disturbing cablegram from the Florentine dealer: "Minister refuses exportation of Taormina. Prince went to Rome to solicit permission. Everything packed except ceiling."[27] One senses the growing impatience

of Stanford White and William C. Whitney in the correspondence, as when Bardini wrote to White in July: "Everything is going well as regards the ceilings, which is not the case in the Taormina affair, because you are too much in a hurry. The shipment cannot be made without the permission of the government."[28] The matter lingered on through the summer, with Bardini writing again in August that "the Taormina business continues in status quo. . . . The Ministers at Rome are nearly all away on leave until the beginning of October, which means that you will still have to wait."[29] Writing to White the next month, Bardini tried to explain the situation further and convince the architect that he was making every effort, legal and otherwise, to get the necessary approval for export:

> In regard to the Taormina affair, it would distress me greatly if Mr. Whitney believed that it is my fault that it has not yet gone through. The Prince of Cerami is quite ready to deliver all woodwork, but it is not possible to have all this woodwork gotten out of the country without permission of the Ministry of Public Instruction, resident in Roma. It is also impossible to get it out of the country secretly, as it is too bulky. . . . I have promised 10,000 francs recompense (since you authorized it) to a person of influence in the Ministry, so that he should obtain a permit for us, and we will then end by getting it. Only it is impossible to say when.
>
> I would also call your attention to the fact that the choir you bought from Mr. Handelaer, at Paris, was stopped when it reached Mondane, Franco-Italian frontier, and was sent back to Turin, where it remained six months at the Custom House before a permit could be obtained. The Taormina affair is still more difficult, because it is a question of historic woodwork, and if the Ministry refuses at first to give a permit for exportation, it is only with patience and perseverance that one will finally succeed in getting the required permit.[30]

Bardini was never able to obtain the necessary permission to export the boiserie—which greatly disappointed both White and Whitney—for the Italian government made it increasingly difficult to send its national treasures beyond its borders. Some time later, Charles Coleman wrote to White that "the Taormina quire [choir] was for sale last year, and that a certain person went there to look at it with a view to possible purchase. . . . I should certainly . . . demand the return of the money, but

in truth I doubt much if Mr. Whitney will ever see his money or the quire again."[31]

ITALIAN LAW AND THE EXPORTATION OF ANTIQUITIES

Before about 1870, Italy was so preoccupied with its struggles for independence and unification that it could not turn its attention to protecting its national artistic patrimony. Before 1860, the northern section was under Austrian rule, whereas the region around Rome continued as the Papal States; Naples and Sicily constituted the Kingdom of the Two Sicilies, and Sardinia was the domain of Victor Emmanuel. With the Risorgimento of the 1860s led by Giuseppe Garibaldi, unity was finally achieved after Victor Emmanuel II was proclaimed king in 1861, Italy annexed the territory of Venice in 1866, and the king brought the Papal States into the fold in 1870.

But it was some time before the legislators could enact a code that properly protected the national treasures, so the government turned to the Pacca Edict. Bartolomeo Pacca (1756–1844) had been a cardinal and papal diplomat under the ancien régime and during the Napoleonic era had witnessed the wholesale exportation of magnificent works of art to Paris. Although many of those pieces were returned after the fall of Napoleon, the sale of treasures from the palazzos in and around Rome continued, until Pacca issued his edict, on 7 April 1820, which forbade the exportation of art and antiques without the approval of the papal government. During the mid-nineteenth century, the problem subsided, and the edict was nearly forgotten; but once unification was achieved, it was revived as the law of the entire land, until legislators could create new protective laws. As the Rome correspondent of *La Figaro* explained, the Pacca Edict "is the only law of the Pontifical Government maintained by the new masters of Rome. [It] . . . forbids the exportation from Italy of ancient masterpieces and of antiquities having an acknowledged artistic value."[32]

Finally, in early 1892 the Italian parliament passed a bill that established consistency in regard to the exportation of antiquities. The essential feature of the legislation was that parliament would make an annual appropriation for the purchase of works of art by the state; in theory, this would keep the item in question in Italy and make it available to the people by placing it in a public collection. But the woefully inadequate appropriation was quickly used up each year, and many owners and dealers were deprived of the rich market among foreign buyers.

AN ART-RICH BUT DESTITUTE ITALIAN NOBILITY

Throughout the nineteenth century, while many countries in Europe enjoyed escalating economic successes, Italy generally did not, except in a few northern regions. Nor did the Italian nobility participate in the Industrial Revolution, and land reforms soon deprived the aristocracy of its hereditary custom of living off the land. Sometimes it was possible to sell a painting by Raphael or a choice piece by Cellini, but many family collections, formed over the course of centuries, were entailed. That meant that although a certain nobleman might own a splendid collection, he was forbidden to sell any portion of it because its founder in the seventeenth or eighteenth century had so willed it. Many a member of the nobility in Rome, Naples, Florence, Taormina, or wherever sat amid riches and splendor, impoverished and hard pressed by creditors of the new socioeconomic order. "The financial straits to which some of the great families of Rome are reduced," one editorial opined, "and the injustice of forbidding them to sell the pictures which are their greatest wealth, in order to enable them to meet their obligations, have brought to light the absurdity of the system."[33]

Nowhere is this story more poignantly illustrated than with the great Borghese family and its renowned collections—its library, paintings, statuary, and splendid palazzo with magnificent furnishings. By 1890 Prince Paolo Borghese was in deepening financial trouble, a situation that did not go unobserved in the press: "Prince Borghese, who has made bad speculations, cannot derive any assistance from his admirable collection of paintings and works of art of all kinds."[34] As the banks began to attach liens to the collection—Borghese's only collateral—the prince took evasive action, as reported in the *New York Times*: "The recent economic crisis at Rome has almost ruined many of the great ancient families, such as the Borghese, Sciarra, and Barberini. . . . Paul Borghese . . . has distributed the works of art which composed the celebrated Borghese gallery among his nine brothers, so as to enable him to lease the apartments given up to the art collection to a bank. . . . It is feared that the example may find imitation on the part of the other great families, and that there may thus be a general breaking up of the fine private art collections at Rome."[35] In August 1891, the *Times* reported that Prince Borghese and his family "have disappeared from Italy since his failure became known. His liabilities amount to 37,000,000 lire and his assets to 24,000,000 lire. The crash is causing failures among other aristocratic families."[36] Only a few months

later, the *Boston Herald* reported: "BORGHESE GALLERY SEIZURE—The action of the [Italian] National Bank, the principal creditor of the Borghese family, compels the seizure of the Borghese gallery, and £320,000 is asked for the collection."[37]

Desperate and destitute, Borghese had sought to sell works from his collection to foreign buyers, with the full knowledge that doing so was illegal. The press noted the failure of the export laws to prevent such sales, with one editorial observing that "from time to time the [Italian] Government learned that this or that painting or statue had been smuggled over the border, to appear in the gallery of some French, German or English collector." The article then specifically cited the nefarious actions of Paolo Borghese: "Attention was directed to that practice eventually by the loss of the Caesar Borgia portrait, supposed to be a Raphael. That picture disappeared from the gallery of the insolvent Prince Borghese, was taken over the border to France in a trunk with a double bottom, and shortly afterward was placed in the gallery of Baron Rothschild in Paris."[38]

The situation remained unresolved for several years, with Borghese forbidden to sell anything to foreign collectors, but neither private nor public funds were available within Italy: "When the treasures of the Villa Borghese . . . were offered for sale, there were no purchasers, for no individual Italian was found with capital enough to become the owner of these famous pictures and statues."[39]

The eagerness of Prince Borghese to dispose of the masterpieces in his collection was, of course, tantalizing to Americans who had the wealth to go after such treasures. In 1899, for example, Bernard Berenson wrote to Isabella Stewart Gardner that Titian's great masterpiece *Sacred and Profane Love* might become available but at the staggering price of about $750,000; it would be the stellar attraction of the museum that she was planning at Boston's Fenway. In the end, however, the advisers who oversaw Gardner's finances would not approve the purchase, and when negotiations collapsed, the prince approached the Italian government with a proposition to sell it the entire collection. The offer was accepted, and a plan was devised to pay for the collection by instituting an admission charge to tourists who wished to see the Roman Forum.

By 1902, the famous Villa Borghese itself was sold to the government for $660,000, with $80,000 of that amount provided by King Victor Emmanuel III. Thus did the great collection formed by Cardinal Scipio Borghese in the seventeenth century, and handed down within the fami-

ly from generation to generation, pass from a private princely collection to the public institution it is today.

PRINCE SCIARRA-COLONNA

Nor was Paolo Borghese's story unique, for other noble houses had similar histories in the late nineteenth century. In the early 1890s, Prince Sciarra-Colonna of Rome also sought to extricate himself from debt by secretly selling his patrimony, and he knew that the best prices could be had from foreign rather than Italian buyers. When his creditors heard of his plan, they appealed to the courts to seize his paintings on their behalf. But Sciarra produced legal papers proving that his ancestors had entailed the collection, and accordingly it had to remain forever intact in the possession of the family. The Ministry of Education—under which such matters fell—then offered the prince $500,000 for eight of his best pictures, but he refused, claiming that his Raphael alone was worth nearly half that. When the ministry reminded him that his documents of entailment forbade the sale of the art to private parties, the prince simply declared that no such papers existed, and, sure enough, the documents had disappeared.

Some time passed before the rumors resurfaced that Sciarra had smuggled a group of paintings out of the country, at which point the government took charge of the gallery and discovered that not only was Raphael's *The Violinist* missing but so were Titian's *The Gamblers* and *Portrait of a Beautiful Woman*; *Modesty and Vanity,* then believed to be by Leonardo da Vinci but reattributed to Bernardino Luini; and Perugino's *St. Sebastian*, along with Guido Reni's *Mary Magdalen* and several others. The paintings were believed to be in Paris, but Prince Sciarra-Colonna refused to disclose their whereabouts.

A brief article in the *Collector* about these events concluded that such things went on regularly and that "[a]nother phase of the same business is the smuggling of valuable ancient books and manuscripts out of the country. This goes on constantly, with the connivance of corrupt priests who have the guardianship of the great monastic collections. It is a notorious fact that almost any book in the Vatican Library, for instance, can be acquired by you or me, provided we can pay enough for it and know to whom to entrust the contract of filching it."[40]

The secretary of the United States legation in Rome, C. A. Dougherty, described a similar situation in a long article published in the *New-York Tribune* in 1894. After referring respectfully to the sad plight of the Borghese family, he recounted the story of another Roman nobleman, "of lineage as

illustrious as the Borghese, but of temperament dissimilar, and of practical mind." The prince in question, who was nearly bankrupt, possessed two grand galleries filled with masterpieces of the Renaissance and Baroque eras; these he offered to sell to the Italian government, which, alas, had no funds. The prince then turned to "a certain foreign government and . . . several enormously rich connoisseurs." Dougherty continued: "Clever artists, who made a specialty of copying famous paintings, were engaged in the Prince's gallery. Several original 'old masters' went out from Italy to other lands, while marvelously exact fac-similies [*sic*], with all the complexion of age, took the vacated places in the old frames, and went back to their respective positions on the walls. . . . The galleries had remained closed during six months, and when they were reopened there was nothing to indicate that everything of interest was not exactly as before."[41]

While Stanford White only occasionally bought masterpieces of the quality found in the Borghese and Sciarra collections, their stories illustrate the predicament of many Italian noble families that were eager to sell items from among their possessions, thus explaining why so many antiquities were available on the market in Rome, Venice, Florence, Naples, and elsewhere. Hundreds of the lesser Italian nobility faced similar indebtedness, with no assets other than the paintings, antiquities, and furnishings of their palazzos or villas that had been held in their families for centuries. Many resorted to complicity in smuggling such treasures across the borders and in eluding the payment of export and import duties.

TARIFFS AND THE AVOIDANCE THEREOF

As if getting a government export license to ship an artwork out of Italy was not difficult enough—or impossible, as proved to be the case with Prince Cerami's historic boiserie—there was the matter of paying the export duty, which was 20 percent of the price. Next came the worst part of the transaction: the tariff levied on antiquities and works of art under customs laws when such objects entered the United States. The rate could be as high as 60 percent. If an American buyer paid $100,000 for an objet d'art, by the time he or she actually possessed it the cost could rise to $150,000 to $180,000 with the assessment of export-import duties.

When Junius Spencer Morgan died in London in April 1890, his son, J. Pierpont Morgan, inherited his father's two houses in England, each of which was full of magnificent paintings, sculptures, manuscripts, and furnishings—Thomas Gainsborough's *Mrs. Wilbraham,* for example, and

George Romney's *Emma Hamilton,* as well as an Italian landscape by J. M. W. Turner and thousands of other items. J. Pierpont wanted to bring those choice items to New York to add to his own growing collections, but he could not because of the enormous amount of duty that he would have to pay. Fortunately, a number of people had the wisdom to see the advantage of allowing the Morgan collections then housed in England to be brought into the United States, but it was 1909 before their lobbying paid off when Congress agreed to allow the fine arts generally to enter duty free. Accordingly, the Morgan collections were brought over, around 1913, and much of their contents ended up in the Metropolitan Museum of Art.

The story of Charles M. Ffoulke provides a similar example. Ffoulke, of Washington, D.C., had a passion for tapestries, about two hundred of which he kept in a leased convent in Florence: "He cannot enjoy [them] at home because of a high [import] tariff. It is cheaper to keep them in Italy and to make pilgrimages to their shrine! Mr. Ffoulke's collection is in part composed of 130 examples of the celebrated Barberini tapestries purchased from the Barberini family of Rome."[42]

Congress had enacted tariff laws in the mid-nineteenth century that attempted to protect American artists from floods of paintings by contemporary European painters, but by about 1890 the practice of art had become such an international affair that the customs code seemed antiquated.[43] Congress then passed the McKinley Act, reducing the duties on the fine arts from 30 percent to 15 percent. A few years later, however, the Dingley Act of 1897 set a tariff of 20 percent on most items, but on others the duty remained as high as 60 percent.[44]

Embedded within the restrictive tariff laws lay the seeds of ingenious circumvention. Otherwise respectable citizens, Stanford White among them, indulged in the most devious schemes to avoid the hated duty tax. One common practice was to have the dealer from whom one purchased items in Paris or Rome or wherever make out one inventory with accurate pricing to serve as the bill to be paid, but it was accompanied by a second invoice, reduced by about half, for the buyer to present to the customs official at the point of importation. An example of this is found in Stanford White's purchases from dealers named Romano in 1900, as noted by Charles Coleman, who advised White: "Fedele Romano made out a second bill for your use if necessary in the C.H. [Customs House] at New York instead of 1800 lires, 1260 lires. . . . Also Francesco Romano did the same, making the second bill for 1205 lires instead of 2200 lires, as per bill enclosed."[45] The jovial but shrewd old merchant of ancient and exotic fabrics, Vitall Benguiat, once wrote to White about some Renaissance velvets

and rich vestments and, after quoting a price, noted, "I can value them much less, and you will not have any difficulty in the Custom House."[46]

Jules Lowengard of Paris also endeavored to assist his customers in the avoidance of tariffs, confiding to Stanford White that he had been to see a certain gentleman who told him that the current duty on tapestries was 40 percent, adding, however, "that he has means of passing things *very* much cheaper—and of course he took jolly good care not to indicate to me the means. He keeps his business to himself & I cannot blame him for it. I heard that even now goods (antiques) can be passed even free—if they are left for a certain time in a Paris dwelling."[47]

CAVEAT EMPTOR: FRAUDS, FAKES, AND FORGERIES

"There have been golden ages of art fraud, and we are . . . living in one of them at present."[48] These lines, taken from a brief article published in 1892, remind us of the perils faced by collectors or their agents—such as Stanford White—during the Gilded Age, when great amounts of available money and a craze for Europe's ancient objects of virtu created temptations that extremely talented forgers and clever, if unethical, dealers could not resist.

Stanford White tended to do business with established dealers who wanted to protect their reputations. But by buying in the quantities that he did, and sweeping through a dozen shops and galleries in a single day, as was his custom, it was inevitable that innumerable spurious pieces were found among the great masses of paintings, sculptures, and furnishings that he shipped back to the United States for his clients' residences or his own. To be sure, he did not want to be duped or to pay the high price of an original masterpiece for an object known to be a fake or a reproduction. But if a sculptured marble sarcophagus caught his eye, and he knew that it was right for a client's entrance hall as a jardiniere, or container to hold potted plants, his only care regarding its authenticity was whether the dealer was charging him for the real thing or for a modern copy. Also, we should remember that whether a piece was authentic or a forgery was of minor concern to White and his patrons for another reason: they were in the habit of having reproductions made to their order and specifications, particularly furniture; if someone for whom White was decorating a house had one Louis XV chair and wanted twenty-four, the original simply went to Allard's or to Carlhian & Beaumetz in Paris with an order for twenty-three copies of it. White and his clients were quite used to and comfortable with high-quality reproductions.

White was not a collector in the sense that Henry Clay Frick was, or Henry Huntington or J. Pierpont Morgan—men who were committed to the formation of collections of only the most superb, unquestioned masterworks by the most famous artists. At times, it seems more accurate to say that White was more a "gatherer" than a collector, searching for decorative pieces that would work well in a patron's salon, library, or billiard room. If he assisted a client in forming a picture collection, he went about it in a way very different from that of, say, Joseph Duveen, and White's interests were not those of the scholarly connoisseur Bernard Berenson.

Nevertheless, when Stanford White went abroad on his nearly annual foraging expeditions, he entered a world beset with pitfalls for the unwary or the gullible. In fairness to White and the American millionaires of the Gilded Age who bought prodigiously in Europe, only to have later generations of curators and art historians determine that their "masterpieces" were forgeries or student copies, we should examine, if only briefly, the business of misattribution and deceit that fooled even the directors of the Louvre, South Kensington Museum, Metropolitan Museum of Art, Museum of Fine Arts in Boston, and innumerable other distinguished institutions.

Late-nineteenth-century Paris, Rome, Florence, and London were hotbeds for the production of high-quality but bogus furniture, ceramics, coins and medals, sculptures, and paintings. Duveen's once wrote to Stanford White regarding a marble fountain that he had bought in Italy and that the firm had shipped to him in New York without opening the crate to inspect it as it passed through London. "We did not see it at all," the dealers explained, "but . . . we never guarantee any marbles from Italy as 99 pieces out of 100 are made up, as you know."[49] American newspapers and periodicals constantly warned visitors to the Continent, especially those going to France or Italy, about the dangers of buying fakes. Collectively, those who dealt in such forgeries were known around the art world as the Black Band, and its members eagerly awaited the arrival of the tourist season each year. One author, in an article titled "Sham Antiquities in France" that referred to the Black Band, noted that "they still take a diabolical and professional delight in entrapping unwary antiquarian tourists by offering sham curios, articles of vertu, pottery, coins, and medals for sale."[50]

Travelers were warned to beware of the *truqueurs*—as the forgers of furniture were called in France (their artistry was known as *truquage*)—with their tricks of the trade, their chemistry, their worm farming, their skillful abuse of objects to make them look old. Their tools and devices need not be complicated or expensive, one article explained, for walnut juice gives

"an agreeable mellowness of tone" to new wood, and "nitric acid . . . imitates pretty closely the ravages of ants, and holes bored with a fine augur easily give the worm-eaten appearance which appeals to the lover of the antique in carved furniture." The author then noted that "in Paris, live worms are kept to do the work [of the augur drill], and do it better and to order." The names and identities of the most ingenious forgers are known, and, although notorious, many were treated with the respect due a successful businessman. In Rome, for instance, Romano Palesi was internationally known and praised for his forgeries of antique furniture and was known as the Wormwood King. This author then observed that one had to be especially careful regarding china and porcelain because "at Cage's manufactory at Versailles the *faience de Nevers* is reproduced to perfection; but . . . if the buyer prefers his purchase 'antique,' Mr. Cage will bake it for him until the glaze crackles; it is further mellowed in a manure heap. . . . The special marks of favorite potters are easily imitated."

The writer then continued: "At Venice the reproduction of the old palatial furniture is a thriving industry, and the same at Florence." Regarding the ivory triptychs that were manufactured at Versailles, he explained that the golden tint was gained by "boiling [them] in oil, then plunging [them] into boiling water, and drying [them] before a hot fire which cracks the ivory to perfection. These require a very skilled eye to detect, as the carving is often meritorious."[51]

Bronzes made by famous sculptors of the Renaissance and Baroque periods held a special appeal for millionaires of the Gilded Age. In fact, their willingness to pay large sums for such bronzes gave rise to a brisk business in forging them. Florence, Rome, and Paris were the chief centers for such activities. While fakery in bronzes had long been practiced in Italy, the modern history of Italian bronze forgeries began in the 1850s and 1860s with a young peasant, Giovanni Bastianini (1830–1868), of a destitute family from the area of Florence and Fiesole. Largely untrained, he was a genius whose love of art centered on the great Renaissance sculptors Donatello, Ghiberti, and Mino de Fiesole. He saw their work every day as he walked the streets of Florence or visited its churches. A charcoal-seller-turned-antiquarian named Freppa recognized Bastianini's extraordinary talent and set him up in a secluded studio, where all the young man had to do was make bronze, marble, or plaster sculptures in the manner of the Renaissance.

His work was so good, so like authentic pieces of the quattrocento and cinquecento, that Freppa had little trouble selling them to prominent dealers, who, in turn, sold them to distinguished collectors and art museums.

Bastianini's bust of Lucrezia Donati and marble relief of the Virgin and Child, for example, were gladly welcomed into the near-sacred halls of the South Kensington Museum, London. His bust of the hooded monk Girolamo Savonarola was set in a place of honor in San Marco, Florence, and the director of the Louvre personally bought for that august collection Bastianini's sculptured portrait of the sixteenth-century Florentine poet Girolamo Benivieni that was then displayed in the same gallery as Michelangelo's marble *Captives*.[52] When Freppa learned of the high prices that the dealers were getting, while they were paying him and Bastianini only a pittance, he blew the whistle and exposed every forgery he could, wherever they existed in renowned museums or private collections, and many directors, curators, dealers, and collectors throughout Europe were embarrassed.[53]

An article in the *New York Times* in 1868, the very year of Bastianini's death, cautioned Americans traveling abroad about the dangers of buying bronzes in Paris.

> There are in Paris upwards of two-hundred manufacturers of bronzes. The number of workmen employed by them directly and indirectly amounts to nearly thirteen thousand. . . . The yearly value of the productions of these establishments is about 50,000,000 francs. The countries to which they are principally exported are Great Britain, the United States, Russia, Belgium and the Low Countries. Among the houses that hold the first rank in the manufacture are those of Barbedienne, justly celebrated for its severe classic taste [and] Lerolle which cultivates principally the styles of the Renaissance and Louis XVI.[54]

With that many foundries and a workforce of thousands of skilled technicians, it was inevitable that an industry in forgeries should thrive, and it did.

Among forgers of paintings, one of the best known was Federico Joni, who maintained a large workshop, even school, of forgers in Siena. Mary and Bernard Berenson were so taken by his work that they asked him to be on the lookout for originals that they might buy after he had made his bogus copy. Berenson once wrote to Isabella Stewart Gardner, saying, "I warn you that more and more impudently do the Italian dealers trade in forgeries, and the greatest of this ring are the Costantinis."[55] Emilio Costantini was a Florentine dealer of shady reputation from whom White occasionally bought things; Costantini's son could produce on request a phony Fra Angelico or Botticelli or Simone Martini or whatever his father

happened to have a market for. These forgeries were very well done, and many are known to have entered American collections—those of Senator William A. Clark and Charles Yerkes, for example.

The large-scale production of forgeries of Renaissance and Baroque paintings, and the casualness with which some dealers applied attributions to old canvases, explains the necessity of the enormous task of sorting through collections throughout the twentieth century. That Americans were duped is demonstrated by the case of Stanford White's fellow architect James Renwick, who died in 1895. Renwick bequeathed to the Metropolitan Museum of Art ninety paintings—"Old Masters"—out of the approximately three hundred that were in his collection. The matter went before the proper committee, and, to the surprise of many, the Met declined to accept the gift. Samuel P. Avery, a New York dealer and patron, chaired the Paintings Committee, which was assisted by several experts; the group "came to the conclusion that the genuineness of the pictures attributed to the old masters was too doubtful to make it advisable" to accept the gift, according to an article in *American Architect and Building News*. The writer went on to say that it was "something of a disappointment to think that the Museum is not . . . to have the Murillos and Correggios and Titians and Paul Veroneses that Mr. Renwick thought he was bequeathing to it."[56]

I will discuss Stanford White's collection of paintings, sculptures, china, tapestries and other fabrics, bric-a-brac, and bibelots in chapter 6. For the present, I will note only that he bought heavily for many years in the same arenas that Renwick did, an art and antiques landscape beset with many hazards. As we turn to the analysis of several specific houses and their grand chambers that were decorated by Stanford White, it is good to be aware of the nature of the world in which he conducted the business of acquiring antiquities—or facsimiles thereof. While most of the things he acquired were genuine, some inevitably were not.

THE WILLIAM C. WHITNEY AND OLIVER HAZARD PAYNE HOUSES

LOUIS SULLIVAN'S CRY FOR A BRAVE NEW ART AND ARCHITECTURE THAT were ahistorical and expressive of new technologies and materials would have fallen on deaf ears among the Whitney–Payne crowd, or among the J. P. Morgan–Astor–Vanderbilt–Rockefeller circles, for that matter. Although many new-money people had blazed new trails in finance and industry, they turned instead to the art forms of the Old World aristocracy to help satisfy their need for social status. This was evident on a grand scale in the buildings that they erected for the World's Columbian Exposition (Chicago, 1893) and in the redesigning of Washington, D.C. (1901–1902), as the modern classical city that we know today. The houses built or remodeled by William C. Whitney and his family offer particularly interesting case studies of the desire for Old World culture, and of the role played by Stanford White in the decoration of their interiors with objets d'art collected on his European buying trips.

To avoid confusion in connection with the several houses designed or remodeled by White for members of the Whitney and Payne families, here is a list of the homes I will consider in this chapter; except where otherwise noted, all were in New York City:

1889–1890	William C. and Flora Whitney residence, 2 West Fifty-seventh St. (remodeling of the Frederic Stevens house)
1894	Oliver Hazard Payne residence, 852 Fifth Avenue
1897–1902	William C. Whitney residence, 871 Fifth Avenue (remodeling of the Robert Stuart house)
1898	Harry Payne and Gertrude Vanderbilt Whitney residence, 2 West Fifty-seventh Street (former William C. Whitney house)
1900–1902	William C. Whitney estate, Westbury, Long Island
1902–1906	Payne and Helen Whitney residence, 972 Fifth Avenue
1905–1906	Harry Payne and Gertrude Vanderbilt Whitney residence, Westbury, Long Island (former William C. Whitney residence, inherited by his son in 1904)

WILLIAM COLLINS WHITNEY AND 2 WEST FIFTY-SEVENTH STREET

William Collins Whitney (1841–1904) was a modern-day Croesus who spent vast sums to surround himself and his family with Old World magnificence. Of seventeenth-century Puritan lineage, he left Massachusetts to attend Yale University, where he was a classmate of Oliver Hazard Payne.[1] After graduating in 1863, Whitney attended law school at Harvard and was admitted to the New York bar in 1865. One of the leading figures of the political reform movement that finally ousted Boss Tweed from the nest of corruption known as Tammany Hall, Whitney rose to national attention with the prominent role he played in the election of Grover Cleveland as president in 1884. Meanwhile, he had married Flora Payne, daughter of the politically powerful senator Henry Payne of Cleveland and younger sister of Whitney's former college classmate Oliver Payne.

When President Cleveland appointed William C. Whitney to his cabinet as secretary of the navy in 1885, the Whitneys moved to Washington, D.C., where Flora's natural talent for fashionable entertaining revolutionized the social scene. At the rear of their mansion, they erected a large ballroom—its bright red walls trimmed with yellow and gold—and entertained lavishly. Never had high society in the District been invited to indulge in such splendor.[2]

William Whitney proved himself a capable administrator, revamping a decrepit fleet and restoring respect to American naval power, a prelimi-

nary to subsequent American imperialism. But at the end of Cleveland's term in 1889, the Whitneys returned to New York, where William renounced political ambition to concentrate on making sufficient millions to support the sybaritic lifestyle that he now envisioned for himself and his family. He soon became the very standard by which success was to be measured, and no less a social critic than Henry Adams, when looking about to assess the advantages of education, selected William Collins Whitney as his model, declaring that he discarded "political ambition like the ashes of smoked cigarettes; had turned to other amusements, satisfied every taste, gorged every appetite, won every object that New York afforded, and, not yet satisfied, had carried his field of activity abroad, until New York no longer knew what most to envy, his horses or his houses."[3]

To ensure that Flora and her husband would have a suitable domicile from which to launch their entrance into high society, Oliver Payne presented his sister with a fine four-story house on the southwest corner of Fifth Avenue and Fifty-seventh Street. This structure, of red brick with stone trim, was formerly the home of the socialite Adele Stevens. The house, which had been designed for her in 1875 by George Harney, was different from other town houses in New York City. In style, it broke with the ubiquitous brownstone that dominated the grid of New York streets, for Adele Stevens's house was Romanesque, with five towers and numerous gables.

Inside, the rooms were different, too. For the interiors, Harney had gone to Europe, seeking treasures in the same manner that Stanford White would a few years later. *Art Amateur* reported, "Much of the fine old wood-work used in the interior . . . was brought from Belgium by Mr. Harney himself, having been obtained by him from dismantled monasteries and nunneries."[4] The Flemish ballroom came from a grand house in Ghent, and the walls of the dining room were covered with "old Spanish leather, collected piece by piece laboriously in Spain, and put together" in the Stevens house.[5] The house—which contained ancient carved marble fireplaces, oak parquet floors, Gobelins tapestries, and antique furniture upholstered with Beauvais tapestry—was one of the finest in New York in the late 1870s and early 1880s, and it was one of the first to incorporate Old World antiquities as the decorative theme for creating an aristocratic ambience.[6] That Adele Stevens had ambitions toward such an ambience is supported by her decision to divorce her husband and move to France, where she married into one of the foremost noble families and became the duchess of Talleyrand-Perigord. She therefore no longer needed her New York residence.

As fine as the house was, Stanford White was nevertheless called in to renovate the place. He obtained many treasures to fill it during the trip that he and Bessie took to Paris in 1889 (see chapter 1). White made the rounds of antique shops and decorators' establishments, buying lavishly on the Whitneys' behalf. The final bill for the remodeling and the furnishings came to $200,000, most of which was paid by Oliver Hazard Payne. But the neighborhood made it a good investment, for just across Fifty-seventh Street rose the mansion of Alice and Cornelius Vanderbilt II, while across Fifth Avenue (on the site today occupied by Tiffany's) stood the grand house of Collis P. Huntington, the California railroad magnate; diagonally across from the Whitney residence was that of Tessie Oelrichs, best known today for Rosecliff, the cottage she commissioned Stanford White to build for her in Newport, Rhode Island.

BECOMING A MILLIONAIRE, A NICKEL AT A TIME

The Whitneys' lifestyle required huge sums of money; indeed, to them and their crowd, money was the lifeblood of their very existence. Everything, especially the mansions they built and decorated, was meant to show that they had money in abundance. Surface transportation throughout the burgeoning metropolis had been a crazy quilt of eighteen or so independent trolley lines, usually in poor repair and indifferent to time schedules. Working in partnership with Thomas Fortune Ryan (1841–1911) and Peter A. B. Widener (1834–1915), Whitney bought the diverse lines, brought them under one holding company, and then reorganized them and converted them from horse-drawn to electrically powered vehicles. As passengers dropped their nickels into the fare box, William C. Whitney and his partners became richer and richer—a nickel at a time, to be sure—but Whitney's share soon totaled $40 million, at which point he retired to devote himself to the proper pursuits of a gentleman: traveling, collecting, breeding and racing horses—and building and decorating great mansions.[7]

Whitney became an avid builder, and by the time of his death his properties included 70,000 acres in the Adirondacks with a grand lodge and assorted support structures; the LaBelle Horse Farm in Kentucky; a "cottage" in Lenox, Massachusetts, and an 11,000-acre game preserve at October Mountain near Lenox; 2,000 acres surrounding Joy Cottage, a large antebellum house, complete with a broad piazza and a row of two-story white columns, in Aiken, Georgia, with stables and private racetrack; a baronial mansion perched amid 450 rambling acres in Westbury, Long

Island; and the New York City house at 871 Fifth Avenue, at the corner of Sixty-eighth Street.[8]

Meanwhile, Oliver Hazard Payne (1839–1917) had also done rather well for himself. Upon leaving Yale in 1861, he marched off to join the Union forces, achieving the rank of colonel, a designation he retained for the rest of his life. Shortly before the war ended, he returned to Cleveland and joined with John D. Rockefeller, who was then organizing the monopolistic giant known as Standard Oil. Payne became its treasurer, and by the time he moved to New York to be near Flora and his nieces and nephews, his wealth from oil company holdings was enormous. By now, the Whitneys had four children—Harry Payne, Pauline, Payne, and Dorothy—and, it would seem, every success in the world.

But it had long been known that Flora had a cardiac condition, and on 23 January 1893 she suffered a heart attack; a week later, she was dead. William, the children, and Oliver were devastated and entered a long period of mourning. But three years later, William shocked all of society—and especially Oliver Payne—when he suddenly married a handsome widow, Edith Randolph. Oliver exploded, feeling that the memory of his beloved sister had been defamed by William. Oliver Payne swore that he would ruin William C. Whitney financially, which Payne in fact tried to do but was unsuccessful, so he began a campaign to lure Whitney's children away from him by promises of gifts of fabulous wealth. It worked with two of them, Pauline and Payne, who left their father to side with their uncle, but Harry Payne and little Dorothy remained loyal to their father.

The fine mansion at 2 West Fifty-seventh Street was an exquisite residence, but it was in truth Flora's house; Payne money had bought it, and Flora's ghost seemed to linger there.[9] Anyway, his new wife should have a house of her own, so William gave that fine mansion to his elder son, Harry Payne Whitney, who the previous year had married—in what has to be the most outstanding example of marrying "the girl next door" (or across the street)—Gertrude, daughter of Alice and Cornelius Vanderbilt II. In later years, Gertrude Vanderbilt Whitney founded the Whitney Museum of American Art.

871 FIFTH AVENUE

That same year, 1896, William C. Whitney bought the residence of Robert L. Stuart, the late sugar mogul, 871 Fifth Avenue, on the corner of Sixty-eighth Street—with 55 feet facing Central Park and 200 feet on

the side street. The house was fairly new, having been completed in 1883, and its first life is known today through photographs of Stuart's enormous art gallery.[10] Once more, Stanford White was called in and given carte blanche to make it the grandest of the grand Fifth Avenue residences. White was qualified in both innate taste and a natural talent for spending money, especially other people's. While the exterior remained essentially unchanged, the entire interior was gutted so that the architect-decorator could start afresh.

In the 1890s, Stanford White seldom missed an annual trip to Europe. In the summer trips of 1898 and 1899, his chief purpose was to find ceilings, walls, stained-glass windows, fireplaces, tables, chairs, and so on to fill the house of William C. Whitney. White bought prodigiously, and Count Boni de Castellane blamed wealthy Americans such as Whitney (and his agent, White) and Isabella Stewart Gardner for the escalation of prices of antiquities: "These competitors in art are responsible for the abnormal rise in the price of antiques, which makes it impossible for many of us to re-purchase our family treasures, often, alas! dispersed through marriage, misfortune or death."[11] For this one house alone, White had fifty-four rooms to furnish, although, to be sure, only about a dozen of the more important chambers received his personal attention.

In 1896 and 1897, William C. Whitney and Stanford White frequently discussed remodeling 871 Fifth Avenue. But the overall plan for the decoration of the major rooms came together in White's mind while he was touring Europe in the summer of 1898. His letter to his patron reveals that he was envisioning the interiors with the eye of a decorator. From Paris, White wrote that he was convinced that he could "accomplish a scheme based on renaissance lines which will be successful and satisfactory to all of us," and he then outlined his thoughts in a passage that provides an insight into how his mind worked as he was creating interiors:

> The *Entrance, Staircase and Hall* of marble. The . . . outside gates of wrought iron & glass. For this I have got some work to use as a model. For the main inside doorway, I have got a beauty from Bardini. Most of the marble work will of course have to be new, but I have got [old] pieces to work in.
>
> *Main Hall* For the ceiling I have got a beautiful carved & painted Renaissance ceiling from Bardini while the woodwork, which I hope I have secured in Sicily [from] Bardini, will more than cover

the walls with a richly carved & paneled wainscot and give me all the wood I want for the staircase (this woodwork was offered [to] Bardini and I told him to get it at once. . . . [But] I am afraid . . . Mrs. Jack Gardner was in Sicily at the time and may have got ahead of us!).

Two Front Rooms. For these rooms I have got two fine paneled and painted ceilings from Bardini and I have got two fine renaissance mantel pieces. My idea would be to treat the balance of the rooms very simply—covering the walls with red velvet—with red velvet & gold curtains, or one room in velvet & the other in Damask (I have got the velvet but no silk as yet). The corner room to be treated exactly like your front room at 57th St., while my idea of the other room is to keep it, by a selection of things, purely renaissance in character—and to this end I have got a lot of things—amongst them (of Bardini) a magnificent portrait by [Justus] Susterman of a Medici in armor to go over the mantel piece.

Dining Room—for the Dining Room I have got a beautiful carved and panelled hardwood ceiling—there are traces of painting on it, now hardly discernable—and the ceiling now has the most beautiful light brown tone imaginable. I have seen no mantel piece better for this room than the one we have. For the balance of the room I still cling to the treatment I have always thought of, and I beg you will let me do it. I am sure it is the best foil to the other rooms and that it will be absolutely unique in America & I am willing to stand as guarantee that you will like it—that is a marble (warm in color around the border) floor with a great rug nearly covering it. . . . Door & window architraves of rich marble—the walls covered with the painted canvases I have. They are really so dark and rich that they count like painted leather. Hangings [tapestries]—against which you can put your sideboard, furniture or even hang pictures or bas reliefs. . . . And if you do not like the final result . . . , as they need not be stretched on the wall but can be put in frames like your leather—they can be taken off in a jiffy, and you can replace them with leather.[12]

White then mentioned marble columns for the conservatory, a fireplace for Edith Whitney's room, some gilt work and paintings, and "an exqui-

site little marble arched doorway from Bardini," as well as a fountain with cupids and a wall fountain, plus some marble "troughs and fountains to hold flowers." A list of odds and ends of furnishings followed, concluding with the understanding that White would gladly take back any pieces that were bought in Whitney's name but not used in his house. White continued:

> There is one extravagance . . . which I have "en train" which I hope you will approve—in order to get the flow of light we need, the end of your hall is nothing but a screen of marble columns and glass which of course must be obscure, and upon the successful treatment of which much of the success of the hall will depend. Bardini's glass of course is the finest, but it is too rich. . . . When I visited the Vicomtesse de Sauve with Kopp . . . I found her hall and dining windows filled with some beautiful old 15th century painted glass with historical subjects—from a Renaissance chapel, which had been in the house for years. We nearly got evicted from the house because I asked her to sell it—but afterwards she relented & said if she sold it she would want 150,000 francs for it—I am afraid I will not get it & I can always back out if you do not approve. . . . The ballroom is really now the only thing which troubles me & there I think we may have to call in Allard's help. . . . I am on the track of a large mantel—in any case I have always felt that most of the Ball room would have to be made of new work, working in your tapestries & such old work as we can find. If, however, we could get a splendid old ceiling it would be a great thing.[13]

Photographs of the Whitney interiors taken soon after the house was completed testify to the success of White's expeditions (figures 15–30 and plate 3). Nearly everything visible to the eye came from Europe and ranged from an ancient Roman sarcophagus to eighteenth-century French Louis XVI–style furniture. The result was an amalgamation of diverse styles of objects from varied origins, often separated by centuries or a millennium in date, shipped across the Atlantic, reassembled in their opulent diversity by Stanford White, and given new life in the United States in a Fifth Avenue mansion. The main effect was that of Old World culture but especially Old World aristocracy—which was exactly what the great plutocrats of Gilded Age America desired.

We can gain some idea of the assorted antiques, large and small, that

White picked up on Whitney's behalf in 1898 from a list that the architect submitted to his client the following February, which is quoted here in part:

> Mantel in fiesole stone, for southwest corner room,
> 2 bronze door knockers,
> 1 gilt and walnut table with marble top,
> 2 gold candelabra,
> 1 marble mantel for northwest room,
> 2 marble Cupid legs [Cupids, later used as newel posts],
> 1 font in marble, 2 marble capitals,
> 2 sarcophagi, in marble, for troughs for flowers,
> 3 chairs in red, 3 chairs in green,
> 1 arched marble door and iron gate,
> 1 renaissance cabinet,
> 1 Spanish openwork bed,
> 1 gold Italian bed,
> 1 stone doorway for entrance door, Italian painted and coffered
> . . . ceiling for southwest . . . room,
> 1 coffered and illuminated ceiling for hall,
> 1 coffered and painted ceiling for dining-room,
> 1 painted frieze for wall over staircase,
> 1 painted Venetian frieze [for the dining room],
> 1 ceiling with large octagonal coffer in middle,
> carved walnut panelling choir and sacristy from church in
> Taormina [never actually obtained]
> Received for the above, 333,000 fr.[14]

A settling of accounts—a five-page typescript affair—shows that Whitney had advanced $244,085, on which White drew for his purchases in 1898 and 1899.[15] That was, in the purchasing power of the 1890s, an enormous sum in itself—the equivalent of about $3.5 million today—but records show that many more acquisitions were made beyond that list. An idea of the extent to which the architect was buying Old World antiquities at this time appears in a communication from Duveen Brothers to White: "The large shipment of 48 cases has left."[16]

THE ENTRANCE, VESTIBULE, AND RECEPTION HALL

One entered the Whitney residence through great iron and bronze gates obtained through Raoul Heilbronner in Paris; they had originally guarded the old Palazzo Doria in Genoa. The Fiesole marble doorway, said to

be of the Renaissance period, had doors that contained panels of light walnut with inlay.

The walls of the entrance hall were of white marble ornamented with green onyx pilasters (figure 15). A large oak Renaissance refectory table, with scroll supports that terminated in claw feet, had been acquired from Duveen Brothers; it had originally been used in an Italian monastery. For this room, White had purchased from Stefano Bardini of Florence a set of six Italian Renaissance armchairs with carved frames that were upholstered in red silk damask and finished with red galloon and fringe. Two long white marble benches had cushions covered with antique red Genoese velvet, and against the walls stood two white marble sarcophagi—one adorned with a central relief of an acanthus wreath flanked by two nude boys, and the other with a mask surmounted by a portrait medallion.

From the entrance hall, one entered the stair hall, which had an elaborate, square-coffered ceiling and marble walls (figure 16). A sixteenth-century Italian cassone, or chest, painted with figures added color to the room.[17] Atop the cabinet (at the left in figure 16) was placed a painted metal Italian Renaissance statuette "in the manner of Verrocchio" of the Christ Child standing. The 1942 catalogue for the sale of these Whitney items further informs us that "this statuette was purchased in Toulouse [France] by the late Stanford White."[18] Handsome Oriental carpets covered much of the marble-inlay floor.

From the spacious stair hall, doorways opened on the left into Whitney's large office and into the Marie Antoinette reception room. On evenings of grand entertainments, the office became a cloak room for gentlemen, whereas the Marie Antoinette room became the ladies' powder room (figure 17). The walls of the latter were mainly white and gold, with large mirrors and panels of blue brocade; a similar fabric was used for the drapes at the two French windows that overlooked Fifth Avenue. This room was of a noticeably lighter tone than were reception rooms of an earlier generation, for White here adopted the white paneling of the walls, trimmed with gilding, of the salons of the style of Louis XVI. Edward Simmons, a decorative artist sometimes employed by White for his interiors, remembered that "Stanford set the fashion here. . . . [He used] a decided lightening of the color scheme, so much so that a 'gag' was to call the firm 'McKim, White and Gold.'"[19] From Henry O. Watson, White had obtained a Louis XV sofa with a carved and gilded frame; it was upholstered in Beauvais antique tapestry with scenes from La Fontaine's *The Robbers and the Donkey*, and its delicate color scheme was dominated by

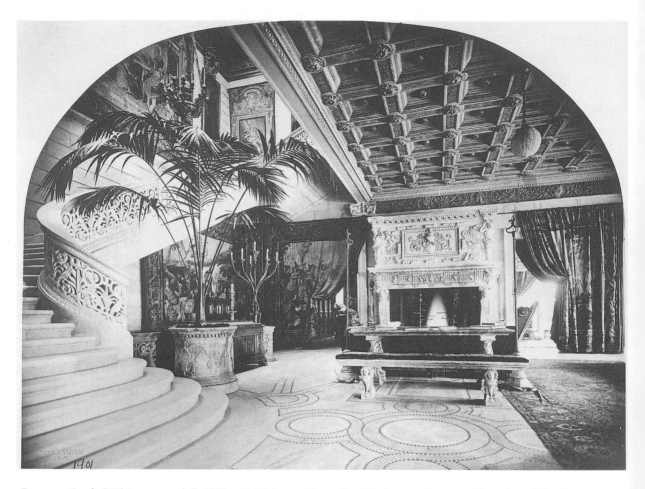

FIGURE 15. Stanford White, entrance hall, William C. Whitney residence, 871 Fifth Avenue, 1897–1901. The sculptured Renaissance fireplace in the entrance hall was made of Pentellican marble, and before it sprawled a large polar bear–skin rug; Oriental carpets covered much of the rest of the floor. An example of Stanford White's ability to create new uses for old pieces was a pair of marble cupids that once decorated a Greek palace. White turned them into newel posts for the William C. Whitneys' grand stairway. (Collection of The New-York Historical Society)

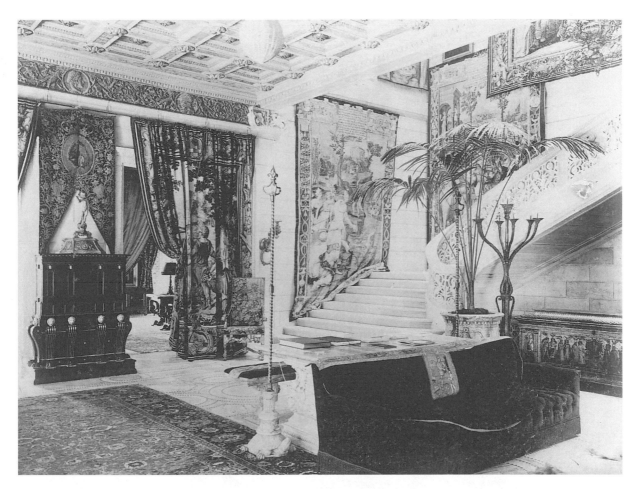

FIGURE 16. Stanford White, stair hall, 871 Fifth Avenue, ca. 1901. Accessories for the stair hall included "two tall thin candelabra, gilt" and "tall antique marble candelabra for lighting standards," according to a list at Columbia University's Avery Library, dated 30 March 1900, that itemized pieces in the Whitney house, room by room. It was a common practice to adapt antique pieces such as these in order to use that new wonder, electricity. Similarly, ancient marble sarcophagi became jardinieres filled with potted palms and ferns. Under the stairway was a colorful, mid-sixteenth-century Italian cassone, or chest, with painted and carved figures that White had obtained from Stefano Bardini of Florence. (Drawings and Archives, Avery Architectural and Fine Arts Library, Columbia University in the City of New York)

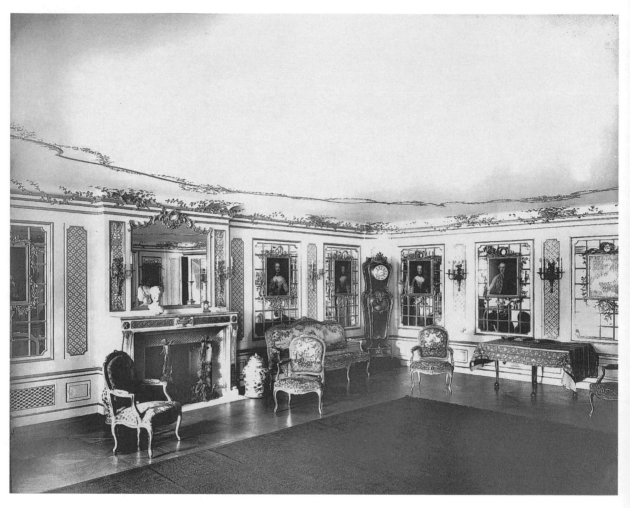

FIGURE 17. Stanford White, Marie Antoinette reception room, 871 Fifth Avenue, ca. 1901. On the walls of the reception room in the Whitney residence were hung "a number of remarkably good copies of [works by] Boucher, Nattier, Lancret, Pater, Watteau and other [French] painters of the eighteenth century," according to the *New York Times* of 5 January 1901. These portraits—thirteen in all, in oil on canvas and each about 30 by 24 inches (76.9 × 61.5 cm)—are believed to be likenesses of princes and princesses of the French royal family. (Museum of the City of New York)

rose, ivory, and soft blue. Also from Watson came six Beauvais tapestry chairs with pastoral scenes, as well as a tall clock with marquetry and bronze fittings that stood in one corner. A carved and gilded Louis XV table had a slab top of Egyptian marble.

THE GRAND STAIRWAY AND THE MAIN HALL

From the reception hall rose a grand staircase to the second, or main, floor. The stairway, designed by Stanford White, was made of Istrian marble with ornately carved balustrades, executed in New York by contemporary marble carvers. The walls were decorated with a pair of tapestries from about 1550 representing the mythological adventures of Diana—*The Taunting of Niobe* and *The Drowning of Britomartis* (figure 18). They were part of a famous set, four of which belong to the Château d'Anet, which Henri II built in 1547 for Diane de Poitiers, whereas two others are in the Musée des Antiquités at Rouen. The hem of the goddess's skirt contains the interwoven *H* and *D* monogram.[20] White had acquired these for Whitney in Paris from the dealer Emile Peyre, probably on the same buying excursion during which he purchased two tapestry portieres—for the doorways into Whitney's office and the Marie Antoinette room—from another dealer, Fernand Robert, who was Isabella Stewart Gardner's agent in Paris.

The stairway led from the reception hall to the main hall on the second floor, an area that rivaled the celebrated ballroom in its lavishness (figure 19). From this great hall, one gained entrance to the principal rooms of the house—the library, drawing room, dining room, and ballroom. A sizable area in itself, it ran the entire width of the house and was two stories high. The coffered, gilded, and painted ceiling, created in Renaissance Italy in the sixteenth century, had been discovered by White when it was installed in Stefano Bardini's palace in Florence and acquired specifically for the Whitney house; the one hundred coffers had blue grounds with gilded rosettes, and the separating beams were ornamented with rosettes and arabesque designs. Just below the ceiling cornice was a seventeenth-century frieze, obtained by White from Heilbronner of Paris and visible in figure 19, that had been extracted from the château of Vicomte Sauze in the south of France; its relief work, which had sixteen medallion heads surrounded by griffins and arabesques, was painted dark blue and accented with gold. At one end of the hall and above the Sixty-eighth Street entrance were seventeenth-century Flemish stained-glass windows that had

FIGURE 18. *The Drowning of Britomartis,* Flemish, ca. 1550. Displayed in the grand stairway of the William C. Whitney residence at 871 Fifth Avenue, this tapestry (15¼ × 9½ feet [4.65 × 2.9 m]) represents an allegory of chastity, showing the goddess Diana coming upon the nymph Britomartis, who, fleeing the advances of King Minos, is about to drown at sea but is rescued by fishermen. However, once she is put ashore, she again encounters the enraptured king of Crete. *The Drowning of Britomartis* and related tapestries may have originally been at Anet, the château owned by Diane de Poitiers, mistress of King Henri II, for Diana's robe bears the entwined *H* and *D* monogram. (The Metropolitan Museum of Art, Gift of the children of Mrs. Harry Payne Whitney, in accordance with her wishes, 1942 [42.57.1])

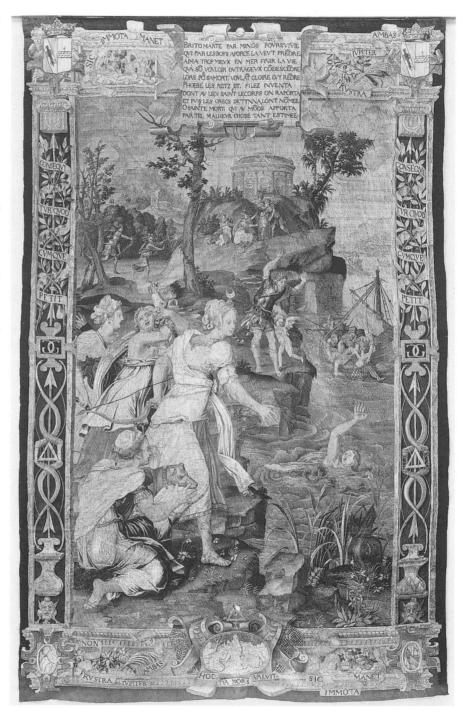

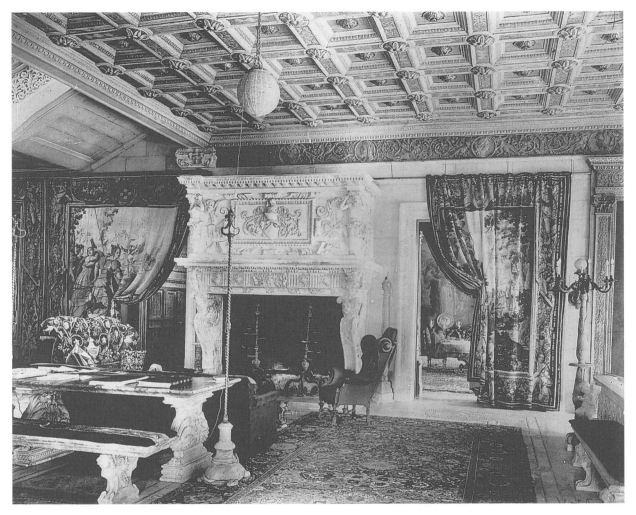

FIGURE 19. Stanford White, main hall, 871 Fifth Avenue, ca. 1901. The sixteenth-century Italian ceiling, about 35 feet square, had been acquired from Bardini; it contained one hundred coffers, each of which had a gilded rosette set against a blue background. Just beneath the ceiling was a seventeenth-century frieze that had been part of the château of Vicomte Sauze, and it was ornamented with sixteen medallion heads amid griffin and arabesque motifs; it had a dark blue background, with gilded decorative features. The huge Oriental carpet came from Vitall Benguiat. (Museum of the City of New York)

also once graced the château of Vicomte Sauze. The main panel represented the fathers of the church and was reportedly very bright in color.

The great carved stone fireplace—which stood more than 12 feet high and 5 feet deep with a cavernous opening—had originally been a part of the château of the Sieur Franc de Conseil at Aigues-Mortes in the time of Henri II (r. 1547–1559); it had been taken to Paris by Mr. Worms de Romilly and installed in his home, and from there it came to New York. The mantel was supported by two great scrolls that ended in human heads, and above them, in the overmantel, were caryatids at the corners. The three reliefs of the overmantel represented a church (right), a medieval town (left), and an escutcheon bearing a helmet with a lion's head in the center.

Furnishings for the main hall included a set of gilded Louis XIV armchairs—upholstered in Flemish tapestry of floral designs—that had been purchased from Emile Peyre of Paris. The three sofas, with carved and gilded frames, were done in old Genoese red velvet. In this hall were also two white marble benches and a large Italian Renaissance table, whose supports were ornamented with reliefs of putti and trophies. Whitney owned several painted cassones of the Renaissance period, and a quattrocentro example in this hall was said to resemble the work of Pinturicchio; its polychromed panel had a gold background with a central motif of the Virgin and Child enthroned, flanked by numerous saints, Old Testament personalities, and Virtues. Several items that White had acquired from the antique-fabrics dealer Vitall Benguiat gave color to this room, including a seventeenth-century Spanish ecclesiastical banner of embroidered red Genoese velvet and a Spanish Renaissance cope, also made of Genoese red velvet, embroidered with full-length figures of the Virgin and Child with five saints.

Whitney had an extensive collection of paintings dispersed throughout the more important rooms. Late in 1900, he had acquired a large equestrian portrait of Charles I, attributed to Sir Anthony Van Dyck, that he hung in the spacious main hall. This was a duplicate of the original (in Windsor Castle), which was painted by order of the monarch for Sir John Byron of Newstead, in whose family it had remained for about two hundred years, until Sir John Borlace Warren of Nottinghamshire bought it. Warren sold it to a dealer, who sold it to Whitney. King Charles is represented in full armor with his equerry walking at his side, and the painting's great gilded frame was more than 10 by 7 feet. Where the stairway led into the hall was a large fifteenth-century altarpiece by Lorenzo Costa that de-

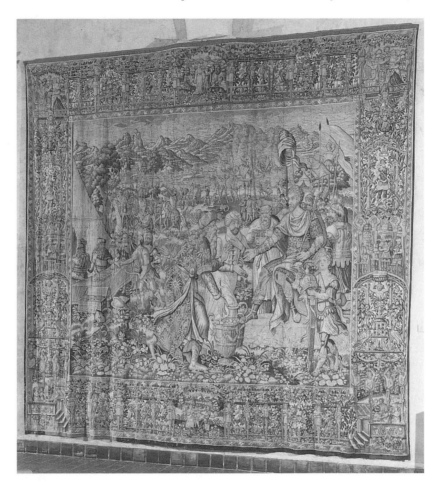

FIGURE 20. *Titus Receiving Tribute from Tyre,* Flemish, 1540–1560. *Titus Receiving Tribute from Tyre* (16 × 14 feet [5.06 × 4.26 m]) was formerly displayed in the main hall of the William C. Whitney residence at 871 Fifth Avenue. Whitney always sought the finest quality furnishings for the house that White was remodeling for him. This tapestry and its companions were the pieces that the British borrowed for the coronation of King Edward VII. (Worcester Art Museum, Worcester, Massachusetts. Bequest of Mrs. Harry Payne Whitney [1942.36])

picted a Madonna and Child seated between two standing figures, Saint Thomas and Nicodemus. It had belonged to the Collegio dei Jesui and may have been owned by or commissioned by one of the dukes of Ferrara. In the nineteenth century, it had entered an English collection, and Whitney acquired it from A. H. Buttery, a London art dealer.

The walls of the main hall were hung with an extraordinary set of six sixteenth-century Brussels tapestries depicting the War of Flavius Titus against Jerusalem (figure 20). Each panel measured about 14 by 10 feet wide, although one was 21 feet wide. Duveen Brothers acquired them in 1901 from the widow of a Marquis Nicolai, and through Stanford White the panels were sold to Whitney. The set was so admired that the British

borrowed it for the pageantry of the coronation of King Edward VII. The Ispahan carpet, which was more than 25 feet long and said to be sixteenth-century Indo-Persian in origin, was obtained from Vitall Benguiat. The various collectibles of the room offered a typical cultural mix, including a pair of chiseled brass and gilt Italian candlesticks, with repoussé designs, about 26 inches high; numerous Japanese and Chinese porcelain jars and bronze vases; and a small bronze version, 40 inches tall, of Augustus Saint-Gaudens's *Diana of the Tower.*

THE LIBRARY AND THE DRAWING ROOM

On either side of the fireplace of the grand hall were doorways leading to the ballroom corridor (left) and the dining room (right). One could also enter the library and the drawing room from the central hall. The library had an antique Italian ceiling with thirty-five coffers arranged in rows of seven by five; each coffer was blue with a gilded rosette in the center (figure 21). White had acquired this ceiling from Simonetti of Rome. On one wall stood a fifteenth-century Italian white marble fireplace with a carved frieze. Duveen Brothers of London charged 20,000 francs for the wall paneling, and the door frames were composed of ornately carved Italian walnut. A focal point for the room was an Italian marriage chest obtained from Emile Peyre on one of White's visits to Paris. The library walls were adorned with several notable paintings—*Miss Jacobs* by Sir Joshua Reynolds, bought by Whitney himself at the Blakeslee-Fischoff sale (New York, 1900), and *Madonna and Child,* attributed to Fra Filippo Lippi. *Portrait of a Man* (*Venetian Nobleman in Armor*), said to be by Scipione Pulzone, who was called Gaetano, depicted a young man in black and gold Spanish Renaissance armor. It was purchased around 1900 by Agnew's of London from the Patrizi family and was hung above the fireplace. On the large oak Henri II table with carved caryatids was a small panel bearing a three-quarter-length portrait of a nobleman and his wife, reportedly by Lucas Cranach the Elder; it had been in the collection of Hollingworth Magniac, Esq., in London until 1892, when a dealer bought it.

The library's furnishings were also an eclectic mix. For example, there were six antique oak high-back Jacobean chairs, their splats carved with open scrollwork; one of these was set just to the right of the fireplace. The room also held four Chippendale chairs, and a Napoleonic Empire library chair; a large red silk-velvet sofa with carved and gilded ball feet was placed before the fireplace. A large armchair (at left in figure 21) was upholstered in red velvet and ornamented with long fringe. White probably

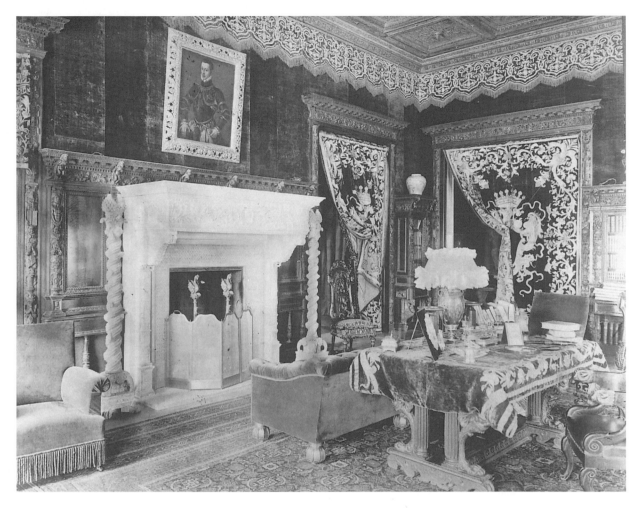

FIGURE 21. Stanford White, library, 871 Fifth Avenue, ca. 1901. The library of the Whitney residence boasted a potpourri of objets d'art, including Ming porcelain jars, a pair of Japanese bronze vases, and a set of Italian Renaissance candlesticks of carved and gilded wood that were decorated with cherubs' heads. Two sculpted marble Italian Renaissance columnar standards flanked the fireplace; each was more than 7 feet tall and had cabbage finials and bases carved with rams' heads. White had obtained the standards from Bardini of Florence. (Collection of The New-York Historical Society)

FIGURE 22. Book-cases, sixteenth century. Installed in the library of the William C. Whitney residence at 871 Fifth Avenue, six richly carved oak and walnut bookcases (four wall cases and two corner cases) were formed from sixteenth-century choir stalls that had been removed from a church in Naples and a chapel elsewhere in Italy. The carvings atop the cases were attributed to Giovanni Marliano da Nola (1500–1550) and are known as *The Baptism of Christ* and *Faith, Hope, and Charity.* Antique choir stalls were in great demand in the United States, both as collectibles in their own right and as pieces to be transformed into some new form, as White did. In 1907, for example, the Metropolitan Museum of Art acquired a set of handsomely carved sixteenth-century choir stalls that originally came from southern Italy. (Drawings and Archives, Avery Architectural and Fine Arts Library, Columbia University in the City of New York)

bought the fabrics from Vitall Benguiat. The bookcases offer an example of the transformation that ancient objects often underwent after White acquired them, for the carvings originally had been parts of choir stalls (figure 22).

The drawing room, which was next to the library and overlooked Fifth Avenue, also opened onto the main hall (figure 23). White had purchased the antique ceiling of this elaborate salon from Bardini, who had acquired it from the palazzo of a prince in Rome. It was composed of twenty coffers done in green, gold, and copper with painted arabesques and gilded pendant rosettes. The cornice was red with much gilding, and the walls were covered with approximately 200 yards of figured crimson Renaissance velvet that had been obtained from Benguiat. The white marble fireplace, a modern copy of an antique, had a frieze ornamented with cupids as the central motif and was flanked by eagles.

Among the furnishings were a walnut cabinet from the time of Henri II, bought by White in Paris from Emile Peyre, and from the same dealer came an Italian Renaissance harp (at the left in figure 23). The other harp, of the period of Louis XVI, had a head rail embellished with French chinoiseries. The large table, also of the Louis XVI era, was ornately carved

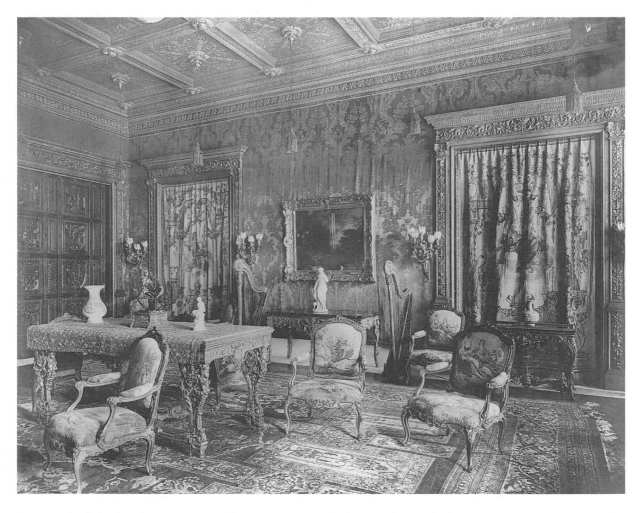

FIGURE 23. Stanford White, drawing room, 871 Fifth Avenue, ca. 1901. The three door frames in the drawing room were antique—sixteenth-century Italian—their pilasters and entablatures painted dark blue with gilt arabesques. A sliding door (*left*) was the work of Giovanni Marliano da Nola of Naples, and its panels contained reliefs of grotesque heads and strap work. (Museum of the City of New York)

and gilded, its caryatid legs adorned with shells and foliate designs, and topped with a slab of marble that was more than 7 feet long. From Duveen's, White had obtained a pair of small Louis XV tables with marquetry and gilt ormolu mounts and a Louis XV drop-front secretary, also with marquetry and chiseled gilt ormolu ornaments. The table against the wall had a carved gilt frame and a green marble top; on it was placed a small marble figure of a girl with an urn, perhaps representing the Greek goddess Hebe, attributed to one of Louis XV's favorite sculptors, François-Antoine Vasse (1681–1736), and this piece, too, came from Duveen Brothers. The oak floor was covered with a silk carpet 23 feet long that was said to have come from a Persian palace.

Among the elegant furnishings of the drawing room were a suite of six armchairs, two bergeres, and a sofa (figure 24) and a fire screen in the style of Louis XV. The chair frames—which, according to the sale catalogue of 1942, were "of a later date," probably 1860 to 1900—were carved and gilded, with scallop shells on the crest rail, leafage ornament on the arms, and bow-knotted festoons of flowers on the seat rail. These were covered with antique silk tapestries wrought from designs by François Boucher of pastoral scenes of rustic courtship, in soft pastel tones of rose, pale blue, and ivory; they, too, came from Duveen Brothers. A tapestry of Boucher design—representing a fortune-teller—also adorned this room, as did a pair of French Renaissance tapestries with scenes from the legends of Bacchus.

The walls of the salon (drawing room) displayed a number of paintings, and the stellar attraction of the room was a full-length, early-seventeenth-century portrait of the duke of Villiers, Viscount Grandisson, by Sir Anthony Van Dyck. Whitney had acquired this portrait from the Viennese art dealer Jacob Herzog for about $60,000.[21]

Among the other paintings in the salon were a portrait of a man attributed to Tintoretto and the likeness of a member of the Medici family, said to be by Justus Susterman, that White had bought from Bardini. In this room, too, were two portraits by Sir Thomas Lawrence, representing Mrs. Siddons and Lady Hertford, and above the table in figure 23 is Thomas Gainsborough's *The Woodsman's Return*; a Mr. Lambert of London had owned the Gainsborough until it came into the Whitney collection by way of the New York dealer Henry O. Watson. Also in this room were an eighteenth-century French portrait of a lady thought to be by Boucher or by Jean-Marc Nattier, and an English picture, John Hoppner's *Dancing Girl* (*Mademoiselle Hillsburg*).

Soon after Stanford White took on the task of remodeling William C. Whitney's house, he received a letter from Duveen Brothers of London,

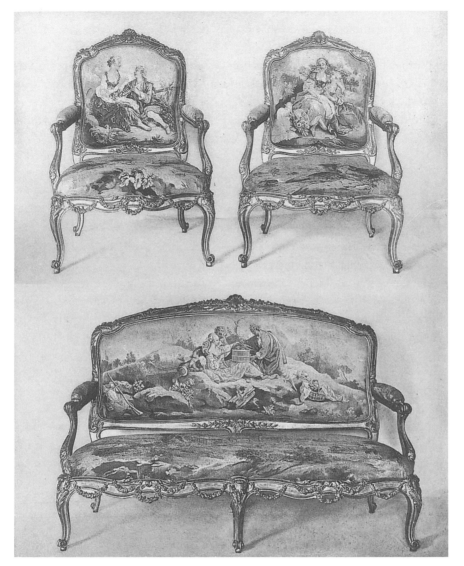

FIGURE 24. Armchairs and sofa, eighteenth century. This illustration is from the sale catalogue of 1910 and depicts items from the drawing room of the William C. Whitney residence at 871 Fifth Avenue. The chair on the left appears in figure 23 (*right*). (From *The Palatial Mansion of the Late James Henry Smith*. Courtesy, The Winterthur Library: Printed Book and Periodical Collection, Winterthur Museum, Winterthur, Del.)

saying that the firm had sent him an engraving of a full-length portrait of a lady by George Romney: "It is a portrait of Diana, Lady Milner, and we bought it from the present Sir Frederick Milner. . . . It has never been exhibited and was bought on condition that it goes to America, as [the owner] will not allow it to remain in England. . . . If you want it, please wire us."[22] The verso of this letter reveals that the patron retained the right

to reject any object that his decorator brought to his attention, for there appears a scribbled notation that reads: "Dear White, I do not care to consider this. [signed] W. C. Whitney." Allard's of Paris also offered White paintings from time to time, as when Georges Allard sent a photo of a portrait by Jean-Baptiste Greuze that Allard had taken the American to see two days earlier: "The execution is exceedingly fine and if Mrs. Whitney is looking for something really artistic it would be difficult to find anything more charming."[23] That Stanford White was indeed himself a buyer of old European paintings is confirmed by photographs of the picture gallery in his own New York City house (see figure 63).

Decorator pieces in the grand salon included a small marble figure (on the large table in figure 23) acquired from Duveen's, titled *L'Oiseau Mort*, that was attributed to Etienne Maurice Falconet (1716–1791); it shows a young girl sitting on a tree stump, contemplating the dead bird she holds in her lap. On the same table was a small bronze version of Antonio Canova's famous group of Hercules hurling Lichas into the sea. At the end of that table was a Chinese vase of the K'ang-hsi period (1662–1722) on which were painted numerous butterflies in enamel, while on the table at the far right, in front of the curtained doorway in figure 23, is a Chinese imperial vase of the Ch'ien-lung era (1735–1796), profusely embellished in bright enamel colors. In this room was also a 34-inch bronze version of Frederick MacMonnies's *Bacchante*. The room was illuminated by twelve wall sconces with ormolu decoration and tulip-shaped shades of the Louis XV period but recently electrified. To the modern eye and modern taste, the richness of the room may well seem overwhelming, but although assembled in a matter of only three or four years, this drawing room was supposed to approximate that of a château, palazzo, or country house, the interior of which was an accumulation of centuries and of many generations, of some great and noble European family.

MR. WHITNEY'S DINING ROOM

From the hall, one entered the dining room by passing through the elaborate "Golden Doorway," which consisted of a pair of Corinthian columns with decorated shafts supporting an entablature adorned with scrolls and arabesques (figure 25). Three walls of the dining room were covered with sixteenth-century Italian murals on canvas that depict a courtly scene set outdoors. In one panel, a black-bearded Asian monarch is surrounded by many figures in white turbans who pay homage to him; elsewhere, prisoners—who are not Asian—are paraded, while several of the potentate's followers blow on great trumpets. One man plays a lute be-

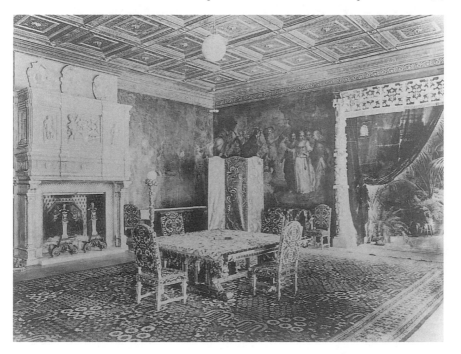

FIGURE 25. Stanford White, dining room, 871 Fifth Avenue, ca. 1901. The dining room was large, measuring 36 by 33 feet. Its ceiling was one of several that White had obtained from the dealer Bardini in Florence, and it had originally come from a palazzo in Genoa. It was coffered, with forty-two compartments, each of which contained an arabesque design with central rosette on a black background. The beams were blue with gilded rosettes at the crossings. White could have seen innumerable examples of similar wall treatments—applied murals—on his travels in Italy, at the Città di Castello (now the Art Museum), for example. (Collection of The New-York Historical Society)

side a group of four gentlemen; beyond them a lady disembarks from a galley. Nothing found in the archives thus far identifies the origin of this remarkable work except that it was a "Venetian frieze."

Atop the antique overmantel were three heraldic shields, bearing coats of arms in relief, that White had acquired from Simonetti of Rome. The fireplace—which was made of Fiesole marble and contained what was regarded as the finest set of firedogs in the United States—was described as delicately carved, with pilasters, three panels, and a frieze of arabesques; the central panel had a "representation of a fight on a bridge and included a number of figures in high relief. On each side is an arched niche with a single figure in the round. . . . All of this beautiful structure was once picked out with gold, much of which is still visible."[24]

A large antique mahogany table, 11 feet square, stood on a Persian rug, and the dining room contained a set of thirty-five Italian chairs, their frames carved and gilded, that were upholstered in ruby-red cut-velvet leafy scroll designs on a golden-yellow silk ground. The room also held two sixteenth-century Italian sideboards, elaborately carved with a Madonna and Child in the central skirt of each, plus garlands of fruit and flowers and huge paw feet. A French Gothic side table had been procured

from Emile Peyre of Paris, and a sixteenth-century Flemish folding screen was covered in leather that had a decorative array of flowers and exotic birds in bright colors against a gilded background. The decoration of the dining room was further enriched by the pictorial marquetry of the sliding door (plate 3); White had obtained this panel, which depicts the Last Supper, for the Whitney house on one of his European trips.

THE BALLROOM CORRIDOR AND THE BALLROOM

Guests entered the ballroom either from the dining room or through a long corridor behind the dining room, and White also lavished rare treasures on this hallway. The ceiling was paneled with blue and gold squares, and the frieze was a continuation of that in the main hall. On 2 June 1898, White wrote to Whitney that he had "bought the old black chapel panelling for 85,000 francs ($17,000) and the draft is on the way here against me. The freight and duties on this will be $3500.00."[25] He was referring to the woodwork from the chapel of the Château de La Bastie d'Urfe, Saint-Etienne, in the Loire Valley (figure 26). This château dates from the mid-sixteenth century, the era of Henri II, and White obtained the woodwork through Emile Peyre of Paris. Although it came from a French château, it was of Italian workmanship, for it is signed "FRANCISCI ORLANDINI VERONENSIS OPUS 1547." The wood panels are inlaid marquetry arabesques and religious scenes such as St. Peter after his betrayal of Christ, St. Jerome with a lion, and Elijah fed by the ravens. The twenty-two pictorial panels, which lined both sides of the corridor, include interior and urban scenes as well as landscapes. The ballroom passage contained a seventeenth-century Flemish stained-glass window that came from the château of Vicomte Sauze, a companion to that installed in the main hall. Furnishings included a sixteenth-century carved and gilded table with grotesque animal heads, obtained from Bardini, and a fifteenth-century Damascus prayer rug that White got from Benguiat. Five antique Italian throne chairs, also carved and gilded, were upholstered in red Genoese velvet, and several tapestries adorned the walls. Arthur Acton of Florence had supplied the "old silk damask" for the curtains. As in the other rooms, the aesthetic acumen of Stanford White unified all these varied and diverse furnishings and architectural parts.

The most spectacular room in William C. Whitney's house was the two-story ballroom, one of the largest in New York City, measuring 63 feet long by 45 feet wide (figure 27). If the Whitneys were to establish social equality with the Astors and the Vanderbilts, the ballroom, of all the rooms in the house, had to be something truly special. When finished, it

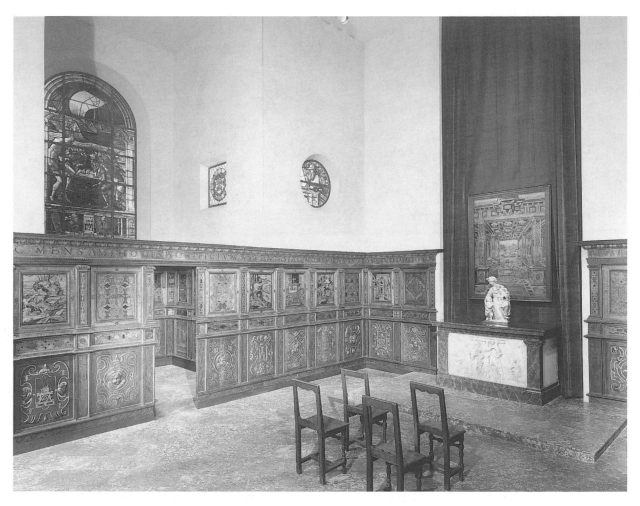

FIGURE 26. Francesco Orlandini, intarsia paneling, 1547. This paneling, originally made for the Château de La Bastie d'Urfe and installed in the ballroom corridor of the William C. Whitney residence at 871 Fifth Avenue, reaches a height of about 7 feet and is 98 feet long. Its pictorial panels represent religious and genre scenes as well as landscapes. (The Metropolitan Museum of Art, Gift of the children of Mrs. Harry Payne Whitney, in accordance with the wishes of their mother, 1942 [42.57.4 (1-108)])

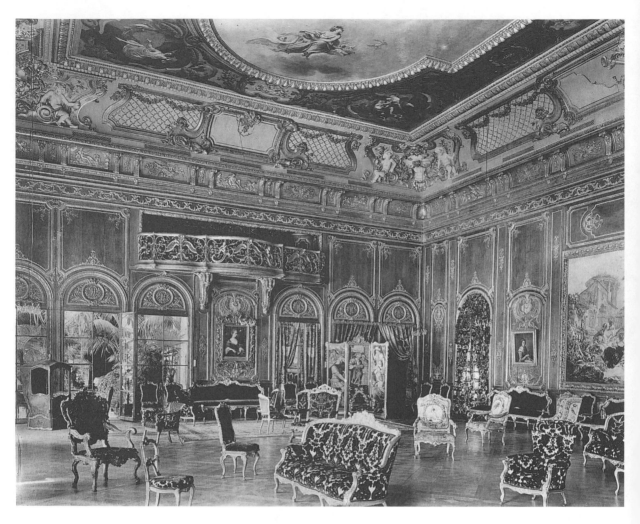

FIGURE 27. Stanford White, ballroom, 871 Fifth Avenue, ca. 1901. In the seventeenth century, this walnut paneling, picked out in gold, originally graced the walls of a château near Bordeaux, the residence of Phoebus d'Albert, baron de Foix, a chevalier of the time of Louis XIV and for a while the king's field marshal. The baron's monogram appears in the lunettes above the doors and windows. In the early nineteenth century, this boiserie was taken to Paris to be installed in a grand house, and it was in Paris that White bought it for the Whitneys' ballroom. (Museum of the City of New York. The McKim, Mead & White Collection [90.44.1.177])

had the desired effect. One *New York Times* society columnist became almost breathless when he first saw it, declaring that the scene in the ballroom, while guests were dancing the cotillion, reminded him of "some Court ball in a European palace. . . . The scene when the supper was at its height, with hundreds of beautifully gowned women, decked with flashing jewels and surrounded by Old World treasures of art, was more suggestive . . . of a banquet in some old Venetian palace in the time of the Doges than one in the metropolis of the New World."[26]

Edith Wharton often took note of the significance of the ballroom in her novels; in *The House of Mirth* (1905), published only a few years after the Whitney house was completed, she had one of her characters, Lawrence Selden, survey the scene of a ballroom and give a description similar to that provided by the *Times* reporter: "The company, in obedience to the decorative instinct which calls for fine clothes in fine surroundings, had dressed rather with an eye to Mrs. Bry's background [the ballroom] than to herself. The seated throng, filling the immense room without undue crowding, presented a surface of rich tissues and jewelled shoulders in harmony with the festooned and gilded walls, and the flushed splendours of the Venetian ceiling."[27] The Whitney ballroom could arguably be called the culmination of the evolution of this splendid and luxurious appendage to the American mansion.

The large ballroom as a discrete entity in an American home was of recent development, arriving with the Gilded Age itself after the Civil War. To justify the allocation of such a large space to a room that might well be used as a ballroom only one night out of a given year, the ballroom often doubled, in other Fifth Avenue mansions, as an art gallery and a reception area, as did Caroline Astor's ballroom in her mansion at Fifth Avenue and Sixty-fifth Street, as designed by Richard Morris Hunt (figure 28). But when Whitney and White added the ballroom onto the back of the Stuart house, they determined that it would be an extraordinary room, its space and its existence devoted entirely to the gala entertainments of a ballroom, without confusing the issue by making it serve also as an art gallery. White eliminated what had been Stuart's famous art gallery, because to White the more important function for so large a space was as a decorative and elegant setting for that highlight of the social season, the grand ball. Whitney evidently agreed. This allocation of space was typical of White, for within a given residence he tended to place such paintings and sculptures as formed a collection throughout the several more prominent rooms, rather than have one space devoted exclusively to them. The art gallery as a dis-

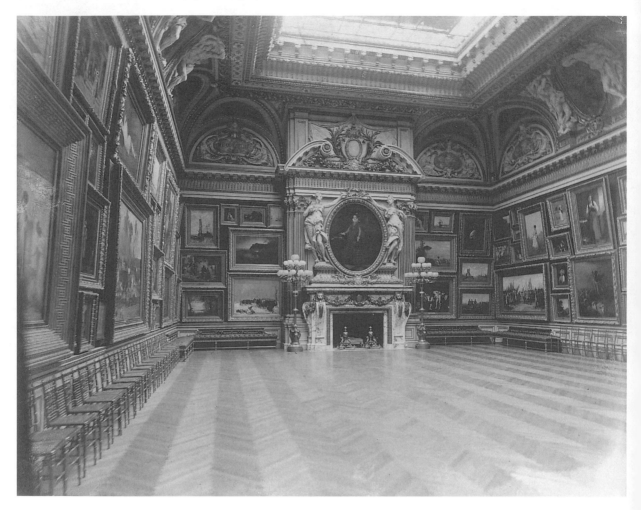

FIGURE 28. Richard Morris Hunt and, probably, Allard et Fils, ballroom and art gallery, Caroline Astor residence, 840 Fifth Avenue, ca. 1895. This room was the "holy of holies" of New York high society, the venue of the annual Astor Ball. Caroline Astor's ballroom in her earlier mansion at Fifth Avenue and Thirty-fourth Street could accommodate only four hundred people, thereby defining society's exclusive "400." By the time Richard Morris Hunt's new ballroom was completed, the charmed circle of New York society had grown to about twelve hundred privileged souls. (Collection of The New-York Historical Society)

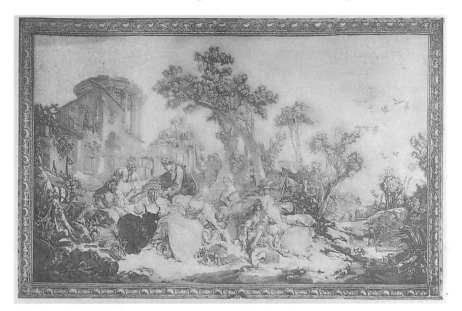

FIGURE 29. François Boucher and Jean-Baptiste Henri Deshayes, *Catching Birds* (*La Pipee aux Oiseaux*), ca. 1755. *Catching Birds* (19 × 12 feet [5.91 × 3.7 m]), of wool highlighted with silk, was part of a set of tapestries that hung on the walls of the ballroom in the William C. Whitney residence at 871 Fifth Avenue; it is now in the collection of the Art Institute of Chicago. Another set in the ballroom depicted scenes from the *Iliad* and was drawn by Deshayes, while still another, from Brussels looms, is called *The Battle of the Romans and the Sabines*. (From *The Palatial Mansion of the Late James Henry Smith*. Courtesy, The Winterthur Library: Printed Book and Periodical Collection, Winterthur Museum, Winterthur, Del.)

crete entity had become de rigeur in Gilded Age mansions of the 1860s and 1870s; the most notable examples were those of Alexander T. Stewart and William Henry Vanderbilt. Some American millionaires continued this practice, but according to Stanford White's priorities, art became more a part of the decorative ensemble than the purpose of an entire room, although his own house in New York did have a large picture gallery.

As if the lustrous surfaces of the seventeenth-century boiserie, ornamented with rich carving and decorative gilding, were not enough, the walls of Whitney's ballroom were further enhanced with a number of large tapestries that had been woven from designs by François Boucher and Jean-Baptiste Henri Deshayes (1729–1766), Boucher's son-in-law. One tapestry from Boucher's series, *Les Beaux Pastorales,* is partially visible in figure 27 at the far right. It depicts a group of young people outdoors, engaged in a fowling party in which birds are caught and placed in little cages to be kept as pets (figure 29); the landscape includes classical ruins at the left—a circular temple—and a rustic cottage at the right. The reporter covering the housewarming on the evening of 4 January 1901 declared that this set was "in texture, design, and color . . . among the most beautiful decorative tapestries in the world."[28]

Stanford White capped the walls of the ballroom with a coved cornice

of gilded ornamentation, which formed a transition to the equally ornate ceiling; in the center of the ceiling was a large allegorical painting, dating from the early eighteenth century, in which Eros, nymphs, and other characters in amorous adventures float about amid clouds. The cornice is decorated with bas-reliefs depicting nude gods and goddesses attended by cupids and other mythological personages, alternating with reliefs of music trophies—decorative compositions of musical instruments such as lyres, harps, and trumpets and sometimes wreaths.

At the corners were nude youths, done in the manner of grand French Baroque and Rococo galleries. A special feature of the room was the so-called Monkey Gallery, an antique Italian balcony of wrought iron decorated with playful monkeys that White had acquired in Paris from Raoul Heilbronner; this balcony served as the musicians' gallery. The balcony was supported by two elaborately carved and gilded brackets from a town hall in Italy—an example of White's acquisition of stray antiquities for which he knew he would later find a use in one or another of his interiors.

Regarding the lighting of the ballroom, Duveen Brothers wrote to the architect-decorator from London that its people in New York were prepared to set up, at the offices of McKim, Mead & White for White's approval, an antique "rock crystal wall-light intended for Mr. Whitney's Ball Room," as an example of several to be used in the room: "I need hardly tell you that they are extremely fine and unique and the very thing for this room. They will, of course, be fitted for electric light." The writer then made a request of White: "Kindly do not let any chandelier or wall-light manufacturers in New York to get hold of this design."[29] An accounting of bills paid in September 1898 recorded that McKim, Mead & White had "Paid Duveen re Ballroom 25,000 francs."[30] Allard and Sons was also involved in the execution of the interiors. The harp in the ballroom had been acquired from Allard's, and in early January 1901 the firm notified Stanford White that its men in New York had prepared "one large Fontainebleu bracket [sconce] modelled especially for the Ball Room of Mr. Whitney's residence. We have this bracket ready at our warerooms—subject to your approval."[31]

The furniture was a combination of antique and modern reproduction in the styles of Louis XIV, Louis XV, and Louis XVI and included thirty or so side chairs and armchairs, as well as a number of settees and sofas placed about the ballroom. William Baumgarten once contacted White to tell him, "We have just received a fine lot of 24 arm chairs, covered with antique tapestry, suitable for halls or dining room; the frames are modern of French walnut. They are an exceptional lot."[32] As I noted earlier, if a client could obtain but one antique chair, the craftsmen at Allard's could

replicate it in any number required. American craftsmen were soon nearly as proficient as Europeans in that kind of work, as Harriet Elizabeth Spofford noted when she observed in the 1870s that "at present Louis Seize furniture is made in America with a nicety and purity quite equal to that which characterizes the best examples, and its wonderfully beautiful carving is unrivaled by any that comes from abroad."[33]

Duveen Brothers had acquired an especially handsome set of eleven pieces—a sofa, two bergeres, and eight armchairs—from Prince Nicholas Obidine, who had gotten them from a château near Le Mans, France; the Beauvais tapestry covers illustrated scenes designed by Jean-Baptiste Oudry (1686–1775) and taken from the fables of Jean La Fontaine (1621–1695). Four very large Italian sofas came from a palace in Florence, their carved and gilded arms terminating in dolphins, while mermaids adorned the back rail; one of these appears below the Monkey Gallery, and two more are against the wall at the right in figure 27.

An inventory of the furniture in the ballroom includes a Louis XV sedan chair (at the left in figure 27), whose leather surfaces were ornamented with landscape scenes and coats of arms. As was often done, it had been converted into a curio cabinet. A four-panel sixteenth-century Flemish tapestry screen (right of center in figure 27) was ornamented with life-size figures.

As White traveled about Europe searching for appropriate items for his client's interiors, he regularly purchased things on his own—on speculation—knowing that he would someday find just the right place for them among his many commissions. A good example of this is the full-length portrait of a woman and child that he placed in the great hall at Whitney's Long Island estate in Westbury (figure 30). This painting came from White's private gallery in his New York City residence (see figure 63). White openly conducted his activities as a dealer, which he carried on outside the business of the firm of McKim, Mead & White, and his patrons understood that he intended to make a reasonable profit from such transactions.

THE CRAZE FOR "LOUIS" STYLES AND WHITE'S VERSION
OF THE PERIOD ROOM

While Stanford White was decorating William C. Whitney's ballroom, a critic wrote of the availability of furnishings of the type that White was using; referring to displays currently on view at the New York firm of W. & J. Sloane, the critic observed that "the three Louis, XIV, XV and XVI, still reign in the hearts of the public and the interior decorator," and stated that Aubusson and Beauvais tapestries "are favored for drawing-room

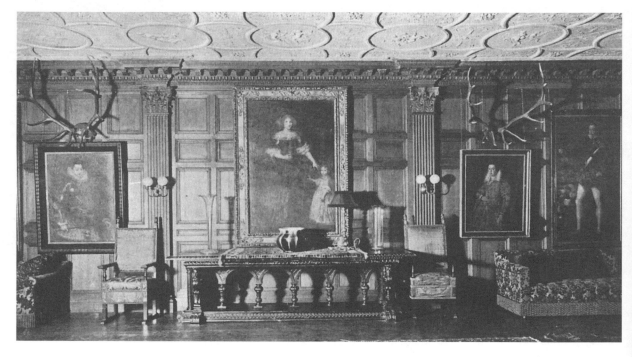

FIGURE 30. Stanford White, great hall, William C. Whitney estate, Westbury, Long Island, ca. 1900. Estates on Long Island were favorite weekend retreats during New York's social season, which lasted from mid-September (when society returned from Newport) to around April 1 (when much of society departed for Paris or elsewhere on the Continent). In this view of the great hall at William C. Whitney's estate, the huge many-branched antlers hung on paneled walls gave the feeling of an old English hunting lodge. (From *A Monograph of the Works of McKim, Mead & White, 1879–1915*)

furniture with woodwork of gold, and harmonize well with Marie Antoinette effects. . . . One can find in limitless variety occasional chairs, screens, writing-tables, and cabinets, all in excellent and tasteful reproduction of those that found their first homes in the palaces and chateaux of la belle France."[34]

By the late 1890s, the French period room had become fashionable among Gilded Age millionaires, for the very rich wanted to live like the kings and queens of France, and the furniture that the wealthy Americans chose helped establish just the ambience they desired. As early as 1888, an author writing in *Art Amateur* complained that "everything is 'Louis Seize' or 'Louis Quinze' or 'Louis Quatorze.' . . . Feeling dissatisfied with our elegant but colorless Colonial style, and with the ridiculous travesties which have been made of the Queen Anne style, everybody turns to the French modes."[35] An 1887 editorial described the fascination with the "Louis" styles, declaring that there was "no abatement in the rage for drawing-rooms in the style of the three monarchs who last sat upon the French throne. Paris and London have been ransacked by our Herters and Watsons until there is hardly a first-class piece of old furniture or a fragment of genuine tapestry of the best periods of Louis Quinze or Louis Seize to be had for love or money." Nevertheless, the writer confessed, "some how or other you can get all [you] want. . . . The copyists are kept very busy, and the supply from that source at least shows no danger of giving out. You can buy genuine 'Beauvais' . . . and all the furniture that 'actually belonged to Marie Antoinette' that the heart can desire." The anonymous critic then went on to discuss the growing popularity of the French period room: "Mrs. William Henry Vanderbilt's Louis XIV salon of course is famous; but it is not finer than the Louis XV salon of Mr. William K. Vanderbilt, with its [Paul] Baudry painted ceiling. . . . For Mr. Cornelius Vanderbilt's Louis XVI music room, the oak panelling all came out of an old French chateau; but surely it was a shame to paint and gild it. Mrs. Ogden Goelet's Louis XVI drawing-room is perhaps the finest example in the city of that style."[36]

The question arises: Did Stanford White create for any of his clients an authentic period room? The answer is no, if *period room* means an assemblage of interior architecture and furniture that is archaeologically and academically correct. That was for the scholar-curator to do in museums and later in the restoration of historic houses. In fact, the Metropolitan Museum of Art was already, by the time of Whitney's housewarming in 1901, beginning to install paneled rooms with authentic boiserie saved from the Tuileries and from a château near Saint-Cloud, and furnish them with French decorative arts from the Hoentschel collection, which J. Pierpont

Morgan had bought in its entirety and then presented to that institution.[37] Earlier I noted that the Metropolitan Museum of Art acquired in 1906 and installed a 1718 bedroom from the Palazzo Sagredo in Venice (plate 1).

Although Stanford White was both intelligent and knowledgeable, he was at heart a decorator, not a scholar, and he never meant his interiors to be historically accurate reconstructions. He would have found that tedious, and his patrons probably would have found the results boring. He was never troubled by the incongruity of mixing cultures and/or stylistic periods—as in placing a great fluffy polar bear–skin rug before an Henri II fireplace. White assembled rooms with the flair of a decorator, and they were intended to express the wealth of their owners through their lavishness and a joie de vivre in their sumptuousness. His patrons *lived* in his "period rooms" with an ease and zest that disdained the notion of untouchable museum pieces. Ceilings from Venetian palazzos, boiseries from Louis XIV châteaux, furniture from an English country house, and wall brackets from an Italian town hall were, to White, but decorative objects to be assembled at his pleasure, quite possibly all in the same room.

STANFORD WHITE AS DECORATOR AND AGENT
FOR COLONEL OLIVER PAYNE

Earlier I noted that Colonel Oliver Payne was actively involved in the remodeling of the house of his sister, Flora, and her husband, William C. Whitney, at 2 West Fifty-seventh Street, with Stanford White as decorator. Even after the break between Payne and Whitney over the latter's remarriage after Flora's death, White was able to keep both men as clients. Although "friends" might be putting their relationship too strongly, White and Payne seem to have been on good terms; White was occasionally a guest of Payne's, as when the architect vacationed at the colonel's winter retreat in Thomasville, Georgia. In chapter 4, Payne will appear again, as the man who paid the bills for the mansion that Stanford White designed and decorated for the colonel's nephew, Payne Whitney.

White was engaged in a number of projects at the behest of Oliver Hazard Payne—some small, others large. For example, Colonel Payne's yacht, the *Aphrodite*, was at one time the largest and most luxurious steam yacht afloat, and Payne took annual transatlantic excursions to Europe and the Mediterranean in it. White, who was involved with the decorating of this sea-going palace, arranged for Philip Martiny, a leading sculptor of the time, to make a bronze figure of the goddess Aphrodite for it; when the stat-

uette did not turn out as White thought it should, at his own expense he commissioned the sculptor to do it again, incorporating several suggestions from the architect. The Stanford White Papers contain a number of instances of White's perfectionism and of his insistence that something be redone at the firm's expense before he would find it aesthetically acceptable.

After Colonel Payne acquired the property at 852 Fifth Avenue, on the corner of Sixty-sixth Street, he frequently turned to Stanford White for assistance in decorating the interiors, around the turn of the century. Payne, too, arranged advances on which White could draw when buying for him, either in this country or abroad. We get a glimpse of this in a letter that the architect-decorator hurriedly wrote to Payne just before dashing off on a fishing trip to the Ristigouche Club in Canada, where he would join William Kissam Vanderbilt:

> I meant to bring a lot of things up to your house to try, but I really have been driven to death to get off. . . . I have a balance of 51,000 francs to account to you for, on the 125,000 you sent over to me in Paris. Against this are the things which I bought as per the inclosed list, and which I have had separated, and, if anything happens to me, from which you can take your pick. Although I have not traced it, I am sure you paid me $650.00 twice on Allard's account, and, besides this, I owe you $2500.00 which you loaned me on the [painting by George Frederic] Watts, and which you now hold.

White then provided a list of objects that included a painting by Jean-Baptiste Greuze, a green vase, a majolica vase, a marble faun, a head of Venus, a Greek table, a small gilded walnut table, an oval portrait of Madame Récamier, and a "portrait of Vierge Le Brun [*sic* (Vigée-LeBrun)], at the age of 20, by herself."[38]

The colonel, an avid collector of paintings, frequently turned to White for assistance. The art dealer René Gimpel recalled that in 1906 his father had sold to Oliver Payne "through the intermediary of Stanford White . . . one of the most beautiful Constables in the world, *Salisbury Cathedral,* for $20,000."[39] Henry Adams once visited the colonel's beautifully decorated house in the company of the painter John La Farge, noting that the objets d'art they saw were things "such as kings mayn't now have; they are what I want; especially his [painting by] Rubens; but he has also one 15th century tapestry [and] Stanford White has framed it exceedingly well. The Colonel's personal passion is for his Turner, the Piazza by all sorts of lights, but I . . . was more interested in a Velazquez head of the Infanta."[40]

On 12 April 1900, Duveen's of London sent White a catalogue for the forthcoming sale of the "Peel Heirlooms," with illustrations of portraits by Van Dyck that the two parties had discussed. The earlier communication is interesting because it reveals the transference of art treasures from one social class to another, and from the Old World to the New, for the Peels, like many of the nobility, had come on hard times. Duveen's sent the following letter to both Stanford White and Oliver Payne:

> The celebrated collection of pictures and works of art belonging to the Peel Family will be coming onto the market for auction in the [next month] by order of the Court of Chancery and confirmation of the House of Lords. There are many fine things, and amongst these we would especially mention the two celebrated full-length Van Dycks representing a Genoese Senator and his wife. These pictures were purchased by Sir D. Wilkie, [from] the Balbi family from the Spiniol Palace at Genoa for the Right Hon. Sir Robert Peel. . . . If you are interested in these pictures we shall be very happy to represent you [at the auction].[41]

Among the McKim, Mead & White Papers at the New-York Historical Society is an intriguing, if mystifying, document: "List of Things bought by Col. Oliver H. Payne and stored by Mr. Stanford White in Loft at 120 West 30th St." The address was that of a warehouse where White rented space and stored many of his own things. Among the items owned by Payne were

One oil painting—Claude Monet (No. 1)	$4,000
One oil painting—Charles James Fox, by Sir Joshua Reynolds	1,500
One oil painting—Cupid in Distress—Richard Westall	240
One oil painting—Claude Monet (No. 2)	3,450
Peacock Embroidery	1,000
Dutch Portrait	1,400
Four Arabesque tapestries	16,000
Old Spanish leather, bought [by White] of F. Schutz, Paris	2,150
Four old gold and Spanish mirrors and two candlesticks	1,522
One lot Hispano-Moresque tiles	3,000
One carved and painted Italian Ceiling	3,750
Old carved oak and gilt Francis I door	4,250
Painted Italian friezes	6,280
Four Adam mantels	400
Three pairs of doors from Toroni Palace	375[42]

The list suggests not only that Payne was adding to his art collection but that a great many things—doors and a ceiling from European palaces, for instance—were being accumulated in preparation for a major interior-decorating campaign, possibly for the house that Stanford White designed for the colonel's nephew Payne Whitney (see chapter 4). Oliver Payne admired the French Impressionist painters, and the Monets were intended for his own residence.

EPILOGUE OF 871 FIFTH AVENUE

Edith Whitney died several years before the remodeling of 871 Fifth Avenue was completed, and her husband was not fated to enjoy his splendid house for long, for he died in 1904. At that point, the house and all its furnishings were immediately purchased as a package by a quiet, short, little-known stockbroker named James Henry "Silent" Smith, whose nickname was well applied. But then those formidable grandes dames of high society, Annie Stewart and Mamie Fish, "discovered" the mousy little Smith and turned him into a party animal. Meanwhile, his uncle, George Smith, had died and left his nephew many millions of dollars. James Henry Smith is in the group in the photograph taken at the famous James Hazen Hyde Ball that includes Stanford White and Mamie Fish (figure 31). "Silent" Jim began keeping the company of Annie and William Rhinelander Stewart—he joined them on long yachting excursions, they shared his box at the opera, and so on. Soon rumors circulated that the Stewart marriage was in trouble; in August 1906, Annie Stewart divorced William and one month later married James Henry Smith, who by then was the owner of William C. Whitney's mansion and collections at 871 Fifth Avenue. For their honeymoon, the newlyweds sailed for Japan, but by the time they reached Kyoto, "Silent" was quite ill. He died there in March 1907.

The Whitney-cum-Smith mansion, the executors of "Silent's" estate announced, was now to be auctioned off, lock, stock, and gilded barrel, and it was for that sale-that-never-happened that an illustrated sale catalogue was published—*The Palatial Mansion of the Late James Henry Smith* (1910). But shortly before the sale was to be held, Harry Payne Whitney stepped in and bought the house, virtually as William C. Whitney had left it when he died. Harry and Gertrude lived in the house for about twenty years, occasionally adding to its many treasures.

Harry died in 1930 and Gertrude kept the house intact, although she increasingly spent her time at the Whitney estate in Westbury, working in

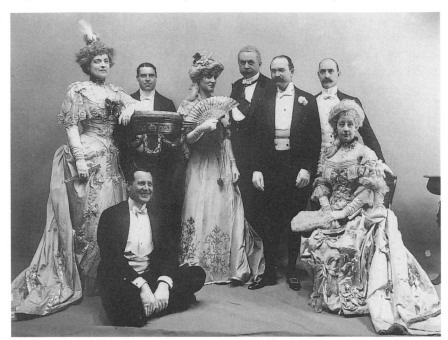

FIGURE 31. James Hazen Hyde Ball at Sherry's Hotel, New York, 31 January 1905. From the left, seated, are Sydney Smith and Mamie (Mrs. Stuyvesant) Fish; from the left, standing, are Mrs. Sydney Smith, Philip A. Clark, Adele Sloane Burden, Stanford White, James Henry Smith, and J. Norman de R. Whitehouse. The famous ball, hosted by the heir to the Equitable Life Assurance fortune, was held in the fashionable ballroom that White had designed in 1898. White moved easily among society folk, many of whom were friends and clients. (Museum of the City of New York, The Byron Collection)

her sculpture studio there. But by 1942, the Fifth Avenue house had become a dinosaur as the avenue itself changed from private residences to high-rise apartments or commercial establishments. In that year, she announced that the house and its contents would be sold.[43] A few days later, she died. The auction that followed was one of the great events of the day, glamorous because of the high-society audience that attended the several days of the sale, offering a momentary respite from the bad news of the early stages of World War II. The sale was nevertheless sad, for it marked the end of a way of life among the fashionable set, and all those treasures collected by Stanford White only a few decades earlier were dispersed far and wide. But to continue the story of Stanford White's adventures in mansion decoration, we return to the turn of the twentieth century and to his work on the Payne Whitney house.

Four

The Payne Whitney House

THE VOLUMINOUS DOCUMENTS CONNECTED WITH THE PAYNE WHITNEY house in the folders of the McKim, Mead & White Papers at the New-York Historical Society offer an exceptional opportunity to study the nuts-and-bolts business of creating a grand mansion in the Gilded Age. That is, once Stanford White had formed a concept of the house and its various rooms, and the firm's draftsmen had applied his visions to paper, who actually executed those designs? The papers reveal a fascinating collaboration of decorator houses and furniture makers—such as Allard and Sons, A. H. Davenport of Boston, and T. D. Wadelton of New York—and of dealers, including Duveen Brothers of London and New York, the great fabrics importer Vitall Benguiat, and the famous carpet specialist Dirkan "The Khan" Kelekian. How these firms and individuals worked with the architect to carry out his plans and how they worked with one another are important aspects of this analysis of the Payne Whitney house.

Payne Whitney (1876–1927) was the second son born to Flora and William Collins Whitney and was the younger brother of Harry Payne Whitney. To review, after Flora Payne died prematurely and William C. Whitney remarried three years later, Flora's brother, Oliver Payne, became enraged and tried to lure Whitney's four children away from their father, succeeding with two—Payne and Pauline—but failing with the

other two, Harry Payne and Dorothy. Colonel Payne, who was unmarried and childless, showered his affection and his millions on young Payne Whitney. During his lifetime, Uncle Oliver heaped one magnificent gift after another upon his favorite nephew, and when he died in 1917 he bequeathed to him a fortune of $32 million. Payne Whitney himself became a successful financier in New York City, and when he died in 1927, he left an estate of more than $194 million.

Payne Whitney married Helen Hay (1876–1944) on 2 February 1902. Stanford White was a guest at the wedding, and his present to the newlyweds was a small bronze version of the celebrated *Diana of the Tower* by Augustus Saint-Gaudens, which perched atop Madison Square Garden.

Helen was the daughter of John Hay, who in his early career had been Abraham Lincoln's private secretary and later served as secretary of state under presidents William McKinley and Theodore Roosevelt. A woman of many interests, Helen Hay Whitney was a patron of the arts, a poet who had eight volumes of her verse published, and an avid horsewoman; she owned Greentree Stables, which was renowned in racing circles.[1] The Whitneys had two children—John Hay "Jock" Whitney and Joan Whitney (Payson).

A GIFT OF 972 FIFTH AVENUE

Uncle Oliver presented Payne and Helen with a splendid gift, the property at 972 Fifth Avenue, and he asked Stanford White to design a house for them to go on that plot, between Seventy-eighth and Seventy-ninth Streets, facing Central Park (figure 32). A lawn separated the property from the James (later, Doris) Duke mansion (1912), designed by Horace Trumbauer, to the south; to the north were the Augustus Van Horne Stuyvesant residence and, at the corner of Seventy-ninth Street, the Isaac Fletcher "house-of-Jacques-Coeur-look-alike" mansion (1899), the work of C. P. H. Gilbert. The lot boasted 70 feet of frontage on Fifth Avenue and ran 100 feet deep, with an L-shaped alley that was 15 feet wide and connected with Seventy-ninth Street, behind the Stuyvesant and Fletcher houses.

Designed by White in 1902, the house contained forty rooms. Construction continued until 1905, and work on the interiors dates from 1904 on. Beginning in January 1902 and continuing for several years, Colonel Payne was sending $10,000 to $20,000 a month to McKim, Mead & White. By the

FIGURE 32. McKim, Mead & White, Payne Whitney residence, 972 Fifth Avenue, 1902–1907. Erected on a lot on Fifth Avenue between Seventy-eighth and Seventy-ninth Streets, the Payne Whitney residence was unusual in that it had a lawn space (*bottom right*) that remained undeveloped between it and its neighbor to the south, the James (later, Doris) Duke mansion, which stood at the corner of Fifth Avenue and Seventy-eighth Street. That open area allowed McKim, Mead & White to design an additional wall of windows, a rare luxury for houses built in the middle of a block. (From *A Monograph of the Works of McKim, Mead & White, 1879–1915,* vol. 3, plate 290)

time of White's death in the spring of 1906, most major work on the interiors was completed, but the house was not actually finished until 1909.

The facade of the house that White designed is five stories high with a bow front, each story clearly demarcated by an entablature, or cornice, that lines up with that of the corresponding story of the adjoining house to the north. White exercised his knowledge of the classical vocabulary in an innovative rather than a slavish or an academic manner, thus keeping the classical tradition alive instead of allowing it to petrify, as sometimes happened in Beaux-Arts classicism. Typical of White, the bold articulation

of the several levels and bays was relieved by the most delicate of orna-
mental touches—figures in the spandrels of the second story, garlands in
the headers of the third floor, and figures again, like Wedgwood reliefs,
above the windows of the fourth level; ornamented brackets support a
beautifully detailed overhanging cornice as the termination of the build-
ing. For the facade White selected a gray granite.[2]

The facade, like the rest of the house, was a collaborative effort. J. C.
Lyons's masons constructed the basic shell and erected the facade, and on
2 February 1903 the firm of Ellin & Kitson, architectural carvers, pro-
posed "to furnish the marble and execute the carving of six panels for Mr.
Payne Whitney's house." However, on the same proposal, written in
pencil, is the added notation: "Mr. White decided on granite panels. . . .
O'Connor to do carving."[3] Evidently, White wanted the reliefs to be ex-
ecuted in a finer style than Ellin & Kitson's sculptors could offer, so he
asked Andrew O'Connor to make models for them. In February 1905,
the sculptor Adolph Weinman sent the architects a bill, which stated that
an artisan named "Grignola . . . carved the six granite spandrels above the
2nd story windows for O'Connor for $1350" and that O'Connor had
provided the models from which Grignola made his granite carvings.[4]
Weinman himself executed some sculptural ornamentation, for in
November 1905 he wrote to White, "I should like you to call at my stu-
dio . . . to inspect the relief figures of cherubs on brackets above entrance
to Payne Whitney house."[5] Two months later, the sculptor sent his bill
to the firm for "remodelling of panel for side of doorway of Payne
Whitney house and for modelling of lion's head for same building."[6] On
5 June 1906, Weinman submitted another bill for supervising the carving
of the doorjamb ornaments.

THE ARCHITECTURAL INTERIORS

Several interior-decorating firms worked on the rooms of the Payne
Whitney residence. Foremost among them were Allard and Sons of New
York and Paris, A. H. Davenport of Boston, and T. D. Wadelton and
Company of New York; they were the main contractors for producing
the reproduction furniture, executing the finish carpentry, or installing the
paneling of one room or another under White's direction.

By 1905—three years after plans had been drawn up—Helen Hay
Whitney was becoming increasingly impatient to move into her new
house, and she made her wishes perfectly clear. As the spring of 1906 ap-

proached, Stanford White notified Colonel Payne that such construction work as remained "would be placed in the hands of T. D. Wadelton."[7] T. D. Wadelton and Company executed the carpentry as the house was going up and was on the scene as early as the fall of 1903, when it agreed "to build a scaffold at Mr. Payne Whitney's house . . . , so that the carvers can reach the rough stone around the three windows on the second story."[8] A contract from the following year gives an indication of the type of work that Wadelton's firm was prepared to do: "I propose to complete the work as described below, in accordance with your drawings, specifications and instructions for the House of Payne Whitney . . . for the sum of $10,000: Complete the trim of the Library Hall Landing, Breakfast Room, Boudoir of Mr. and Mrs. Whitney's Bedrooms, and Lobbies and door jambs, window shoes of Bedrooms, and including Herring Bone Oak Floors—Papier Mache and Plaster ornaments. Painting of woodwork. Furnishing Hardware and Mirrors and including an allowance of $650 each for the mantels = $2600."[9]

Earlier in his career, Wadelton had worked as a draftsman for the firm of McKim, Mead & White. After he set up his own business for carpentry and cabinetmaking, the architectural firm employed Wadelton and his workers many times in connection with its numerous commissions. Wadelton claimed that he had done work in more than twenty buildings erected by McKim, Mead & White, including the residences of William C. Whitney, Henry Poor, Clarence Mackay, Charles T. Barney, and Levi P. Morton, as well as the Payne Whitney house. At the last, his work seems to have been limited to interior architectural construction rather than fine finishing, which was handled by other firms, although Wadelton's craftsmen did do some gilding and burnishing on the woodwork in several rooms.

Allard and Sons

Allard's of Paris had long been recognized for the excellence of its craftsmanship in architectural interiors and furniture making; in 1878 it was awarded both the Legion of Honor and the Gold Medal at the International Exposition in Paris. Throughout the last quarter of the nineteenth century, Jules Allard and his sons, particularly Georges, became the leading figures for the execution of lavish Beaux-Arts interiors and furnishings. As I noted earlier, White was familiar with the Allard establishment from his annual visits to Paris, and he and Jules Allard sometimes

went together to look at some magnificent newly created or restored interiors in the French capital. By 1885 the house of Allard had opened a branch in New York City.

Allard's was brought into the Payne Whitney residence project in July 1905 to complete the architectural interiors of several major rooms. An undated list titled "Residence of Payne Whitney, Esq." and undoubtedly from mid-1905, was prepared by the office of McKim, Mead & White for Allard's to use as a basis for submitting a bid on the work to be done at 972 Fifth Avenue. It reads, in part,

> Reception Room: Floor in oak marquetry. Old marble door trim and painted wooden doors. Marble border of Breche, and marble base, both four inches in width, around room. Walls treated in mirrors, with light gold frames, as shown. Ceiling decorated as shown.
>
> Study: Ceiling coffered in teak painted and gold ornament. Set old Tiffany Studio mantel as shown, including the price of the mantel—$1,500. Walls covered with old or new leather at $4. a ft. Door trim and doors of teak.
>
> Dining Room: Woodwork throughout in light yellow mahogany, with carved ornament and ceiling gilded. Give a separate price on ceiling. Allow $4000 for old doorway at end of room. Wainscot carved and inlaid as shown, and picked out in gold. Griotte marble base, and a border one foot wide around floor. Floor in large veneered teak plank, keyed. Lower part of mantel in onyx.
>
> Salon: Allow $4,500 for old doorways. Set and piece out old ceiling: pick out new and old work with burnished gold. Mirror doors. Woodwork throughout of oak gilded. Allow $10,500 for mantel. Floor of teak in large planks, keyed, with breche marble and brass border.
>
> Library: Mantel to top of bookcase of onyx. All woodwork throughout library of English oak. Ceiling of English oak, with ornaments of papier mache picked out in gold. Give separate estimate on ceiling and floor in teak, large planks. Doorway with Irish green columns.[10]

Allard's submitted a detailed bid, was awarded the contract, and on 7 July 1905 sent the architects a room-by-room estimate, based on the specifica-

tions just listed, and a plan to ¼-inch scale; it is interesting because of the relative expense of each room:

Reception Room	$7985.00
Study	$6850.00
Dining Room	$23,560.00
Salon	$33,240.00
Library	$16,765.00
Studio	$10,590.00[11]

The total came to $98,990 of Colonel Payne's money, to which McKim, Mead & White would have added its commission. The Allard artisans began work at once.

A. H. Davenport of Boston

The craftsmen at A. H. Davenport were among the leading cabinet- and furniture makers in the United States in the late nineteenth and early twentieth centuries. Numerous architects frequently called on them to complete the interiors of and make reproduction furniture for grand houses and great commercial and civic projects. I will discuss Davenport's more fully in chapter 5 in connection with its work on the Mackays' Long Island château, Harbor Hill.

Although the firm was located in Boston, one of A. H. Davenport's associates, Francis Bacon, made regular trips to New York City or to Long Island or wherever Stanford White needed him in connection with a house he was erecting. On 14 November 1904, for example, Bacon wrote to White from Boston to say, "I expect to be in New York on Wednesday and can show you the lay out of furniture which I have prepared for the Payne Whitney House."[12] In the spring of 1905, White was preparing to go to Europe on what would be the biggest buying trip of his life. To coordinate White's acquisition of antique objects with the new furniture to be made in Boston, someone at Davenport's—probably Bacon—drew up a list of things that his firm had been commissioned to make. It was titled "Schedule of Furniture Ordered for Mr. Payne Whitney's Residence" and dated 1 May 1905:

Study	1 mahogany writing table, 5 × 3	$285
	1 " desk chair in cotton	43.
	2 " light chairs in cotton @ $30	60.
	1 stuffed sofa in cotton	80.
	1 " easy chair in cotton	55.

Dining Room	1 mahogany extension table (Price later)	
	12 " side chairs in cotton @ $73	876.
	4 " arm chairs @ $85	340.
Boudoir	1 stuffed sofa in cotton	90.
	2 " easy chairs in cotton	110.
Library	1 mahogany writing table, 7' × 4' 3"	470.
	2 " revolving bookstands	750.
	2 walnut and ebony ottomans in cotton	280.
	2 large stuffed sofas in cotton	330.
	1 gold arm chair in cotton (copy of old chair at Penshurst)	240.
	1 mahogany desk chair in cotton (copy of old chair from Cromwell Hall)	210.
	2 large size stuffed easy chairs in cotton	110.
	2 low stuffed easy chairs in cotton	100.[13]

There followed a list of items for the furnishing of several bedrooms—four-post canopy beds, a large wardrobe, night tables, easy chairs, and the things normally found in bedrooms—as well as furniture for a nursery.

Stanford White always had the final word in matters of design, and the general scheme for color and architectural ornament came from his drawing board or sketch pad. However, when dealing with first-rate artists or artisans, he tended to give them freedom to create in their own way, after explaining his ideas to them about what he wanted. Such was the case when Louis Comfort Tiffany became involved in the execution of the doorway for 972 Fifth Avenue.

White's assistant, Daniel T. Webster, sent him a note regarding the completion of the entrance:

I attach herewith estimates for the Entrance Gates in the vestibule for the Payne Whitney residence:

John Burkhardt's figure	4950
Tiffany Studios	4960
William H. Jackson Company	3973[14]

"John Burkhardt's figure" has not yet been identified, but White often used the William H. Jackson Company for masonry construction; in this

case, Jackson's workers probably did the stonework into which the doors and grilles, made by Tiffany's, were set.

In June 1905, Tiffany Studios had presented White with a proposal to create the doors and grillwork, but nothing came of this. Tiffany's submitted a second proposal, virtually a restatement of the first, nine months later; in it, Tiffany's agreed to make a pair of entrance doors plus "one pair of inner vestibule doors, of polished steel with brass ornamentations, with separate glass frames to swing, hardware all complete, also two stationary [*sic*] side panels, to be made of old wrought iron work, furnished by the owner, to be polished by us, with new brass border around the two grilles, to be made by us; all the above set complete for the sum of $4960."[15] This proposal was accepted. Tiffany Studios also mentioned working from a ¾-inch to 1-foot scale-model drawing and in the first agreement proposed to make an iron railing for the staircase and two balconies for the second floor.

THE ENTRANCE HALL

The entrance hall was an oval room with a bold cornice supported by pairs of Ionic columns wrought of a grained marble (figure 33). A fireplace inserted into the wall is visible at the left in figure 33; Weinman sent White a bill for "modelling shield for fireplace in entrance hall . . . $600 [and] For carving of two shields for same fireplace $200."[16]

The focal point of the entrance hall was a fountain whose main feature was a marble figure of Cupid; Stefano Bardini is said to have obtained this statue in Rome from Prince Paolo Borghese, who was then experiencing a financial crisis. In 1902 Bardini sent it to Christie's auction house in London, but it failed to sell, and White was able to buy it from the dealer in Florence in 1905. Scholars of Renaissance sculpture today are debating the attribution of this controversial piece to Michelangelo.[17] White again called on Adolph Weinman to execute part of this hybrid fountain, to produce three marble turtles that he sculpted from a model that either White or the Whitneys had given to him.[18] The turtles appear on the corners of the base that supports the statue. Potted palms were placed within a circular basin at the foot of the fountain.

Among the paintings placed in the entrance hall were the Bramantino panels; some uncertainty remains regarding both the number and the subjects. Bartolomeo Suardi (ca. 1465–1530), called Il Bramantino, was a northern Italian painter who became a follower of Bramante (hence his nickname) in Rome and a friend of Raphael. The so-called Bramantino

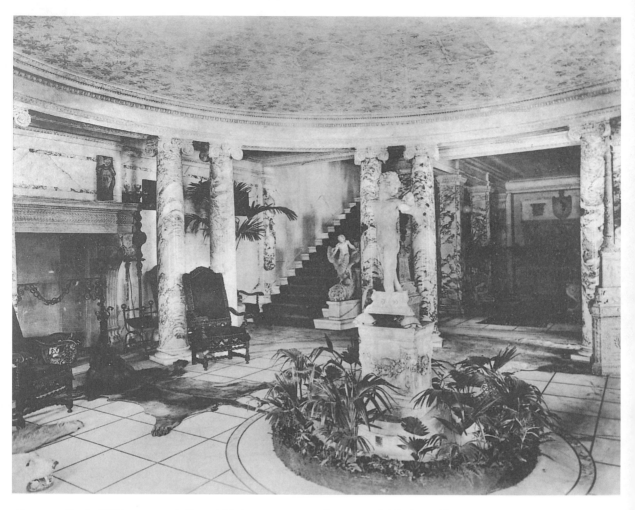

FIGURE 33. Stanford White, entrance hall, 972 Fifth Avenue, ca. 1905. The entrance hall had a marble floor whose coldness was relieved by the occasional animal skin rug, like the one in front of the fireplace. Rugs of this type were used in many major rooms, adding an exotic touch. Among the McKim, Mead & White Papers at the New-York Historical Society is an account of 21 December 1906 that notes Stanford White's purchase of such items, including three polar bear–skin rugs, at $600 each; two grizzly bear rugs, at about $175 each; two lion skins, one at $1,250 and the other at $500; a Bengal tiger rug, at $175; and a cheetah skin and leopard skin for $25 each. (Collection of The New-York Historical Society)

panels were painted in the early sixteenth century as adornments for the Gonzagas' palace of San Martino di Gusnago near Mantua, and there they remained until about 1880, when they were removed before the castle was razed. Thirty-four came into the possession of a collector named Henry Willett of Brighton, England, but after his death they were sent to auction at Christie's in London, in April 1905. At that time the Metropolitan Museum of Art purchased twelve panels, six went to the South Kensington Museum of London, and, according to a *New York Times* report, "an American has purchased six."[19] Whether the unidentified American was Stanford White, another dealer, or a collector remains unknown, but in any case an unspecified number of Bramantino panels were in the possession of Payne Whitney for use in his entrance hall by late 1905 or early 1906. Stanford White was probably involved in their acquisition because the Whitneys rarely acted on their own in such matters. The panels obtained by the Met are bust-length profile portraits shown in arched niches that were decorated with garlands (figure 34); the Whitneys' portraits were probably similar.

By the fall of 1906, both Duveen's and Allard's were involved with the pictures for the entrance hall. Although this part of the decoration was being carried out several months after White's death, the subcontractors were still following his plans and concepts. In October 1906, Allard's acknowledged receipt of an order for gilt frames "for the Bramentino [*sic*] panels for the Entrance Hall."[20] On 26 November, Allard's informed McKim, Mead & White that its workers had finished the twelve frames "for the pictures of the Hall, Ground Floor" but then continued: "We understand that Mrs. Whitney has found some objection to the frame which is now at the building. We would like to know what you desire to have done in this matter."[21] The problem was evidently resolved, for on 21 December, Allard's wrote to the architects to say that the firm would complete the rest of the frames for the Bramantino panels according to the model that had been submitted. Also in November 1906, Duveen Brothers confirmed that Helen Whitney "agrees to purchase four paintings now hanging in the hall at the price of $850 each."[22] The entrance hall was therefore handsomely adorned with both paintings and a sculptured fountain.

The major rooms of the house were located on the second floor, which was gained by means of a grand stairway. Construction of this staircase was done by Guastavino Company workers, who were famous for the great vaults that they had created throughout the city. The elegant stairway ap-

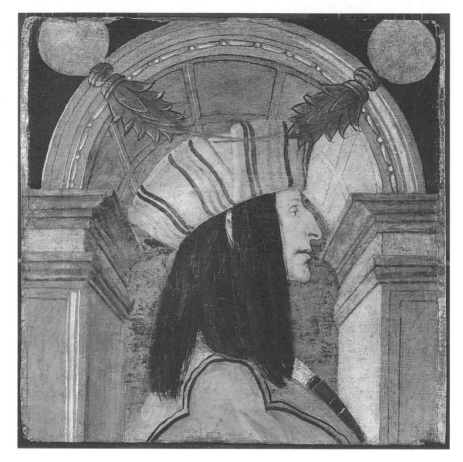

peared to be unsupported, an illusion that required the expertise of the most experienced master masons available—the Guastavinos.[23] After they had completed the construction of the stairway, the Guastavinos subcontracted its tiled surface treatment to the Atlantic Terra Cotta Company, whose complaints to the builders reveal the problems that often arose as designs were translated from paper to execution. The tile company representatives noted that they had made the work exactly according to the specifications given them, but White continually asked them to make changes and to experiment at the company's expense: "We have changed this work to a great extent and still have a very unsatisfactory piece of work in the eyes of the architects. This . . . we do not deem any fault of ours, and as it seems a matter of a considerable amount of experimenting

to attain anything like the results the architects desire, we find it necessary to advise you that we cannot experiment any longer without being paid for it."[24] This is yet another example of Stanford White's perfectionism and his demands that work be done and redone until the desired aesthetic effect was attained.

Adolph Weinman again entered the picture with some decorative sculpture for the newel post of the stairway. In June 1906, he wrote to Webster, asking for the measurements of the base of the "Eagle with boy for the newel for Payne Whitney house"[25] (at the foot of the stairs in figure 33). After he received the information that he needed, Weinman replied that he further proposed "to model and cast in plaster and supervise carving of cornucopia for Newel for stair . . . for the sum of $150."[26]

THE MIRRORED SALON

The Mirrored Salon, or reception room, was the most sumptuously decorated of any room on the first floor; when finished, its lustrous brilliance made it a remarkable exercise in interior decoration (figure 35). From my analysis of the entrance hall and the stairway, it is clear that fine interiors were not executed by a single group of workers or a single dealer; instead, a variety of specialists were called in to produce whatever a given project required—from polar bear–skin rugs to a seemingly unsupported staircase. For the execution of his designs for the Mirrored Salon, White called on Allard's for the architectural interior, although the firm of Waters, Nichols and Crowninshield was in some way involved with the furnishings.

The Mirrored Salon—or the Venetian Room, as Helen Hay Whitney dubbed it—was (and is, having been restored in 1997) an extraordinary room. The most striking feature is its walls, which are lined with mirrors that are decoratively trimmed with either gilded enframements or marble. The room is not large, only 14 feet, 10 inches square, but it would seem that Stanford White set out, in this little jewel, to challenge Louis XIV and his Hall of Mirrors at Versailles. By this date, White had also seen the ballroom that Richard Morris Hunt had created for Marble House in Newport, which similarly relies on mirrors, not only for decorative effect but to enlarge, by illusion, the space of a relatively small room.

The reception room ceiling has a large allegorical painting, set within a quatrefoil enframement, the work of James Wall Finn (1867–1913), one of White's favorite decorative painters. In May 1906, Webster, White's assistant, contacted Wadelton about his responsibilities there: "The ceiling painting will be placed in position by other contractors upon your smooth

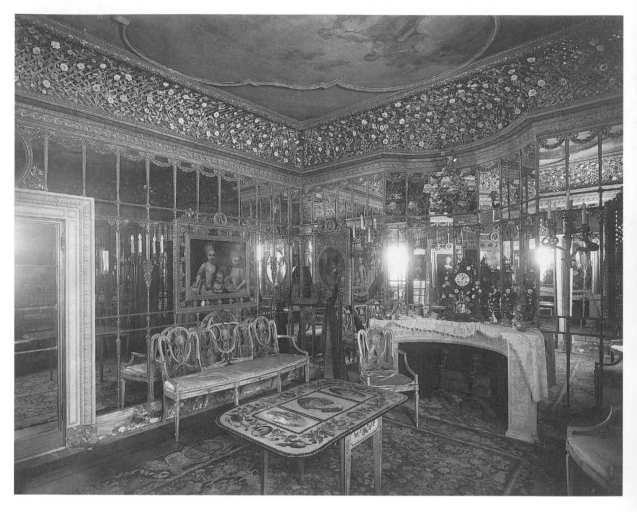

FIGURE 35. Stanford White, Mirrored Salon, 972 Fifth Avenue, ca. 1905. The suite of furniture seen in the photograph, original to the Mirrored Salon, is of late-eighteenth-century French workmanship. Each piece has a little painted portrait or scene set within an oval format. White purchased all the furnishings, including the clock on the mantel, in Europe in 1905. Hanging on the walls are eighteenth-century French and Italian portraits in elaborate gilded frames. This is the only room that survives intact in the house. (Museum of the City of New York. The McKim, Mead & White Collection [90.44.1.423])

finished ceiling, but you are to insert the small pictures on the wall panels furnished by the owner." Webster then continued his instructions to Wadelton: "MIRRORS: Cover the walls . . . with selected plate glass mirrors, set to perfect alignment in large sections."[27]

The reception room has an ornamented marble fireplace; above it is a coved overmantel. The latter leads up to a handsome coved cornice that is richly decorated with a lattice-and-flower design that runs around the room. The mirrored door is trimmed with white marble, while a grained marble rims the floor. Among the Payne Whitney folders in the McKim, Mead & White Papers at the New-York Historical Society is an enigmatic memorandum dated 13 January 1903 to Stanford White from Webster. It concerns the discovery of a misplaced mirrored ceiling and is interesting because it reveals the cavalier attitude toward an architectural element as large as a ceiling; it also suggests that White was buying such things in such numbers that he occasionally lost track of them. Unfortunately, the house for which the mirrored ceiling was intended is not identified beyond "Mr. Whitney's." The date of 1903 makes it very late for William C. Whitney's house at 871 Fifth Avenue but too early for Payne Whitney's house, the rooms of which were not yet ready to receive their architectural decoration. Nevertheless, the letter is worth quoting because it shows how the decorating business was carried on amid the hurry-scurry of numerous projects evolving contemporaneously; it concerns a ceiling that White had bought in Europe, at least as early as 1898, and that now, five years later, was about to be put to use in one of the houses he was decorating. Webster wrote:

> In regard to Mr. Whitney's Mirrored Ceiling, I have all the missing parts at Duveen's, and have requested them to put the same up as soon as possible. We laid the pattern and the moldings out on the floor in Mr. Duveen's shop, and in the bottom of the case which contained the moldings we found the mirrors, which were packed in a very careless and insecure manner, so that many of the mirrors were broken. Duveen states the case was never opened in his shop. I noticed, however, that some of the mirrors were wrapped in American newspapers, dated May 1898. I immediately called at Allard's and ascertained from Mr. Bouche that the ceiling had once been placed together in their shop, and the mirrors at that time were all intact. They had repacked it and evidently stored it in their department at the Manhattan Storage Warehouse, though they stated right along it was not in their possession.

As this case has, evidently, been knocking around for four or five years, you can imagine what state the mirrors must be in.

Harry delivered eighteen portraits, some of which are painted on the wood and others on canvas. The ceiling only contains ten of these, so I do not know where the balance are to go, though they all are at present at Duveen's.

The large centre ring forming part of the design was found in the stable on 21st St., as were the portraits. The case containing the moldings and the mirrors were at Allards compartment in the Manhattan Storage Warehouse with portions of the background, the balance of the background, evidently, having been sent to Mr. Whitney's stable, by mistake, where I found it.[28]

Stanford White as Agent for the Payne Whitneys

At this point, let me digress from my room-by-room analysis to consider the matter of Stanford White's buying spree in the summer of 1905 to acquire antique furnishings, bibelots, and curios for the Payne Whitney residence. Uncle Oliver placed $300,000 (about $3.7 million today) at White's disposal for the interior furnishings. By the spring of 1905, the Whitneys' house was far enough along in its construction and execution of the architectural interiors that White could turn his attention to filling its main rooms. A letter, dated May 1905, indicates that White was actively acquiring objets d'art for the Whitney house even before his departure, for he wrote to Colonel Payne: "I forgot to send you with the accounting I gave you of Payne's $300,000 account a memorandum showing what the purchases were. They were approximately as follows," and he appended a list:

For tapestries	$65,000
rugs	32,000
red velvet	21,000
the Cluet [*sic* (Clouet)] picture	25,000
ornamental marbles and marble furniture	17,000
furniture, bric-a-brac	88,000[29]

Although it is not as specific as the list drawn up to guide White in his purchases for the Frederick Vanderbilt house in Hyde Park, New York, a few years earlier (see chapter 1), an itemization by room—composed in the spring of 1905 before White's departure—for things needed for "Paynie's" house reads in part:

First Story: Hall: Old furniture to be bought.

> Reception Room [Mirrored Salon]: Furniture to be bought in Europe.
>
> Study: Old leather to be bought for walls. Furniture by Davenport.

Second Story: Hall: Old things to be bought in Europe.

> Dining Room: Table and chairs by Davenport. Sideboards etc. to be bought in Europe.
>
> Drawing Room: Furniture to be bought in Europe.
>
> Breakfast Room: Furniture to be bought in Europe. See about having special rug made for this in Savonnerie. . . .

[Third Floor] Library: Davenport to make large desk, with cloth top. Two large sofas. Two easy chairs. Two revolving book stands. One gold arm chair—Kent. One desk chair. Two low stuffed easy chairs.[30]

Similar instructions follow for several bedrooms, a boudoir, and a nursery on the third floor, and for Helen Whitney's studio on the top floor. The furnishings were thus to be a combination of new pieces, usually reproductions to be made by Davenport's, and antiques to be purchased by White while he was abroad.

And so Stanford White set off for Europe, where Payne and Helen joined him for part of the summer. Henry Adams saw White in Paris and wrote to his friend Elizabeth Cameron to tell her that the architect had visited him the preceding evening, in great excitement because the Whitneys had "bought the Clouet [portrait of] Henry II from Azay for 130,000 francs to put up in the salon. You remember it perhaps, the mounted [equestrian] portrait, like that in the Henry II room in the Louvre. . . . With their tapestry in the dining-room their house will be a museum. They meant it to be Italian but it is getting to be French altogether."[31]

In a letter from November 1905, White mentioned nearly thirty dealers whom he visited, but there were more. Among those listed were many now-familiar names—Vitall Benguiat and Duveen Brothers in London; Gimpel, Lowengard, and Heilbronner in Paris; Bardini in Florence; and Bernheimer in Munich. White acquired a whole list of things from Simonetti in Rome, including a marble sarcophagus with two cupids and a coat of arms, a marble high relief, a round coat of arms and a rectangular coat of arms, a marble doorway, and a fifteenth-century pulpit.[32] From the Galerie San Giorgio in Rome, White bought another sarcophagus, a bas-

relief Madonna, velvets and embroideries, an "Arch of door in stone," plus several pieces of furniture, including a carved and gilded wooden table.

The sheer number of goods he purchased may be estimated by the number of cases shipped to New York after the 1905 buying spree. The shipping agent Ramponi & Cremonesi of Rome wrote to White that it had shipped, on orders from the dealer G. Giaccomini, twenty-nine cases of antique objects that left Naples on December 15.[33] Davies Turner & Company arranged the shipping from Florence of twenty-six crates of candlesticks and cupids, firedogs and frames, and similar items obtained from Stefano Bardini, scheduled to leave Genoa in January 1906. Several crates had left Florence earlier, from the dealer Giuseppe Salvadori, and Arthur Acton arranged for the transportation of "13 cases Furniture and marble purchased by Stanford White."[34] From Raoul Heilbronner of Paris came another twenty-three cases of "gilt carved woodwork . . . , Boiserie paneling—Henri II . . . , Iron gate . . . , Gilded wooden altar top . . . , Renaissance chest," and the like, while F. Schutz, also of Paris, contributed fifteen cases, shipped in September 1905. Another dozen large wooden boxes arrived from Bernheimer's of Munich. The scale on which White bought was, to say the least, impressive.

There were shipping arrangements to be made, export papers to be obtained, import duties to be paid at the United States Customs House, insurance policies to be taken out, storage to be set up—all in the course of doing business. In September, as crate upon crate began to arrive, Whitney's secretary contacted White: "I understand from Mr. Payne Whitney that you will have his things, as they arrive from the other side, stored in Mr. Barney's stable. Will you kindly advise me whether you will take out the fire insurance in his name as fast as necessary, or whether you would prefer to advise this office and have me take care of it here?"[35]

The next month, White received a letter from J. W. Hampton, Jr., and Company, "Customs Brokers and Forwarders," asking for White's instructions regarding nine cases of his goods that the firm had gotten through customs and stating that Hampton's would hold the goods until notified to deliver them to the Payne Whitney house.

A list of dealers and expenditures, titled simply "Purchases," shows how freely White was spending Colonel Payne's money:

E. Glaenzer, Sundries	$27,145.00
Duveen Brothers [probably of New York]	155.00
V. Benguiat	7,875.00

D. G. Kelekian	4,285.00
R. Heilbronner	41,570.00
S. Bardini	8,300.00
Duveen Brothers [probably of London]	5,476.00
Baumgarten	2,550.00
R. Heilbronner	5,327.00[36]

And so in the fall of 1905 and the following winter, the furnishings for 972 Fifth Avenue began to arrive by the wagonload.

THE SALON

At the top of the grand staircase to the second floor was the most lavish room of the house—the salon, or drawing room (figure 36). Allard's estimate of 1905 shows that it was by far the most expensive to complete, at $33,240 for Allard's work alone; added to that was the cost of the furniture made by Davenport's, plus the antique ceiling and the furniture that White had acquired while he was in Europe. In reference to the salon ceiling, Henri L. Bouche of Allard's wrote to White that he had sent a man to the Whitney house, where the ceiling was stored, to take its measurements: "It occurs to me that it would be best if we were to remove [it] to our shop, so as to be able to lay it on the floor, all the old woodwork of the ceiling and cornice. If you will kindly send us an order so that the people at the house will allow us to take these pieces, you will greatly oblige."[37] A couple of weeks later, Allard's again contacted White about the ceiling, noting that the firm preferred a certain form of gilding for it, "which is practically all gold"; the writer then added: "It will be an easy matter to do the dulling and toning down on the ceiling after it is up" in the Whitney salon.[38]

The walls of this room were covered with an antique green velvet obtained from Vitall Benguiat. In May 1906, Allard and Sons notified McKim, Mead & White that it had received the fabric "intended for the lining of the walls and the making of the window curtains in the salon of Payne Whitney."[39] There follows a list of the eight lots, which contained a total of 898 yards of material. The room would require nearly half the fabric, as someone at Allard's spelled out: "We beg to say, the wall hanging will take 275 yards. The curtains and lambrequins [valances] for the five windows will take 167½ yards, viz 442½ yards out of the lot of 898 yards which we have in our possession." The writer then asked whether the architectural firm could send him the "old embroideries for the application on the lambre-

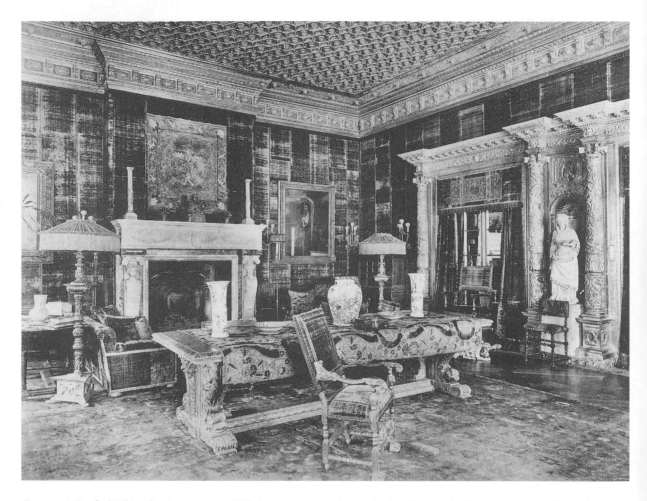

Figure 36. Stanford White, drawing room, 972 Fifth Avenue, ca. 1905. Among the furnishings in the drawing room was a long oak table with dolphins carved on its end supports. The table was covered with a gold and crimson cloth with pineapple motifs, of late-fifteenth-century Italian craftsmanship. Several great "state" chairs with carved and gilded frames were upholstered in red velvet or brown leather, all said to be Italian of the seventeenth century, as were a pair of carved and gilded cathedral torchères that had been converted to modern usage with the addition of shades and electrical wiring. (Museum of the City of New York)

quins."[40] Two weeks later, a member of McKim, Mead & White's staff notified Allard's that he was sending additional materials from which to complete the curtains and portieres for the salon; among the items were sixty-one embroidered escutcheons, a large embroidered Renaissance panel that had been acquired from the dealer Kelekian, a bishop's hat in red velvet with gold embroidery, thirty-one rolls of galloon (a braid or ribbon used for trim or binding), and two large rolls of fringe.[41]

The marble Renaissance mantel had male and female herms as well as other carved ornamentation—military trophies, floral baskets, the motif of a cardinal's hat over a cross and an oak tree, and festoons of fruit. The andirons were impressive; the sale catalogue of 1946 described them as "wrought with ram's masks and figures of satyrs, and surmounted by a finial figure of Cupid, the base in the form of winged griffins and amors flanking a nymph seated upon a rampant lion."[42] The room contained a life-size gilded terra-cotta bust of a cardinal and several painted portraits, all of aristocracy: one represented Philip II of Spain and was believed to be by the school of Antonio Moro, whereas another portrayed Maria Carolina, queen of Naples, and was dated 1788; a French portrait of the sixteenth century was said to be of Marguerite de Valois. Judging by the catalogue's descriptions, these portraits resemble the images on the walls of Stanford White's own picture gallery (see figure 63).

Against one wall of the drawing room was an architectural arrangement known as the portico (figure 37). This complex piece is an excellent example of White's ability to design an ensemble by combining varied parts from various periods and cultures, with Allard's artisans supplying the new parts necessary to bring everything together, creating an assemblage that defied classification with the usual art-historical terminology. Although the portico was completed after White's death, it was made according to his design.

The portico was composed of an entablature supported by elaborately carved columns, one at each end and a pair in the middle. Antique columns framed the mirrored doorways at both ends, while the central pair of columns flanked a polychrome limestone statue of the Virgin Mary, 55 inches high, said to be of the fifteenth century, thus creating a kind of classical tabernacle. While its employees were working on the ensemble, Allard and Sons wrote to McKim, Mead & White, asking, "Will you kindly tell us what pedestal is going to be used for the statue placed in between the columns of the new portico? This we require in order to know how to finish the square base of the columns at that point."[43] A few days

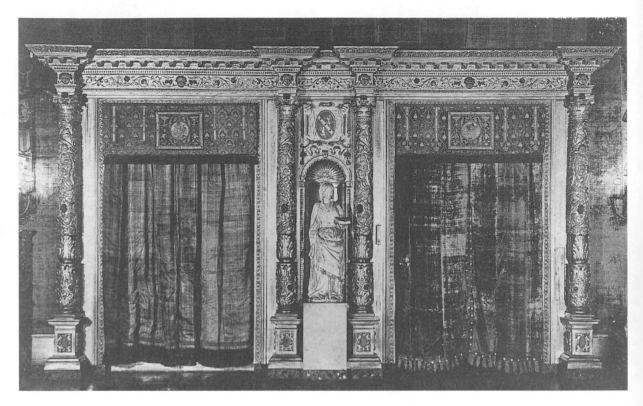

FIGURE 37. Stanford White and Allard and Sons, portico for the drawing room, 972 Fifth Avenue, ca. 1905. A description of this ensemble appeared in the sale catalogue of 1946: "Broken leaf-carved cornice above a narrow frieze carved with cherub heads and scrolling floral vines, and supported on four swelling columnar pillars with Corinthian capitals and elaborately carved with acanthus and figures of putti and birds amid a welter of spiraled grapevines. At the center, a niche surmounted by a coat of arms enclosed within a draped strap work escutcheon. Contains elements of the period. . . . Total width 22 feet 4 inches." (From *Public Auction Sale . . . at the [Payne] Whitney Residence,* p. 105, lot 472. Courtesy, The Winterthur Library: Printed Book and Periodical Collection, Winterthur Museum, Winterthur, Del.)

later, Allard's sent a note saying that the marble pedestal for the statue was to be made by Batterson & Eisele, a marble-working firm in Edgewater, New Jersey, that did other work in the Payne Whitney house.

In early September 1906, Allard's informed Webster that the portico would soon be completed, adding, "We will do all the gilding that we can in the factory while the last pieces are being finished."[44] Allard's was also making the doorway for the salon at its "factory" and notified the office of McKim, Mead & White that it would prefer to do the gilding there rather than at the Whitney residence, stating that "we do not think that the work can be done [there] as well as at the factory, especially as the gilding is water gilding and the water runs off too easily."[45]

Another instance of Stanford White's perfectionism and constant supervision of details is evident in a note from Allard's to McKim, Mead & White: "We . . . note that Mr. White is dissatisfied with a portion of the cornice in the Drawing Room. We will await the new full size detail and will make a section so that this cornice can be submitted on his return from vacation."[46] Ten days later, Allard's notified White that the new model for the cornice was ready for his inspection and that the firm would not proceed until he had approved it. Another letter from someone at Allard's to White suggests White's personal involvement with even the smallest details: "I have ordered from Paris the hardware necessary for the Drawing Room windows and doors, as per your selection made yesterday."[47]

Slowly, this grandest of the grand rooms in the house was nearing completion. The understandably impatient Helen Whitney had informed McKim, Mead & White that she was returning from Newport at the end of September 1906 and asked that the architects have the drawing room finished by then. While all concerned worked to that end, they missed the deadline. In the middle of October, Allard's was still hanging the curtains and lambrequins for the large window in the salon, and a letter dated 1 November refers to the portieres of the salon. Allard's informed the architectural firm that it was sending a sample of the material it was using for the lining of the portieres: "We think that if Mr. Davenport uses the same thing, which can be purchased at W. & J. Sloane, it would make the portieres of the Hall correspond with those of the Salon."[48] This is a good example of the collaboration among the several decorators involved.

By the end of October, the house of Allard's could submit a final accounting for the salon alone:

Allard & Sons' bills rendered to Oct. 20th	25,948.71
Antique Wood Work used in Room	18,000.00
Teak Wood Floor	1,035.00
Marble Work—Bill rendered F-555	1,479.60
Upholstering Walls	675.00
5 Window Decorations	1,700.00
2 pairs of Portieres	625.00[49]

The total came to nearly $50,000 for the part that Allard's either executed or supervised; McKim, Mead & White submitted another bill to Colonel Payne for the furniture that was made for the room or had been purchased in Europe.

THE DINING ROOM

In Allard's estimate of 7 July 1905, the dining room was second to only the salon in its cost (figures 38 and 39). The room had an antique coffered ceiling that White had acquired in Europe; the 1946 sale catalogue described it as "Tuscan, Late XV Century" (figure 40).[50] The style of the ceiling was remarkably close to that of the Gubbio Studiolo, the study of Duke Federico de Montefeltro of Urbino, Italy, which dates from 1476 to 1480 and is now installed in the Metropolitan Museum of Art (plate 4).[51] The Met's example provides some idea of the color and gilding that brightened the Whitneys' dining room.

The dining room walls were lined with a wainscoting said to be sixteenth-century Umbrian, and White did purchase such things in Italy. But it was probably composed of partly antique materials and partly new work, for in August 1906 Wadelton wrote to the office of McKim, Mead & White that the "dining room wainscot is waiting the setting of the stone [window] pilasters, meanwhile the measurements have been taken for cornices of wainscot which is being worked on at the factory. . . . The samples for decoration of Dining Room wainscot . . . are made, awaiting Mr. McKim's inspection."[52]

Above the wainscoting, the walls were covered with a modern tapestry that imitated the style of fifteenth-century Flemish weaving; it ran around the room, except where interrupted by the door, windows, and fireplace. Against each side wall was a built-in console with gray marble top; these, too, were modern but executed in the style of the adjacent ancient wainscoting—an example of how Allard's craftsmen could use one portion of an interior that was antique as a model for the fabrication of significant parts of the rest of a given room. The tall torchères that flanked the doorway and the fireplace were antique, but they had been electrified and fitted with modern glass globes.

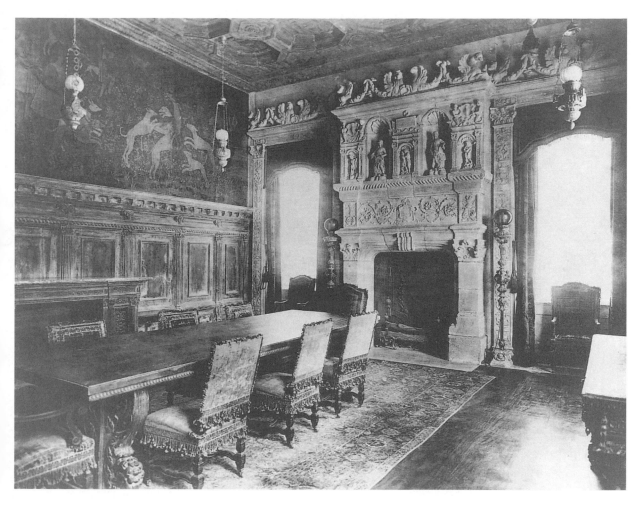

FIGURE 38. Stanford White, dining room, 972 Fifth Avenue, ca. 1905–1906. Above the wainscoting, the dining room walls were covered with tapestry specially woven for this room in imitation of the antique. George P. Reinhard, a New York decorator who became involved with the Whitney interiors after White's death, wrote to the architectural firm regarding these "Flemish" tapestries and "the new design for the Dining Room window [draperies] in which will be incorporated figures and animals after the style of the Flemish tapestry which is being made for the Dining Room walls" (George Reinhard to MMW, 19 December 1907, MMW Papers, NYHS). These wall tapestries may have been woven on looms set up by William Baumgarten in New York City for the project. (Collection of The New-York Historical Society)

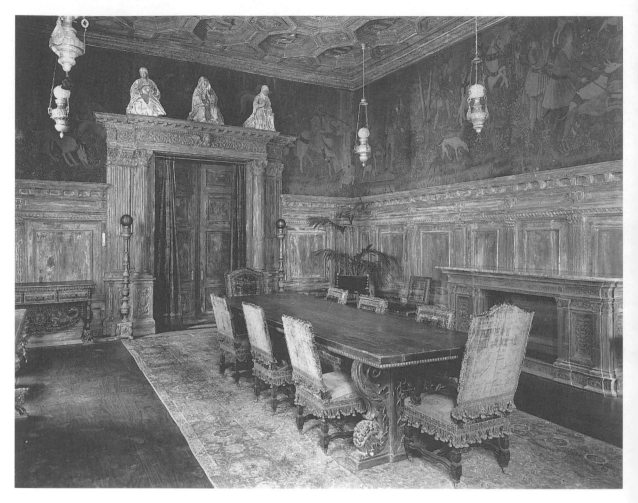

FIGURE 39. Stanford White, dining room, 972 Fifth Avenue, ca. 1905–1906. The doorway to the dining room was in the wall opposite the fireplace and window wall. It had a cluster of two finely carved free-standing Corinthian columns flanked by pilasters of similar design that supported a lintel enriched with a delicate scrolling leaf-and-vine motif, with a winged cherub's head in the center. The doorway was almost entirely new work, but atop it were three antique terra-cotta figures, apparently of the fifteenth century and acquired independently, representing (*left to right*) St. Anne, the Virgin Mary, and St. John the Evangelist. (Museum of the City of New York. The McKim, Mead & White Collection)

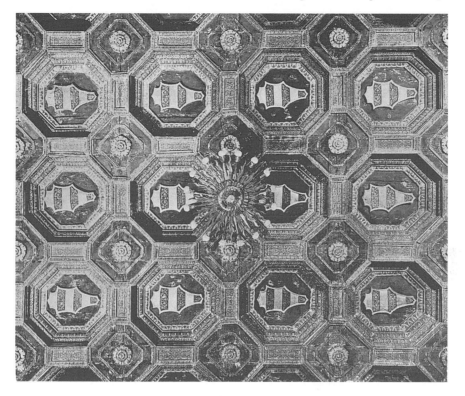

The sixteenth-century French fireplace, wrought of Caen stone, stood 15 feet tall and was remarkable for its carvings. The mantel itself had rams' masks and cherub figures at the corners, while the frieze was ornamented with a delicate rinceau on either side of a monogrammed escutcheon. The chimney breast had two large niches, each containing a figure of a warrior maiden, and three smaller niches held images of Adam and Eve. A decorative cornice, composed of grotesque sea monsters, spanned the crest of the fireplace and the windows as well. Flanking the windows were pilasters with ornate foliate reliefs, which were of a later date. This end wall was treated rather the way the portico of the salon was: it was assembled from diverse parts gathered from different places by Stanford White, for the ensemble was composed of at least three, and possibly four, separate components. White saw the several parts as a single entity—the fireplace, the cornice, and the window pilasters—which was his typical way of handling an entire wall. The sale catalogue of 1946 recognized his whole-wall design by selling this assemblage, like the portico of the salon, as one lot.[53]

On either side of the fireplace were large windows with hangings produced by Allard's. The decorators wrote to McKim, Mead & White to say that they would complete "two pairs of portieres with lambrequins—one for the Dining Room and one for the Salon Door. . . . The curtains, lambrequins and portieres to be trimmed with silk fringe imitating the antique . . . [and] have appliqued on them coat of arms belonging to Mrs. Whitney."[54]

The dining room furniture was a mix of antique and modern. The carved walnut table was from sixteenth-century Florence and probably had served as a refectory table in earlier times. It had voluted vasiform end supports that were boldly carved, ending in clusters of blossoms. The sale catalogue of 1946 listed sixteen "Louis XIV style" dining chairs (lots 514 and 515) with carved walnut frames covered in rose velour, but it is doubtful that all sixteen were antique, for it was common practice to provide Allard's craftsmen with one or more authentic antique examples from which they replicated however many additional chairs the client needed. The dining furniture was set on a late-sixteenth-century Ispahan Persian palace carpet, its roses, greens, light blues, and golds softened by time and use.

THE LIBRARY

Entrance to the library was through an elaborate doorway that the 1946 sale catalogue described as "Spanish Renaissance" in style, with panels carved with grotesques, figures of saints, leafage, and military trophies. The walls of the library were of applied leather, a covering used frequently for rooms of the Gilded Age. Its pattern was made up of bright colors with exotic birds among flowering trees and writhing serpents at the bases of the trunks. The 1905 estimate submitted by Allard and Sons indicates that the room was to have a beamed ceiling of English oak with papier mâché ornamentation—all gilded, including the cornice—and that the floor was to be teak with a border of Irish green marble.

A sheet of final accounting figures lists an intriguing item for the library: "Dewing, Library. . . . $1000."[55] Thomas Dewing (1851–1938) was White's close friend and carousing buddy, and the architect often arranged for him and other artist-friends to execute decorative paintings for the interiors that the architect was creating. But whether this item referred to a painting bought for the library or to some decorative painting done in that room remains unknown.

While Allard and Sons was completing the architectural interior of the library, A. H. Davenport's craftsmen were working on the furniture for the room, which I listed earlier.

Color Plates

PLATE 1 Bedroom and bed alcove from the Palazzo Sagredo, Venice, ca. 1718. Above this alcove, which is set between Corinthian pilasters, flutter seven little amorini, appropriate images for an eighteenth-century palatial bedroom. Other cupids hold up a painting by Gasparo Diziani that, equally appropriately, represents Dawn expelling Night from the sky. The ensemble is an early example of institutional interest in obtaining and creating period rooms. (The Metropolitan Museum of Art, Rogers Fund, 1906 [06.1335.1]. Photograph © 1982 The Metropolitan Museum of Art)

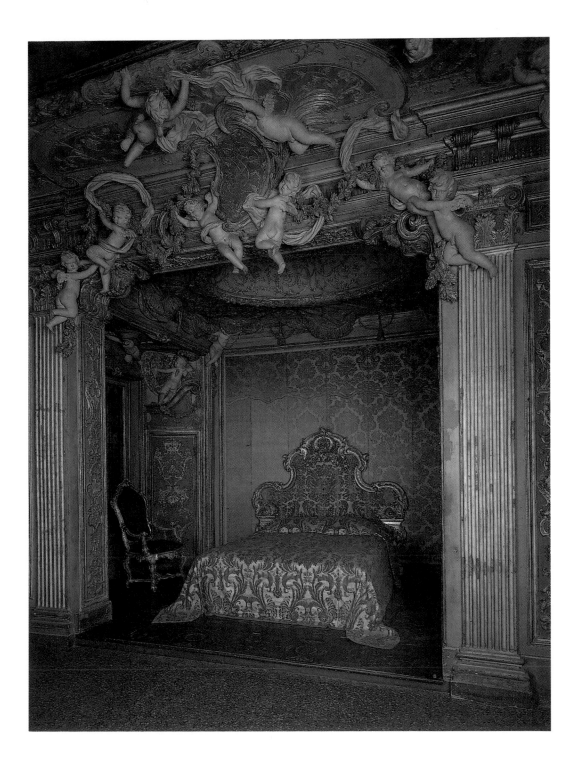

PLATE 2 Richard Hermann van der Boijen, state dining room, Breakers, Newport, Rhode Island, ca. 1894. Although Richard Morris Hunt was the architect of the Breakers and provided general guidelines for its interiors, their execution was placed in the hands of the artisans at Allard et Fils of Paris. They carried out the designs drawn up by Richard van der Boijen, who was in the employ of Allard's, creating this masterpiece of Gilded Age high-style interiors. Allard's designers, artisans, and agents could supply architects such as Hunt and his patrons with any of the items seen in this photograph, from architectural adornments to antique fabrics. In anticipation of the lucrative American market for such things, Jules Allard—a friend of Stanford White—established a branch office and manufactory in New York in 1885. (Photograph © Richard Creek for the Preservation Society of Newport County)

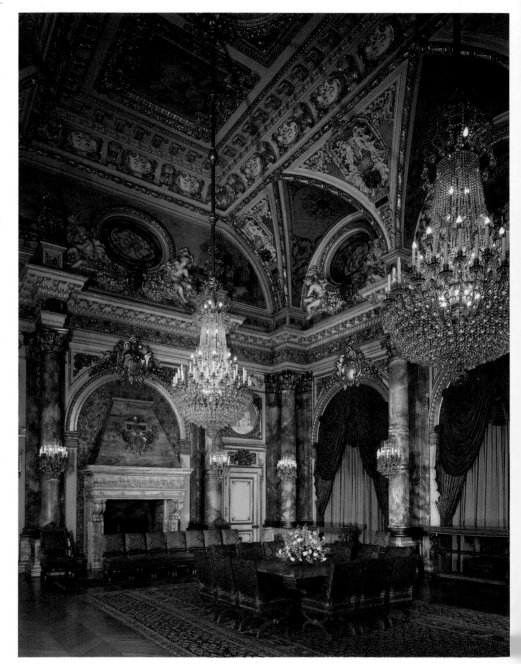

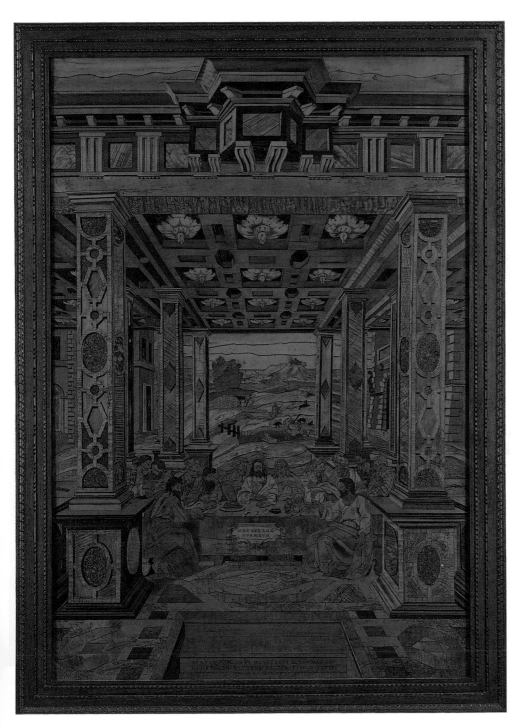

PLATE 3 Fra Damiano da Bergamo, *The Last Supper*, ca. 1548. This marquetry (intarsia) panel (60½ × 41 inches [154.3 × 103.7 cm]) was installed as part of the sliding door separating the main hall and the dining room in the William C. Whitney residence at 871 Fifth Avenue. This extraordinary example of inlay—commissioned by Claude d'Urfe, the French delegate to the Council of Trent—was originally part of an altarpiece that was made for the chapel of La Bastie d'Urfe, his château near Lyons, by Fra Damiano da Bergamo (ca. 1480–1549). The Metropolitan Museum of Art owns another panel, which depicts the finding of Moses and was designed by the sixteenth-century architect Giacomo da Vignola, that was wrought in intarsia by Fra Damiano. (The Metropolitan Museum of Art, Gift of the children of Mrs. Harry Payne Whitney, 1942 [1942.67.4 (108)]. Photograph © 1982 The Metropolitan Museum of Art)

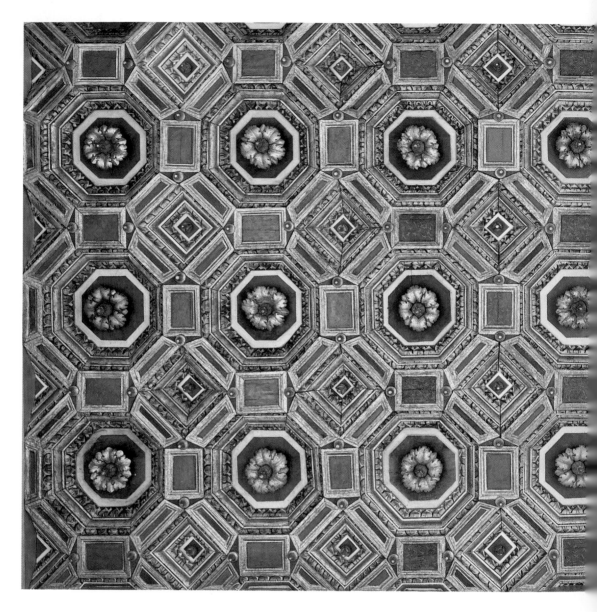

PLATE 4 Ceiling from the Studiolo, ducal palace of Federico da Montefeltro, Gubbio, 1476. Designed by Francesco di Giorgio (1439–1502) and executed by Giuliano da Maiano (1432–1490) of Florence, this wood, polychrome, and gilt ceiling and the intarsia paneling of the Studiolo from Gubbio are excellent examples of how cherished interiors survived over time and were moved from place to place. The room began as part of the ducal palace south of Urbino and was moved to Florence in 1673. Two hundred years later, Prince Filippo Massimo Lancellotti acquired it for his villa outside Rome, but it was never reassembled there. In 1937 the Lancellotti family sold it to a German dealer, Adolph Loewi of Venice, who shipped it to New York for sale. The Metropolitan Museum of Art bought it two years later. (The Metropolitan Museum of Art, Rogers Fund, 1939 [39.153]. Photograph © 1996 The Metropolitan Museum of Art)

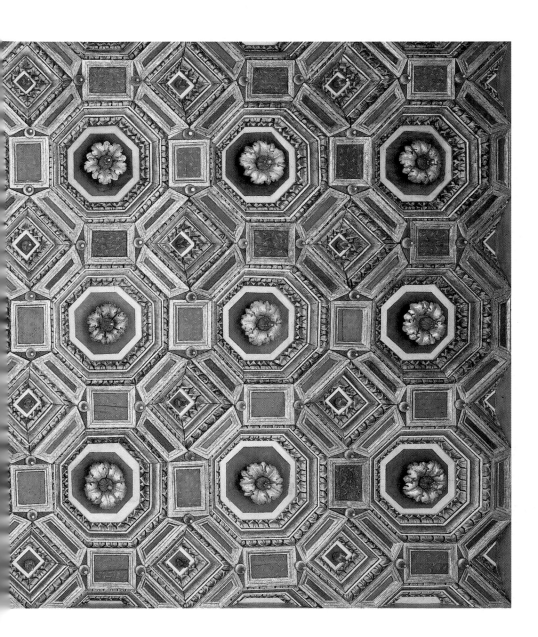

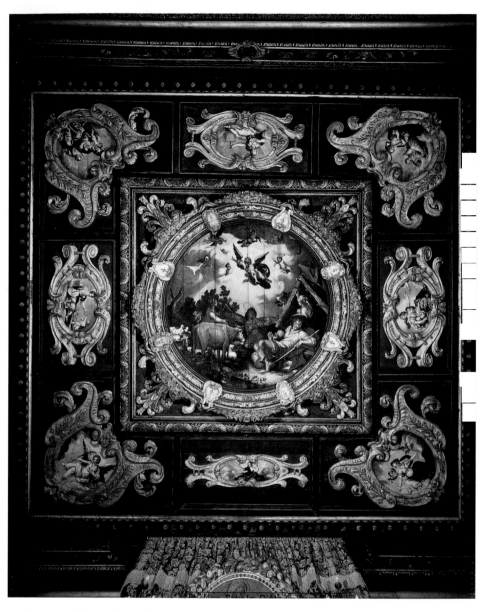

PLATE 5 Ceiling, Italian, early eighteenth century. The robustly three-dimensional gilded and painted ceiling from Stanford White's drawing room is approximately 21 feet square and was created in Italy. The central panel, 6 feet in diameter, is placed within an elaborate square gilded frame with red background, while eight smaller images are set off by scroll-form gilded frames. The circular panel is an early-eighteenth-century copy of *The Annunciation to the Shepherds*, a painting by Abraham Bloemaert (1564–1651) that was widely copied and known through a much-circulated engraving by Jan Saenredam. In 1907, at the sale held at White's house after his death, William Randolph Hearst bought this ceiling and shipped it to California. Now it is installed in the Doge's Suite at Hearst Castle, San Simeon. (Hearst Castle®/CA State Parks)

THE BEDROOMS AND MASTER BATHS

Payne and Helen Whitney had separate bedrooms, as was the custom of the day among affluent families. Davenport's made much of the furniture for these rooms, although Allard's correspondence frequently referred to the finishing of such things as canopy beds, armchairs, bedspreads, curtains, and the like. Helen Whitney's suite of boudoir and bedroom was the most lavish of all. Her boudoir contained a sofa and two stuffed easy chairs produced by A. H. Davenport, and there is a reference to built-in bookcases, the contents of which reflected her literary interests. Her bed was made in Boston of satinwood, but Allard's was involved in the creation of the canopy; the firm once wrote White a letter that revealed that nothing was to be considered acceptable for the house until it had his approval: "If you will kindly call on Monday we will show you the bed canopy, which is all ready for your inspection."[56] The walls in her bedroom were painted white.

Each master bedroom had its own bathroom. The floor of Helen Whitney's bathroom was a mosaic executed by Batterson & Eisele, which also produced the bathtub, carved from a single large block of marble. On 14 May 1906, Daniel Webster sent White a note acknowledging that someone named Stanley "telephoned that you spoke of having Finn paint the ceiling of P. and Mrs. Whitney's bathrooms."[57] In 1898 and 1899, James Wall Finn, the artist who painted the ceiling of the Mirrored Salon, had painted the ceiling of Sherry's famous Manhattan ballroom, also designed by Stanford White. White also commissioned Finn to paint the ceiling of Clarence Mackay's library at Harbor Hill. In 1903 Finn had done the murals for the Lyceum Theater in New York City, designed by Herts & Tallants, and he also worked at the behest of Charles Follen McKim, who commissioned him to "paint decorations derived from antique bookplates and arms devices of cardinals and convents" for the west room of J. Pierpont Morgan's library on Thirty-sixth Street.[58]

White's designs for the bathrooms also called for the services of a sculptor. In June 1906, Adolph Weinman wrote to Webster about the scale model for the canopy that went over Helen Whitney's bathtub, saying that he had not yet begun the full-size model of the "cherub holding drapery as I thought best to see whether Mr. White approves of the scheme."[59] At the end of July, Weinman reported that the full-scale model of the canopy had been completed and set in place in the bathroom, and he asked permission to take the model of the cherub back to his studio.

The most curious item in Helen Hay Whitney's bathroom was the Louis XIV–style armchair to be used as a toilet chair. Allard's artisans made it to measure and were required to make numerous alterations before the seat was acceptable: "The chair having to be made a little deeper and higher, there is quite an amount of work to be done."[60] Whether they were working from a design by Stanford White is not known. We do know that the bathroom contained a second, regular chair, for Allard's notified McKim, Mead & White that "the enamelling of the other arm chair for this bath room will cost twelve dollars."[61]

EPILOGUE FOR 972 FIFTH AVENUE

Stanford White was a perfectionist who thought nothing of redoing something if it did not turn out as he had envisioned it or of changing the architectural or interior plans that he had drawn up if a better solution came to him. All this increased the bills from the artisans who executed his designs. As early as the spring of 1905, Colonel Oliver Payne was expressing to White his concern about the rising costs of the Payne Whitney residence. White felt obliged to respond to his friend and patron:

> I know that all kinds of small extras have crept in and that the changes I made in the treatment of the smaller rooms after I went abroad and cabled over to stop all work until my return, have added over a hundred thousand dollars to the price of the house, and I have dreaded to speak to you about it until the house was far enough finished for you to see the result, as, although I feared that you would be angry at first, I thought if you saw the money had been wisely spent and that I had given Payne and Helen a house to live in which was really of the very first water and could stand in beauty with any house in the world, that you would forgive me and I believed in my heart that you would in the end approve of what I had done, but your saying to me yesterday that you could not see where the money has gone has taken all the sand out of me and made me very unhappy for I know from the character of the work and in comparison with other houses that it is not extravagant.[62]

But Stanford White's extravagance with Oliver Payne's money was not the only problem that plagued the project. Although White provided architectural drawings to the craftsmen who were executing the rooms, much of the room concept remained in his head, and when he was slain

on 25 June 1906, the delicate nuances of decoration vanished, too. The McKim, Mead & White Papers that postdate his death are full of correspondence between people trying to sort out what belonged to White, what Colonel Payne had paid for, where certain things were stored, how such-and-such an item was to be incorporated in which room, and so on. A plaintive frustration of hopeless entanglement runs through these pages. At best, the firm often faced decisions about whether to continue with what White had begun, as illustrated by the following letter from Allard's to McKim, Mead & White in which the decorators sent the architects a sample of fabric that was to be hung in the hall of the second floor: "We take this opportunity to remind you that Mr. White had at one time made an offer to Mr. Benguiat for the lot of this green velvet, which is to be purchased in France. The quantity is a little over 150 yds." White had offered $4,000 for the lot, but Benguiat told Allard's that he could not possibly import it to London for less than $5,000, "which makes this velvet a little more than $30.00 per yd. Awaiting your kind decision in this matter . . . , Allard & Sons."[63]

Then there was the matter of the changeover from Allard's to Alavoine and Company six months after White's death. Lucien Alavoine was a Parisian competitor of Allard's who established a branch of his firm in New York City. Alavoine bought out Allard and Sons' business in New York, effective 1 January 1907, just as the Whitney house was being finished and accounts settled. Sometime shortly after that, a clerk at Alavoine's wrote to Webster, enclosing a check for overpayment in the amount of $125.34, explaining, "I beg to apologize for this error which was caused by the fact that Mr. Allard took with him to Paris all the books referring to [the Payne Whitney house] so that when the accounts were settled by your firm I could but receipt the bills and return same to you."[64]

A typescript, with many penciled alterations and notations, in the McKim, Mead & White Papers at the New-York Historical Society, appears to be an attempt to figure out the final costs of the house. J. C. Lyons was paid $460,164 for constructing the shell. Interior marble work, done mostly by Batterson & Eisele, came to $93,744, while the "Finish of Balance of House" cost $249,419, most of which went to T. D. Wadelton and Company and Allard and Sons. The custom furniture amounted to $36,000, much of which was paid to A. H. Davenport of Boston, and Stanford White's purchases of items abroad and at home totaled $74,172. "Mr. White's trip" is included at $8,486, the cost of his 1905 buying venture on the Whitneys' behalf. On top of that was the fee charged by the

firm of McKim, Mead & White, $45,982. A few other expenses—such as insurance—were itemized, bringing the cost of the house to $976,083.80. But still other charges made up a long list of various items, materials, and services that added another $178,640 to the final bill. Altogether, the house and its furnishings cost Colonel Payne well over $1 million. Henry Adams could not resist expressing an opinion:

> It is pitiable to see how the Colonel is pleased to build Helen's house, and how Helen and Payne try to like what he does, and to fit their bourgeois or bohemian tastes to his. The Colonel has gone the road that you and I and all the grown ones have gone; and cares for nothing but the best; but young people don't want the best, and ought not to be allowed to have it. You and I and our friends ought to have it all. The Colonel is far more interested in the house than the children are; and I bluntly told him to buy the Marquand window [La Farge's *Peonies in the Wind*] for it, if he wished to give it a cachet once for all. I wonder whether Stanford White would let him do it.[65]

Payne Whitney died in 1927, but Helen Hay Whitney lived in the house until her death in 1944. Their son, John Hay "Jock" Whitney, found the house to be too large, the interiors outdated, and the maintenance and taxes very expensive. In 1946 Parke-Bernet conducted an auction of the interiors and furnishings. Such items as the Louis XV jade-green silk and gold brocade table cover edged with silver lace, purchased from William Baumgarten, attracted active bidding. Also sold was a little Gothic figure of the Virgin, 28 inches high and polychromed, that White had obtained from Heilbronner of Paris; the Italian Renaissance ceiling in the salon went to a dealer from Mexico for $1,000. The Whitneys had acquired William Westall's painting *Rustic Courtship* at the sale of Stanford White's collection in 1907. White's influence on the collecting habits of his young patrons extended even beyond his death, for at the Elia Volpi sale of treasures from the Palazzo Davanzati, held in New York City in 1916, the Whitneys purchased the so-called Vasari Table, a sixteenth-century Florence piece at which, apocryphal legend had it, Giorgio Vasari wrote his famous *Lives of the Most Eminent Painters, Sculptors, and Architects*.

Only the entrance hall fountain, with its Michelangelesque cupid, and the Mirrored Salon were spared. The little reception room was carefully dismantled and placed in storage. The gutted building was sold to a developer in 1949, but three years later the French government bought it to

serve as the Cultural Services branch of its embassy. In 1997 a Whitney descendant made a gift of the Mirrored Salon, along with the money to restore and reinstall the room in its original location.[66] And so the Payne Whitney house survived the inexorable encroachment of commercial buildings and high-rise apartment houses on Fifth Avenue, one of the few great urban mansions of the Gilded Age to do so.

Five

THE MACKAYS AND HARBOR HILL

ALTHOUGH BY 1938 THE GREAT AGE OF MANSION BUILDING WAS LONG past, the *New York Times* obituary for Clarence Mackay praised the beauty of Harbor Hill, as his Long Island estate was called, and the rare items it contained: "In its dignified and magnificent gray stone chateau, built in 1900, are treasures consisting of paintings by old masters, old armor, tapestries and banners. The Mackay collection of medieval armor is one of the greatest private collections in the world. Harbor Hill is considered one of the most beautiful, most spacious, most completely equipped country places in America."[1] Mackay was the personification of second-generation wealth in the Gilded Age, for his parents were among the newest of the new money. But within a single generation, he learned how to spend the family fortune to encapsulate himself within an imitation French château in which Old World antiquities abounded. The story of the inherited wealth that made it possible began in the American West, where fortunes were made overnight in the gold fields and silver mines.

Clarence's father, John William Mackay (1831–1902), was born to a penniless family in Dublin that emigrated to the United States in 1840. In 1851 he, like so many others, rushed to the gold of California, only to experience the disappointment of thousands of forty-niners who had preceded him. He moved to Virginia City, Nevada, and by 1868 had joined

in a partnership with James Fair. They began reworking the abandoned Comstock Lode and in 1873 hit the "Big Bonanza," which made them instant millionaires. During the next few years, their mine served up more than $300 million worth of silver, the equivalent today of $2.5 billion.

In 1867 Mackay married Marie Louise Hungerford, a widow of Virginia City. She had one daughter, and she and Mackay later had two sons, one of whom was Clarence.[2] John William invested wisely in San Francisco real estate, banks, and railroads, but in 1876, when Clarence was two, the family moved to New York City. However, the Mackays spent most of their time in Europe, where the press delighted in covering Marie Mackay's penchant for spending lavishly on jewelry.

Even from Paris, the "bonanza silver king" continued to make enormous amounts of money. He joined with James Gordon Bennett in the "cable wars," and they were able to break the monopoly of their formidable foe, Jay Gould. In 1883 Mackay and Bennett laid two transatlantic cables connecting the United States and Europe, and three years later Mackay organized the Postal Telegraph Company to compete with Gould's Western Union lines across the North American continent. His company was laying a cable across the floor of the Pacific Ocean when he died in 1902, leaving twenty-eight-year-old Clarence a fortune then valued at $500 million.

CLARENCE HUNGERFORD MACKAY

Clarence Mackay (1874–1938) spent much of his youth abroad, mainly in Paris, enjoying the cosmopolitan lifestyle that his father's wealth made possible. After attending college in Paris and Windsor, England, he was trained in the family business of intercontinental cable and telegraph communications. He joined his father's firm in 1894 as a twenty-year-old vice president and proved so capable that he soon assumed administrative control. In 1928, incidentally, the Mackay cable and telegraph interests became the International Telephone and Telegraph Corporation.

As a young man, Clarence was an active sportsman, loved horses, and developed a large stable of thoroughbreds. Like Stanford White, he belonged to all the major clubs of New York City, and he became a prominent board member of cultural institutions, including the New York Philharmonic Orchestra, the Metropolitan Museum of Art, and the Metropolitan Opera Company.

On 17 May 1898, Clarence Mackay married Katherine Duer, a descendant of an old Knickerbocker family. A strong-willed independent woman

and an early feminist, she was, even from childhood, rather imperious. One of her early playmates, Consuelo Vanderbilt, later recalled that Katherine "wanted to dominate us all; she was one of those who assumed it to be her right. She was always the queen in the games we played, and if anyone was bold enough to suggest it was my turn she would parry, 'Consuelo does not want to be Queen,' and she was right."[3]

In later years, Stanford White once described Katherine as she was dressed for one of the costume balls for which La Belle Epoque was famous; his words suggest the appropriateness of Old World architectural settings in New World mansions. Writing to his wife, White observed that Katherine Mackay went as Theodora, empress of the Eastern Roman Empire, in a gown "of spun silver and gold all encrusted with turquoise, and with a great turquoise and silver crown on her head. . . . Her train was at least ten feet long and was carried by two little . . . negroes with gorgeous gold dresses."[4] Even the gossip-scandal sheet *Town Topics* had to concede that Katherine was "a delightful extravagant young woman . . . a perfect specimen of wilful, wistful beauty."[5]

As a wedding present, John William Mackay gave Clarence and Katherine a 600-acre tract of park- and woodlands on the crest of Wheatley Hills, near Roslyn, Long Island. The property, overlooking Hempstead Bay and Long Island Sound, adjoined that of William Collins Whitney. The manor house was erected near the center of the tract, with the approach from the south.[6] Picturesque roads and bridges wound through the property from the main road, connecting a host of auxiliary structures, from the Trinity Episcopal Church (which Katherine had McKim, Mead & White design as a memorial to her parents) to the gatehouse, which resembled a seventeenth-century French provincial farmhouse, to the conservatory, stables, dairy and farm buildings, and kennels. Broad lawns, terraces, and formal gardens were encircled by oak and chestnut forests that were planted with rhododendron bushes, laurel, and dogwood.[7] It was in every sense a modern-day baronial estate (figure 41).

STANFORD WHITE: FRIEND AND ARCHITECT

Stanford White was on friendly terms with the Mackays, just as he was with most of his Gilded Age millionaire-society clients. On 15 October 1899, for example, Tessie Oelrichs signed the guest book when she visited the Whites at their Long Island retreat, Box Hill, not far from the Mackays' Harbor Hill; Charles Follen McKim was also a guest that weekend. The

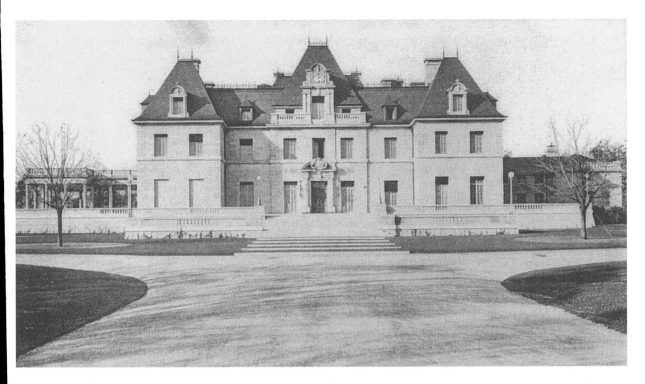

FIGURE 41. McKim, Mead & White, Clarence Mackay estate, Harbor Hill, Roslyn, Long Island, 1899–1902 (interior work, to 1906). From the beginning, Katherine Mackay wanted a château in the mode of the early French Renaissance. Stanford White, too, admired most things French—the French people, their history and culture, and their architecture. While on his first tour of Europe in 1878 and 1879, early in his career, he wrote excitedly to his mother, "We are now in the valley of the Loire, and surrounded by magnificent old chateaux" (SW to Nina White, 30 August 1878, SW Papers, NYHS). (From *Architectural Record,* October 1904, p. 299)

Mackays often received the welcome gift of a salmon after White had been on a fishing expedition at the prestigious Restigouche Camp in Canada with William Kissam Vanderbilt.[8] In 1904 White joined Clarence as a traveling companion in Mackay's private railroad car when the two went to see the Louisiana Purchase Exposition in St. Louis. White was often a weekend guest at Harbor Hill, and the architectural firm's correspondence contains frequent notes, such as the one that Katherine dashed off to Stan: "Clary & I are going to Roslyn on the 4:20 today and I wish to remind you that we expect you to spend tonight with us. Let me know if you will come with us or take the 5:30."[9] Stan and Clarence were planning a trip to Europe when White was killed.

White's relationship with Katherine was often tempestuous. As work on Trinity Episcopal Church on the estate neared completion, Katherine wrote to McKim, Mead & White, in her demanding and domineering way, that what she wanted the firm "to do is this: Correct their error in the color of those rafters and trim at their own expense. . . . I want samples submitted to me and I want you to see that this work is started by Monday next."[10] A letter that Katherine wrote to White from Newport at the beginning of the Harbor Hill project reflects both her personality and the extent of her participation in the design of the mansion: "I have decided to begin on those plans at once so will you express me as soon as you can get this, some books about the drawings [engraved plates] of Louis XV chateaux. Very severe style preferred. Also of halls Henry II (French) staircases Henry II. Should you be coming to Newport the end of this week I should be glad as I really want to begin at once. On enclosed sheet you will find my idea of ground floor. Upstairs will have to be explained to you verbally. Hope you will give this your immediate attention."[11] Katherine could specify that she wanted a "French this" or a "Louis that" in full confidence that White could obtain it for her on one of his European buying trips. She also realized that the building and furnishing of a house could be a severe test of any relationship, and she occasionally expressed her appreciation to her architect: "You and I have certainly continued friends through these two years of building and I want to tell you I am perfectly satisfied with the result of your work and thank you for this personal interest you have shown."[12]

A FRENCH CHÂTEAU MODEL, BUT SEVERE

The elevation and plans for Harbor Hill show that both clients and architects had recourse to numerous books on architecture and their engraved

plates; they consulted such references for the interiors as well. Stanford White had never experienced years of training at the Ecole des Beaux-Arts in Paris—as had, say, Richard Morris Hunt—where White would have been exposed daily to engravings of antique architecture and to examples of still-standing edifices from the Renaissance, Baroque, and Rococo periods. He did travel throughout Europe, a keen observer of the details of architecture wherever he went, and in educating himself in such matters, he also turned constantly to numerous design books with their many illustrations of Italian palazzos, French châteaux, and English country houses.

White had an extensive architectural library. Once, while on vacation, he wrote to his mother, asking her to take two of his books of photographs to his office, "one of old pictures, and the other of old English houses and furniture."[13] A folder at Avery Architectural Library contains about thirty-five bills from Scribner's for books purchased by the architect, their subjects ranging from collecting china to designing Italian gardens. A bill from Manzi, Joyant & Company, book dealers of London, Paris, and Berlin, shows that in 1900 White bought—while he was working on the Mackays' Harbor Hill—several books, including a set listed as "Royal Interiors," another set referred to as "Wallace coll[ection] Paintings," and an item titled "Les Arts."

One book that White sent to Katherine was Claude Sauvageot's *Palais, châteaux, hôtels et maisons de France du XVe au XVIIIe siècle*. In volume 2, plate 3, she found what she was looking for—an engraving of the Château de Maisons-sur-Seine, erected according to the designs of François Mansart in 1642 to 1646 and commonly referred to as the Château de Maisons. In July 1899, she wrote a letter to her architect that shows quite clearly how studiously she was approaching the matter: "Thank you for your sketches and your books arrived. . . . The plan where the sides project is what I want. I have made notes on it to give you points. I do mean a very severe house. The style of the full front view of Maisons . . . comes nearest to what I mean. And even that has the windows too ornate to suit us. I want my floor on the north side over the library. . . . Also: over the hall facing the water a suite for Clarie [Clarence] the same as mine."[14] Work on the plans progressed rapidly, and by 7 November 1899 Katherine could notify White by telegram: "Expressed all plans to you yesterday. Send tracings of new plans to Allard and Davenport direct and . . . say these are the final plans."[15] Even at this early date, it had been determined that Allard's and Davenport's were to be the two primary decorator houses involved with the interiors.

ALLARD AND DAVENPORT, AGAIN

The craftsmen of Allard and Sons were involved at Harbor Hill early in the swift production of the architectural interiors and furnishings—so swift, in fact, that Allard's employees often completed their work in the factory before the house was ready to receive it. Moreover, the correspondence between Allard's and White reveals that, although Allard's had long had a branch office and factory in New York City, a large amount of the work was still done in Paris and shipped to the United States. In September 1900, Allard's informed McKim, Mead & White that the firm was eager to begin work on the interiors and that it had had in storage, for three months in New York, eighty crates of materials awaiting installation. A few months later, Allard's wrote to Clarence Mackay, enclosing an insurance policy "which our Paris House has taken on all the woodwork manufactured and ready in storage in Paris for your Roslyn residence. This also covers all the furniture which is ready to be shipped from Paris."[16] Another letter, from November 1901, shows that by 9 June 1900 Allard's had a contract "for decorative work, furniture, etc. amounting to $62,745.25," and, the firm added, "we have all of our decorative work finished—all the furniture delivered, and respectfully request a 3rd payment of $25,000." The same letter then noted that "we have had this furniture in storage for six months."[17]

A. H. Davenport and Company was located in Boston, but it did much business elsewhere. As necessary, A. H. Davenport himself would journey to New York and Long Island to confer on the Mackay house.[18] But most of the time he remained in Boston, for by 1900 he had established a branch in New York City, with Victor Twiss in charge, because McKim, Mead & White and other architects had so much work for his firm there.

In 1880 Albert H. Davenport (1845–1906), a native of Malden, Massachusetts, had purchased the Boston furniture-making company where he had long worked as an accountant, and in the next quarter-century he turned the business into one of the leading American decorator houses of the Gilded Age. As early as 1885, his artisans had supplied the furnishings for the throne room of King Kalakaua's Iolani Palace in Honolulu, as well as some furniture for McKim, Mead & White's house for Henry Villard on Madison Avenue in New York City. Davenport's was one of the primary providers of furnishings for the refurbishing of the White House in Washington, D.C., that was undertaken by McKim, Mead & White in 1902 and 1903, as well as for many grand mansions being erected in New York and the developing Back Bay area of Boston.

At one time, the firm had 14 architectural and furniture carvers on the staff, as well as a full complement of designers, cabinetmakers, upholsterers, seamstresses, and other artisans—about 150 employees in all—most of whom worked in a five-story factory in Boston.

Davenport kept a foreman on site at Harbor Hill, and at times several of his men were at work there. In January 1903, the Boston decorator sent White an estimate for a pair of doors for the house, noting that "this estimate includes board of men, railroad fares, and all [their] expenses."[19] Another letter refers to the coordination between Davenport's firm and Allard and Sons at the Mackay mansion; someone at the Boston establishment wrote to Fred Adams of McKim, Mead & White to say, "We are beginning work on the doors for the Mackay hall and it is important that we have . . . a section of the doors as Mr. Allard is making his part, so we can determine as to the thickness of the hall side. We [also] want [sections of] the salon and the library doors."[20]

THE ARCHITECTURAL INTERIORS

Many artisans, craftsmen, and tradesmen would be involved from the start of construction with the eight or nine major rooms of Harbor Hill. Among the several decorator houses that participated in the creation of the architectural interiors were Duveen Brothers; its correspondence appears regularly in the Mackay folders of the McKim, Mead & White Papers, and the same files contain letters and bills from Eugene Glaenzer's firm. T. D. Wadelton and his craftsmen were active on the site, as was the ornamental painter James Wall Finn. But the two main houses were A. H. Davenport and Allard and Sons.

Davenport's was charged with executing White's designs for the grand staircase, main hall, dining room, and billiard room on the first floor and for Clarence Mackay's bedroom and study on the second floor; the salon, "Stone Room," and library on the first floor, as well as Katherine's suite on the second floor, became the responsibility of Allard and Sons.

The first floor contained the entrance hall, with a grand staircase to the left and the enormous main hall straight ahead (figure 42). To the right of the entrance hall was the billiard room. From the main hall one entered, to the left, the salon or drawing room, which adjoined the "stone room," another salon in the far-left corner; its counterpart in the other corner was the dining room. Between the dining room and the billiard room were service areas—the kitchen, pantries, scullery, and so on. On the second floor were the rooms of Katherine's suite, consisting of the anteroom, sitting room, bedroom, and large bathroom. Clarence's more modest suite

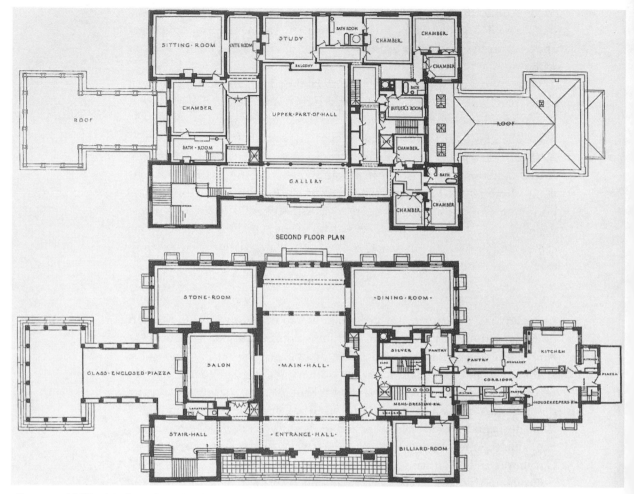

SECOND FLOOR PLAN

FIGURE 42. McKim, Mead & White, plans for the first and second floors, Harbor Hill, Roslyn, Long Island, 1899. (From *A Monograph of the Works of McKim, Mead & White, 1879–1915,* vol. 2, plate 169)

joined Katherine's along the north side of the house. Bedrooms for the servants were on the third floor.

Construction of the building progressed rapidly, no doubt at the urging of the mistress of the mansion, and by June 1900 the house was ready for the craftsmen of Allard's and Davenport's to commence the ornamentation of the interior shell. On 8 June, A. H. Davenport submitted an estimate of $22,892 "for the woodwork in Mr. Mackay's house," noting that the entrance vestibule and the staircase would be done in American oak with a plaster ceiling (figure 43) and that the estimate did not include the price of "the stone mantel which Mr. White sold them [the Mackays] separately."[21] Here was an example of Stanford White's acting as dealer as well as architect, in selling to the Mackays an ancient fireplace that he had acquired in Europe and had kept in storage. But controversy was inevitable, as shown by a letter from Davenport to White regarding the color of the carpeting for the staircase. "I had always understood," he wrote, "that the stair carpet was to be red to go with the black oak. I heard last week that Mrs. Mackay was pleased with all that had been delivered and said if Mr. Mackay did not like his room, it was his own fault for she took the sketches to him and tried to get him interested. Failing in that she took the responsibility to place the order."[22] A few days later, Victor Twiss, of the New York branch of Davenport's and supervisor of its activities at Harbor Hill, wrote to Katherine Mackay, his patience obviously tested to the point that he was barely able to retain his self-control; Twiss explained that he had been ill and therefore absent on the day his men tried to lay the carpeting on the stairs:

> I was . . . greatly surprised to learn that you would not permit them to lay it, as it was red instead of green. Now, I have never had green suggested by you for this carpet. Red was the color that I suggested when the order was given by you and the color that I have on memorandum. There were no curtains or wall covers in connection with this stair carpet to call for any special shade; so, I did not submit a sample or colored sketch, as in the case of the principal rooms that we made rugs for. . . . I am quite sure that if you had suggested green, I would have been very particular to have you designate the shade, as I never would, under any circumstances, suggest a green carpet to go with black oak woodwork.[23]

Katherine petulantly gave in, and the red carpet was laid upon the stairs.

FIGURE 43. Stanford White, entrance hall and staircase, Harbor Hill, Roslyn, Long Island, ca. 1900. The entrance hall was beautifully paneled, and the glory of the staircase was its rich carving, all executed by A. H. Davenport's talented artisans. As the stairway rose toward the second floor, its paneling was adorned with a large tapestry. In the McKim, Mead & White Papers relating to the house is one of Clarence Mackay's business cards, on the back of which is a scribbled notation: "Boucher tapestry hung by Duveen on stairs" (Mackay folder, MMW Papers, NYHS). A large grandfather clock stood on one landing. (Collection of The New-York Historical Society)

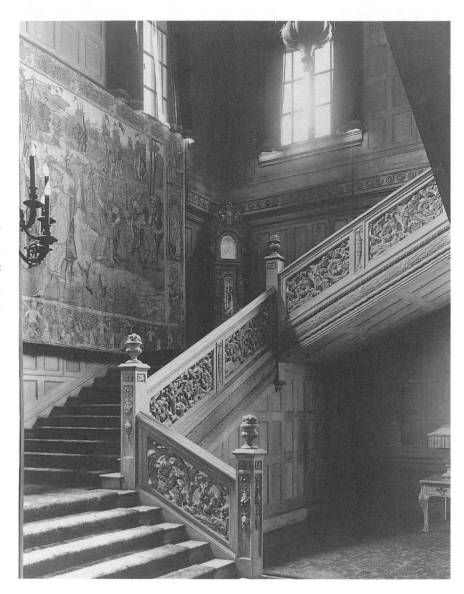

THE MAIN HALL

The main hall was to be the room in which Mackay would display his celebrated collection of medieval and early Renaissance armor and related paraphernalia (figure 44). To him it was the most important room in the house, and extraordinary care was to be taken to ensure that it was done properly. To accommodate his client in this respect, Stanford White proposed something that gives some insight into how an interior designer might proceed. As the room neared completion, White wrote to Mackay: "In order to make something which will really show as nearly as possible exactly the effect of the hall, the best thing to do would be to have some good, big, fine photographs of it made from different points of view. These I will have printed upon paper from which drawings can be made, and the result can be re-photographed and touched up and it will be almost like a photograph itself. With your permission I will send down Sidman . . . , the best architectural photographer I know of."[24] On this letter, Mackay scribbled his agreement to the plan but that same day sent White another note in which he stressed the importance of the great chamber: "Please start on same [photographic project] at once, and I must ask you to give it your most careful consideration, as my heart is wrapped up in making a success of that hall."[25] The room was very much on his mind, for a few days later Mackay again wrote to White: "I do not care to have [photos] of any of the other rooms taken, as the hall is the centerpiece, so to speak, and in my opinion everything in the house depends on its success."[26]

The paneling of the main hall was, like the fireplace, antique, obtained by White while he was traveling abroad. Herbert Croly and Harry Desmond noted the passion for original boiseries plucked from noble and ancient European palazzos or châteaux in their book of 1903. They observed that while an architect can normally import only the designs of such buildings for his exteriors, he can obtain the actual material itself for his interiors, ready-made by skilled craftsmen of centuries past:

> The agents of rich Americans have invaded Europe and torn out the very walls and ceilings of these old houses, so that, in many instances, the paneling that once lined the dining-room of an English "Baron" now adds a dim distinction to the meals of an American banker, while his drawing-room is focused by some

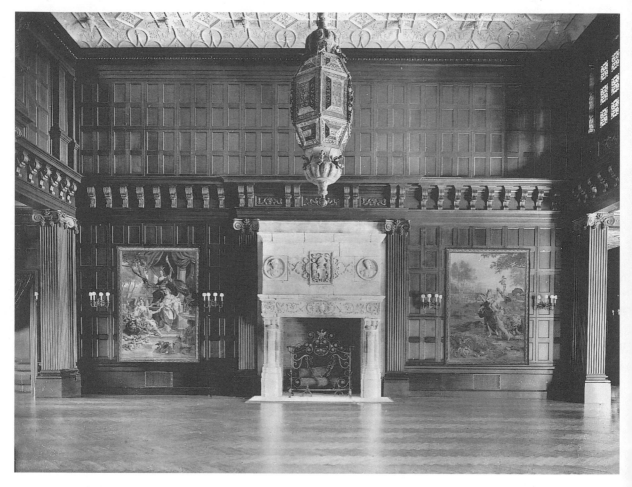

FIGURE 44. Stanford White, main hall, Harbor Hill, Roslyn, Long Island, 1901–1902 The main hall was the largest room in the house, measuring 48 by 80 feet and 38 feet high. The focal point was the antique fireplace that White had procured on his European travels. In February 1902, masons of Robert Fisher & Company, whom White often employed, were reconstructing the fireplace and modifying it to make it fit in its new home. (Museum of the City of New York)

fine gray Italian mantelpiece. . . . By the skillful use of these materials and fragments [the architect-decorator] can . . . produce the effect of time and distinguished associations. He can surround the most modern of people with the scenery and properties of a rich and memorable historic past.[27]

Stanford White turned over the old boiserie to Davenport's workers, who were to alter it so it would fit the dimensions and apertures of its new home. But its surfaces, too, required modification, for they had darkened from coats of varnish accumulated over centuries. With some pride, however, Davenport wrote to White that one of his workers had found a solvent that "worked to a charm," and he was sending the architect a sample that had been taken down to bare wood in preparation for application of the final finish. Work proceeded apace, and the refinishing of all the panels was almost complete when another problem arose.

White was, at this time, executing the interiors of the William C. Whitney house in New York City, and Katherine Mackay was sufficiently familiar with Whitney's paneling to tell him that she wanted something similar. In the summer of 1901, a somewhat distraught Davenport wrote to White that he was sending him three sections of old panels, one of which was finished in the manner of the Whitney hall. However, that finish presented an almost insurmountable problem, as Davenport explained: "You will see . . . that it will be impossible to wash off the stain and refinish according to Mr. Whitney's color, so that in order to get the Whitney color, it will be necessary to scrape and plane and recarve all the work that is now finished. There is about two thirds of the main hall that is polished and ready to ship, among it being the carved moldings and carving, all the large pilasters and caps, so you will see it will be an expensive as well as a long job to scrape and recarve them." Davenport said that redoing the paneling in that manner would require another three to four weeks and cost $15,000 to $18,000 more. He concluded his letter by saying, "I had one car load already to ship when you telephoned Mr. Bacon in regard to the color. I am holding that now waiting your decision. I had hired about twenty extra men to work at the house to hurry it some. All these men will have to be discharged if the color of the woodwork is changed."[28] Katherine was persuaded not to make the change at that late point.

For the doorways leading off the main hall, White designed a spectacular arrangement of columns and matching pilasters. The columns were to

be of green Connemara marble with white marble bases and capitals. Robert C. Fisher & Company supplied the monolithic shafts, obtained from a quarry in Ireland, but the bases and capitals were executed by the Piccirilli Brothers of New York City, renowned for their excellence in marble carving. Davenport's produced the wooden pilasters of the same design, which were applied to the wall behind the columns-in-the-round. To ensure a consistency of design between the columns and the pilasters, A. H. Davenport wrote to Fred Adams: "The full sized detail of the cap over the pilasters on the Mackay hall does not work out quite right as you have it drawn, and as I presume you wish these carved the same as the caps on the marble columns, I thought I would ask you if the marble man was not carving from a model, and if he was, if you could not get us a cast of the model. . . . Then I would be sure to have the cap look like his in detail."[29] When all the complexities of these columns were finally worked out, Katherine Mackay struck again, for she did not like them. "Will you oblige me," she wrote to White, "by having them removed *at once*. . . . I wish the four columns removed within one week & I expect you to see it is done."[30] And so it was.

THE SALON, OR DRAWING ROOM, AND THE STONE ROOM

Stanford White designed the drawing room in a Louis XV style, and it was executed by the house of Allard "as per designs submitted" (figure 45).[31] According to Allard's estimate, the paneled walls were to be painted "pure white with light lines of mauve color," with the molded plaster ceiling, also wrought in a Louis XV motif, to be pure white. "All the ornamentation shown on the drawings to be carved wood," the estimate continued, with all mirrors to be "of the best French plate. The doors are to be faced with mirrors, also the panels between the windows to contain mirrors."[32] Allard's evidently produced the final design for the ceiling, for someone there wrote to Fred Adams early in 1902 to say, "We beg to send herewith [the] drawing of the ceiling for the Drawing Room in Mrs. Mackay's residence."[33] The full-length Sargentesque likeness of Katherine Duer Mackay, by the French portraitist Theobald Chartran and mounted in a great gilded frame, was hung above the fireplace. The latter was also a creation of the house of Allard, for the estimate included a "mantel piece to be in Pavonazzetto marble, the ornamentation on same to be in finely chiseled gilt bronze."[34] Before the fireplace stretched a huge polar bear–skin rug, which offered a marked contrast to the elegant eighteenth-century furniture that surrounded it.

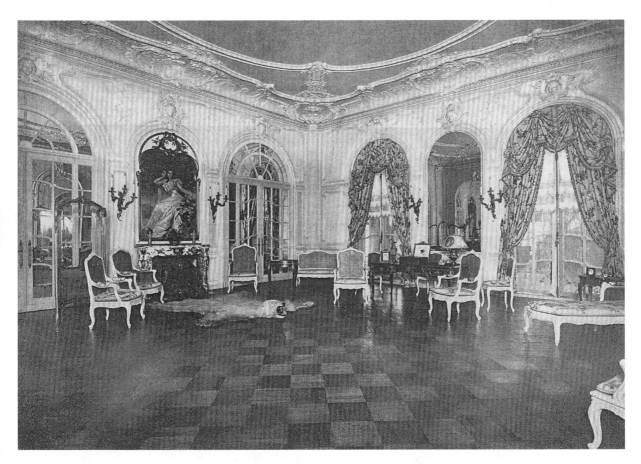

FIGURE 45. Stanford White, drawing room, Harbor Hill, Roslyn, Long Island, 1901–1902. Allard and Son's craftsmen produced much of the furniture for the salon, including a large carved and gilded table and two fancy small tables, plus a tea table; the firm's artisans also made a chaise lounge, a sofa, two bergeres (large, deep armchairs), and a console table. The room was lighted electrically by eight three-branch sconces of the "Fontainebleau" design that were also created by Allard's workers, in a French bronze and lacquered gold finish. The room itself was done in the style of Louis XV, with cream-colored walls and a molded ceiling. (From Barr Ferree, *American Estates and Gardens*)

William Baumgarten provided some furnishings for the drawing room, including two richly carved walnut tables, two carved armchairs with caned seats and backs, six side chairs to match, a settee to go with the chairs, and an assortment of cushions done in antique brocade or tapestry. White had long worked with Baumgarten, but new names appear from time to time as well. W. A. Stromeyer's establishment was, according to its letterhead, a producer of "Fine Furniture and Upholstery in all its Branches" and was located on East Ninth Street in New York City. Early in 1905 a Mr. Rarig of that firm wrote to one of White's assistants: "Mrs. Mackay called and stated that she had given Mr. Stromeyer an order for four chairs, copying the one that Mr. White has, in red velvet, in his big room to which Mrs. Mackay directed Mr. White's attention. Mrs. Mackay wants to be sure that the right chair is copied, and asked if Mr. White himself could point it out to Mr. Stromeyer. She would like to see Mr. White about the matter—remarking that she supposed he would not care to come to lunch; and finally requested, in case Mr. White came to the opera tonight, that he come in to see her."[35]

In March 1903, Clarence Mackay bought two rugs from A. A. Vantine of New York, importer of silk fabrics and rare carpets. One was a Kirman, 23 by 35 feet, and the other a Kurdistan that measured 19 by 35 feet; they were placed in the two salons. In reference to the Stone Room, a letter from Duveen Brothers regarding "the tapestry of Mr. Mackay" reported that "we have the same in hand . . . [and] are repairing it. . . . We also beg to say that the ceiling will be put up on Saturday in our place," another window on the activities of the house of Duveen at Harbor Hill.[36] The Stone Room was a second salon, less formal than the main drawing room, and so named because of the omnipresence of stone, for even the walls were of that material.

THE DINING ROOM, BILLIARD ROOM, AND LIBRARY

That Davenport's firm was responsible for the creation of the dining room is shown in a letter that the decorator sent to Fred Adams in the summer of 1901: "I find on my return home this morning that we did not have any blue prints of the elevations of the dining room . . . and the scale drawing from which we worked, as well as the full sized details have been sent to the house with the work, as a guide for the men in putting it up."[37] The walls of the dining room were paneled in an English Renaissance mode, new work crafted by Davenport's artisans and not ancient boiserie (figure 46).

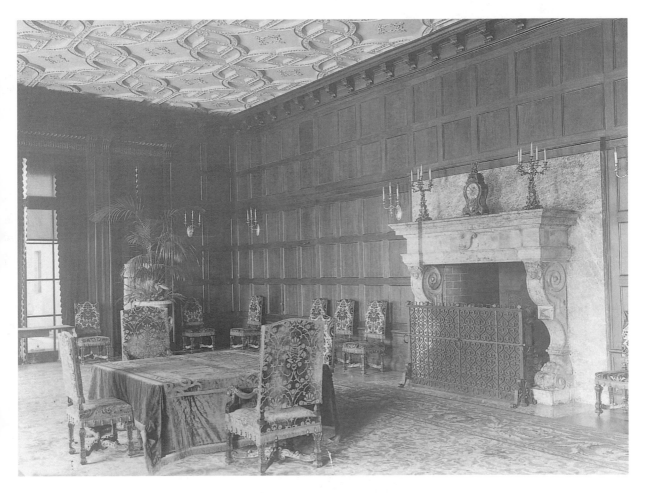

FIGURE 46. Stanford White and A. H. Davenport and Company, dining room, Harbor Hill, Roslyn, Long Island, 1901–1902. Davenport's artisans executed the English oak paneling and the ceiling for the dining room. They also created a pair of English oak sideboards, and the chairs were reproductions of a sixteenth-century type, upholstered with a fabric that imitated the antique. The fireplace, however, was a genuine antique. (Collection of The New-York Historical Society)

Davenport's supplied Axminster carpets for several main rooms at Harbor Hill, including the dining room. In July 1901, Victor Twiss wrote to Fred Adams to ask, "Can you give me a sketch showing the manner in which the floors are to be laid in the following rooms in Mrs. Mackay's house—namely, Dining Room, Library, and Mr. Mackay's study and Bedroom. I desire this in order that I may make the rugs the proper sizes for these rooms, and if there are any borders I want to arrange it so that the rugs do not encroach on them."[38] But Allard and Sons also obtained specially made carpets for the Mackay mansion, for in April 1902 Adams notified White that Allard's had informed him that the Mackay carpets, woven in England, were expected to arrive in New York by steamer the next week and that special arrangements had been made to get them through customs quickly.

Working from Stanford White's designs, A. H. Davenport and Company provided the architectural interior for the billiard room. This new type of room had become popular in Gilded Age mansions as a retreat for men after a dinner party, where they could enjoy cigars along with a game of billiards (figure 47). An antique fireplace was installed by Fisher's stonemasons, who set it within paneled walls.[39] Mounted deer and antelope heads, many with great wide antlers, gave the room the feeling of an old European hunting lodge. White and, one presumes, Clarence Mackay liked the use of deer and moose heads, believing that they added a masculine quality to a room. The pool table, of course, was new, although Europeans had played some form of billiards since the fourteenth century.

The library at Harbor Hill was located on the first floor, directly behind the main hall, although for unknown reasons it does not appear in the plans. It, too, was a room of special importance to Clarence Mackay. "I wish some time you would take a run down to Harbor Hill in your automobile," Mackay wrote to White, "and see how that new room (library) is progressing. It is a very important piece of work, and I should be very much obliged if you would . . . give it your personal supervision."[40] Katherine, too, took an interest in the library, making her wishes known, as usual, in no uncertain terms. "I will not have the tapestry anywhere but in the library," she informed her architect, "hung on the window as I said and I wish it hung this week."[41]

A letter that she wrote to White on another occasion is further evidence of her direct involvement in the design of the room:

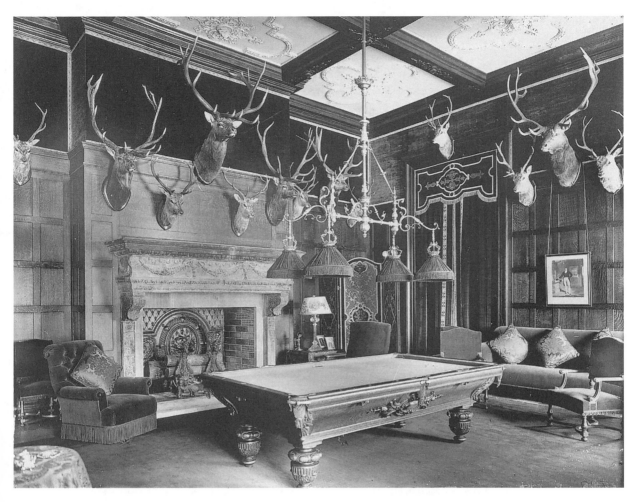

FIGURE 47. Stanford White, billiard room, Harbor Hill, Roslyn, Long Island, 1901–1902. Mounted deer heads, a favorite decoration for billiard rooms, could be purchased like any other commodity, and the demand for them was such that people specialized in obtaining and hanging them. In this view of the billiard room, thirteen deer heads are visible, and probably that many more rimmed the room. That Mackay simply bought them instead of tracking and shooting the deer himself was not an issue—anymore than it was with the polar bear–skin rugs and tiger skins, also purchased like commodities, that decorated many such rooms. (Museum of the City of New York)

> Will you treat my library in the following two ways: First:
> Renaissance Plaster ceiling to look like old marble. Marble win-
> dows and door trims, marble mantel pieces. Walls covered with
> that red stuff from Baumgartens. The two best tapestries hung on
> the two panels where the book cases now are. . . . 2nd: Louis XV:
> Boiserie to ceiling; French walnut; unpolished finish. No gold.
> Tapestries framed in panels. Large French mantel piece. . . .
> Tapestry curtains at all windows. My other two tapestries used as
> portieres. No color in room. Plaster ceiling with cupids. . . . Please
> make me two colored drawings of these, very carefully and *think*
> about it, as I want the room fine when I do it.[42]

The centerpiece of the library was an antique mantel acquired by
White, probably through Stefano Bardini in Florence or Jacques
Seligmann in Paris. Installed by the stone-working firm of Robert Fisher
& Company, it required some modification and the addition of a bust of
Voltaire. Fisher's correspondence mentions the bust as the crowning fea-
ture of the fireplace; the bust was based on the portrait by Jean-Antoine
Houdon and created by the Piccirilli Brothers, marble carvers of New
York City.[43] Above the mantel was a painted portrait of Clarence's father,
John William Mackay, set within a robustly carved and gilded frame that
was produced by Allard's.

The house of Allard, the main contractor for the library, outlined its
contribution in the estimate of 1899:

> We hereby agree to execute and put up complete all the wood-
> work . . . as per designs submitted. The woodwork to be of
> French Oak and Gold. . . . The cornice to be of Fibroud Plaster,
> painted to imitate the Oak, and the ornamentation gilt to match
> the woodwork. . . . The hardware for the doors to be of French
> manufacture in gilt bronze. . . . We will hang the walls with green
> stripe velours as per sample submitted [and] we will manufacture
> and put up window draperies as per design submitted, using the
> same velours as for the walls. . . . We agree to furnish and put up
> Eight electric brackets—Louis XIV [and] Two ceiling fixtures as
> per design submitted.[44]

Allard's also furnished the portieres for the library doorways, according to
a letter from the firm to one of White's assistants, a Mr. Sudlow: "For the
portieres of the Library, the material will have to be made to match the

curtains and walls, and this material cannot be found in stock any where. We would be greatly obliged to get an early reply as we have to count on two or three months to have any material made."[45]

James Finn was called in to execute the decorative painting on the library ceiling. In February 1903, Finn had presented an estimate for his work that included the gilding of the cornice, the "painting of all ornamental panels and a border . . . , water color gilding in goldleaf and burnish, and finishing same in antique patina [for] ceiling, cornice [and] frieze."[46] But White did not receive word until late March 1905 that "Mr. Finn came down today with his men to start his work" on the library.[47] By then, Katherine Mackay had had all she could take of workers constantly under foot, and she issued an ultimatum, as Sudlow informed White: "Mrs. Mackay gives us until Thursday to have everybody out of the [library], including Mr. Finn's men. . . . The men Mr. Finn now has here, working all day Saturday and Sunday, could, with the addition of six more men, finish on time; therefore, it will be necessary to get six more men at once."[48]

KATHERINE AND CLARENCE MACKAY'S SUITES

Katherine's and Clarence's suites were on the second floor. Katherine's suite was the creation of Allard and Sons, whose contract specified that all work would be done according to White's sketches, in the style of Louis XV. The woodwork would be of French walnut, and "all the ornamentation [was to be] carved and lightly gilt with gold powder." All the doors were to be faced with French mirrors, and the wall panels contained "heliotrope moire silk as per sample accepted." The overdoors in every room were to be decorated with "pretty motives [*sic*] taken from 'Boucher,' representing cupids. These paintings to be treated in natural or very light colors." All the hardware was to be of Louis XV design, produced in France, and finished in gilt bronze. The ceiling and cornice would be decorated in a composite material, with the ornamentation to correspond with the style of the room and treated in light cream colors with a little gilding, "as the small apartments in the Palace of Fontainebleau are treated." The mantel of the boudoir was to be of "Breche Violette marble, carved as shown on the drawing," and that of the bedroom would be made from cipolino marble, also with "ornamentation as shown on the drawing."[49]

Clarence Mackay's suite was more modest, consisting of a bedroom, bathroom, and study. From the study, one could step out onto a small balcony that overlooked the main hall.

THE MAIN HALL: MEDIEVAL ARMOR, MOOSE HEADS, AND BANNERS

What Clarence Mackay saw as he stood on the study balcony and looked down on the main hall was truly impressive, for amid the colorful flags and numerous moose heads was probably the finest private collection of medieval and Renaissance armor in the United States (see figure 44). As I have shown, Clarence Mackay took a personal interest in this grand chamber and in January 1903 wrote to White to say, "I approve of the general scheme of the hall, as set forth in your memorandums, and in your colored drawing of the hall itself."[50]

A number of moose heads were interspersed among the banners in the manner of a grand European hunting lodge, placed there at Stanford White's suggestion. In November 1902, Mackay wrote to White, expressing his growing concern about the escalating costs of the house, specifically regarding the cost of the moose heads: "I know that this is a very small matter to you, and that you do not like to burden yourself with too many figures, but I look upon it in an entirely different aspect. . . . De Lancey, at Gunther's . . . states that the price [of the moose heads] he mentioned to you was $3500."[51] Nevertheless, in his letter of 2 January 1903 Mackay told his architect that "the moose heads have been bought," but he then added that "the rest of the description of proposed furniture is open until we hear from the other side," by which he meant Europe. An undated memorandum in the Mackay files informed White that "Mr. Delancy says he can start at any moment you say to put the Moose heads up."[52]

Although Allard's and Davenport's crafted most of the furniture for the rest of the mansion, the furnishings for the main hall were acquired mostly from European sources. There were, for example, the late medieval choir stalls. Stanford White had come upon these carved wooden stalls while traveling about Europe, but their end pieces had to be replaced, because they either were missing or had deteriorated. In December 1902, William Baumgarten notified White that "we have today received a cable from Europe, reporting that the four new ends for the stalls, to be made like the old ones, of old wood and of the same artistic quality, will cost delivered here $800 for each piece."[53] By August 1903, Baumgarten had received the end pieces from Europe and would put them together with the old work as soon as he received instructions from White about their assembly. When completed, the former stalls became seating areas amid the armor collection.

The Mackay Collection of Armor

By December 1902, Clarence Mackay had decided that he wanted to fill his main hall with arms and armor as well as moose heads and banners. Stanford White presented him with a plan to do so, and Mackay replied, "As to your distribution of armor for the hall itself, it certainly sounds very well on paper."[54] White proposed that he contact, among others, Arthur Acton, his agent in Florence, and F. Schutz in Paris, for both armor and furniture for that area. From Schutz came the following reply:

> I don't possess any old flags at the present time. This article is very rare and we find some pieces from time to time and I have been told they are paid very dear. I wrote lately to my commercial friends abroad if they had some flags and armor; if they offer me anything of that sort I will give you the description and prices. . . . For the armor I know very fine series about 12 pieces, each one making a large panel in red velvet with an armor in the middle. Formerly I wanted to buy them but the owner did not wish to sell any of them, perhaps it would be different and to be able to afford with him. I am writing him if he want to sell them. I will send you details and photo if possible.[55]

The following month, Mackay replied to a letter from White, saying, "In answer to yours of the 16th, enclosing my letters which you propose sending to Acton and Schutz, I wish to say that after looking over them carefully, I think you have covered the ground very thoroughly."[56] By then, White had formulated the plan of sending Acton on a kind of grand tour to scout out antiquities on Mackay's behalf, to which Mackay agreed. Acton lost no time, and on 20 February 1903 he notified White that he was leaving Florence the following day for Palermo, to begin his trip. He began in Naples and then went on to Palermo, Barcelona, Marseilles, Madrid, Seville, Paris, Turin, Vienna, Munich, Dresden, Berlin, and London, his expenses paid with an advance provided by Clarence Mackay. Acton was looking primarily for medieval and early Renaissance armor, but he searched out other furnishings as well, contacting White at regular intervals to alert him about items as they came on the market. From London, for example, he cabled White: "Three complete suits [of armor at] Christies, going tomorrow, two at two hundred, one at four hundred pounds."[57] From London, he cabled Duveen Brothers: "Nine demi suits

with helmets entirely genuine, will cost us about two thousand pounds and advise White strongly to buy."[58] When the trip was over, Acton provided White with an itemized list of what he had found. Here is an abbreviated version:

> *Naples* 1 Doorway travertine stone, good period 15th century.
>
> *Palermo* Collection of armour as per photographs.
>
> *Marseilles* Pastel portrait Louis XV
>
> 7 Decorative panels by Boucher, complete set for a room . . .
> French Renaissance cabinet, large
>
> *Barcelona* large collection of Church vestments, gold embroideries, Byzantine crosses rock crystal.
>
> *Retiro* Important tapestries, wood carvings, paintings, chairs in a condition that one seldom sees and unrestored but could not tell me of any armour in Spain for sale.
>
> *Emil Pares* 1 large Ren[aissance] altar frame . . . 16th cent., would do to make into a small doorway or overmantel.
>
> *Nicolas Garmon* 1 Blue and silvered embroidered banner.
>
> Alberto Gonzalez: 2 complete suits [of armor], 2 half suits fluted and two or more trophies of swords, spears, maces, etc., two handed swords, 6 helmets and a silk banner.
>
> *Paris* Bachereau. About ten suits varying from three to ten thousand francs and some chalpreins. 1 suit partly new. 1 half suit Pisan. 1 Banner. 1 two handed sword.
>
> *Paris* Heilbronner. 1 fine marble pedestal, Ren. suitable for base of a standard.
>
> *Florence* Galli Dunn. 3 full suits of plain armor. 2 Two handed swords.
>
> Egger. Took me to see a private collection of which 2 Maltese suits were for sale, poor and heavy but there were other extraordinarily fine pieces, shields, suits that could be bought if it came to actual business.
>
> *London* Fenton, Oxford Street. 1 suit horse armour. Maximilian.
>
> *Dresden* Louis Martin. Says he will look for horse armour. 1 Fine lance and banner. 1 Helmet gold damascene. 1 life size horse [armor] of the Historisches museum.[59]

Which, if any, of these pieces were actually purchased for the main hall at Harbor Hill is difficult to say, but Mackay did form a sizable collection of arms and armor in a very brief period.

In order to assist his patron in forming that collection, White had first to inform himself. To this end, a letter to the architect from Scribner's attests: "We send you herewith a copy of [Charles] Boutell's Arms and Armor [in *Antiquity and the Middle Ages* (New York, 1870)], as [you] ordered. . . . We will be pleased to import the other two books, namely, 'Les Arms [Paris, 1890] par G. R. Maurice Maindron' and 'Ancient Armor and Weapons in Europe' by John Hewitt, London [1860]. . . . We send you herewith a circular of an important new work on armor, which we think will prove of interest to you."[60]

White also conferred with whatever armor experts he could find. One such person was Rutherford Stuyvesant, the curator of the arms and armor collection at the Metropolitan Museum of Art. Stuyvesant sent White an interesting letter in reply: "In regard to armor, it is very hard to find and the only dealer I know is Bachereau [of] Paris. . . . He has quite a large collection of arms and armor—some of it quite good, but his prices are high. The duc de Dino collection is for sale, but only as a whole. It is the best private collection in existence, and too good to be used for decorative purposes. Mr. Fernand Robert, of . . . Paris, can give you full particulars of this collection. I have the illustrated catalogue, [and] . . . I am very anxious for the Museum to buy this collection."[61] Acton did in fact visit the Paris dealer M. V. Bachereau. The famous collection of the duc de Dino-Perigord was the hottest item in the arms and armor market of that day, and it was purchased, as Rutherford Stuyvesant had wished, in 1904 for the Metropolitan Museum of Art, creating the basis of its collection in the Arms and Armor Court. A few years later, that institution bought from Bachereau the famous armor for man and horse, mounted—from the period of Louis XIII—that became the centerpiece of the Met's Arms and Armor Court, to which Clarence Mackay gave four of his large tapestries on extended loan.[62] White had numerous friends and dealers on the lookout for things for Mackay's great hall of armor. Samuel P. Avery, an art dealer in New York City, had once been charged with the sale of a pair of swords that belonged to an ailing English widow who was eager to dispose of them. He sent them to Stanford White, who promptly brought them to Clarence Mackay's attention. Mackay replied: "Yours received with swords. I like them very much and I authorize you to offer to buy them for $55. apiece. . . . Let me know if Avery has accepted your offer."[63] Avery did accept the offer.

In the end, Mackay's arms and armor collection was not only large but also of impressive quality. His earliest piece was a ninth–century

FIGURE 48. Suit of armor of George Clifford, English, late sixteenth century. This suit of engraved steel, once part of the Clarence Mackay collection, belonged to George Clifford (1558–1605), third earl of Cumberland, a peer who sat as judge of Mary, Queen of Scots. Mackay also acquired the dress harness of Anne de Montmorency (1493–1567), a constable of France who fought under five kings, and another suit that belonged to Henry Herbert (1534–1601), second earl of Pembroke and a nephew of Catherine Parr. At the turn of the twentieth century, competition for suits of armor such as this was very keen, and some European dealers, such as M. V. Bachereau of Paris, specialized in armories. (The Metropolitan Museum of Art, Munsey Fund, 1932 [32.130.6])

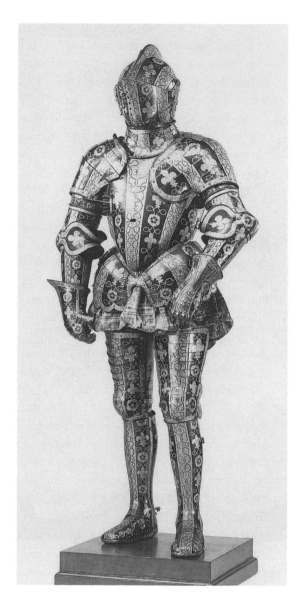

Merovingian helmet, but he had nearly a dozen full suits of armor, dating to "the days when France, Italy and Germany nurtured an armor industry that was a fine art" (figure 48).[64]

THE MACKAY COLLECTION OF PAINTINGS AND SCULPTURES

Clarence Mackay formed the art collection at Harbor Hill, for Katherine took little interest in such things. Clarence had not only the interest but also a fine eye for quality and the money with which to acquire major pieces. An art critic observed that Mackay's was "one of the most distinguished art collections ever formed in America."[65] No less a personage than Edward, duke of Windsor, recalled being a guest at Harbor Hill: "I spent the day going through the place, marvelling at all it contained. The art treasures alone would have sufficed the needs of an ordinary museum, and I particularly remember a vast hall lined with figures in armor that had been obtained from various old European collections."[66] The art dealer Germain Seligman observed that the Renaissance paintings were of "superlative quality, the sculptures and bronzes were equally fine, his Gothic tapestries were famous, and his arms and armor collection was renowned for its size and beauty."[67] The art collection as a whole was of European, not American, art, for as a rule the millionaires of Mackay's generation turned away from contemporary native talent to collect Old Masters from England and the Continent.

Because Mackay's collection of paintings and sculptures was formed more with the assistance of Joseph Duveen than that of Stanford White, I will only summarize it here to provide an idea of the richness of the interiors at their prime. Mackay owned a Duccio, *The Calling of Saints Peter and Andrew* (now in the National Gallery of Art in Washington, D.C.), and eight panels from an altarpiece (1437–1444) by Sassetta, originally from the church of San Francesco in Borgo San Sepolcro and now in the National Gallery in London. He also owned a portrait of a lady attributed by Bernard Berenson to Pisanello and a magnificent *Adoration of the Shepherds* by Andrea Mantegna (figure 49) that the Metropolitan Museum of Art bought from the Mackay estate.

Stanford White did assist his clients in the acquisition of fine paintings, at least to some degree, according to a letter from Louis Ehrich of Ehrich Galleries, in New York, to the architectural firm a few months after White's death: "When I was in Italy this summer, I met so many dealers of pictures and antiquities who had put aside art treasures for the inspection of Mr. Stanford White that I was forced to realize how great an in-

FIGURE 49. Andrea Mantegna, *Adoration of the Shepherds,* 1495–1505. In addition to *Adoration of the Shepherds*—a tempera and gold painting (21⅞ × 15¾ inches [55.6 × 40 cm]) transferred from wood to canvas—the Mackay Collection contained a portrait of a young man by Botticelli and Giovanni Bellini's *St. Jerome Reading,* both of which are now in the National Gallery of Art in Washington, D.C. Perhaps the greatest treasure of all among Mackay's paintings was Raphael's *Agony in the Garden* (ca. 1505), now in the Metropolitan Museum of Art. (The Metropolitan Museum of Art, Anonymous gift, 1932 [32.130.2])

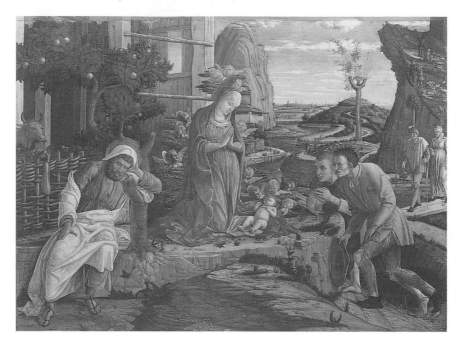

fluence he must have had on the art-acquisitions of our people." Ehrich then went on to say, "At my last public sale, Mr. White purchased seven of my paintings."[68] That Ehrich's letter ended up in the Mackay files of the McKim, Mead & White Papers suggests that White had some role in the formation of the collection.

The sculpture collection presented a brilliant survey of Italian Renaissance artistry. It included a bust of the youthful St. John the Baptist by Donatello, and Desiderio de Settignano was represented by a bust of a lady from Florence. The connoisseur W. R. Valentiner acclaimed a marble bust of the Madonna by Mino da Fiesole as "one of the most enchanting productions of the early Renaissance."[69] The terra-cotta bust of a man of the Ginori family by Benedetto da Maiano was formerly in the renowned Liechtenstein Collection, and Verrocchio's bust of Lorenzo de Medici at Harbor Hill was probably a later version of those now in the Louvre and in the Isabella Stewart Gardner Museum in Boston.

As Clarence Mackay began to have financial troubles in the 1920s and 1930s, such notable connoisseurs as Samuel Kress and Andrew Mellon bought pieces from his collection. Many items ended up in prestigious

collections, among them the National Gallery in London, the National Gallery of Art in Washington, D.C., and the Metropolitan Museum of Art in New York, surely a testament to their quality and authenticity.

MISCELLANEOUS NOTES ON THE FURNISHINGS AT HARBOR HILL

The boxes relating to the Mackays in the McKim, Mead & White Papers at the New-York Historical Society abound in references to furniture and furnishings designated for Harbor Hill but often do not identify the specific room. Still, these references present a fuller picture of Stanford White's involvement in the project and his dealings with both his patrons and the various dealers. Clarence Mackay had a splendid collection of tapestries, and he called on White for advice in their acquisition. "Here is a letter which explains itself," he wrote White. "You might go and look at the tapestry, and let me know what you think."[70] An accounting list for the Mackay residence reveals that White bought $11,100 worth of tapestries in Paris on his client's behalf, and Duveen Brothers of New York was sometimes involved in their acquisition as well.

Someone at John T. Keresey & Company, "Importers of Oriental Rugs and Embroideries," of 35 East Twentieth Street in New York, wrote to Mackay in the fall of 1902 to call his attention to an especially beautiful sixteenth-century Persian carpet that measured 12 by 22 feet, acquired on Keresey's most recent trip to the Near East: "We are quite sure that it is the only rug of this period outside of a private or museum collection in this country or Europe . . . and we have the Persian Minister's declaration at Constantinople of its authenticity. At your leisure, it would give us great pleasure to show you this piece."[71] On 21 October 1902, Mackay wrote to White seeking his advice about Keresey: "Who is he, and is he any good?"[72]

Mantels were of special importance in the business of decorating fine interiors, for a mantel often was the focal point of a room and even in summer remained its decorative centerpiece. Antique examples were especially desirable, and White obtained them from many sources. Stefano Bardini in Florence seems to have had an endless supply of such things. "Sending photographs [of] mantels, doors, ceilings. How many ceilings wanted?" he once cabled from Italy.[73] At about this time, Mackay sent White a note that said, "In regard to the mantel, you can find out from Bardini what he wants for it."[74] Sometime later Bardini cabled White: "Mantel engaged by [George] Gould, 5 Washington Square. Ask him permission. Will send immediately."[75]

Jacques Seligmann in Paris, too, frequently offered White choice antique mantels, but Mackay was always concerned about their cost: "Enclosed please find photographs of mantelpiece. . . . I should like to hear further from Seligman[n] as regards the last price that he will take for same, as I will tell you right here that I would not think of paying such an absurd price as 100,000 francs for any mantelpiece."[76] A few months later, Seligmann wrote to White again about mantels, and his letter is revealing about how business was then being done:

> I saw the chimney pieces today, and they are so undoubtedly old and genuine that I undertake to guarantee [them]. . . . I am sending a photographer to the castle today. . . . I want to remind you of the conversation we had in New York. I told you I would give you the exact price asked for by the proprietor of the chimney pieces, to which you would have to add 10% commission for the agent, and that we would buy them joint account. If Mr. Clarence Mackay does not want one or the other you may be sure we will sell them to somebody else, as they are harder to purchase than to sell. You can't imagine how beautiful the large chimney piece is, and then there is the whole pedigree with it. I am having also the ceilings photographed and will send them to you. Do you think of coming over to Europe? I hope so, then I can take you to the castle.[77]

A letter from Seligmann to White two months later shows the keen competition for the really fine antique fireplaces: "I . . . beg to tell you that since Mr. [George] Vanderbilt has bought the chimney [for his estate, Biltmore], prices have gone up, as you know. . . . I hope to see you in Paris this summer, and to be able to show you some very fine things I have just bought."[78]

Among the McKim, Mead & White Papers is an undated typescript titled "Final Balance due on [Mackay] House." One item listed therein again reminds us that Stanford White was himself active as a buyer of antiquities, which he would then sell at a profit to his clients. The document notes that White was paid $600 for the balance owed him on a mantel and $8,200 for the balance on "stone statues," presumably of the "garden statue" type.[79]

Another undated typescript, "File Mackay House," refers to the collection of Asian ceramics and other small objects that adorned the rooms at

Harbor Hill. It mentions twenty-eight items in all, but I will quote only a few of them here to give an idea of the sumptuousness of the rooms:

1. Two bowls of Chinese blue and white porcelain, dragons inside, figures outside.
2. Small vase of Chinese blue and white porcelain; short neck. Chrysanthemum flowers.
5. Small jar of Chinese porcelain. Hawthorn decoration in blue and white. Kang-hsi. specimen.
21. Two carved ivory boxes. Chinese porcelain. Eight sided.
23. Ivory bowl with ivory cover. Chinese. A unique piece.
24. Small snuff bottles of Chinese porcelain.

Although one room or another might be referred to as a "Louis XV" room, variety prevailed throughout the great mansion: Oriental carpets were overlaid with polar bear skins; rooms featured Renaissance paintings and bronzes but also Chinese blue and white ceramics; the furniture was both old and new; and that new wonder, electric lighting, made to fit into an early French Renaissance–style candelabra, illuminated tapestries and arms and armor. In their eclectic tastes, Clarence and Katherine Mackay were following a pattern set for them by Stanford White, and eclecticism was, to be sure, the taste that guided the decoration of most great mansions of that era.

THE LATER HISTORY OF HARBOR HILL

Clarence Mackay was Catholic, Katherine was Episcopalian, and their marriage was a stormy one that deteriorated until Katherine packed up and moved to Paris in 1913, leaving their three children—and the château at Harbor Hill—with Clarence. A year later, she divorced him to marry a noted New York surgeon, Dr. Joseph A. Blake. She eventually divorced him, too, and lived in a New York town house on East Eight-seventh Street until she died of cancer in 1930.

Clarence Mackay continued to live at Harbor Hill, although the place came to be known as "Heartbreak House," in part because of the divorce and in part because one daughter, Ellin, married the songwriter Irving Berlin, much against the wishes of her family. She was promptly removed from the Social Register. The stock-market crash of 1929 punished Mackay severely, and he commenced selling some major works in his collection. It even became necessary, for economy, to close the great house in Roslyn

for most of the 1930s, although Clarence and his new wife, the opera singer Anna Case, did entertain there occasionally. Clarence died in 1938.

The executors of Mackay's estate put Germain Seligman in charge of selling such objets d'art as remained in the house. In his reminiscences, the dealer observed that by then "the once popular and expensive Renaissance and 18th century decorative arts, the tapestries, the arms and armor had lost their appeal to the buying public."[80] Some sales were conducted in London, some at Seligman's gallery, but some were held at Gimbel's Department Store in New York City, where middle-class buyers outnumbered the millionaires by far and one of Mackay's prized eighteenth-century swords sold for $1.95.

During World War II, the United States government used the estate as a radar station, but after 1945 it was again unoccupied—a type of dwelling that had been glorious in its day but that nobody in postwar America wanted. A real-estate developer from Manhattan bought the property in 1954, tore down the mansion, and partitioned the 600 acres of park- and woodlands into little parcels containing two- and three-bedroom houses. Only McKim, Mead & White's gatehouse survives, along with the Episcopal church that Katherine Duer Mackay had built as a memorial to her parents.

 Six

*F*ROM THE POOR HOUSE TO THE WHITE HOUSE: GRAMERCY PARK, HENRY POOR, AND STANFORD WHITE

GRAMERCY PARK, WHERE LEXINGTON AVENUE BEGINS AT TWENTY-FIRST Street, is a delightful green square rimmed by brownstones. Its origins go back to 1831, when an enterprising landowner drained swampland and marked out sixty-six plots surrounding what then became and has remained a private park for the residents. By the 1840s, Alexander Jackson Davis had built a pair of row houses on the west side, while on the south side are the National Arts Club, once the home of Samuel J. Tilden, and the Players Club, which Stanford White redecorated in 1888 for the actor Edwin Booth. On the northeast corner of Lexington and Twenty-first was the home of Henry Poor, and on the opposite corner, at 121 East Twenty-first Street, was the house of Bessie and Stanford White (figures 50 and 55). Gramercy Park was, according to Elsie de Wolfe, "a spot hallowed in history, closed in from the outside world, and where the oldest and most interesting American families had their houses."[1]

Stanford White and Henry Poor were brought together under many circumstances: White decorated the interior of Poor's house, allowed Poor to display hundreds of items from White's personal collection in that house, and owed Poor a large sum of money. They were also carousing buddies; for example, they and James Breese organized the infamous "Pie Girl Dinner," an all-male gathering of friends who were entertained after

FIGURE 50. Henry Poor residence, 1 Lexington Avenue, interiors by Stanford White, 1899–1901. Henry Poor's house was across the street from Stanford White's residence, and both houses overlooked Gramercy Park. When originally built, Poor's residence had been two separate houses, which White turned into one grand mansion. (Collection of The New-York Historical Society)

the meal by a host of pretty giggling young women who cascaded out of a large pie.[2] White and Poor frequently went about town together—to cabarets, parties, secret hideaways, and the like—in an enjoyable debauchery of bachelor life, although both men were happily married.

Henry Poor (1844–1915), a financier and broker with offices on Wall Street, bought two adjoining town houses on Gramercy Park North that Stanford White began to transform into one large mansion in 1899. The *New York Times* reported that "the art treasures of the two houses were especially valuable, and had been collected for Mr. Poor by the late Stanford White, who had been commissioned to search Europe for them."[3]

A triangular camaraderie existed among White, Poor, and Charles Coleman, White's agent in Capri and Naples. In October 1900, Coleman concluded a letter to White by saying, "Give my love to Henry. . . . I hope the dear boy is well." In that letter, Coleman urged White "to put me in the way of going to Spain on your account, or that of any of your clients for the purchase of tapestries, velvets, brocades or furniture. . . . Friend Henry and one or two others might find it worth their while."[4] Although the trip to Spain never worked out, Coleman continued to look for and purchase items for Poor's newly renovated interiors; Coleman once informed White that he was bargaining "for you and Poor" for several large ancient terra-cotta amphorae that had been found at Bosconati, and in the next letter Coleman told the architect that he had bought them and was having them shipped to New York.[5]

HENRY POOR'S ENTRANCE HALL, DRAWING ROOM, AND DINING ROOM

The splendor of Henry Poor's residence was evident from the entrance hall on the first floor. The Italian Renaissance ceiling, taken from an Umbrian palazzo, was ornamented with twelve panels depicting the divinities of Mount Olympus; its decorative parts were painted in subdued tones of violet, gray, dusky red, and orange. The antique carved stone mantel and overmantel were "highly elaborated . . . with [their] ornament of mascarons [grotesque masks] and cherubs, birds, and fruits in high relief."[6] White incorporated four Italian carved stone columns into the architectural decorations, and a pair of Italian marble-topped tables added to the adornment of the hall. The reception room was done in off-white with elaborate decorative painting on the walls (figure 51).

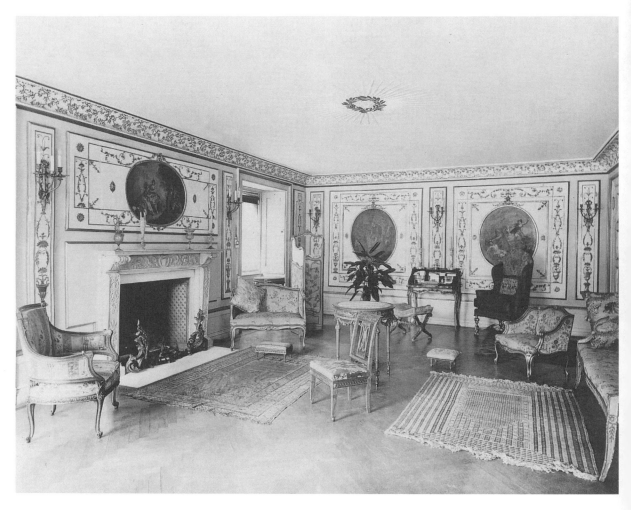

FIGURE 51. Stanford White, reception room, 1 Lexington Avenue, 1900–1901. White chose an eighteenth-century French motif for the decoration and furnishing of the reception room. This was about as close to a "period room" reconstruction as White ever designed, for his eclectic spirit rebelled at any academic restraints on his creation of interiors. (Collection of The New-York Historical Society)

Early in 1901, Stefano Bardini wrote to White from Florence, enclosing a bill for "one Renaissance doorway," which may be the one in figure 52, marking a grand entrance to Poor's drawing room.[7] This doorway set the style of much of the decor of the salon. One of the most curious pieces in the room was an antique Roman altar known as the "Tabernacle of San Stefano in Fiano," a conversation piece of the late twelfth to the mid-thirteenth century. It was 13 feet high, with four marble columns supporting a marble entablature, and it was decorated with porphyry mosaics. The fireplace had a carved mantel ornamented with a pair of kneeling Italian altar angels (figure 53). Colorful beams enclosed the fifteen panels of the Italian Renaissance ceiling, and each panel was decoratively painted. The room was furnished with a large antique Italian walnut table, gilded, with cherubs carved on the end supports. Two large antique Italian armchairs were gilded and upholstered in Renaissance tapestry. An Italian Renaissance settee—carved and gilded, of course, and upholstered in crimson silk—was joined by four old Spanish high-back chairs bearing a carved coat of arms and motto. The seats also were covered in crimson damask.

The dining room (figure 54) also had an Italian Renaissance marble doorway, heavily carved with cherubs in relief holding a shield that supported a crown with an angel's head. The mantel in this room was marble and of Italian artistry, and an Italian marble tabernacle, with enamel and mosaic decoration, was set within the bay window, where it was surrounded by large plants. The walls were paneled, in new work, and a large Oriental carpet covered the floor. The walnut sideboard was Bolognese and had been acquired by White in Europe.

White's practice of buying treasures on speculation and reselling them to clients, thereby turning a nice profit, nearly became a problem in connection with his work on the Henry Poor house. A disgruntled employee of McKim, Mead & White once spread the story that White had cabled Poor from Venice to tell him that he had a chance to buy, at a certain price, a beautiful ceiling out of a palazzo that would be perfect for the Renaissance library that White was developing in Poor's house. Poor agreed, and sometime thereafter the ceiling was delivered to 1 Lexington Avenue. But, the rumor went, White had actually purchased the ceiling years earlier, stored it in his warehouse all the while, and sold it to his friend at many times what it had cost him. The story was never substantiated, and the archives reflect no hint of ill feeling from Poor toward White; even if the story was true, that was something White did regularly, and his practice of doing so was well known among his clients.

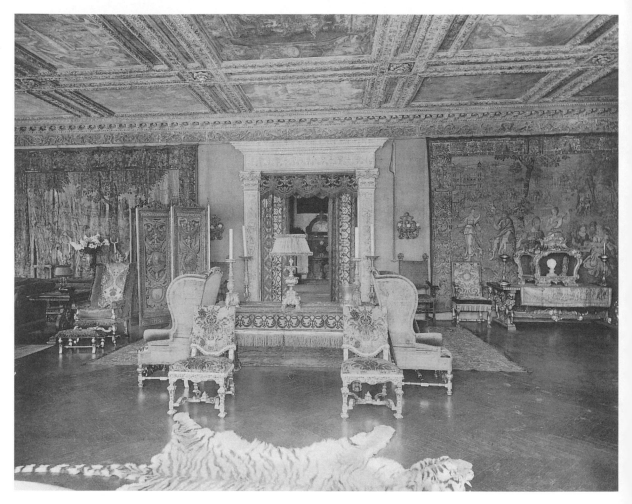

FIGURE 52. Stanford White, drawing room, 1 Lexington Avenue, 1900–1901. Poor had a large collection of exceptionally fine tapestries that White had procured for him; two adorned the walls of the drawing room. At a time when many members of the European nobility were discarding tapestries as old-fashioned, Americans were eager to acquire them because they contributed to the Old World cultural ambience that they desired. The bronze, soft red, and gray coffered ceiling was of Italian Renaissance vintage, while a sixteenth-century Ispahan carpet of pale red and dark blue was laid on the floor. Elsewhere, a sprawling tiger skin rug covered the floor. Opening off the drawing room was a large glazed conservatory-type porch that served as a winter garden. (Collection of The New-York Historical Society)

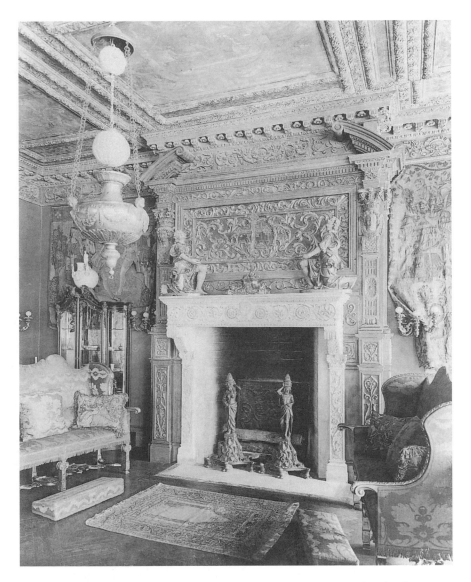

FIGURE 53. Fireplace, Italian. To warm an area as large as the drawing room, White placed an ornate Italian Renaissance fireplace at each end. In the one seen here, the kneeling angels on the mantel are Italian or Spanish, of the eighteenth century. Between them is a small bronze crucifix. The religious nature of many items that White used in his interiors was acceptable to his patrons because the interiors of the palazzos or châteaux of the Italian, French, or Spanish nobility would have displayed objects connected with Roman Catholicism, and that made them desirable to Americans such as Henry Poor, whether or not they were Catholic. Those items had become transformed from religious objects of spiritual veneration to cultural objects of purely social and aesthetic meaning. In earlier Protestant American homes, the Bible was often the only religious object to be seen. (Collection of The New-York Historical Society)

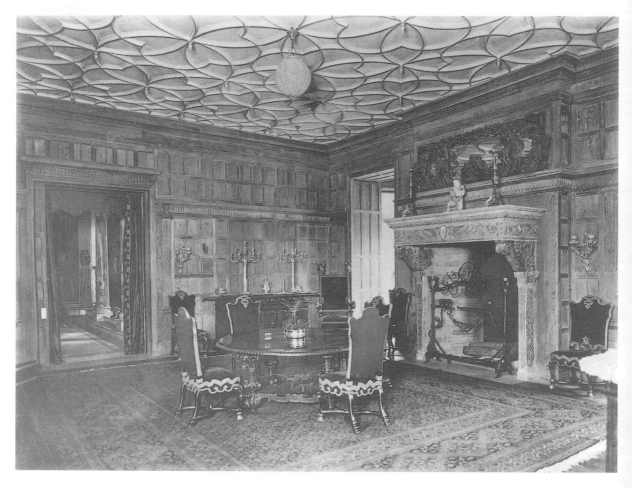

FIGURE 54. Stanford White, dining room, 1 Lexington Avenue, ca. 1900–1901. Poor's dining room provides an example of how White took one major antique item and developed the whole room around it. In this case, the ancient fireplace set the mode for the room, and then Allard and Son's craftsmen created the paneled walls in imitation of late-sixteenth-century English work; the ceiling, too, was modern, not ancient, but the final effect was one of antiquity. (Collection of The New-York Historical Society)

Although they often complained that he was spending too much of their money on their houses, not one ever raised a question of unethical practice or of price-gouging.

Indeed, when White sent Poor the final bills for the remodeling and redecorating of his house, the financier wrote to his architect-friend to express his appreciation for his services: "I am more moved than I can tell you at the further evidence of your kindness in the limitation of charges, for I had not expected it," and he then went on to say that he was grateful for White's personal interest and incessant attention to the work, confiding that "there remains a debt of gratitude and affection that I never can discharge." The letter continued: "Any excess of cost over the original estimates amounts to nothing in view of the result obtained. . . . I am enraptured, as you know, and feel that we have the most beautiful house in the world; and, charming as it is to live in, the greatest delight that [my wife] Constance and I feel in it, is that it embodies so much of your own personality and charm, and it will be a perpetual reminder to us of the many happy hours you have spent with us during its construction."[8]

THE STANFORD WHITE HOUSE

The Whites had been renting the second house in from the northwest corner of Lexington Avenue and Twenty-first Street. Henry A. C. Taylor had lived in the corner house until McKim, Mead & White designed a finer one for him farther uptown, and in 1898 the Whites persuaded him to rent them number 121 (figure 55). White began redecorating immediately, while Bessie and their son, Larry, lived at their Long Island estate, Box Hill. Like that of Henry Poor's house, the exterior of White's house was not of a particularly distinguished design—it was not, for example, of the distinctive character of the Petit Château, which Richard Morris Hunt had created for the William K. Vanderbilts at Fifth Avenue and Fifty-second Street about 1880. The glory of the White residence was its interior, which suggests that White, in this case anyway, was content to express himself through interior decor rather than exterior elevation design.

The lower level contained the entrance hall and reception room. The second, or main, floor had four large rooms that were laid out en suite, with wide central doorways providing a view from one end of the house to the other (figure 56). The front room facing the park was the drawing room; next came the main hall with staircases to the floors below and above, followed by the dining room and, finally, the music room. The

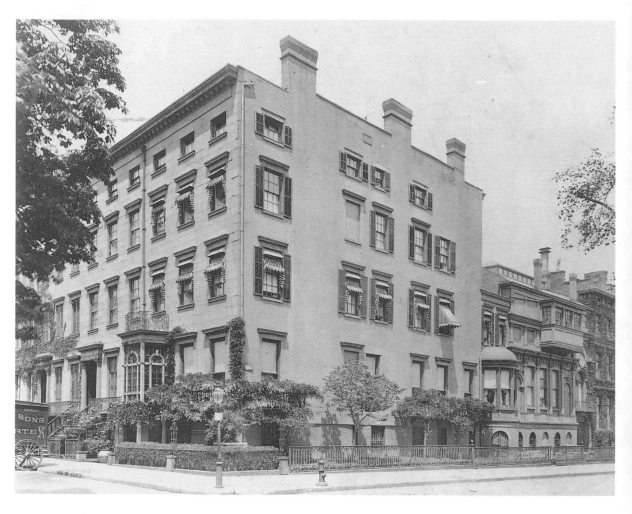

FIGURE 55. Stanford White residence, 121 East Twenty-first Street, interiors by Stanford White. Stanford White's house had a frontage of 32 feet facing Gramercy Park and ran to a depth of 131 feet on Lexington Avenue, with the entrance on Twenty-first Street. On the lower floor was an entrance vestibule and a reception room, beyond which were the servants' hall, kitchen, and laundry. (Collection of The New-York Historical Society)

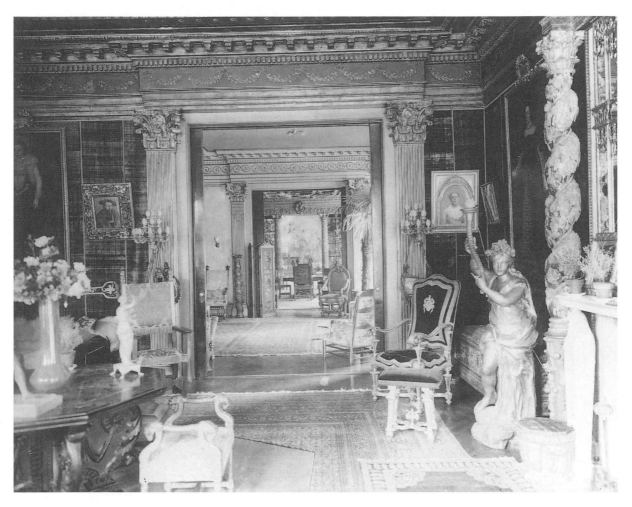

FIGURE 56. Stanford White, en suite view of the second floor, 121 East Twenty-first Street, ca. 1900. In his remodeling of the four rooms of the second floor, White arranged large doorways to create a feeling of spaciousness and openness from one end of the house to the other. The Whites entertained often and generously, and this suite of rooms was a showcase for Stan's ideas about interior decoration; in a sense, these rooms reflect his aesthetic credo in its purest form of execution. (Collection of The New-York Historical Society)

third floor contained the Green Room—White's study—at the front, and Stanford's and Bessie's bedrooms. The main feature of the third story was the large art gallery at the back, above the music room. In the arrangement that White devised, almost every room was lighted by windows along the Twenty-first Street and Lexington Avenue sides, and the art gallery received illumination during the day from a skylight. The servants' rooms were on the top floor, and a stable stood just behind the building.

Margaret Terry Chanler, of the Astor family—whose daughter Laura married the Whites' son Lawrence—recalled many years later that the interiors were "full of beautiful and interesting things collected in many lands: pictures, statues, tapestries, old furniture, rich spoils of the past. There was much old Italian gilded carving on twisted columns, and elaborate picture frames. Stanford White was the initiator of the fashion for antique furniture that has since run its course."[9] His house was, in fact, a kind of warehouse from which friends and clients might select items for their own interiors.

Allard and Sons executed much of the remodeling in White's house, working from his designs. At one point, White complained to Allard's manager that his artisans, who were working on one of the old Italian ceilings, had taken the finish down to the bare surface, making it look like a new ceiling, which was exactly what White did not want. But a faux pas of that sort was unusual for Allard's skilled craftsmen.

Surviving photographs of the rooms in his house show that White's style of decorating possessed a certain clutter component. Because White was furnishing his own rooms, he presumably did them in a manner that explicated his own theory of interior decoration in its purest mode. Here he was unhampered by the imposing will of a patron—a Katherine Mackay or a Tessie Oelrichs, for example—and Bessie went along with whatever Stan wanted to do. These rooms represent unadulterated Stanford White, the pack-rat collector of masterpieces and bric-a-brac, which he delighted in displaying side by side. Although his clients frequently left aesthetic decisions up to him, his residence at 121 East Twenty-first Street was his best opportunity to do it his way.

THE ENTRANCE HALL AND THE RECEPTION ROOM

The entrance to the house was set between two sets of columns and a pair of bronzed iron gates. Eight green marble columns framed the entrance hall, and between them stood four marble sarcophagi of Roman vintage. An Italian Renaissance carved stone fireplace occupied the center of the

Lexington Avenue wall, while one of White's many fine tapestries—a millefleur—hung on the opposite wall, and an antique Greek altar was but one of several focal points in the room. The inventory for the entrance hall reads like an invoice prepared by Stefano Bardini or Raoul Heilbronner following one of White's visits to his establishment.[10]

The reception room, also on the first level, had a white marble mantelpiece with brass accessories. On the floor was an "India Rug," and a "hawking" tapestry was displayed on one wall. Two old marriage chests, probably Italian, added color; four "leopard & wildcat" skins contributed an exotic note. Three round Empire mirrors reflected the colors of four blue Italian vases and a blue Dutch flower vase, and a Mexican vase stood on its own stand. A painting by White's friend Thomas Dewing was set within a gilded frame that was probably designed by White himself.

Access to the second, or main, floor was by a stairway leading off the reception room. The antique Italian newel posts on the lower level were extraordinary, with carvings of rampant lions clutching cornucopia, supported by a base carved with cherubim. The railing was of gilded wrought iron, and the steps were covered with an Axminster carpet. A red velvet embroidered hanging decorated the stairway wall.

THE DRAWING ROOM

The ceiling of the drawing room (figure 57 and plate 5), of ancient Italian origin, was probably one of several that White had purchased from Stefano Bardini of Florence. Within its boldly three-dimensional gilded enframements it had "a large central painted panel [representing] 'Angels Bringing Tidings of Christ's Birth,' within a circular frame. On the outside are four shields and four painted female heads, and this is incased in a square red and gold frame; beyond are eight painted panels of Biblical subjects."[11] The walls of the room were of a brilliant cardinal-red antique Genoese velvet, the seams of which were concealed by a dull gold galloon. The fabric "showed its antiquity in its threadbare effect, but it is a rare commodity, and it was estimated there were 114 yards of it on the walls."[12] The bay window that jutted toward Twenty-first Street, overlooking Gramercy Park, had an antique Italian domed ceiling.

An elaborate cornice, gilded and decorated with swags in the frieze, was supported visually by pilasters with fantastic Corinthian capitals, also gilded. Against the east wall of the drawing room was a marble fireplace ornamented with caryatids, and above the mantel was a mirror with an ornate gilded grille applied to it. The whole was enframed with a pair of twisted, carved, and gilded columns and a broken pediment above.

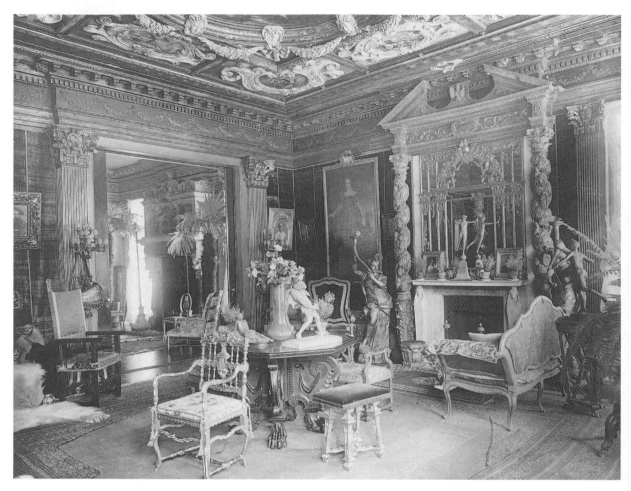

FIGURE 57. Stanford White, drawing room, 121 East Twenty-first Street, ca. 1900. The original bronze model of Augustus Saint-Gaudens's *Diana of the Tower,* now in the Smithsonian American Art Museum in Washington, D.C., graced the fireplace mantel; the full-size version of this sculpture floated atop the tower of Madison Square Garden, which White had designed. Two gilded, nearly life-size Baroque statues of allegorical figures holding cornucopias flanked the fireplace. *Diana the Huntress,* a running figure also in bronze, showed the goddess with bow in hand and occupied a gilded stand just behind a Rococo-style settee. (Collection of The New-York Historical Society)

The furniture was a mixture of multiple styles, from the curving elegance of the "Louis-something" settee to the rectilinear rigidity of a seventeenth-century oak-frame armchair with gilded finials. This mix-and-match approach was characteristic of White's method of decorating, and it qualified as a period room only in the sense that it was composed mainly of period pieces. An overwhelming decorative effect was the goal of Stanford White's aesthetic credo.

Among other furnishings were an ornately carved and inlaid octagonal table in the center of the room, on which were placed a faun, an antique bronze reclining satyr; a marble sculpture of a little boy; a small bronze version of the Venus de Milo; and a large vase for flowers. In front of the table was one of three gilded stools with red velvet upholstery. The drawing room also held two large velvet sofas with gilded feet, a gilded escritoire (writing desk), two carved and gilded mosaic-top tables, and five large carved and gilded armchairs. A white marble sarcophagus probably was used as a jardiniere, or container for potted plants.

Many bibelots added to the overall effect. Exotic vases and colorful fabrics abounded. The insurance inventory of 1899 lists four red velvet robes embroidered with gold, one of which bore the papal arms; there were four church embroideries and four hangings, all in red velvet and gold, plus six tapestry-and-gold pillows and a square of silk brocade. Placed about the drawing room were two Chinese jars decorated with butterflies, three large blue Japanese jars, two "Constantinople bottles," a brass pitcher from India, a Venetian glass vase, and a "Black Mexican Vase, Basket shape." Urns, carved chests, a foliated capital converted into a stool, potted ferns, swatches of colorful fabric thrown casually about—all contributed to the artistic jumble that White desired.

In addition, a number of portraits adorned the walls, with the crimson of the wall covering setting off their bold gilded frames. Three large, probably full-length, images depicted Mary Tudor, Johanna of Spain, and a woman in black. The drawing room also displayed two royal portraits, *Henry VIII* and *Edward VI*. Also hanging in the drawing room were the portraits of White's mother, Nina, and father, Richard Grant White, by Daniel Huntington, along with a second likeness of Nina White by Abbott Thayer.

THE MAIN HALL

The main hall, or stair hall, had a plain ceiling but an extremely ornate cornice with a delicate scroll motif encircling the frieze (figure 58). Fluted Corinthian pilasters framed the doorways, the two windows, and the fire-

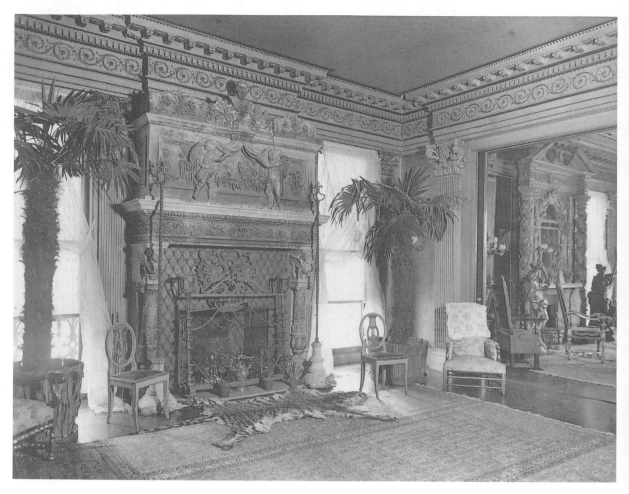

FIGURE 58. Stanford White, main hall, 121 East Twenty-first Street, ca. 1900. A reporter who covered the 1907 sale at the house was impressed with the variety, in style and period, of the numerous chairs that White had put together in one room: "The collection of chairs is in itself noteworthy, comprising antique Sicilian convent chairs, Colonial [American] chairs in carved mahogany, Hogarth armchairs also in mahogany, Napoleonic armchairs in the Roman style, late sixteenth century French armchairs, and various elaborate Italian throne chairs, together with many beautiful tables to match" (*New York Times,* 26 November 1907, p. 8). Eclectic diversity of this type was typical of White's interiors. (Collection of The New-York Historical Society)

place. The late-sixteenth-century Henri IV fireplace had an unusually or-
nate overmantel, on which stood two winged cherubs before three bas-
relief panels; the cherubs held the swags of a small baldachino (canopy)
that was topped with the bust of a bearded man wearing a toga. At each
corner of the fireplace was a decorative column that terminated in a
winged sphinx-like bust.

A large patterned carpet covered the floor, and the walls were hung
with tapestries. The furniture included a number of chairs of various styles
and periods, from the carved and gilded seventeenth-century throne-like
pieces to the simple clean lines of American Federal lyre-back chairs, iden-
tified as "Empire" in the inventory. A tiger skin, spread before the hearth,
reflected White's love of animal hides as part of his multicultural decora-
tive scheme, a primitive note among the sophisticated designs of Western
civilization. A reporter covering one of the 1907 sales at the house men-
tioned "the beautiful skin rugs. . . . There were interesting leopard skin
rugs, one made of 12 entire skins. . . . Two of five skins each with two
unmounted heads. . . . Two large Mongolian tiger skins with mounted
heads."[13] At the entrance to the dining room stood two twisted columns,
their surfaces decoratively carved.

THE DINING ROOM AND THE MUSIC ROOM

The dining room was the most elaborate room in the house (figure 59). It
had an extraordinarily ornate Venetian Renaissance ceiling of intricate
patterning composed of carved and gilded enframements surrounding
painted scenes of mythological subjects. An equally decorative Italian
Renaissance fireplace was set in the east wall, with an overmantel that re-
sembled an altar with a large painting incorporated into it. The upper and
lower portions of the fireplace were an example of White's arranging a
marriage of disparate parts that were united by Allard's craftsmen. White
often married separate objects to form a curious hybrid and felt no pangs
of aesthetic corruption in doing so. On the mantel, standing between a
pair of Baroque sculptured angels, was a small bronze version of Frederick
MacMonnies's spritely *Bacchante and Infant Faun*, a miniature of the life-
size sculpture that was expelled from the Boston Public Library on moral
grounds but found a home in New York's Metropolitan Museum of Art.[14]

A long and wide Oriental carpet ran down the middle of the floor from
the main hall to the entrance to the music room. On this was set a ma-
hogany claw-footed dining table, around which were placed seventeenth-
century chairs; altogether there were fourteen Cromwellian side chairs

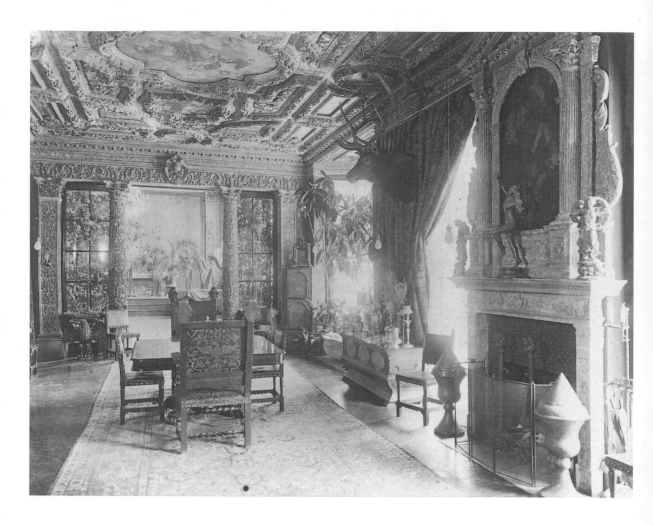

FIGURE 59. Stanford White, dining room, 121 East Twenty-first Street, ca. 1900. The ceiling of the dining room was of the Italian Renaissance period, and its paintings, of the coronation of the Virgin Mary (central panel), flanked by images of Mary Magdalen, were framed by gilded and richly carved moldings. In an Italian Renaissance fountain stood the marble figure of Silenus, who continuously poured water into a shell-shaped basin where live trout swam. When the Princeton Club bought the house in 1907 for its clubhouse, the *New York Times* reported that an agent of the club attended the sale to purchase any item that the Princetonians wished to retain, such as the elaborate mantel and overmantel. The ceiling of this room was bought by architect Howard Greenley on behalf of a client. (Collection of The New-York Historical Society)

with leather seats and backs, and four large armchairs. On a painted chest in front of one window was assorted bric-a-brac, while flanking the doorway were a red curio cabinet to the right and a carved eagle-base table to the left. A potted rubber tree grew in front of one window.

This room also contained a series of Raphaelesque Italian Renaissance tapestries, the largest of which was 11 feet high and 17 feet wide. These were the tapestries that White had purchased from Emile Gavet of Paris, who wrote to the American architect as he was beginning to decorate his Gramercy Park residence: "I send you the photos of three tap[estries] of Raphaelesque design of which we spoke when you were last here."[15]

White's tapestry collection was extensive, with examples adorning the walls of most major rooms of the house. A *New York Times* story about the 1907 sale mentions a seventeenth-century Gobelins tapestry that measured 10 by 15 feet, and an "antique eighteenth century French tapestry panel, representing the rescue of a lady from a burning palace—probably depicting the sorceress Armida being rescued by Rinaldo, from the [romantic epic of 1562] by Tasso. This hanging had a companion piece of similar size, weave and design." A rare French sixteenth-century millefleur tapestry "recalls the famous Lady with the Unicorn series at the Musée de Cluny . . . showing the arms and devices of the Duke of Burgundy on a Gothic floriated ground."[16]

The Metropolitan Museum of Art bought one of White's tapestries at the 1907 sale (figure 60). A mid-sixteenth-century Flemish example of the grotesque type, it shows Minerva with shield, spear, helmet, and aegis among allegorical images of war and peace and surrounded by grotesqueries. The borders are related in design to the Raphael tapestries in the Loggi of the Vatican. The *New York Times* referred to this particular tapestry in declaring that the collection being placed on the auction block "comprises among other things a half-dozen of the choicest tapestries ever shown and put up for sale in New York. Of these the Italian Renaissance tapestry in the grotesque style is one of the most striking. The design is of extreme richness and of elaborate detail. . . . The background is of a rare Venetian red, covered with an elaborate embellishment of arabesques, armorial emblems, caryatids, classical subjects, and garlands which are typical of the early Italian school. . . . The borders are of exceptional beauty, with figures uplifting a coronet and coat of arms."[17]

Leaving the dining room, guests passed through an Italian Renaissance doorway that consisted of two ornately carved free-standing columns that supported the equally decoratively carved architrave and cornice; a glazed

FIGURE 60. *Minerva with Grotesques,* Flemish, 1530–1550. *Minerva with Grotesques,* a tapestry of silk and wool (13¼ × 12½ feet [4.04 × 3.81 m]), possibly was made in the workshop of Joost van Herzeele, after designs by Perino del Vaga. In addition to the central image of Minerva, the grotesques, and the mythological figures, this tapestry contains the arms of the Doria family of Genoa. To White and his patrons, objects whose provenance associated them with nobility were especially desirable. The *Minerva* tapestry is known to have made its way to Paris by 1873, and Emile Gavet sold a companion piece, with Neptune as the central figure, in 1897. White bought the *Minerva* at that time or soon after, but he then sold it sometime before 1906 to his client Annie Kane. (The Metropolitan Museum of Art, Bequest of Annie C. Kane, 1926 [26.260.59])

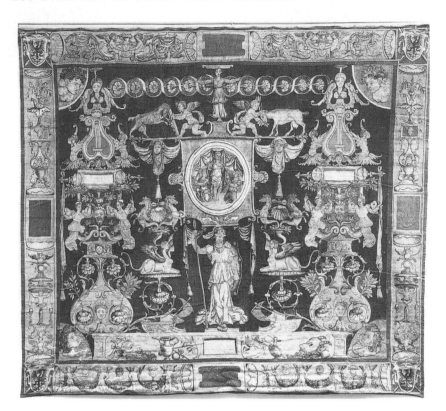

space separated the columns from the pilasters applied to the wall that were carved in an identical pattern. Plants placed just beyond the glass panels gave the music room the atmosphere of a conservatory.

Within the music room was a display of musical instruments, many of which had been collected by Stanford's father, Richard Grant White, and on the little stage was a semicircle of a half-dozen gilded harps (figure 61). Margaret Terry Chanler remembered musical evenings there, specifically mentioning "a half-circle of eighteenth-century harps [that] stood at the back of the stage; when there was music they seemed to listen and vibrate."[18] Other musical instruments in the room included a "semi grand" Steinway piano and a painted and gilded harpsichord, a viola da gamba and a cello, several lutes, an armadillo mandolin from South America—actually made from the hide of the animal—another mandolin from Africa, and a red zither. On the Oriental carpet were placed a pair of gilded sofas with old rose upholstery, a red sofa, and another done in white brocade.

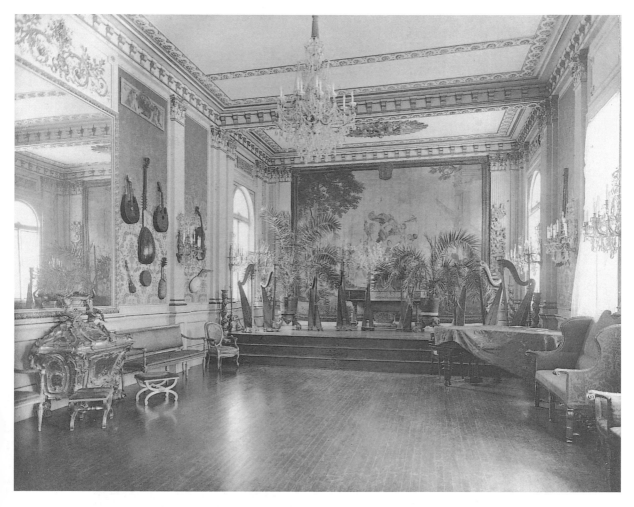

FIGURE 61. Stanford White, music room, 121 East Twenty-first Street, ca. 1900. White's love of music was both genuine and of long standing. During his youth, he often attended the concerts of his father's string quartet, in which Richard Grant White played the cello. Stanford White shared his interest in music, particularly the works of Beethoven and Mozart, with his partner Charles McKim, the critic Royal Cortissoz, the writer Richard Watson Gilder, the painter Thomas Dewing, and the sculptor Augustus Saint-Gaudens. The group met frequently on Sunday afternoons in Saint-Gaudens's studio on Fourteenth Street for private musical performances by quartets that they collectively hired. This dedication to classical music continued in concerts arranged in White's home on Twenty-first Street to which he invited New York's highest society as well as artists and writers. (Collection of The New-York Historical Society)

The Whites entertained socially as often as they were guests at the homes of friends and clients, and music was the favored form of entertainment after dinner or on a Sunday afternoon. Stanford White himself enjoyed music thoroughly, and one of his biographers has pointed out that he was perhaps the only man in New York in the 1890s who went to the opera because he wanted to listen to the music.[19]

THE GREEN ROOM: FURNISHINGS AND PAINTINGS

On the third floor, at the front of the house and facing Gramercy Park, was the Green Room—essentially a library, study, and sitting room—the walls of which held a great many paintings (figure 62). The focal point of the room was an ornamented white marble fireplace with a profusely carved overmantel that enframed a large painting, *Bacchante*, by Robert Van Vorst Sewell. The room contained an upright Chickering piano with rosewood case, a mahogany claw-footed library table, a pair of writing desks with inlay work, and two bookcases. A sofa and a large wingback chair were placed near the fireplace with an Oriental carpet between them, and six additional chairs, with gilded frames and blue and yellow upholstery, were set about the room.

Although the "rooms of the basement, main and second floors are liberally garnished with old and modern canvases,"[20] much of Stanford White's enormous art collection was exhibited on the third floor. There, in the Green Room, was a small but exquisite collection of contemporary American art. By its makeup, it was quite different from the collection found in the much larger picture gallery at the other end of the house, which contained mostly European paintings dating from the Renaissance to the early nineteenth century.

The collection in the Green Room was marked by a diversity of styles that reflected White's refusal to be limited in any way in the things with which he surrounded himself. For example, two paintings were by Arthur B. Davies, *Lucia and Sylvia* and *Nude Figure*, and two were by Albert Pinkham Ryder, *Pegasus* (now in the Worcester Art Museum) and *In the Stable* (*Cow in a Barn*); a third Ryder, *The Three Witches*, hung in the picture gallery. White owned two landscape paintings by Edward Steichen that were probably also located in the Green Room, and he had acquired several pictures by William Merritt Chase, two of which he bought out of the artist's studio, *Back of Madrid* and *Afternoon Tea in the Garden*; Chase's *The Waterfront—Brooklyn* and *A Water View* were also in the Green Room. Childe Hassam was represented by *Sunset—Sea* and *A Scene near Paris*.

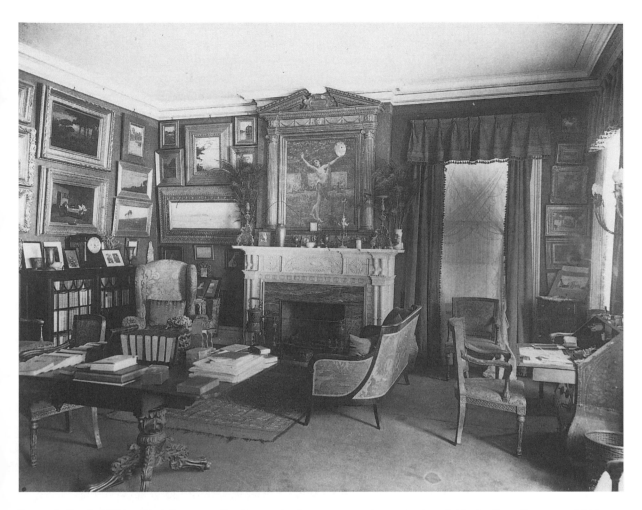

FIGURE 62. Stanford White, Green Room, 121 East Twenty-first Street, ca. 1900. Accessories abounded in the Green Room, as might be expected, given White's multicultural clutter aesthetic. Among these items were three vases from Tiffany's; a Japanese vase and an Etruscan vase; a small statue of Minerva and another of a vestal virgin, both in bronze; a pair of Italian vases; and a French clock, plus small tapestries thrown casually over a sofa. On the walls were hung White's extensive collection of paintings by contemporary American artists, most of whom were personal friends. (Collection of The New-York Historical Society)

Flower pieces by J. Alden Weir and John Twachtman were there, as were landscapes by Worthington Whittredge, Dwight Tryon, Abbott Thayer, Theodore Robinson, Homer Dodge Martin, John La Farge, and Willard Metcalf. Metcalf's *Bacchanalian Orgy* was displayed in the picture gallery. The inventory of 1899 lists two landscapes by George Inness in the Green Room, but the *New York Times's* coverage of the 1907 sales identified four works by that artist in White's collection: *Conway Valley; Sunset, Italy; The Villa Borghese;* and *Italian Landscape.* The several views of Italy included a picture titled *Venice* by an artist identified only as Bruce, plus others depicting the isle of Capri, as well as *Canal Scene in Venice* by White's friend and agent Charles Caryl Coleman, who lived on Capri. The collection also contained figural pieces— the female nude was one of White's favorite subjects. George de Forest Brush's *Girl in a Window* was in the Green Room, and his *Leda and the Swan* was in the picture gallery. Only occasionally did White's tastes carry him close to the modern movement that was then arising; his three paintings by Ryder and two by Davies were as avant-garde as he ventured.

Stanford White's wide range of friends included many artists. He felt comfortable with them, they liked him, and they were frequently among his carousing buddies. Moreover, he formed his collection of contemporary American art in part by his patronage, generously helping out a destitute painter by either buying a work or commissioning one—and paying for it in advance. I will cite three examples of this relationship here—in letters from Kenyon Cox, Thomas Dewing, and Charles Curran—but White had many more. Kenyon Cox wrote to White on 16 April 1892: "Many thanks for the check, which came this morning, as well as for all your kindnesses in the matter. I will paint your little nude next winter as well as I know how and for as little as possible. Of course, every cent is of importance to me now, and I appreciate your kindness in letting the $100 go over on the commission. 'Mademoiselle' will be at The Players [Club] on lady's day—early, for I have my school in the afternoon. I shall take great pleasure in presenting you to her if you will be there."[21] By May 1893, Cox could inform White that the nude was finished, and the painter invited White to his house to see it, to see if it pleased him. Another painting by Cox known to have been in White's collection was titled *Flying Shadows,* and it was hung in the Green Room.

White and Thomas Dewing corresponded frequently in an informal manner that testified to the closeness of their friendship; they frequently joked with or chided each other, or made social plans. A letter from the

painter with the greeting "Dear Stanny" is a good example: "You have been to my studio once or twice and I have not been there so I am delighted to be able to ask you, what becomes of your business when you are away fishing? [Charlie] Freer wants you to dine with him here at my studio next Saturday at 7. Can you see our friend? You know I told you to keep this date."[22] Freer owned a number of Dewing's paintings and made a gift of one of them—*The Garden*—to White; at the sale of White's collection in 1907, it was purchased by George Webster, who bequeathed it to the Museum of Fine Arts in Boston. Dewing's *Goddess in a Wood* and portrait of Ella Batavia Emmet were displayed in the Green Room, while his *Study of a Nude; Nude, Fishing; Two Women;* and *Two Women on a Seat* were shown in the picture gallery. White at times designed the frames for Dewing's paintings, several examples of which are in the Freer Gallery in Washington, D.C.[23]

The volume of correspondence between Dewing and White suggests a continual relationship and close male bonding, approaching that of White's friendship with the sculptor Augustus Saint-Gaudens. Also, Dewing sometimes alerted White to objets d'art that had come onto the market, as when he wrote to White, probably from England: "Send and buy two busts, original marbles, of Malibran & Grisi in Dowdeswell's Gallery in Bond Street, London. He wanted 50 pounds a piece but would take less."[24]

As the following letter shows, in the 1890s White was assisting Charles C. Curran; the prices suggest an artist who has not yet become famous:

> Dear Mr. White
> The titles & prices of the pictures I leave [at your office] are as follows:
>
> | An old cherry orchard in wintertime | $25.00 |
> | Going for a Drive | $50.00 |
> | Corner in a Greenhouse | $45.00 |
> | The Sick Children | $50.00 |
> | Springtime | $35.00 |
>
> In case you should care for any of them I shall be very glad.[25]

Another letter to White shows the deep gratitude that Curran felt: "Your note of yesterday inclosing two checks, one for $400 and one for $100 came this morning—I can only say that I thank you very much—I shall

take great pleasure in painting the picture you wish, and shall give you the fullest measure as to the best work I can do. I will have the joy of doing the kind of work I have wanted to do for a good while."[26] By 1899 White owned a number of paintings by Curran, including several that were shown in the Green Room—two titled *Sirens*, one called *Old Cherry Orchard* (possibly one of the paintings from the list that Curran left at White's office), as well as *Woman and Cabbages* and *Nude*.

By 1898 John Singer Sargent certainly did not need assistance from Stanford White, but a letter from that year suggests the warm friendship that existed between the two men. Sargent wrote to inform White that he had just received a crate containing a special treasure that the architect had purchased:

> A box has arrived from Allard, who writes me that it is sent to my care at your command, and that I must unpack it to see if it is all right. It is a Velasquez head of an infant, in perfect condition and color. Meanwhile I have screwed it up again in its case, renewed my fire insurance and hired a policeman to watch my house until I hear from you what is to be done with it. My abode is not proof against fire or burglars, and I must turn into a dragon and sit on this treasure.
>
> How are you and when are you coming over? If you do, come to Fulham Road [site of Sargent's home]. . . . Same message to McKim, and love to you both.[27]

White owned an early work by Sargent, *Street Scene in Venice*, which was in the Green Room but is now owned by the National Gallery of Art in Washington, D.C.; reportedly, this picture was a gift to White from the artist.

A few paintings in the Green Room were not by American artists, among them several works by French painters. At the A. T. Stewart sale in 1887, White had purchased one of the prizes—Jean-Léon Gérôme's *Corneille and Mollier*, a picture that had won a medal of honor at the French Salon. White also owned Jean-Auguste-Dominique Ingres's *Bacchus Finding Ariadne on the Island of Naxos*; a landscape by Gustave Courbet; and Giovanni Boldini's *Gardens of Versailles*. Scipione de Garta's *Two Princesses of Naples* rounded out the works by foreign artists.

The Green Room was White's favorite place in the house, the space that was most personal to him. Edward Simmons, another artist-friend whose painting *Night—Waterscape* hung on its walls, remembered White's presence there: "When he fitted up his house in Gramercy Park . . . a

flight or two up was his room. Vercingetorix in his cave with all his spoils piled up around him! Everything he cared about (and he wanted it at once) and a heterogeneous mass of priceless books, paintings, draperies, all in careless disorder, was happiness to him in his own den."[28]

STANFORD WHITE'S PICTURE GALLERY

On the third floor of the Whites' residence a hallway led past Bessie's and Stanford's bedrooms to the far end of the house, where the large picture gallery was located (figure 63). This hall was lighted by stained-glass windows, and the walls were covered with colorful ornamental tiles. According to the *New York Times,* "By the stairs giving access to the gallery is an alcove with fountain surrounded by old blue tiles, bas-reliefs, and other antique objects."[29] Some of this tiling is visible through the doorway in figure 63. Tiles were often an important part of decorative schemes during this era, and White used them frequently. He was a member of the famous Tile Club, a group of his cronies who met regularly to sketch designs and scenes on tiles. As a reporter noted in his account of one of the 1907 sales: "Col. Colt bought one lot of tiles inserted in the walls at the entrance to the picture gallery. . . . Stanford White, it was said, bought an entire mosque in Constantinople to obtain these tiles."[30] The anteroom to the art gallery also contained ten Italian Renaissance bas-reliefs, two marble statues of Venus and Leda, and a carved marble sarcophagus.

Entrance to the art gallery was gained through a large, elaborately carved and gilded Spanish Baroque doorway. The *New York Times* observed that White "delighted in old Spanish carvings, altar-pieces, cloths, and reliquaries."[31] Somewhere he had found a set of wrought-iron gates that he incorporated into the doorway. At either side of this grand ensemble was a gilded twisted column, the type that White and his patrons were so fond of. The richly sculpted architrave was crested with a broken pediment that provided a space to display three gilded sculptures: two standing winged angels and a little shrine containing a figure of the Virgin Mary holding the Christ Child. A cupid reclined on each of the raking pedimental cornices. The mixture of sacred and profane images and the variation in scale of the figures suggest that White here arranged a marriage of disparate parts, which he did frequently, with the assistance of the artisans from Allard's.

The picture gallery was large, with exposed beams that recalled the great halls of European lodges. Further emphasizing this style were a moose head and twelve sets of antlers set between the beams. Curiously, in the inven-

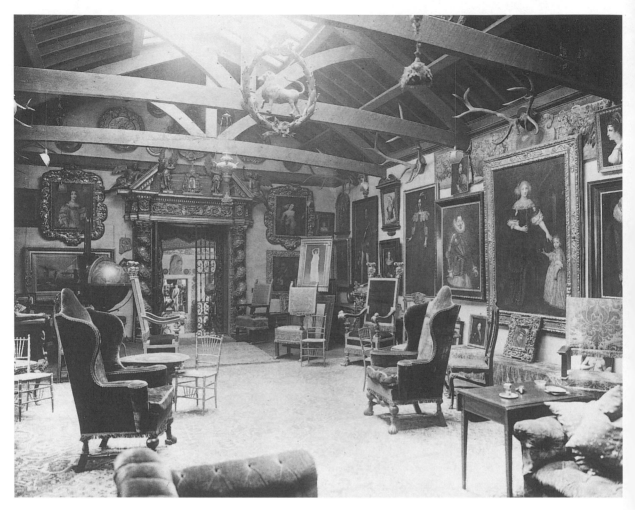

FIGURE 63. Stanford White, picture gallery, 121 East Twenty-first Street, ca. 1900. The end wall of the picture gallery was dominated by a grand Henri II fireplace with a white mantel and a massive entablature with a frieze of floral garlands carved in bold relief; the overmantel was supported by four fluted Corinthian columns and four matching pilasters, the whole surmounted by a life-size marble bust. Portraits composed the greatest number of works in White's painting collection, and the *New York Times* took note: "The picture gallery as it stands has too many portraits in it for the best effect; it suggests too much the wearisome rows of family portraits one finds at the country seats of old families in Europe" (31 March 1907, p. 2, p. 11). That, of course, was just the effect that White was hoping to achieve—a re-creation of the European nobility's habit of hanging portraits depicting several generations of ancestors. Both White and his clients were pleased with the halo effect of these "borrowed" family portraits, as most of White's social acquaintances came from no more than a generation or two of prominence and wealth. (Collection of The New-York Historical Society)

tory of 1899 the dozen antlers were valued at $750, and the "doorway, carved and gilt with columns & boys," was estimated at $800; that is, the doorway was assessed at only $50 more than the collection of deer horns.

At the end of the room opposite the entrance was a great Henri II fireplace that was guarded by a pair of stone lions. On either side of the hearth were old wooden marriage chests, carved and studded in decorative patterns, of Italian origin. A varied assortment of chairs—some carved and gilded, others upholstered in antique velvet—were placed randomly about the room and set on Oriental carpets. Other accessories included a gilded lion encircled by a wreath that hung from a rafter and an antique celestial globe, seen just to the left of the doorway in figure 63.

STANFORD WHITE AS DEALER IN PAINTINGS

White had many contacts in Europe and England who regularly offered him important paintings. Once, while White was in Paris, Emile Lowengard invited him to go with him to see two fine paintings by Jean-Baptiste Greuze "and some other pictures and also some Renaissance bronzes."[32] Harry Payne Whitney had commissioned White to find him a Reynolds portrait of the highest quality; in November 1897, Godfrey Kopp wrote to White, who was then in London, to say that he had arranged for them to see an extraordinary portrait of a beautiful lady by Sir Joshua Reynolds, adding that he knew White was looking for "the finest existing picture by Reynolds. . . . I will not show it to anyone else being absolutely sure that it is the exact thing you want."[33] Within a week Kopp wrote to White again to say that he had been in contact with the owner of the Reynolds portrait and had obtained a contract for a price of £14,000, informing White that the owner "would also sale [*sic*] the furniture you have admired at the condition that it should go with the picture."[34] Some years later, Kopp offered White a painting of Danaë, confiding that "I have now got more proof that the picture originally comes from the Duke of Modena's collection. . . . I really think that your friend Mr. Whitney or Mr. Mackay or even Mr. Payne ought not to let such a rare opportunity escape."[35] In December 1897, Kopp had written to White about another of his contacts: "Re the Philippe de Champagne portrait and Rigaud's portrait of Louis XV, I have mentioned in my former cablegram, [that the vicountess] has decided to sell these two."[36]

Offers of paintings came from diverse contacts, as when one named (Giovanni?) Boldini told White that he hoped the Titian would still be

available when White returned from salmon fishing in Canada; Boldini then added that he was glad that White was pleased with the Velázquez portrait of "Mary Ann of Austria, 2nd wife of Philip IV," which Boldini had sold to him.[37] Stefano Bardini in Florence occasionally sent White a photograph of a painting that had come quietly on the market, such as the life-size portrait of Madame Teodochi Albrizzi, "painted in Venice in 1791 by Madame Vigee Lebrau [*sic* (Vigée-Lebrun)]."[38] In November 1897, Bardini had offered White a portrait said to represent "Ferdinand des Medici," perhaps the painting by Justus Susterman that eventually adorned the salon in William C. Whitney's house (see chapter 3). White also maintained accounts with Asher and Charles Wertheimer, leading picture dealers of London, and with Paul Durand-Ruel of Paris from whom he bought several paintings.

Although a few American painters were represented in the picture gallery, the collection there consisted mainly of works by European artists, from the thirteenth to the nineteenth century. The attributions given here are those applied at the time of White's ownership; many pictures would, no doubt, be reassigned today.

THE ENGLISH AND FRENCH SCHOOLS

From the English School, White owned an early-seventeenth-century full-length portrait of a lady with a child (at the right in figure 63). Also in the gallery were Sir Peter Lely's full-length portrait of a seated woman placing a tulip in a vase and Sir Godfrey Kneller's likeness of Lady Dilke and her son. Thomas Gainsborough's *Lady Carr* and Sir Joshua Reynolds's *Miss Ridge* (once called *Kitty Fisher*) were particularly prized; White had acquired the latter from Charles Wertheimer. White had purchased George Romney's *Lady Hamilton as Ariadne* from Charles Sedelmeyer in Paris, who had written to White in September 1900 that he had shipped to the architect a case "containing the picture by Romney which you have bought from me. It is packed so that you can leave the case behind if you wish to take the picture as luggage [that is, smuggle it] with you."[39] Also hanging in the picture gallery were a portrait of a child with a doll by Sir Thomas Lawrence and *Portrait of a Young Girl* by Sir William Beechey.

Portraits by England's great masters were then leaving the grand country houses in increasing numbers. Joel Duveen wrote to White in January 1898 to alert him that "we are after a very fine Sir Joshua and a fine Gainsborough. If we get them we shall send you photos."[40] The following April, Duveen informed White that "we have . . . bought a fine [Sir

Thomas] Lawrence picture of Mrs. Whittington, photograph of which I enclose herewith."[41] But often such offers concerned paintings that were beyond White's means, as when another London dealer, George Donaldson, once wrote to White with great excitement: "I have just had a big go—the biggest of my life, having bought two of the most famous pictures in England—one, the finest portrait in the world, by Titian—the "Ariosto"—and the other the great Vandyke [*sic*] of the two young brothers—Lords John and Bernard Stuart—one in white and blue with his foot on a step and his elbow coming out at you—life size of course. . . . From Lord Darnley, Cobham Hall. Very dear. . . . The National Gallery wants them badly, but the war is not yet paid for." [42]

White's collection also included three genre pieces said to be by William Hogarth: *The Deceitful Lover* and its companion, *The Tell-Tale Mirror,* and *A Visit to the Debtors' Prison.* Among other genre subjects were William Etty's *Rustic Courtship* and *The Signal.* A marine view was attributed to J. M. W. Turner. White also owned a couple of portraits thought to be by Hans Holbein the Younger, but where they were hung is uncertain.

The older French School was represented by a portrait of René du Puy du Fou by a follower of François Clouet that White bought from Gimpel & Wildenstein in Paris. Pierre Mignard's portrait of Margaret of Orleans and another of an unidentified lady were in the collection, as were additional portraits by unspecified members of the Van Loo family. *Venus and Faun* by Jean-Antoine Watteau, which White had also acquired from Gimpel & Wildenstein, showed Venus sleeping under a tree, with a swarthy faun creeping up on her from behind while Cupid played with a torch nearby.

More recent French paintings included a landscape by Theodore Rousseau that White had purchased at the George I. Seney sale in New York City and Jules Lefebvre's *Diana.* Mario Fortuny had a genre piece—*The Butcher's Shop*—in the collection, as did Sebastien Leclerc, *Blind Man's Bluff,* which showed a group of young men and maidens on a grassy knoll. White also owned three color sketches by Gustave Boulanger that were studies of Peace, Dance, and Music, made in preparation for the murals that he painted for the theater at Monte Carlo.

THE DUTCH, FLEMISH, AND SPANISH SCHOOLS

In the picture gallery, the Dutch School was represented by a portrait of a lady said to be by a follower of Cornelis Janssen and two likenesses of elderly women attributed to Quentin Matsys. *Portrait of a Nobleman* was as-

signed to the school of Michiel Mierevelt, and *Portrait of a Dutch Lady* to Henri Goltzius. *Lady with a Fan* was believed to be by Cornelis de Vos. Of the Flemish School, White owned *Lot and His Daughters,* attributed to Anthony Van Dyck, and *Visit of the Magi* by Jan Van Sorel.

The Stanford White Papers yield almost no comments about the paintings that he collected. However, an early letter to his mother, sent while he was traveling around Europe in 1878, provides an insight into his enthusiastic response to great art, if stated in a somewhat irreverent fashion; from Antwerp he wrote:

> I fairly gorged [on] Rubens there. 14 portraits in one old wain-scotted room and two by Vandyke were enough to take your breath away. In the museum I don't know how many pictures; heaps of fat legs and brawny arms and blear-eyed frowsy women, whose modesty is of the most fragile kind. "Fat Mrs. Rubens," says an old author irreverently of the Assumption, "sits as firmly and comfortably on the clouds as if in an armchair, and gazes placidly on the wondrous scene around her—nor does her aerial flight cause her the slightest ecstasy or emotion. Ought she not to be ashamed of herself, to sit there in her flimsy attire and personate a goddess—and a virgin, too." Both the raising and descent from the cross in the cathedral are painted with an entirely different palette, and are so wonderful that you would feel like pounding the man who said Rubens was not the greatest painter in the world.[43]

Among the correspondence between Stanford White and Raoul Heilbronner, a Paris dealer, is a letter to White that reads in part: "The eight pictures from Spain . . . will be sent in three or four days."[44] White's picture gallery held a full-length portrait of the earl of Dorset, painted in England by a Spanish artist in the sixteenth century, and Frederico Zucchero's *Portrait of Mary Tudor* was given a place of honor in the drawing room. At the sales of White's possessions in 1907, several paintings were listed as by Spanish artists, one of whom was Claudio Coello. Of the latter's two portraits of women, full length and standing, a reporter observed that White "favored Spanish painters like Coello, because of the strong decorative qualities of their stiffly clad and quaint figures."[45] We know that White owned *Head of an Infant* by Velázquez, which Sargent mentioned in his letter, and a copy of a Velázquez painting made by William Merritt Chase.

THE ITALIAN SCHOOL

The inventory of 1899, the sales catalogues of 1907, and the photographs of the picture gallery reveal that the Italian School was strongly represented in White's collection. Unlike the works from the schools that I have already discussed, the Italian paintings included a number of religious subjects in addition to portraits and genre scenes. The earliest was a painting titled *Madonna and Child* by a follower of Cimabue that dated from the thirteenth century. Also from the early Italian School was one by an unknown artist that was called *Nativity.* The Madonna and Child theme was further represented in works said to be by Domenico Ghirlandaio and Fra Filippo Lippi. Pietro Longhi's *A Visit to the Convent* was more a genre than a religious subject.

Of the portraits, several were outstanding—Tintoretto's *Father and Son,* placed just to the right of the doorway (see figure 63), and Bronzino's *Portrait of a Man,* along with Carlo Dole Moroni's *Portrait of General Tilhomme* and Giovanni Batista Moroni's *Portrait of a Nobleman.* Genre pieces included Adolphe Monticelli's *Fete in a Garden.* Among the other paintings were the early Italian *Portrait of a Young Woman,* believed to represent Nora, the sister of the duke of Ferrara, a three-quarter-length portrait showing the subject holding a handkerchief in her left hand.

The inventory of 1899 lists many paintings by anonymous artists of unknown nationality, itemized only as *Classical Subject, Cupid and Psyche, The Adoration,* and *Flight into Egypt*; five pictures titled *Madonna and Child,* seven listed as *Portrait of a Man,* and seven as *Portrait of a Woman*; several nudes; and many more. Stanford White's art collection was personal, idiosyncratic, and eclectic: he bought what appealed to him. He never intended to form a collection that would show with consistency the major schools, movements, and periods from antiquity to the turn of the twentieth century. Nor in his arrangement of his pictures in one room or another did he attempt anything like a didactic history of Western art. He did not set out to rival J. Pierpont Morgan and Henry Clay Frick, men who had the money to go after the most superb examples by the most important artists.

White enjoyed his paintings, but he saw them in terms of their place within an overall decorative scheme. As one reporter observed of White's collection, it "contains no pictures that are ever likely to go to sensational figures at a sale; but most of them have the better quality of things which

are comfortable to dwell with and see every day."[46] Another piece in the *Times* reported that "it is generally understood that the architect purchased his paintings not for the names of artists that they represented, but because of their decorative effects and because they pleased him."[47]

White compiled no catalogue of his collection, and even the inventory of 1899 was made only for insurance purposes. He seldom, if ever, researched any of his paintings—they were there on his walls for their contribution to the decorative scheme that he had devised for a given room, and he felt no urge to pursue a scholarly or an academic study of them. And their great gilded frames certainly appealed not only to his eyes but to those of his friends and clients. To be sure, the collection represented a "stock-in-trade," and should one of his patrons be in need of an "ancestral portrait" to go above the fireplace in the parlor that White was decorating for him or her, the picture gallery offered a wide selection from which to choose. For example, the full-length portrait of a mother and child (see figure 63), which was in White's collection when that photograph was taken around 1900, reappears in figure 30 as a focal point in the great hall of William C. Whitney's country house in Westbury, Long Island, as does the portrait of a man—in armor, with a ruff at his neck—seen just to the left of the mother and child portrait in both photographs.

EPILOGUE

WHAT WAS SPECIAL ABOUT STANFORD WHITE, DURING THE PERIOD OF
La Belle Epoque, insofar as interior architecture and furnishings were con-
cerned? Richard Morris Hunt had certainly made use of decorator houses
such as Allard and Sons, and Ogden Codman went to Paris regularly to
obtain antiques or reproductions that were beautifully wrought by French
craftsmen. Cass Gilbert used some of the same artisans that White did in
decorating the interiors of buildings that he designed; at the Union Club
in New York City, for example, Gilbert turned to T. D. Wadelton, whose
firm supplied fourteen card tables and forty-six armchairs for the club's
card room, made from designs drawn up by Gilbert himself.[1] George B.
Post called on Allard's for the execution of some of his finest interiors.
Architects of the period often chose to design furniture for the interiors
that they had created—Frank Lloyd Wright and the California firm of
Greene and Greene are good examples, although they worked in tradi-
tions very different from those followed by White.

The degree to which Stanford White collected, installed, and generally
dealt in European antiques, and the creative manner in which he assem-
bled them, set him apart from other architects. Moreover, there was a joie
de vivre in the spirit with which White swept through dozens of antique
shops and palazzos, castles and country houses on his annual visits abroad,

and he maintained a vast web of contacts among agents, artists, artisans, dealers, and even con men who could provide him with the most remarkable items with which to decorate the gilded mansions of America's new millionaire society. Finally, no other American architect of White's era—with the possible exception of Ogden Codman—devoted as much time, energy, and attention to architectural interiors and their furnishings as White did. This aspect of White's career deserves greater recognition than it has received heretofore, if the man's creativity and his place in history are to be properly assessed.

Stanford White was acquisitive, almost beyond belief. As if the interiors of his house overlooking Gramercy Park were not packed to capacity with treasures obtained from auctions and galleries in New York City and from his excursions to Europe, he filled another whole house with similar items—Box Hill, his country estate on Long Island. Also, he had hundreds, if not thousands, of additional items, large and small, scattered all over New York—in warehouses, on loan to friends, on trial at the homes of clients, stored in somebody's unused stable.

White was a bon vivant and a charming man-about-town, but he also created serious problems for himself, and these were often related to the things that he collected over the years. He firmly believed that he should live as lavishly as his clients, and he was generous to friends and stray chorus girls to a fault. By 1901 he was already deeply in debt when he speculated in the stock market, hoping to make a fortune quickly. The plan backfired, and his indebtedness soared to a staggering $700,000. He borrowed more than he was allowed from the firm of McKim, Mead & White, and he owed Henry Poor about $90,000. Finally recognizing the disastrous state of his financial affairs, he virtually declared bankruptcy and put himself in the hands of his friend Charles T. Barney, president of the Knickerbocker Trust. White signed almost everything he owned over to Bessie, his firm, or friends such as Henry Poor and James Breese, who had at their houses hundreds of items collected by White that stood as collateral for loans.

THE DISASTER OF THE FIRE

White decided to have a great sale of his inventory of antiquities, which he estimated to be worth nearly $300,000. In preparation for the auction, he rented the top floor of a warehouse on the West Side of Manhattan and called in items that were on loan to clients and friends. The proceeds from the sale were to be used to reduce his indebtedness.

At the warehouse, he tagged and numbered nearly a thousand pieces for the sale, which was scheduled to be held on 23 April 1905, the auction to be conducted by the American Art Galleries. The space was a vast cavern, typical of storage facilities, and to provide more lighting to show the pieces to best advantage, White arranged to have an electrical system installed. Disaster struck on the afternoon of 13 February when faulty wiring set the place ablaze, and every piece gathered there was consumed in the conflagration. The *New York Times* for 14 February 1905 reported that "Stanford White's valuable collection of antiques, consisting of tapestries, iron work, pottery, carved wood objects, and statuary, was destroyed yesterday afternoon by a fire which gutted the six-story building at 114–120 West Thirtieth Street."

White could not bring himself to talk to reporters about the loss, but one of his friends told the press that the articles were irreplaceable; it was, the *Times* noted, "one of the finest collections of its kind in the world. The majority of the antiques represented Spanish and Italian art of the fifteenth, sixteenth, and seventeenth centuries. Some of the tapestries were priceless, and the collection of pottery was unique." If the loss of the objects themselves was not bad enough, White had neglected to take out an insurance policy on them; the financial loss was devastating.

Charles McKim wrote to Bessie, who was then traveling in Europe, to express his sympathy, noting that Stan had behaved like a soldier: "It is too terribly sad that all those beautiful things that meant so much . . . should be gone. After two days of stony misery poor old Stan broke down completely, and sobbed at the breakfast table like a child. Then he made his mind up to it and threw it off, so that one would think he had forgotten all about it."[2] Eleven days after the disaster, Stan, by then having pulled himself together, wrote to his wife to tell her about it: "The fire is turning out worse than I expected, but . . . it is impossible even, as yet, to form any idea of exactly what has happened. The floors fell in, and some of the walls on top of them, and then tons and tons of water were poured over the debris, and this froze in a solid mass. . . . Whatever damage has been done, however, is irreparable, and the only thing to do is to pluck up spirit and bear it."[3]

STANFORD WHITE'S DEATH: AN AFTERMATH OF CONFUSION

The fire occurred in February 1905, and, as is well known, in little more than a year the ultimate disaster would strike. On the evening of 25 June 1906, Stanford White was shot to death as he relaxed at his table in the rooftop cabaret of Madison Square Garden, which he had designed. Years

before, White had had an affair with a beautiful young woman named Evelyn Nesbit, an affair that had ended amicably. Eventually, Evelyn married Harry K. Thaw, a spoiled and rather unbalanced son of a Pittsburgh millionaire. Evelyn and Harry Thaw were at the Garden when White walked in. Jealous of White over the affections of Evelyn, Thaw was convinced that his rival was a despoiler of young women and decided to rid the world of him. He walked up to the table where White sat, pulled a revolver from his pocket, and shot White three times, killing him instantly.

The yellow press vilified White, prompted no doubt by Thaw's lawyers, and accused the architect of decadence and immorality. Thaw was tried, but the court ruled that jealousy had driven him to insanity at the time of the crime; he was confined to a mental institution for several years and then released. Meanwhile, his mother had arranged her son's divorce from Evelyn, who disappeared for a while but then told all in her autobiography.[4] Bessie withdrew from New York society for some time, choosing to live much of the year at Box Hill. Fortunately, Bessie had money of her own—family money, some of which descended from the widow of the department store tycoon A. T. Stewart—and Stan had insisted that Box Hill be put in her name.

Stanford White's financial affairs were not all that were left in a deplorable state of confusion by his sudden and unexpected death. He had kept track only in his head of much of what he had been working on. Things belonging to him were scattered everywhere, and large and important jobs remained unfinished—the interiors of the Payne Whitney house, for example. Work was temporarily halted there, and a state of confusion is suggested in a letter from Allard's, of August 1906, which reported that "the Salon . . . has remained practically in the same condition during the last two months."[5] G. W. Koch & Son had been hired to do the parquet floors at the Whitney house, and someone from its office wrote to the architectural firm three weeks after the shooting to say that a bill was enclosed for its workers' time since White's death: "The men claim that they were laid off by order of McKim, Mead and White's superintendent, and they were informed that they would be paid for it. They claim that all the other men in the [Payne Whitney] house were paid, and they have been making frequent demands upon us."[6]

Allard's continued to work on the decor for the salon at the Whitney house, trying desperately to bring the task to a conclusion. White had evidently left many things with Allard's or stored them at its factory, for the firm sent McKim, Mead & White a note in November saying that it was

sending a bill "for removing from No. 28 East 32nd Street three loads of woodwork belonging to the late Mr. Stanford White."[7] Nor were the scattered belongings merely odds and ends, as is evident in another letter from Allard's, dated 14 December 1906: "We understand that you have had photographs taken of the Henri II room which we had mounted together in our factory. Will you kindly let us know . . . if we can take down this work. As requested, we would like to make delivery of all goods belonging to Mr. [Payne] Whitney or to the estate of Mr. White . . . on Monday next."[8]

Many others were also caught in the confusion. Arnold, Constable & Company contacted White's office in reference to a telephone conversation that someone at the architectural firm had had with a Mr. St. John of Arnold, Constable "regarding the rugs for the Payne Whitney House, ordered by Mr. Stanford White, we would say that the bill was paid on July 17, '06. Our books do not show any rugs on approval or loaned against this transaction."[9] In an effort to settle Oliver Payne's financial obligations for the Payne Whitney house, William R. Mead wrote to the colonel in July 1907: "It would appear from a copy of a receipt handed me by Mr. Webster, which receipt is undated and said to be in Mr. White's handwriting, that he received $30,000, being 10% on $300,000, as therein stated, for purchases of tapestries, rugs, bric-a-brac, etc., such purchases being made in the summer and fall of 1905."[10]

THE SALES OF 1907

Several sales of White's belongings were held in the year after his death, and Bessie stipulated that whatever money was raised should be used to repay the debts that her late husband owed to the firm of McKim, Mead & White and to the numerous creditors. Thomas Kirby of the American Art Association in New York City conducted these sales and published catalogues for them. The first auction was held on 4 to 6 April 1907, and the catalogue for it was titled *Illustrated Catalogue of the Artistic Furnishings and Interior Decorations of the Residence no. 121 East Twenty-first Street . . . , to be sold at Unrestricted Public Sale by Order of the Estate of the Late Stanford White*. The second sale was only a few days later, on 11 and 12 April, with a catalogue titled *Old and Modern Paintings belonging to the Estate of the Late Stanford White*. The third sale came on successive days beginning on 25 November 1907 and was accompanied by its own catalogue: *Illustrated Catalogue of Valuable Artistic*

Property collected by the Late Stanford White . . . to be sold . . . by order of the Executrix. A separate catalogue of 1907 was entitled *Catalogue of Antique Marble and Stone Mantels, Sarcophagi, Fountains and Other Valuable Objects collected by the Late Stanford White.* It observed that the offering consisted of "many objects selected by Mr. White for his own use, as well as a large number of items which were intended to be used in construction and interior embellishment of such mansions and buildings as he might be called upon . . . to design and supervise."

Some items listed in the sale catalogues were merely curios, such as the "Armadillo guitar. Type used in South America" and the "Tusk of a hippopotamus, supporting two candle branches." But most entries referred to significant pieces, such as numerous architectural fragments and an "Elaborate Doorway. Antique Italian . . . carved oak and gilded . . . with Corinthian capitals, ht. 10' 11"." Also offered were rare Oriental carpets and numerous French and Flemish tapestries, a set of twelve large late-sixteenth-century French carved walnut sheep-footed armchairs, and another set of eight chairs of the same vintage, carved and gilded, with worsted needlework. A spectacular item was a "Beautiful Antique Louis XIV Ceiling. Composed of numerous inserted mirrors and ten medallion portraits of court beauties, among them Madame de Ludre, Marie de Viguerot Duchesse d'Aiguillon, Mlle. de Lonbes, Madame de Fontange and Mlle. de Monchi, all of which are surrounded by carved and gilt frames of entwined laurel wreath design, and the whole with an outer border of molding to match."[11]

The November sale also offered a rare Henri II boiserie of Italian workmanship (lot 358), decorated with medallions "illustrating many proverbs and sayings connected with love . . . , eight panels with painted canvas insertions," measuring 49 feet wide by more than 8 feet high. Another ceiling (lot 358a) was described as a "Grand French Renaissance White and Gold Ceiling, large center medallion of canvas, with finely painted decoration of 'Danaë, Jupiter and the Golden Shower,' which is surrounded by several elaborately carved and gilt borders of foliated and scroll designs, and a massive outer molding, 11' × 9"." Item number 438 in the November catalogue was listed as an ornate Henri II black and white mantel, measuring 14 feet high and 11 feet wide, with "a massive entablature [and] an elaborate frieze of floral garlands carved in bold relief; and [an] overmantel, supported by four fluted columns and four pilasters of similar design, with bases and Corinthian capitals, the whole surmounted by a life-size bust sculptured in white marble."

Lots 480 to 510 in the November sale referred to stained-glass windows, "mostly sixteenth and seventeenth-century French," with subjects such as a knight praying and such titles as *Descent from the Cross* and *Crucifixion.* The sale included a handsome selection of French and Flemish tapestries, and in the opinion of the *Times* reporter, the collection comprised "a half dozen of the choicest tapestries ever shown and put up for sale in New York."[12] Nearly forty of White's American and European paintings were placed on the auction block, along with Augustus Saint-Gaudens's little *Diana of the Tower,* Frederick MacMonnies's *Pan,* and Philip Martiny's *Aphrodite,* the model for the figurehead of Colonel Payne's yacht.

Indeed, the very ceilings, walls, and fireplaces of the grand rooms of the White residence were up for sale. The *Times* story about the April sale reported that "a representative of the Princeton [University] Club, which is to make over the house and occupy it, was present to bid on anything in the way of decorations the club might wish to retain."[13] The club bought the carved Caen stone Henri II mantel in the picture gallery for $1,100 and, the *Times* recounted, also purchased "the beautiful and elaborate Italian Renaissance mantel and over-mantel in the dining room. . . . Two antique red Verona marble columns, with elaborate capitals opposite the fireplace, went also to the Club . . . , and for the marble mantel and fireplace, Italian Renaissance, in the lower entrance hall they paid $475."[14]

The set of four grand Raphaelesque tapestries in the dining room, each of which was at least 11 feet wide, was broken up and distributed among four buyers, while the ornate ceiling of that room went to Howard Greenley, an architect who bought it for a client. Another architect, Charles Platt, purchased the antique red velvet off the walls of the drawing room, 114 yards of it, presumably also for a client. The ceiling of the drawing room (plate 5) went to William Randolph Hearst for $3,000. The *Times* observed that "it will cost between $200 and $300 to remove the decorated ceilings which the [Princeton] Club did not buy." As I noted in chapter 6, Colonel Samuel Colt bought most of the tiles off the walls at the entrance to the art gallery, and the showman David Belasco purchased the rest of them.[15]

SOCIETY ATTENDS THE WHITE SALE

"Rarely has the sale of a collector's private treasures in modern and old paintings and carvings, in Renaissance ceilings and hearth fronts, in old tiles and tapestries and fountains excited more interest among amateurs than the approaching dispersal of the art objects in the house of the late Stanford White," the *New York Times* reported in March 1907.[16] The

sales became celebrity social events, and at the same time they were a memorial of sorts to a departed friend. They were attended by the who's who of New York society—Virginia and William K. Vanderbilt Jr., Tessie Oelrichs, I. N. Phelps Stokes, Harriet and Robert Goelet, Mamie Fish, Cornelius Vanderbilt III, William Astor Chanler, Kate Pulitzer (wife of Joseph Pulitzer), John Wanamaker, John D. Rockefeller Jr., Mrs. George T. Bliss and George P. Bliss—most of whom bought items that would be mementos of their relationship with White.

Helen Whitney particularly relished the bidding wars with her rival, Gertrude Whitney. Elsie de Wolfe, White's protégé, bought the Louis XIV ceiling with the court beauties. The crowd showed its amusement when Colonel Colt, owner of vast rubber plantations, bought a rubber tree plant for $6. The Metropolitan Museum of Art acquired several items that went into its permanent collection—the Spanish Baroque doorway and wrought-iron gates, for example, that led into the art gallery, and the Italian grotesque tapestry (see figure 60).

Thus were the treasures from around the world—assembled by one very creative person, an aesthetic visionary of artistic inventiveness—dispersed from New York to California. For a while, others tried to continue what White had succeeded in doing—establishing an aristocratic architectural ambience as the backdrop for the tycoons of the Gilded Age—but the days of these nouveaux riches were waning, and few other architects did it with the flair and élan that Stanford White did.

Margaret Terry Chanler remembered White and his personality:

> He was a big red-headed man with a warm pleasant voice; he seemed to tingle with potential energy; there was something meteoric about his exits and entrances. Restless as a whirlwind, he would flash into a roomful of people on his way from one show to another, shake hands here and there, tell us how lovely something was, or how much he hated something else, and rush out again into the white night of Broadway, leaving us all exhilarated and a little breathless. . . . Stanford White was a kind of gay pagan who enjoyed life to the utmost and did much to make others enjoy it; he hated convention, affectation and pretense, and chose his friends in varied walks of life: artists, millionaires, and poor chorus girls shared his good will, and he was much beloved by all who knew him.[17]

Edith Wharton recalled that he was "one of a handful of 'men of exceptional intelligence' who, with their 'new ideas' on art 'stirred the stagnant air of old New York.'"[18]

Stanford White was a dynamo of creative energy and activity—restless, breezing in here to a party and departing, only to reappear elsewhere; working on a Long Island estate one day, supervising the details of a Newport "cottage" the next, and salmon fishing in Canada with William Kissam Vanderbilt by the following day; today in Paris, tomorrow in Brussels, and the next day on his way to Rome—not to mention the numerous escapades with carousing buddies such as the sculptor Augustus Saint-Gaudens or the love affairs with the likes of Evelyn Nesbit.

The several biographies of White's personal and professional life have not given due account of the enormous time and energy he expended as a designer of grandiose interiors and a procurer of the ancient boiseries that lined the walls, of the old Oriental carpets that lay so handsomely on the floors, of the carved and gilded coffered ceilings from some Venetian palazzo, of the richly ornamented fireplace from a French nunnery, of the splendid Louis XIV chairs in sets of twenty-four for a client's dining room, of Louis XV sofas and huge Louis XVI mirrors in ornately carved and gilded frames that reflected the soft lighting of a great Italian chandelier in the center of a grand ballroom.

White's special gift was his extraordinary ability to bring together in a decorative and imaginative manner the diverse objects that re-created in Fifth Avenue mansions and elsewhere the Old World aristocratic ambience that the new American millionaires craved as the backdrop for their lives. His style of decorating could be described as an aesthetic amalgamation of diverse periods and cultures, often arranged in a joyous clutter but always providing the noble veneer of Continental antiquity for which the brassy Gilded Age yearned. His mind spurned stereotypical and predictable academic solutions that tended to petrify glorious styles, such as the classicism of ancient Greece or Rome and the elegance of Louis XV's Rococo.

White was a key figure in the massive transplanting of antique European decorative arts into the New World. Indeed, he did for the decorative arts what men such as Henry Clay Frick and J. Pierpont Morgan did for the fine arts and European Old Masters. White was instrumental in the creation of period rooms, although he took a more cavalier attitude toward that phenomenon than did the museum curators who followed him, for he was neither an architectural historian nor a scholar of the decorative arts in the academic sense.

With the assistance of craftsmen from decorator houses such as Allard and Sons, White could piece together disparate twisted columns, architrave, pediment, and sculptured figures from different ages and create a shrine-like grand entrance to a salon. He could hang enormous tapestries about the room and throw in a few deer's heads, stag horns, and colorful flags and create a modern-day medieval hall. He was exceptional in the contacts that he commanded throughout the cosmopolitan, international network of dealers in antiquities—contacts who were essential to the creation of his grand interiors and to the new profession of interior decorator that he did so much to define. That part of his life was so very important to him as a person and as a creative designer that it deserves to be included in our knowledge of Stanford White, if the whole man is to be understood and appreciated for the rare and varied talents that he possessed.

Introduction

1. Joel Duveen to Stanford White, London, 20 April 1898, Stanford White Papers, Avery Architectural and Fine Arts Library, Columbia University in the City of New York (hereafter, SW Papers, Avery). A vast number of the McKim, Mead & White Papers survive at the New-York Historical Society (hereafter, MMW Papers, NYHS), as do some Stanford White Papers (hereafter, SW Papers, NYHS), although Avery Library became the main repository for them. These are two of the main sources of information for this book. Jean Charles de la Fosse (1734–1789), referenced in Duveen's letter, was a renowned French architect and furniture designer. Pierre Gouthiere (1732–1814) was famous for the metal (gold or gilded) mounts that he created for the furniture for the court of Louis XVI.

2. For the firm of McKim, Mead & White, see Leland Roth, *McKim, Mead & White, Architects* (New York: Harper & Row, 1983), and Richard Guy Wilson, *McKim, Mead & White, Architects* (New York: Rizzoli, 1983). The best biography of Stanford White is Paul Baker, *Stanny: The Gilded Life of Stanford White* (New York: Free Press, 1989).

3. Exceptions are Channing Blake, "Stanford White's New York Interiors," *The Magazine Antiques,* December 1972, pp. 1060–67, and Stephen Garmey, "Stanford White: Designer for a Gilded Age," in *Gramercy Park: An Illustrated History of a Neighborhood* (New York: Balsam, 1984), pp. 115–31.

4. As Germain Seligman recalls in the biography of his father, "To the art merchants of London or Paris, the American market before the turn of the century had not been impressive, representing only a few clients who could be counted upon to come to Europe year after year . . . and with few exceptions, American buying was indiscriminate. . . . To my father [Jacques Seligmann], the American market had hardly seemed to warrant the expenditure of time necessary for the long ocean voyage" (*Merchants of Art: 1880–1960, Eighty Years of Professional Collecting* [New York: Appleton-Century-Crofts, 1961], p. 18).

5. Quoted in "Louis Seize Decoration," *Art Amateur,* June 1886, p. 15.

6. Quoted in Harry Desmond and Herbert Croly, *Stately Homes in America* (New York: Appleton, 1903), p. 453.

7. John Russell Taylor, *The Art Dealers* (New York: Scribner, 1969), p. 75. A contemporary socialite commented on the raids of Old World antiquities by moguls of the Gilded Age: "They sent their experts to France to seek out the art treasures of France and Italy, gave them carte blanche to buy regardless of cost. Medieval chateaux of Touraine yielded up their tapestries and carvings, whole wainscotings, panel by panel; ancient Florentine palaces bade farewell to their frescoes. Suits of armor that had gathered the dust of centuries in grim old Scottish castles were ruthlessly packed and shipped across the Atlantic to lend realism to the newly-built feudal home of some baron of trade" (Elizabeth Wharton Drexel Beresford, *King Lehr and the Gilded Age* [New York: Arno, 1975], pp. 19–20).

8. Boni de Castellane, *How I Discovered America: Confessions of the Marquis Boni de Castellane* (New York: Knopf, 1924), p. 140.

9. The wealthy frequently voiced resentment of the decorator, as in the following, written in 1886: "One's home should express one's own feelings, and not those of some professional decorator who happens to be in vogue at the time. The taste of the latter is . . . bound to be transitory. And we who have to live in our houses . . . seek something that shall be restful . . . , rather than novel and startling, which is the beau-ideal of the tradesman or craftsman whose living depends, like that of the tailor and dressmaker, on changing the fashion as often as possible. . . . If you put your house into the hands of one of these firms, you simply condemn yourself to be a victim of the fad of the hour, and in nine cases out of ten are saddled with furniture which you do not like, and coloring which is wholly at variance with your own taste" ("The Decoration of Our Homes," *Art Amateur,* February 1886, p. 88).

10. Writing in 1882, Mary Elizabeth Wilson Sherwood observed the significance of the Philadelphia Centennial Exhibition: "The Philadelphia Exposition brought us all that the world could do in the way of household furnishings. With the wave of a wand the stuffs went into the shops, and the gentle housekeeper of today steps into a modern upholsterer's to find herself in the Hotel Cluny as to the laces, medieval tapestries, embroidered satins, . . . which await her selection. If she wishes a Lucretia Borgia cabinet or a Caterina Cornaro chest, she has a hundred examples to choose from" ("Certain New York Houses," *Harper's Monthly,* September 1882, p. 681).

11. Edith Wharton and Ogden Codman, *The Decoration of Houses* (New York: Scribner, 1897), p. xix. On the professional relationship between Wharton and Codman and Charles Follen McKim, see Pauline Metcalf, ed., *Ogden Codman and the Decoration of Houses* (Boston: Boston Athenaeum and Godine, 1988), pp. 152–53.

12. Louis Sullivan, *Kindergarten Chats and Other Writings* (New York: Wittenborn, Schultz, 1947), p. 37.

13. Desmond and Croly, *Stately Homes in America,* p. 494.

14. Mr. Dyer [of Bancroft & Dyer, Boston], in *Decorator and Furnisher,* January 1883, p. 126.

15. Candace Wheeler, *Principles of Home Decoration, with Practical Examples* (New York: Doubleday, Page, 1903), and *Yesterdays in a Busy Life* (New York: Harper, 1918).

16. "Louis Seize Decoration," p. 14. André-Charles Boulle (1642–1732), the foremost cabinetmaker to King Louis XIV, was especially known for the profusion of ornate gold or gilded mounts on his furniture.

17. "The Collection and Designing of Furniture," *Architectural Record,* April 1902, p. 119.

18. Ibid.

19. Theodore Child, "Decorative Art in Paris," *Decorator and Furnisher,* December 1882, p. 91.

20. White may have seen Frullini's work at the International Exposition in Paris in 1878. The Italian's artistry was well known in Europe, England, and the United States. For example, White probably knew Frullini's work from visiting Richard Morris Hunt's Château-sur-Mer in Newport, Rhode Island; several pieces of Frullini's furniture from that house are now in the Philadelphia Museum of Art.

21. Doreen Bolger Burke, Alice Cooney Frelinghuysen, and Catherine Hoover Voorsanger, *In Pursuit of Beauty: Americans and the Aesthetic Movement* (New York: Rizzoli, for the Metropolitan Museum of Art, 1986).

22. Desmond and Croly, *Stately Homes in America*, p. 458.

23. Lawrence Wodehouse, *White of McKim, Mead and White* (New York: Garland, 1988); Baker, *Stanny*; David Lowe, *Stanford White's New York* (New York: Doubleday, 1992). Suzannah Lessard presents a personal view in *The Architect of Desire: Beauty and Danger in the Stanford White Family* (New York: Dial, 1996).

24. Baker, *Stanny*, p. 33.

25. Ronald Pisano, "The Tile Club, 1877–1887," *American Art Review,* November–December 1999, pp. 188–97.

26. Charles Moore, *The Life and Times of Charles Follen McKim* (1929; reprint, New York: Da Capo, 1970).

27. Margaret Terry Chanler, *Roman Spring* (Boston: Little, Brown, 1934), p. 226.

1. Stanford White as Dealer in Antiquities

1. Linda H. Roth, *J. Pierpont Morgan, Collector* (Hartford, Conn.: Wadsworth Atheneum, 1987), p. 37; Lawrence Grant White, *Sketches and Designs by Stanford White* (New York: Architectural Book Publishing, 1920), pp. 24–25. See also Paul Baker, *Stanny: The Gilded Life of Stanford White* (New York: Free Press, 1989), p. 235.

2. Duveen Brothers to SW, London, 17 September 1898, SW Papers, Avery. The house of Duveen was run by Joel Duveen and his brother, Henry, and then specialized in fine decorative arts more than in paintings. Later, when Joel's son Joseph became prominent in the firm, he greatly increased the firm's activities in the fine arts, especially the choicest works by the Old Masters.

3. Stefano Bardini to SW, Florence, 10 September 1898, SW Papers, Avery.

4. Stefano Bardini to SW, Florence, 24 July 1898, SW Papers, Avery.

5. Stefano Bardini to SW, Florence, 8 August 1898, SW Papers, Avery.

6. Howard Saalman, *Haussmann: Paris Transformed* (New York: Braziller, 1971); David Pinkney, *Napoleon III and the Rebuilding of Paris* (Princeton, N.J.: Princeton University Press, 1958).

7. Louis Auchincloss, *J. P. Morgan: Financier as Collector* (New York: Abrams, 1990), p. 62. See also André Pérate and Gaston Brière, *Collections Georges Hoentschel, acquisés par M. J. Pierpont Morgan et prêtées au Metropolitan Museum de New York,* 4 vols. (Paris: Librairie centrale des Beaux-Arts, 1908). Morgan purchased the collection in 1906, and it took 364 packing cases to ship it to New York. See *New York Times,* 23 May 1907, p. 9, and 6 June 1907, p. 6. On the Hoentschel collection, see "The Hoentschel Collection," *Bulletin of the Metropolitan Museum of Art,* June 1907, pp. 94–99; July 1908, pp. 129–33; August 1908, pp. 149–53; and March 1910, pp. 5–29; and Nicole Hoentschel, James Parker, David W. Wright, Jean Soustiel, and François Chapon, *Georges Hoentschel* (Château de Saint-Remy en l'Eau: Monelle Hayot, 1999).

8. "Hoentschel Collection," p. 94. This article contains several illustrations of Hoentschel's apartments in Paris that were crammed full of the things he had collected, and it notes that "it has been determined that this collection shall form the beginning of a Department of European Decorative Art, which is to be installed in a section of the [Met] building designed and constructed especially for it. . . . The plans have been prepared by McKim, Mead and White" (p. 98).

9. Duveen Brothers to SW, London, 22 December 1897, SW Papers, Avery.

10. Stefano Bardini to SW, Florence, 24 July 1898, SW Papers, Avery.

11. James Maher has noted that "since the completion of Alva's [Vanderbilt's] chateau at 660 Fifth Avenue in December, 1882, Hunt made Allard his virtual partner in the execution of the interiors of his great palace projects" (*The Twilight of Splendor: Chronicles of the Age of American*

Palaces [Boston: Little, Brown, 1975], p. 279). The same author writes that "Allard had an arrangement with the designer Eugene Prignot, who also prepared designs in the 1850s for the furniture makers Jackson and Graham in London. Many of Prignot's designs for individual pieces of furniture as well as for elaborate compositions of curtains, valences, portieres, and boiserie were published, and furniture he designed won awards in major expositions in Vienna and Paris" (p. 54).

12. Pauline Metcalf, ed., *Ogden Codman and the Decoration of Houses* (Boston: Boston Athenaeum, 1988), p. 24.

13. Nicholas King, quoted in Metcalf, ed., *Ogden Codman and the Decoration of Houses*, p. 45.

14. Jules Allard to SW, Paris, 28 October 1897, SW Papers, Avery.

15. Allard and Sons to SW, Paris, 2 January 1901, SW Papers, Avery.

16. Allard and Sons to SW, Paris, 2 November 1901, SW Papers, Avery.

17. Duveen's to SW, London, 28 November 1900, SW Papers, Avery.

18. Edward Fowles, *Memories of Duveen Brothers* (London: Times Books, 1976), p. 7.

19. Ibid.

20. Pauline Metcalf, "The Interiors of Ogden Codman, Jr., in Newport, Rhode Island," *The Magazine Antiques,* September 1980, p. 488.

21. Fowles, *Memories of Duveen Brothers*, p. 11.

22. Collis P. Huntington had bought from Duveen Brothers a set of tapestries designed by François Boucher that were sent to Paris, where Carlhian & Beaumetz made reproduction sofas and chairs to which the tapestries were applied. But Huntington did not take them, and they were sold to the Paris dealer Jacques Seligmann, at whose establishment they were seen by Huntington's wife, Arabella, who bought them, not knowing of her husband's earlier connection with them. They are now in the Huntington Collection in California.

23. Fowles, *Memories of Duveen Brothers*, p. 20.

24. Frederick Vanderbilt to MMW, Newport, R.I., 13 September 1897, SW Papers, Avery. McKim, Mead & White completed plans for the Vanderbilt mansion in 1896; it was finished in 1899.

25. MMW to Frederick Vanderbilt, contract, 17 September 1897, SW Papers, Avery.

26. Charles Follen McKim to SW, New York, 17 September 1897, SW Papers, Avery.

27. SW to Colonel Oliver Payne, New York, 2 June 1898, SW Papers, Avery.

28. Harry Payne Whitney to SW, undated, SW Papers, NYHS. The strife within the two families, which I discuss in chapter 3, was caused by William C. Whitney's remarrying after the death of his first wife, Flora, who was the sister of Oliver Payne.

29. SW to Harry Payne Whitney, 2 June 1898, SW Papers, Avery.

30. Lowengard's to SW, Paris, 29 October 1897, SW Papers, Avery.

31. Jules Lowengard to SW, Paris, undated other than 1897, SW Papers, Avery.

32. Jules Lowengard to SW, Paris, 21 April 1899, SW Papers, Avery.

33. Godfrey Kopp to SW, Rome, 18 December 1897, SW Papers, Avery.

34. Godfrey Kopp to SW, Rome, 4 April 1898, SW Papers, Avery.

35. Godfrey Kopp to SW, Rome, 11 November 1897, SW Papers, Avery.

36. Godfrey Kopp to SW, Rome, 20 December 1897, SW Papers, Avery.

37. Godfrey Kopp to SW, Rome, 17 October 1897, SW Papers, Avery.

38. Godfrey Kopp to SW, Rome, 15 July 1900, SW Papers, Avery.

39. Robert Fisher & Company to MMW, invoices, SW Papers, Avery.

40. Henry Duveen to SW, London, 10 June 1898, SW Papers, Avery.

41. For the story of Kopp's escapades, see Fowles, *Memories of Duveen Brothers,* p. 27. An account of Kopp's fraudulent adventures, based on Fowles's memoirs, is in Colin Simpson, *Artful Partners: Bernard Berenson and Joseph Duveen* (New York: Macmillan, 1986), pp. 94–101.

42. Boni de Castellane, *How I Discovered America: Confessions of the Marquis Boni de Castellane* (New York: Knopf, 1924), p. 34.

43. *American Architect and Building News,* 6 June 1891, p. 142.

44. On Benguiat, see Wesley Towner, *The Elegant Auctioneers* (New York: Hill and Wang, 1970), pp. 158–75. In April 1919, more than 1,140 items of Vitall Benguiat's stock were auctioned off, and the catalogue of the sale gives a good idea of the rare textiles in which he dealt. See *Rare and Beautiful Textiles and Embroideries Dating from the Fifteenth to the Eighteenth Century* (New York: American Art Association, 1919), and *New York Times,* 4 April 1919, p. 10, and 13 April 1919, p. 18.

45. Vitall Benguiat to SW, London, 1 and 20 November 1897, SW Papers, Avery.

46. V. Benguiat to SW, London, 16 April 1898, SW Papers, Avery.

47. V. Benguiat to SW, London, 18 May 1898, SW Papers, Avery.

48. "Articles in House," 30 March 1900, William C. Whitney folder, SW Papers, Avery.

49. V. Benguiat to SW, London, 8 February 1899, SW Papers, Avery.

50. See introduction, note 4.

51. Benjamin Benguiat to SW, New York, invoice, 18 February 1905, SW Papers, Avery.

52. Let me identify here several names and institutions to which I will refer numerous times in connection with tapestries and carpets. Gobelins, established just outside Paris in the seventeenth century during the reign of Louis XIV, had perhaps the most famous tapestry looms of all. Beauvais refers to the French city of that name where another celebrated manufactory was founded in 1664 and achieved its zenith during the directorships of Jean-Baptiste Oudry (1726–1755) and François Boucher (1756–1770), both of whom made designs for tapestries. At Aubusson, a town in central France, ateliers began weaving tapestries and carpets as early as the fifteenth century and remained renowned through the nineteenth century. Flemish tapestries refers to works woven from the fifteenth century on, in centers such as Brussels, Bruges, and Ghent in present-day Belgium.

53. Joel Duveen to SW, London, 20 April 1898, SW Papers, Avery.

54. Tiffany Studios to SW, New York, 13 July 1903, MMW Papers, NYHS.

55. Quoted in George Sheldon, ed., *Artistic Houses: Being a Series of Interior Views of a Number of the Most Beautiful and Celebrated Homes in the United States* (New York: Appleton, 1884), vol. 2, p. 82.

56. Edith Wharton and Ogden Codman, *The Decoration of Houses* (New York: Scribner, 1897), p. 38.

57. That the middle class imitated the plutocrats' fondness for tapestries was noted in an article of 1887 that informed its readers that a wide range of wallpaper, "in imitation of silks, velvets, tapestries, and brocatelles is to be found at the rooms of Messrs. Frederick Beck & Co. . . . But with this firm the rage for Louis XVI decoration has . . . found striking recognition by the introduction of the novelty of actual canvas panels, painted in colors in imitation of the genuine Beauvais and Gobelins [tapestries]" ("Decorative Wallpapers," *Art Amateur,* October 1887, p. 106).

58. An example of a Merton Abbey work is the *Greenery* tapestry, designed in 1892 by John Henry Dearle but not woven until 1905. See *The Metropolitan Museum of Art Guide,* 2nd ed. (New York: Metropolitan Museum of Art and Abrams, 1994), fig. 63, p. 286.

59. Jules Lowengard to SW, Paris, 21 April 1899, SW Papers, Avery.

60. Ibid.

61. Emile Gavet to SW, Paris, 28 October 1899, SW Papers, Avery.

62. On the Gavet collections, see Emile Molinier, *Collection Emile Gavet* (Paris, 1889); *Catalogue des objets d'art et de haute curiosité, de la Renaissance. Tableaux, tapisseries composant la collection de M. Emile Gavet et dont le vente aura lieu Galerie Georges Petit* . . . (Paris, 1897); and *Catalogue des tableaux anciens et quelques modernes . . . provenant de la collection de feu M. Emile Gavet* (Paris, 1906); and Deborah Krohn, "The Gavet-Vanderbilt-Belmont Collection," in Mark Ormond, ed., *John Ringling: Dreamer, Builder, Collector: The Legacy of the Circus King* (Sarasota, Fla.: John and Mable Ringling Museum of Art, 1997), pp. 139–48.

63. George Donaldson to SW, London, 31 March 1903, SW Papers, Avery.

64. Catharine Hunt, "Richard Morris Hunt," ca. 1905, typescript, vol. 3, pp. 336, 338, American Institute of Architects, Washington, D.C.

65. Ibid., p. 343.

66. On American interest in Chantilly and the duc d'Aumale's restorations there, see three articles in *American Architect and Building News*: "The Palace of Chantilly," 17 July 1886, pp. 34–35; "The Château de Chantilly and Its Treasures," 20 November 1886, pp. 246–47; and "Chantilly," 27 October 1888, pp. 196–97. The fortress-like château at Chantilly was built in the sixteenth and seventeenth centuries, but was destroyed on order of the Convention after the French Revolution. The duc d'Aumale, a son of Louis-Philippe, began its reconstruction around 1874 and gave it to the people of France in 1883.

67. SW to Stefano Bardini, Paris, 27 October 1897, SW Papers, Avery.

68. Stefano Bardini to SW, Florence, 7 November 1897, SW Papers, Avery.

69. Galleries Heilbronner, Paris, shipping lists, undated, SW Papers, NYHS.

70. "February, 1899. Sold to Stanford White, for the Hon. William C. Whitney," inventory on McKim, Mead & White stationery, SW Papers, Avery.

71. Waldo Story to SW, Rome, 12 November 1905, SW Papers, NYHS.

72. Simonetti to SW, Rome, invoice, 20 November 1905, SW Papers, NYHS.

73. F. Schutz to SW, Paris, invoices, 16 August and 14 September 1905, SW Papers, NYHS.

2. Dealers, Agents, Forgers, Export Laws, and Stanford White

1. Charles Loeser to SW, Florence, 16 August 1905, SW Papers, NYHS.

2. Charles Coleman to SW, Capri, 22 October 1900, SW Papers, NYHS.

3. Charles Coleman to SW, Capri, 15 September 1900, SW Papers, NYHS.

4. Charles Coleman to SW, Capri, 18 September 1900, SW Papers, NYHS.

5. Charles Coleman to SW, Capri, 27 September 1900, SW Papers, NYHS.

6. Charles Coleman to SW, Capri, 1 November 1900, SW Papers, NYHS.

7. Charles Coleman to SW, Capri, 8 November 1900, SW Papers, NYHS.

8. Charles Coleman to SW, Capri, 22 October 1900, SW Papers, NYHS.

9. Emma Richards to Charles Coleman, Rome, 3 October 1900, SW Papers, NYHS.

10. Ramponi & Cremonesi to SW, Rome, 22 December 1905, SW Papers, NYHS.

11. G. Giacomini to SW, invoice, 18 December 1905, per Francesca from Trieste, SW Papers, NYHS.

12. A. & A. Iandolo to SW, Rome, invoice, 31 July 1905, SW Papers, NYHS.

13. Bernard Berenson to Isabella Stewart Gardner, Florence, 16 July 1921, in *Letters of Bernard Berenson and Isabella Stewart Gardner, 1887–1924*, ed. Rollin van N. Hadley (Boston: Northeastern University Press, 1987), p. 633.

14. SW to William C. Whitney, Paris, undated (1898?), SW Papers, NYHS.

15. Giuseppe Salvadori to SW, Florence, invoice, 6 September 1905, SW Papers, NYHS. The invoice refers to items to be shipped on the *Princess Irene*.

16. Giuseppe Salvadori, invoice, undated, SW Papers, NYHS.

17. Manifattura di Signa of Florence to SW, Florence, invoice, 26 August 1905, SW Papers, NYHS. The invoice refers to three cases of terra-cotta objects to be shipped to New York on the SS *Cretic*.

18. Guiseppe Santoni to SW, Florence, invoice, 14 September 1905, SW Papers, NYHS. The invoice refers to furniture, metal goods, and velvet goods to be shipped on the SS *Alberia*.

19. Gabriele Egidi to MMW, Florence, 12 October 1905, SW Papers, NYHS. The invoice refers to nine cases to be shipped from Leghorn to New York on the SS *Italia*.

20. Although Volpi had been dealing in antiquities long before 1904, that was the year that he bought the Palazzo Davanzati. By 1911, he had largely completed his restorations, which proved to be financially ruinous for him; in 1924 he was forced to sell his palazzo, and the buyer was none other than Vitall Benguiat, who then made it his Florence residence. The Italian government bought it in 1951 and opened it as a public museum of the early Florence home. See Louis C. Newhall, "The Restored Palace of the Davanzati, Florence, Italy," *American Architect*, 24 July 1912, pp. 25–28.

21. *The Exceedingly Rare and Valuable Art Treasures and Antiquities formerly contained in the Famous Davanzati Palace, Florence, Italy, and recently brought to America by their Owner, The Recognized Expert and Connoisseur, Professor Commendatore Elia Volpi . . . [to be sold] at the American Art Galleries . . . beginning November 16, 1916* (New York: American Art Association, 1916). On Volpi and his sales in New York, see Wesley Towner, *The Elegant Auctioneers* (New York: Hill and Wang, 1970), pp. 319–21. On the types of things that Volpi brought to New York and the various problems he had, see *New York Times,* 20 November 1915, p. 6; 23 November 1915, p. 22; 24 November 1915, p. 8; 18 December 1917, p. 15; and 20 December 1917, p. 20.

22. Isabella Stewart Gardner to Mary and Bernard Berenson, Brookline, Mass., 10 November 1916, in *Letters of Bernard Berenson and Isabella Stewart Gardner,* p. 590.

23. On Bardini's sale in New York, see *De Luxe Illustrated Catalogue of the . . . Treasures and Antiquities Illustrating the Golden Age of Italian Art, belonging to the famous expert, Signor Stefano Bardini . . .* (New York: American Art Association, 1918).

24. Davies Turner & Company, Florence, shipping manifest, 18 January 1906, SW Papers, NYHS. These items were invoiced by Bardini and shipped aboard the *St. Prinz Oscar* out of Genoa on 15 January 1906.

25. Fiorenze Acalia and Cristina de Benedictis, *Il Museo Bardini a Firenze,* 2 vols. (Milan: Electra, 1984). Karl Baedeker described the building as "incorporating various old architectural embellishments, such as the windows of the facade (partly constructed of old altars) and the fine coffered ceilings and marble doors" (*Northern Italy* [New York: Scribner, 1930], p. 636). Another guidebook noted that "many of the rooms have fine doorways brought from demolished buildings" (Stuart Rossiter, ed., *Northern Italy: From the Alps to Rome,* 6th ed. [London: Benn, 1971], p. 448).

26. Stefano Bardini to SW, Florence, 22 January 1898, SW Papers, Avery.

27. Stefano Bardini to SW, cablegram from France, 23 April 1898, SW Papers, Avery.

28. Stefano Bardini to SW, Florence, 24 July 1898, SW Papers, Avery.

29. Stefano Bardini to SW, Florence, 8 August 1898, SW Papers, NYHS.

30. Stefano Bardini to SW, Florence, 10 September 1898, SW Papers, Avery.

31. Charles Coleman to SW, Capri, 22 October 1900, SW Papers, NYHS.

32. Translated in *American Architect and Building News,* 11 April 1891, p. 32. A later issue of the same periodical carried another explanatory notice: "The law at present . . . is a legacy of the past state of the Italian political organization, each of the old States retaining its law of days prior to their union in the present kingdom. In Rome the Pacca edict is in vogue; in Florence there is another law; in Naples a decree of the Bourbons; and in the ex-Austrian States one more liberal than either of the others" (*American Architect and Building News,* 26 September 1891, p. 204). When government export permits were involved, however, it seems the Pacca Edict was called into play throughout the land.

33. *American Architect and Building News,* 19 March 1892, p. 191.

34. *New-York Tribune,* quoted in *American Architect and Building News,* 11 April 1891, p. 32.

35. *New York Times,* 31 July 1891, p. 1.

36. *New York Times,* 8 August 1891, p. 1. The "crash" was the long depression in prices between 1873 and 1896.

37. Quoted in *American Architect and Building News,* 5 December 1891, p. 144.

38. *American Architect and Building News,* 19 March 1892, p. 191.

39. *American Architect and Building News,* 3 June 1899, p. 80.

40. Quoted in *American Architect and Building News,* 19 March 1892, p. 192.

41. Quoted in *American Architect and Building News,* 1 September 1894, pp. 83–84.

42. *American Architect and Building News,* 15 October 1892, p. 48.

43. "American Artists and Imported Pictures—The Movement to Tax Foreign Works of Art," *New York Times,* 7 January 1867, p. 2.

44. *U.S. Statutes at Large* 30 (1897): 203–4, 212; Scott Hodes, "Customs," in *The Law of Art & Antiques: A Primer for Artists and Collectors* (Dobbs Ferry, N.Y.: Oceana, 1966), pp. 67–79.

45. Charles Coleman to SW, Capri, 27 September 1900, SW Papers, NYHS.

46. Vitall Benguiat to SW, London, 16 April 1898, SW Papers, Avery.

47. Jules Lowengard to SW, Paris, 7 October 1897, SW Papers, Avery.

48. "Spurious Works of Art Began Early," *American Architect and Building News,* 2 April 1892, p. 16.

49. Duveen's to SW, London, 21 May 1898, SW Papers, Avery.

50. "Sham Antiquities in France," *American Architect and Building News,* 4 January 1888, p. 55.

51. "Counterfeit 'Antique' Furniture," *American Architect and Building News,* 6 November 1886, pp. 223–24.

52. Edward Fowles recalled how the house of Duveen, too, was once fooled: "One day he [Joseph Duveen] saw an Italian marble Madonna on the staircase at Baron Rothschild's house and promptly bought it for $10,000. When he subsequently showed it to the experts he was informed that it was a forgery of the nineteenth century, made by a well known forger Bastianini, some of whose works were in the Victoria and Albert Museum" (*Memories of Duveen Brothers* [London: Times Books, 1976], p. 12).

53. An interesting case in point is Bastianini's *Portrait of a Lady, Giovanni Albizzi,* a polychromed wood bust created in 1860. A few years later, it was bought by the dealer Francesco Simonelli, with whom White did business. The Duveens eventually acquired it, believing it to be a genuine Renaissance piece, and in 1935 sold it to the Toledo Museum of Art. That institution returned it the next year to Duveen's, which immediately sold it to the Andrew Mellon Charitable Trust, which gave it to the National Gallery of Art in Washington, D.C., in 1937, and there it remains.

54. *New York Times,* 26 April 1868, p. 9.

55. Bernard Berenson to Isabella Stewart Gardner, Fiesole, 12 December 1897, in *Letters of Bernard Berenson and Isabella Stewart Gardner,* p. 109.

56. *American Architect and Building News,* 21 December 1895, p. 129.

3. The William C. Whitney and Oliver Hazard Payne Houses

1. For accounts of Whitney and his family, see Mark D. Hirsch, *William C. Whitney, Modern Warwick* (New York: Dodd, Mead, 1948), and W. A. Swanberg, *Whitney Father, Whitney Heiress* (New York: Scribner, 1980).

2. For a description of the interiors of the Whitneys' house in Washington, D.C., see *New York Times,* 2 January 1886, p. 2. The architect was Charles H. Kelley of New York, and the decorator was a man named Watson, presumably Henry Watson of New York.

3. Henry Adams, *The Education of Henry Adams: An Autobiography* (Boston: Houghton Mifflin, 1918), p. 137.

4. *Art Amateur,* October 1887, p. 107. See also "The House on the Corner of 57th Street and Fifth Avenue, New York City," *New-York Sketch-Book of Architecture,* September 1875, p. 1 and unnumbered plate.

5. Mary Elizabeth Wilson Sherwood, "Certain New York Houses," *Harper's Monthly,* September 1882, p. 688. For illustrations of the Stevens house interiors, see Arnold Lewis, James Turner, and Steven McQuinn, *The Opulent Interiors of the Gilded Age* (New York: Dover, 1987), plates 21–23.

6. An even earlier example was the Deacon house in Boston, which was designed around 1847 by Charles Lemoulnier, who had come over from France only a few years earlier; for the interiors of some of its rooms, he used the boiserie taken from the Hôtel de Montmorency in Paris.

7. For an early account of Whitney's successes, see "William C. Whitney," *New York Times,* 20 November 1898, supplement, p. 1.

8. One account took note of Whitney's numerous properties: "The purchase of Mr. Whitney's Aiken property was made at the same time he gave the order to build to his archi-

tect Mr. George A. Freeman of . . . New York. Mr. Freeman has done considerable work for Mr. Whitney and his son, H. P. Whitney, at Newport, Lenox and Westbury" ("Mr. Whitney's Southern Home," *New York Times Illustrated Magazine,* 16 January 1898, pp. 14–15).

9. Harry Payne Whitney wrote to his father shortly after the wedding, expressing his surprise at the elder Whitney's remarriage, and declaring: "The house is so much Mamma's that it's hard enough to think of somebody living in it in her place" (Hirsch, *William C. Whitney,* p. 571).

10. For an illustration of the art gallery in Stuart's time, see George William Sheldon, ed., *Artistic Houses: Being a Series of Interior Views of a Number of the Most Beautiful and Celebrated Homes in the United States* (New York: Appleton, 1884), vol. 2, p. 87. William Schickel, a German immigrant who had worked for Richard Morris Hunt for a while, designed Stuart's mansion. The interiors were by William B. Bigelow, who a few years earlier had been a partner in the firm of McKim, Mead and Bigelow and in the early 1880s had worked for Herter Brothers, the decorators. Robert L. Stuart died in December 1882, the year before the house was finished; his widow continued to live in it until her death in 1891, after which the property was put on the market.

11. Boni de Castellane, *How I Discovered America: Confessions of the Marquis Boni de Castellane* (New York: Knopf, 1924), p. 34.

12. SW to William C. Whitney, Paris, undated (probably 1898), SW Papers, NYHS.

13. Ibid.

14. "February, 1899. Sold to Stanford White, for the Hon. William C. Whitney," inventory on McKim, Mead & White stationery, SW Papers, Avery.

15. Accounts, box 28, SW Papers, Avery.

16. Duveen Brothers to SW, London, 15 January 1898, SW Papers, Avery.

17. This very same cassone is illustrated in William M. Odom, *A History of Italian Furniture from the Fourteenth to the Early Nineteenth Century* (Garden City, N.Y.: Doubleday, Page, 1918), vol. 1, p. 52.

18. *Important Gobelins, Beauvais and Brussels Tapestries, Fine French Furniture and Paintings . . . Property of the Estate of the Late Harry Payne Whitney* (New York: Parke-Bernet Galleries, 1942), p. 17, lot 90.

19. Edward Simmons, *From Seven to Seventy: Memories of a Painter and a Yankee* (New York: Harper, 1922), p. 240.

20. The Metropolitan Museum of Art bought these Diana tapestries during the 1942 sale. See Edith A. Standen, *European Post-Medieval Tapestries . . . in the Metropolitan Museum of Art* (New York: Metropolitan Museum of Art, 1985), vol. 1, p. 249.

21. *New York Times,* 28 December 1900.

22. Duveen Brothers to SW, London, 15 December 1897, SW Papers, Avery.

23. Georges Allard to SW, Paris, 29 October 1897, SW Papers, Avery.

24. *The Palatial Mansion of the Late James Henry Smith, and Its Exceedingly Rare and Costly Artistic Furnishings and Embellishments,* deluxe ed. (New York: American Art Association, 1910), quoted in B. H. Friedman, *Gertrude Vanderbilt Whitney* (Garden City, N.Y.: Doubleday, 1978), p. 270.

25. SW to William C. Whitney, probably Paris, 2 June 1898, SW Papers, Avery.

26. *New York Times,* 5 January 1901, p. 3.

27. Edith Wharton, *The House of Mirth* (New York: Scribner, 1951), pp. 132, 160.

28. *New York Times,* 5 January 1901, p. 3. This tapestry is now in the Art Institute of Chicago, a gift of the children of Gertrude Vanderbilt Whitney. Another of the series, *The Flute Player,* is in the Cleveland Museum of Art; its provenance includes ownership by Count Boni de Castellane and J. Pierpont Morgan.

29. Duveen Brothers to SW, London, 2 June 1898, SW Papers, Avery.

30. "Accounts Paid," 28 September 1898, SW Papers, Avery.

31. Allard and Sons to MMW, invoice, 2 January 1901, SW Papers, Avery.

32. William Baumgarten to SW, New York, 25 June 1903, SW Papers, Avery.

33. Harriet Elizabeth Spofford, *Art Decoration Applied to Furniture* (New York: Harper, 1878), p. 130.

34. *Art Amateur,* November 1899, p. 133.

35. *Art Amateur,* November 1888, pp. 137–38.

36. *Art Amateur,* October 1887, p. 107.

37. On the matter of the early efforts to create period rooms at the Met, see "French Art of the Seventeenth and Eighteenth Centuries," *Bulletin of the Metropolitan Museum of Art,* March 1910 supplement, pp. 20–29, with numerous illustrations. On period rooms at the Met in general, see James Parker et al., *Period Rooms in the Metropolitan Museum of Art* (New York: Abrams, 1996).

38. SW to Oliver Payne, New York, 2 June 1898, SW Papers, Avery.

39. René Gimpel, *Diary of an Art Dealer* (New York: Farrar, Straus and Giroux, 1966), p. 301.

40. Henry Adams to Elizabeth Cameron, 11 January 1903, in *Henry Adams: Selected Letters,* ed. Ernest Samuels (Cambridge, Mass.: Harvard University Press, 1992), p. 428. The Turner painting, then called *St. Mark's Place* but now titled *Juliet and Her Nurse,* was bought by Colonel Payne in 1901.

41. Duveen Brothers to SW, London, 21 March 1900, SW Papers, Avery.

42. "List of Things bought by Col. Oliver H. Payne," undated, Payne Whitney folders, MMW Papers, NYHS. The name of the colonel's nephew is written at the top of the first page.

43. For accounts of the sale and descriptions of the rooms and objects see *New York Times,* 10 April 1942, p. 19; 26 April 1942, sec. 2, p. 2; 28 April 1942, p. 15; 30 April 1942, p. 22; and 31 October 1942, p.17.

4. The Payne Whitney House

1. For her poetry, see, for example, *Gypsy Verses* (New York: Duffield, 1907). Her father is said to have confiscated all copies of one volume of her poetry out of concern that it would be an embarrassment to the family.

2. Construction was carried out by the firm of J. C. Lyons, while the Otis Elevator Company installed the elevator.

3. Ellin & Kitson to MMW, New York, 2 February 1903, MMW Papers, NYHS.

4. Adolph Weinman to MMW, bill for services, 21 February 1905, MMW Papers, NYHS. A few years earlier, Payne Whitney's future sister-in-law, Gertrude Vanderbilt Whitney, had determined to become a sculptor; she went to Paris to study with Andrew O'Connor and developed a close relationship with him.

5. Adolph Weinman to MMW, New York, 13 November 1905, box 508, MMW Papers, NYHS.

6. Adolph Weinman to MMW, New York, 17 January 1906, box 508, MMW Papers, NYHS.

7. SW to Colonel Oliver Payne, New York, 2 March 1906, MMW Papers, NYHS.

8. T. D. Wadelton & Company, 160 Fifth Avenue, New York City, agreement, on McKim, Mead & White form, 17 November 1903, MMW Papers, NYHS.

9. T. D. Wadelton & Company, contract, 1904, MMW Papers, NYHS.

10. MMW to Allard and Sons, "Residence of Payne Whitney, Esq." (for use in making a bid), undated (mid-1905?), MMW Papers, NYHS.

11. Allard and Sons to MMW, bid, 7 July 1905, MMW Papers, NYHS.

12. Francis Bacon to SW, Boston, 14 November 1904, MMW Papers, NYHS.

13. Davenport's to MMW, "Schedule of Furniture Ordered for Mr. Payne Whitney's Residence," 1 May 1905, box 503, MMW Papers, NYHS. "In cotton" refers to a basic cotton upholstery covering, not the fine velvet, brocade, or whatever that would be applied over it as the finish fabric.

14. Daniel Webster to SW, New York, 7 March 1907, box 508, MMW Papers, NYHS.

15. Tiffany Studios to MMW, New York, 20 February 1906, box 507, MMW Papers, NYHS.

16. Adolph Weinman to SW, New York, 5 June 1906, box 508, MMW Papers, NYHS.

17. The Renaissance scholar Alessandro Parronchi attributed *Cupid* to Michelangelo in 1968 and again in 1981. The issue came before students of Michelangelo once more in 1996 when Kathleen Weil-Garris Brandt, a professor at the Institute of Fine Arts, New York University, declared the marble figure to be by the great Italian master himself. In 2000 the piece, now owned by the government of France, was sent on tour to Florence and Paris, where it was displayed in the presence of works known to be by Michelangelo, to permit experts to make stylistic comparisons. The scholarly community remains divided over the question of its attribution.

18. "I herewith return marble turtle used as model for the three turtles for fountain in Payne Whitney Residence" (Adolph Weinman to Daniel Webster of MMW, probably September 1906, box 508, MMW Papers, NYHS).

19. *New York Times*, 13 September 1905, p. 9. See also *New York Times*, 27 July 1905, p. 1, and 30 August 1905, p. 9. For illustrations of the panels owned by the Metropolitan Museum of Art, see Katharine Baetjer, *European Paintings in the Metropolitan Museum of Art, by Artists Born Before 1865* (New York: Metropolitan Museum of Art, 1995), p. 103. Rollins College in Winter Park, Florida, owns two additional panels, seven more are in two private collections, and the whereabouts of one are unknown.

20. Allard and Sons to MMW, 19 October 1906, box 503, MMW Papers, NYHS.

21. Allard and Sons to MMW, 26 November 1906, MMW Papers, NYHS.

22. Duveen Brothers to MMW, 6 November 1906, MMW Papers, NYHS.

23. Janet Parks, *The Old World Builds the New: The Guastavino Company and the Technology of the Catalan Vault, 1885–1962* (New York: Avery Architectural and Fine Arts Library and the Wallach Gallery, Columbia University, 1996).

24. Atlantic Terra Cotta Company to MMW, 2 May 1905, MMW Papers, NYHS.

25. Adolph Weinman to Daniel Webster, New York, 12 June 1906, MMW Papers, NYHS.

26. Adolph Weinman to MMW, New York, 18 June 1906, MMW Papers, NYHS.

27. Daniel Webster to T. D. Wadelton, New York, 9 May 1906, MMW Papers, NYHS.

28. Daniel Webster to SW, 13 January 1903, MMW Papers, NYHS.

29. SW to Colonel Oliver Payne, New York, 7 May 1905, MMW Papers, NYHS.

30. List, undated (probably spring 1905), MMW Papers, NYHS. William Kent (1685–1748), mentioned in the list, was an English architect and designer of elaborate furniture.

31. Henry Adams to Elizabeth Cameron, 16 July 1905, in *Letters of Henry Adams, 1892–1918,* ed. Worthington Chauncey Ford (Boston: Houghton Mifflin, 1930), p. 460.

32. Simonetti to SW, Rome, invoice, 20 November 1905, MMW Papers, NYHS.

33. Ramponi & Cremonesi to SW, Rome, 22 December 1905, SW Papers, NYHS.

34. Arthur Acton to MMW, Florence, invoice, 2 September 1905, SW Papers, NYHS.

35. F. S. Rollins to SW, 20 September 1905, box 507, MMW Papers, NYHS.

36. "Purchases," undated, MMW Papers, NYHS.

37. Henri L. Bouche to SW, 11 January 1906, MMW Papers, NYHS. In a letter of 30 January 1906, Bouche wrote to White that "it is our intention to do the building of the Whitney ceiling in our shop. It will be much less costly to do it there than at the building."

38. Allard and Sons to SW, New York, 24 February 1906, box 503, MMW Papers, NYHS.

39. Allard and Sons to MMW, New York, 29 May 1906, box 503, MMW Papers, NYHS.

40. Allard and Sons to MMW, New York, 10 July 1906, box 503, MMW Papers, NYHS.

41. MMW to Allard and Sons, New York, 3 August 1906, box 503, MMW Papers, NYHS.

42. *Public Auction Sale . . . at the [Payne] Whitney Residence, 972 Fifth Avenue. . . .* (New York: Parke-Bernet Galleries, 1946), lot 464.

43. Allard and Sons to MMW, 19 July 1906, box 503, MMW Papers, NYHS.

44. Allard and Sons to Daniel Webster, New York, 5 September 1906, box 503, MMW Papers, NYHS.

45. Allard and Sons to MMW, 28 September 1906, box 503, MMW Papers, NYHS.

46. Allard and Sons to MMW, New York, 5 June 1906, box 503, MMW Papers, NYHS.

47. Allard and Sons to SW, New York, 23 May 1906, box 503, MMW Papers, NYHS.

48. Allard and Sons to MMW, New York, 1 November 1906, box 503, MMW Papers, NYHS.

49. Allard and Sons to MMW, New York, "Statement of the approximate cost of the decoration for the salon, residence of Payne Whitney, Esq.," 24 October 1906, box, 503, MMW Papers, NYHS.

50. *Public Auction Sale . . . at the [Payne] Whitney Residence,* p. 104, lot 525.

51. For an excellent illustration of the Gubbio Studiolo ceiling, see James Parker et al., *Period Rooms in the Metropolitan Museum of Art* (New York: Abrams, 1996), pp. 13, 43.

52. T. D. Wadelton to MMW, 25 August 1906, MMW Papers, NYHS. Wadelton awaited McKim's inspection, not White's, because by that date White was dead.

53. *Public Auction Sale . . . at the [Payne] Whitney Residence,* p. 102, lot 522.

54. Allard and Sons to MMW, New York, 15 October 1906, box 503, MMW Papers, NYHS.

55. Final accounting for the Payne Whitney residence, undated, typescript, MMW Papers, NYHS.

56. Allard and Sons to SW, New York, 1 December 1905, box 503, MMW Papers, NYHS.

57. Daniel Webster to SW, New York, 14 May 1906, box 508, MMW Papers, NYHS.

58. Richard Guy Wilson, *McKim, Mead and White, Architects* (New York: Rizzoli, 1983), p. 224.

59. Adolph Weinman to Daniel Webster, New York, 12 June 1906, box 508, MMW Papers, NYHS.

60. Allard and Sons to MMW, New York, 20 December 1906, box 503, MMW Papers, NYHS.

61. Ibid. Another letter refers to the caning of the bathroom chairs, while yet a third indicates that both were to be enameled.

62. SW to Colonel Oliver Payne, New York, 6 May 1905, MMW Papers, NYHS.

63. Allard and Sons to MMW, 4 October 1906, box 503, MMW Papers, NYHS.

64. W. M. Case [or Cast], of Alavoine and Company, to Daniel Webster, undated (probably early 1907), MMW Papers, NYHS.

65. Henry Adams to Elizabeth Cameron, 11 January 1903, in *Henry Adams: Selected Letters,* ed. Ernest Samuels (Cambridge, Mass.: Harvard University Press, 1992), p. 428.

66. Diane S. White, *Stanford White's Venetian Room* (Albany, N.Y.: Mount Ida Press, 1998).

5. The Mackays and Harbor Hill

1. Obituary of Clarence Mackay, *New York Times,* 13 November 1938, p. 1.

2. René Gimpel, *Diary of an Art Dealer* (New York: Farrar, Straus and Giroux, 1966), pp. 326–27.

3. Consuelo Vanderbilt Balsan, *The Glitter and the Gold* (New York: Harper, 1952), pp. 18–19.

4. SW to Bessie White, in *Stanford White: Letters to His Family,* ed. Claire Nicolas White (New York: Rizzoli, 1997), pp. 144–45.

5. *Town Topics,* 21 November 1901, p. 5.

6. Herbert Croly, "The Lay-out of a Large Estate: Harbor Hill, the Country-seat of Mr. Clarence Mackay," *Architectural Record,* December 1904, pp. 531–55. Guy Lowell was the landscape architect.

7. Stanford White occasionally made suggestions regarding the landscaping, as when he wrote to his client: "Now you cannot come up to this great house by a road shaped like an eel,

past your kitchen. You have got to have a fine and dignified approach [as in] the plan I send you" (SW to Clarence Mackay, 18 April 1900, box 263, MMW Papers, NYHS).

8. Gary Hughes, "Beaux-Arts in the Forest: Stanford White's Fishing Lodges in New Brunswick," *Journal of the Society of the Study of Architecture in Canada* 26 (2001): 3–14.

9. Katherine Mackay to SW, undated other than "Friday," box 265, MMW Papers, NYHS.

10. Katherine Mackay to MMW, undated, MMW Papers, NYHS, quoted in Lawrence Wodehouse, "Stanford White and the Mackays: A Case Study in Architect–Client Relationships," *Winterthur Portfolio* 11 (1976): 230.

11. Katherine Mackay to SW, 24 July 1899, MMW Papers, NYHS.

12. Katherine Mackay to SW, 23 May 1901, MMW Papers, NYHS.

13. SW to Nina White, New Mexico, March 1882, SW Papers, NYHS.

14. Katherine Mackay to SW, 27 July 1899, SW Papers, Avery. Several years later, Clarence Mackay wrote to White to ask whether the architect could obtain a copy of Sauvageot's book for him. See Clarence Mackay to SW, 24 February 1903, SW Papers, Avery.

15. Katherine Mackay to SW, cablegram, 7 November 1899, MMW Papers, NYHS.

16. Allard and Sons to Clarence Mackay, New York, 11 February 1901, MMW Papers, NYHS. A memorandum relates to this matter: "To cost of insurance paid in Paris for goods furnished but held because building not ready . . . 21.25. To storage charges in New York for same reason as above . . . 362.17" ("Allard & Sons—Bill, Disputed Items," undated, MMW Papers, NYHS).

17. Allard and Sons to MMW, New York, 27 November 1901, MMW Papers, NYHS.

18. On Davenport, see Anne Farnham, "A. H. Davenport and Company, Boston Furniture Makers," *The Magazine Antiques,* May 1976, pp. 1048–55. Examples of the architectural paneling and carving and of the furniture produced by the Davenport craftsmen may be seen in A. H. Davenport's home in Malden, Massachusetts, now an apartment complex for retired Malden couples. Although Davenport died in 1906, his business continued and, in 1914, merged with the furniture-making firm Irving & Casson, also of Boston.

19. A. H. Davenport to SW, Boston, 6 January 1903, box 264, MMW Papers, NYHS.

20. Davenport's to Fred Adams, Boston, 11 July 1901, box 264, MMW Papers, NYHS.

21. A. H. Davenport to MMW, estimate, 8 June 1900, box 264, MMW Papers, NYHS. A contract, prepared for Davenport's by McKim, Mead & White and dated 9 June 1900, reads: "The Cabinet wood of the Hall in American Oak, including staircase and plaster ceiling; Dining Room woodwork in English Oak; Billiard Room in American Oak including wood mantel and fireplace; Mr. Mackay's Study and Bedroom, all in House at Harbor Hills" (MMW Papers, NYHS).

22. A. H. Davenport to SW, Boston, 24 December 1901, box 264, MMW Papers, NYHS.

23. Victor Twiss to Katherine Mackay, New York, 27 December 1901, MMW Papers, NYHS.

24. SW to Clarence Mackay, 21 October 1902, MMW Papers, NYHS. The photographer was H. Herbert Sidman, whom McKim, Mead & White often hired to take pictures of the exteriors and interiors of its buildings once they were completed.

25. Clarence Mackay to SW, 21 October 1902, MMW Papers, NYHS.

26. Clarence Mackay to SW, 28 October 1902, MMW Papers, NYHS.

27. Harry Desmond and Herbert Croly, *Stately Homes in America* (New York: Appleton, 1903), p. 444.

28. A. H. Davenport to SW, Boston, 14 August 1901, box 264, MMW Papers, NYHS.

29. A. H. Davenport to Fred Adams, Boston, 12 June 1901, MMW Papers, NYHS.

30. Katherine Mackay to SW, undated, MMW Papers, NYHS.

31. This room is illustrated in Barr Ferree, *American Estates and Gardens* (New York: Munn, 1904), p. 29.

32. Allard and Sons, "Contracts for the Decoration and Furniture for the Residence of Mrs. Clarence Mackay . . . ," 25 October 1899, MMW Papers, NYHS.

33. Allard and Sons to Fred Adams, 13 March 1902, MMW Papers, NYHS.

34. Allard and Sons, "Contracts for the Decoration and Furniture."

35. G. E. Rarig to one of SW's assistants, 6 January 1905, MMW Papers, NYHS.

36. Duveen Brothers to SW, 22 January 1903, MMW Papers, NYHS.

37. A. H. Davenport to Fred Adams, Boston, 19 July 1901, box 264, MMW Papers, NYHS.

38. Victor Twiss to Fred Adams, New York, 3 July 1901, box 264, MMW Papers, NYHS.

39. Special Order form "for setting up complete antique mantel in Billiard Rm, with new work as shown on details" (MMW to Robert Clarence Fisher & Company, 1 December 1901, box 264, MMW Papers, NYHS).

40. Clarence Mackay to SW, 10 February 1905, MMW Papers, NYHS.

41. Katherine Mackay to SW, 26 February 1903, MMW Papers, NYHS.

42. Katherine Mackay to SW, October 1904, MMW Papers, NYHS.

43. The Piccirilli Brothers also bid on the additional marble work for the room, which included an "inlaid center, border and outside border of Sienna marble—for floor—also base, pilasters, door trim, window trim, chimney breast and carved lintel running around the room in Caen stone for the amount of $39,330.00" (Piccirilli Brothers to SW, 23 September 1904, MMW Papers, NYHS).

44. Allard and Sons, estimate, 25 October 1899, MMW Papers, NYHS.

45. Allard and Sons to Mr. Sudlow, New York, 27 January 1902, MMW Papers, NYHS.

46. James Wall Finn to MMW, "Estimate for Decorating Ceiling, Library for Mrs. Mackay," 18 February 1903, MMW Papers, NYHS.

47. Unidentified assistant to SW, 29 March 1905, MMW Papers, NYHS.

48. Sudlow to SW, New York, 7 April 1905, MMW Papers, NYHS.

49. Allard and Sons, "Contracts for the Decoration and Furniture."

50. Clarence Mackay to SW, 2 January 1903, MMW Papers, NYHS.

51. Clarence Mackay to SW, 3 November 1902, MMW Papers, NYHS.

52. "Memorandum for Mr. White," undated, Mackay files, box 262, MMW Papers, NYHS.

53. William Baumgarten to SW, New York, 15 December 1902, MMW Papers, NYHS.

54. Clarence Mackay to SW, 2 December 1902, MMW Papers, NYHS.

55. F. Schutz to SW, Paris, 11 December 1902, MMW Papers, NYHS.

56. Clarence Mackay to SW, 16 January 1903, MMW Papers, NYHS.

57. Arthur Acton to SW, cablegram from London, 7 May 1903, MMW Papers, NYHS.

58. Arthur Acton to Duveen Brothers of New York, London, 21 May 1903, MMW Papers, NYHS.

59. Arthur Acton, typescript of journey, inscribed at top of first page "Mackay," undated, MMW Papers, NYHS.

60. Charles Scribner's Sons to SW, 6 January 1904, MMW Papers, NYHS.

61. Rutherford Stuyvesant to SW, undated, Mackay files, MMW Papers, NYHS.

62. For an early view of the Met's armor gallery, see *Bulletin of the Metropolitan Museum of Art,* February 1909, p. 28. The accompanying article states that Mackay's tapestries were early sixteenth century and represented courtly scenes from the lives of Louis XII and Anne of Brittany. The same article notes that "for the reopening of the gallery Mr. Mackay lent also the coronation sword of the Electors Palatine, Archbishops of Mayence . . . , a halfarmor, part of which belonged to Philip II, a casque by Seusenhofer . . . , and a remarkable rapier" (p. 29).

63. Clarence Mackay to SW, 3 February 1903, MMW Papers, NYHS.

64. *Art Digest,* 15 May 1939, p. 7.

65. Alfred M. Frankfurter, "The Mackay Art Objects on View: Selections from a Great Collection to Be Disposed of," *Art News,* 20 May 1939, p. 10.

66. Quoted in Wodehouse, "Stanford White and the Mackays," 233.

67. Germain Seligman, *Merchants of Art: 1880–1960, Eighty Years of Professional Collecting* (New York: Appleton-Century-Crofts, 1961), p. 214.

68. Louis Ehrich to MMW, New York, 13 November 1906, MMW Papers, NYHS.

69. W. R. Valentiner, "The Clarence H. Mackay Collection of Italian Renaissance Sculptures," *Art in America,* August 1925, p. 250.

70. Clarence Mackay to SW, 29 June 1903, MMW Papers, NYHS.

71. John T. Keresey to Clarence Mackay, 20 October 1902, MMW Papers, NYHS.

72. Clarence Mackay to SW, 21 October 1902, MMW Papers, NYHS.

73. Stefano Bardini to SW, cablegram from Florence, 13 February 1903, MMW Papers, NYHS.

74. Clarence Mackay to SW, 21 January 1903, MMW Papers, NYHS.

75. Stefano Bardini to SW, Florence, undated, MMW Papers, NYHS. George Gould, the son of the financier Jay Gould, may have held an option to buy the fireplace in question.

76. Clarence Mackay to SW, 24 February 1903, MMW Papers, NYHS.

77. Jacques Seligmann to SW, Paris, 11 April 1903, MMW Papers, NYHS.

78. Jacques Seligmann to SW, Paris, 12 June 1903, MMW Papers, NYHS.

79. "Final Balance due on House," Mackay files, box 262, MMW Papers, NYHS.

80. Seligman, *Merchants of Art,* p. 214.

6. From the Poor House to the White House

1. Elsie de Wolfe, *After All* (New York: Harper, 1935), p. 90.

2. On the "Pie Girl Dinner," see Paul Baker, *Stanny: The Gilded Life of Stanford White* (New York: Free Press, 1989), pp. 249–51. James Gibbons Huneker also recounts the event in *Painted Veils* (New York: Modern Library, 1928), pp. 147–54. Breese was a photographer of some note and a wealthy man for whom White designed the Orchard, a Mount Vernon–like estate on Long Island.

3. *New York Times,* 14 April 1915, p. 13.

4. Charles Coleman to SW, Capri, 22 October 1900, SW Papers, NYHS.

5. Charles Coleman to SW, Capri, 1 November 1900, SW Papers, NYHS.

6. *New York Times,* 18 April 1909, p. 7.

7. Stefano Bardini to SW, Florence, early 1901, SW Papers, Avery.

8. Henry Poor to SW, New York, 18 March 1901, SW Papers, NYHS.

9. Margaret Terry Chanler, *Roman Spring* (Boston: Little, Brown, 1934), p. 257.

10. In or about 1899, an inventory was taken of every room in the house for insurance purposes. See "Inventory of Household Furniture, Paintings & Works of Art in the House at 121 East 21st St.," SW Papers, Avery.

11. *New York Times,* 7 April 1907, pt. 2, p. 4.

12. Ibid.

13. *New York Times,* 5 April 1907, p. 8.

14. The story of the wanderings of MacMonnies's sprightly nymph is told in Walter Muir Whitehill, "The Vicissitudes of Bacchante in Boston," *New England Quarterly,* December 1954, pp. 435–54. See also Wayne Craven, *Sculpture in America* (New York: Crowell, 1968), pp. 423–25.

15. Emile Gavet to SW, Paris, 28 October 1899, SW Papers, Avery.

16. *New York Times,* 26 November 1907, p. 8.

17. Ibid.

18. Chanler, *Roman Spring,* p. 257.

19. David Lowe, *Stanford White's New York* (New York: Doubleday, 1992), p. 10.

20. *New York Times,* 31 March 1907, pt. 2, p. 11.

21. Kenyon Cox to SW, 16 April 1892, SW Papers, NYHS.

22. Thomas Dewing to SW, undated, SW Papers, NYHS.

23. William Adair, "Stanford White's Frames," *The Magazine Antiques,* March 1997, pp. 448–57.

24. Thomas Dewing to SW, undated, SW Papers, NYHS. The reference to Malibran may

be to Maria Malibran (1808–1836), a noted singer of the Paris Opera. Dowdeswell refers to a well-known London firm of picture dealers, Dowdeswell and Dowdeswell.

25. Charles C. Curran to SW, undated, but on McKim, Mead & White stationery with the imprinted date "189_," SW Papers, NYHS.

26. Charles C. Curran to SW, undated (probably late 1890s), SW Papers, NYHS.

27. John Singer Sargent to SW, London, 14 October 1898, SW Papers, NYHS. On 8 June 1899, Giovanni Boldini sent White a note saying that he was pleased that White enjoyed his Velázquez (SW Papers, Avery). In the 1907 sale catalogue of White's possessions, a painting by Velázquez was listed as item number 577.

28. Edward Simmons, *From Seven to Seventy: Memories of a Painter and a Yankee* (New York: Harper, 1922), p. 241. Vercingetorix (d. 46 B.C.) was the leader of the Gauls in their rebellion against Julius Caesar. Vercingetorix was paraded in Caesar's triumph before being put to death.

29. *New York Times*, 31 March 1907, pt. 2, p. 11.

30. *New York Times*, 7 April 1907, pt. 2, p. 4. Decorative tiles were then readily available in New York City: "Old Persian tiles [are] shown by Mr. [Dirkan "The Kahn"] Kelekian, and . . . Hispano-Moresque [tiles are] exhibited by Mr. Chadwick. In the latter's store on East Eighteenth Street . . . the visitor will be shown modern Spanish wares—blue, dark green, and copper lustred, in which the old traditional forms and patterns are repeated. These wares are sold at modest prices. . . . Mr. Chadwick is the sole agent for the Andalusian potteries [in Spain] which produce them" (*Art Amateur,* December 1899, p. 35). "Col. Colt" refers to Samuel P. Colt (1852–1921), president of the U.S. Rubber Company.

31. *New York Times*, 31 March 1907, pt. 2, p.11.

32. Emile Lowengard to SW, Paris, 1897, SW Papers, Avery.

33. Godfrey Kopp to SW, 11 November 1897, SW Papers, Avery.

34. Godfrey Kopp to SW, 16 November 1897, SW Papers, Avery.

35. Godfrey Kopp to SW, Paris, 16 March 1901, SW Papers, Avery.

36. Godfrey Kopp to SW, Rome, 18 December 1897, SW Papers, Avery.

37. Giovanni Boldini to SW, Paris, 8 June 1899, SW Papers, Avery.

38. Stefano Bardini to SW, Florence, 8 August 1898, SW Papers, Avery.

39. Charles Sedelmeyer to SW, Paris, 10 September 1900, SW Papers, NYHS.

40. Joel Duveen to SW, London, 15 January 1898, SW Papers, Avery.

41. Joel Duveen to SW, London, 20 April 1898, SW Papers, Avery.

42. George Donaldson to SW, London, 13 June 1904, SW Papers, Avery. Titian's *Ariosto* (*Portrait of a Man*) is now in the National Gallery, London, and Sir Anthony Van Dyck's double portrait is at Broadlands in Romsey, England.

43. SW to Nina White, Leon, France, 21 November 1878, SW Papers, NYHS.

44. Raoul Heilbronner to SW, Paris, 21 September 1900, SW Papers, Avery.

45. *New York Times,* 31 March 1907, pt. 2, p. 11.

46. Ibid.

47. *New York Times,* 13 May 1907, p. 9.

Epilogue

1. I am grateful to Valerie Komor of the New-York Historical Society for calling this aspect of Cass Gilbert's career to my attention.

2. Charles F. McKim to Bessie White, 17 March 1905, quoted in Charles Moore, *The Life and Times of Charles Follen McKim* (1929; reprint, New York: Da Capo, 1970), pp. 295–96.

3. SW to Bessie White, quoted in *Stanford White: Letters to His Family,* ed. Claire Nicolas White (New York: Rizzoli, 1997), p. 146.

4. Evelyn Nesbit Thaw, *The Story of My Life* (London: Long, 1914). For the second version of her autobiography, see Evelyn Nesbit, *Prodigal Days: The Untold Story* (New York: Messner, 1934).

5. Allard and Sons to MMW, 25 August 1906, box 503, MMW Papers, NYHS.

6. G. W. Koch & Son to MMW, 10 July 1906, MMW Papers, NYHS.

7. Allard and Sons to MMW, 10 November 1906, box 503, MMW Papers, NYHS. On 4 December 1906, Allard's wrote again to the architectural firm: "We would also like to know what disposition you wish made of the goods belonging to the estate of Mr. White."

8. Allard and Sons to MMW, 14 December 1906, box 503, MMW Papers, NYHS.

9. Arnold, Constable & Company to MMW, 14 December 1906, MMW Papers, NYHS.

10. William R. Mead to Colonel Oliver Payne, 25 July 1907, MMW Papers, NYHS.

11. *Illustrated Catalogue of Valuable Artistic Property collected by the Late Stanford White . . . to be sold . . . by order of the Executrix* (New York: American Art Association, 1907), lot 334.

12. *New York Times,* 26 November 1907, p. 8.

13. *New York Times,* 5 April 1907, p. 8.

14. *New York Times,* 7 April 1907, pt. 2, p. 4.

15. Ibid.

16. *New York Times,* 31 March 1907, pt. 2, p. 11.

17. Margaret Terry Chanler, *Roman Spring* (Boston: Little, Brown, 1934), p. 256.

18. Edith Wharton, *A Backward Glance* (New York: Appleton-Century, 1934), p. 149.

Glossary

amorino A little cupid, a mythological creature expressive of love and passion.

arabesque A pattern characterized by continuous and repetitive scrolling or interlaced vines and plants and/or urns, vases, and figures, which may be of the grotesque type.

architrave The horizontal supporting part above an opening in architecture—that is, above a doorway or window or stretching from one columnar support to another. It is used in the post-and-lintel system but not in arch or vault construction.

bergere A form of deep armchair popular in the late seventeenth and eighteenth centuries, usually upholstered and covered with tapestry fabric.

boiserie Paneling—usually of oak, walnut, or fruit woods—that lined the walls of grand houses from the late Middle Ages to the early nineteenth century. It is usually carved or at least contains elaborate moldings, and it may be stained, painted, or gilded.

caryatid A column carved in the form of a human figure, usually female.

cassone An Italian chest used for storage, often elaborately carved and painted with figural images, sometimes set against a gilded background.

chinoiserie A European style, also used in colonial America, based on Chinese motifs. It originated in the eighteenth century and continued throughout the nineteenth century.

galloon A woven decorative ribbon or trim, sometimes using gold or silver threads.

grotesque A fantastic decorative image that is usually odd or unnatural in form, often purposefully ugly or bizarre. The style began to appear in art in Italy around 1490 and was favored by painters, architects, and furniture makers throughout the Renaissance.

herm A four-sided column or shaft that terminates in a sculptured head or bust.

intarsia (marquetry) The art of making decorative or scenic images with inlay of different kinds and colors of wood, or a form of mosaic using woods instead of tile or stone. It became popular in Italy in the fifteenth century and spread into northern Europe in the sixteenth century.

jardiniere A stone, often marble, container into which potted palms, ferns, and other plants are placed. Ancient sarcophagi were often used for this purpose in the late nineteenth century.

pilaster A flat or half column that is applied to a wall. Decorative and nonstructural, it is usually of one of the classical orders—Doric, Ionic, or Corinthian—or variations thereof.

portiere A decorative textile—with embroidered or woven designs or a tapestry—that was hung across a doorway, taking the place of a wooden or metal door.

rinceau An ornamental scroll pattern that runs continuously, usually in a border or frieze.

torchère A floor lamp, usually tall and columnar and originally oil burning, but altered in the late nineteenth and early twentieth centuries to provide electrical lighting and given a shade or globe to reduce the glare of the new source of light.

Archival and Manuscript Material

Hunt, Catharine. "Richard Morris Hunt," ca. 1905. Typescript. 3 vols. American Institute of Architects, Washington, D.C.
McKim, Mead & White Archives. Museum of the City of New York.
McKim, Mead & White Papers. New-York Historical Society, New York.
Stanford White Papers. Avery Architectural and Fine Arts Library, Columbia University in the City of New York.
Stanford White Papers. New-York Historical Society, New York.

Published Material

Acalia, Fiorenze, and Cristina de Benedictis. *Il Museo Bardini a Firenze*. 2 vols. Milan: Electra, 1984.
Adair, William. "Stanford White's Frames." *The Magazine Antiques,* March 1997, pp. 448–57.
Adams, Henry. *The Education of Henry Adams: An Autobiography*. Boston: Houghton Mifflin, 1918.
———. *Henry Adams: Selected Letters*. Edited by Ernest Samuels. Cambridge, Mass.: Harvard University Press, 1992.
———. *Letters of Henry Adams, 1892–1918*. Edited by Worthington Chauncey Ford. Boston: Houghton Mifflin, 1930.
Auchincloss, Louis. *J. P. Morgan: Financier as Collector*. New York: Abrams, 1990.
Baedeker, Karl. *Northern Italy*. New York: Scribner, 1930.
Baker, Paul. *Richard Morris Hunt*. Cambridge, Mass.: MIT Press, 1986.
———. *Stanny: The Gilded Life of Stanford White*. New York: Free Press, 1989.
Baldwin, Charles. *Stanford White*. 1931. Reprint, New York: Da Capo, 1971.
Balsan, Consuelo Vanderbilt. *The Glitter and the Gold*. New York: Harper, 1952.

Berenson, Bernard. *Letters of Bernard Berenson and Isabella Stewart Gardner, 1887–1924.* Edited by Rollin van N. Hadley. Boston: Northeastern University Press, 1987.

Beresford, Elizabeth Wharton Drexel. *King Lehr and the Gilded Age.* 1935. Reprint, New York: Arno, 1975.

Berti, Luciano. *Il Museo di Palazzo Davanzati a Firenze.* Florence: Palazzo Davanzati, 1971.

Blake, Channing. "Stanford White's New York Interiors." *The Magazine Antiques,* December 1972, pp. 1060–67.

Bode, Wilhelm von. *Die italienischen Hausmöbel der Renaissance.* Berlin, 1902.

Burke, Doreen Bolger, Alice Cooney Frelinghuysen, and Catherine Hoover Voorsanger. *In Pursuit of Beauty: Americans and the Aesthetic Movement.* New York: Rizzoli, for the Metropolitan Museum of Art, 1986.

Castellane, Boni de. *How I Discovered America: Confessions of the Marquis Boni de Castellane.* New York: Knopf, 1924.

Catalogue of Antique Marble and Stone Mantels, Sarcophagi, Fountains and Other Valuable Objects collected by the Late Stanford White. New York, 1907.

Cescinsky, Herbert, and Ernest R. Gribble. *Early English Furniture & Woodwork.* 2 vols. London: Routledge, 1922.

Chanler, Margaret Terry. *Roman Spring.* Boston: Little, Brown, 1934.

Child, Theodore. "Decorative Art in Paris." *Decorator and Furnisher,* December 1882, p. 91.

"The Collection and Designing of Furniture." *Architectural Record,* April 1902, pp. 118–20.

Craven, Wayne. *Sculpture in America.* New York: Crowell, 1968.

Croly, Herbert. "The Lay-out of a Large Estate: Harbor Hill, the Country-seat of Mr. Clarence Mackay." *Architectural Record,* December 1904, pp. 531–55.

"The Decoration of Our Homes," *Art Amateur,* February 1886, p. 88.

"Decorative Wallpapers." *Art Amateur,* October 1887, p. 106.

De Luxe Illustrated Catalogue of the . . . Treasures and Antiquities Illustrating the Golden Age of Italian Art, belonging to the famous expert, Signor Stefano Bardini . . . New York: American Art Association, 1918.

Desmond, Harry, and Herbert Croly. *Stately Homes in America.* New York: Appleton, 1903.

———. "The Work of Messrs. McKim, Mead & White." *Architectural Record,* September 1906, pp. 153–246.

The Exceedingly Rare and Valuable Art Treasures and Antiquities formerly contained in the Famous Davanzati Palace, Florence, Italy, and recently brought to America by their Owner, The Recognized Expert and Connoisseur, Professore Commendatore Elia Volpi . . . [to be sold] at the American Art Galleries . . . beginning November 16, 1916. New York: American Art Association, 1916.

Farnham, Anne. "A. H. Davenport and Company, Boston Furniture Makers." *The Magazine Antiques,* May 1976, pp. 1048–55.

Ferree, Barr. *American Estates and Gardens.* New York: Munn, 1904.

Fowles, Edward. *Memories of Duveen Brothers.* London: Times Books, 1976.

Frankfurter, Alfred M. "The Mackay Art Objects on View: Selections from a Great Collection to Be Disposed of." *Art News,* 20 May 1939, p. 10.

"French Art of the Seventeenth and Eighteenth Centuries." *Bulletin of the Metropolitan Museum of Art,* March 1910, supplement, pp. 20–29.

Friedman, B. H. *Gertrude Vanderbilt Whitney.* Garden City, N.Y.: Doubleday, 1978.

Garmey, Stephen. *Gramercy Park: An Illustrated History of a Neighborhood.* New York: Balsam, 1984.

Gimpel, René. *Diary of an Art Dealer.* New York: Farrar, Straus and Giroux, 1966.

Harris, Susan. "McKim, Mead and White's Domestic Interiors, 1890–1909, a Catalogue of Decorative Treatment." Master's thesis, Columbia University, 1981.

Hewett, J. Monroe. "Stanford White, Decorator." *Good Furniture,* September 1917, pp. 160–79.

Hirsch, Mark D. *William C. Whitney, Modern Warwick.* New York: Dodd, Mead, 1948.

Hodes, Scott. *The Law of Art & Antiques: A Primer for Artists and Collectors.* Dobbs Ferry, N.Y.: Oceana, 1966.

Hoentschel, Nicole, James Parker, David W. Wright, Jean Soustiel, and François Chapon. *Georges Hoentschel.* Château de Saint-Remy en l'Eau: Monelle Hayot, 1999.

"The Hoentschel Collection." *Bulletin of the Metropolitan Museum of Art,* June 1907, pp. 94–99; July 1908, pp. 129–33; August 1908, pp. 149–53; and March 1910, pp. 5–29.

"The House on the Corner of 57th Street and Fifth Avenue, New York City." *New-York Sketch-Book of Architecture,* September 1875, pp. 1–3.

Hughes, Gary. "Beaux-Arts in the Forest: Stanford White's Fishing Lodges in New Brunswick." *Journal of the Society of the Study of Architecture in Canada* 26 (2001): 3–14.

Huneker, James Gibbons. *Painted Veils.* New York: Modern Library, 1928.

Hunter, George Leland. *Italian Furniture and Interiors.* 2 vols. New York: Helburn, 1918.

Illustrated Catalogue of the Artistic Furnishings and Interior Decorations of the Residence no. 121 East Twenty-first Street . . . , to be sold at Unrestricted Public Sale by Order of the Estate of the Late Stanford White. New York: American Art Association, 1907.

Illustrated Catalogue of Valuable Artistic Property collected by the Late Stanford White . . . to be sold . . . by order of the Executrix, November 25th, 26th, 27th and 29th, 1907. New York: American Art Association, 1907.

Important Gobelins, Beauvais and Brussels Tapestries, Fine French Furniture and Paintings . . . Property of the Estate of the Late Harry Payne Whitney. New York: Parke-Bernet Galleries, 1942.

Jourdain, Margaret. *English Decoration and Furniture of the Early Renaissance.* London: Batsford, 1924.

Krohn, Deborah. "The Gavet-Vanderbilt-Belmont Collection." In Mark Ormond, ed., *John Ringling: Dreamer, Builder, Collector: The Legacy of the Circus King,* pp. 139–48. Sarasota, Fla.: John and Mable Ringling Museum of Art, 1997.

Lenygon, Francis. *Decoration in England from 1660 to 1770.* London: Batsford, 1914.

Lessard, Suzannah. *The Architect of Desire: Beauty and Danger in the Stanford White Family.* New York: Dial Press, 1996.

Lewis, Arnold, James Turner, and Steven McQuinn. *The Opulent Interiors of the Gilded Age.* New York: Dover, 1987.

"Louis Seize Decoration." *Art Amateur,* June 1886, pp. 14–15.

Lowe, David. *Stanford White's New York.* New York: Doubleday, 1992.

The Magnificent Tapestries and the Furniture and Interior Woodwork in the Harry Payne Whitney Mansion at 871 Fifth Avenue . . . New York: Parke-Bernet Galleries, 1942.

Maher, James. *The Twilight of Splendor: Chronicles of the Age of American Palaces.* Boston: Little, Brown, 1975.

Metcalf, Pauline. "The Interiors of Ogden Codman, Jr., in Newport, Rhode Island." *The Magazine Antiques,* September 1980, pp. 486–91.

———, ed. *Ogden Codman and the Decoration of Houses.* Boston: Boston Athenaeum and Godine, 1988.

The Metropolitan Museum of Art Guide. 2d ed. New York: Metropolitan Museum of Art and Abrams, 1994.

M. F. R. "Sentimental Approach to Antiques: Stanford White Collection." *Arts and Decoration,* May 1934, pp. 58–60.

"Mr. Whitney's Southern Home." *New York Times Illustrated Magazine,* 16 January 1898, pp. 14–15.

Molinier, Emile. *Catalogue des objets d'art et de haute curiosité, de la Renaissance. Tableaux, tapisseries composant la collection de M. Emile Gavet et dont le vente aura lieu Galerie Georges Petit . . .* Paris, 1897.

———. *Catalogue des tableaux anciens et quelques modernes . . . provenant de la collection de feu M. Emile Gavet.* Paris, 1906.

———. *Collection Emile Gavet.* Paris, 1889.

A Monograph of the Works of McKim, Mead & White, 1879–1915. Introduction by Leland Roth. 4 vols. 1915–1920. Reprint, New York: Blom, 1973.

Moore, Charles. *The Life and Times of Charles Follen McKim.* 1929. Reprint, New York: Da Capo, 1970.

Nesbit, Evelyn. *Prodigal Days: The Untold Story.* New York: Messner, 1934.

Newhall, Louis C. "The Restored Palace of the Davanzati." *American Architect,* 24 July 1912, pp. 25–28.

Odom, William M. *A History of Italian Furniture from the Fourteenth to the Early Nineteenth Century.* 2 vols. Garden City, N.Y.: Doubleday, Page, 1918.

Old and Modern Paintings belonging to the Estate of the Late Stanford White . . . April 11th–12th. New York: American Art Association, 1907.

The Palatial Mansion of the Late James Henry Smith, and Its Exceedingly Rare and Costly Artistic Furnishings and Embellishments. Deluxe ed. New York: American Art Association, 1910.

Parker, James, et al. *Period Rooms in the Metropolitan Museum of Art.* New York: Abrams, 1996.

Parks, Janet. *The Old World Builds the New: The Guastavino Company and the Technology of the Catalan Vault, 1885–1962.* New York: Avery Architectural and Fine Arts Library and the Wallach Gallery, Columbia University, 1996.

Pératé, André, and Gaston Brière. *Collections Georges Hoentschel, acquisés par M. J. Pierpont Morgan et prêtées au Metropolitan Museum de New York.* 4 vols. Paris: Librairie centrale des Beaux-Arts, 1908.

Period Furniture, Tapestries, Rugs, Paintings, Textiles, Silver, Glass and Other Objects of Art, Property collected by the Late Stanford White, with additions sold by order of the various owners. New York: American Art Association, Anderson Galleries, 1934.

Pinkney, David. *Napoleon III and the Rebuilding of Paris.* Princeton, N.J.: Princeton University Press, 1958.

Pisano, Ronald. "The Tile Club, 1877–1887." *American Art Review,* November–December 1999, pp. 188–97.

Pollen, John Hungerford. *Ancient and Modern Furniture and Woodwork in the South Kensington Museum.* London: Chapman and Hall, 1874.

Public Auction Sale . . . at the [Payne] Whitney Residence, 972 Fifth Avenue. New York: Parke-Bernet Galleries, 1946.

Rare and Beautiful Textiles and Embroideries Dating from the Fifteenth to the Eighteenth Century [sale catalogue for the collection of Vitall Benguiat]. New York: American Art Association, 1919.

Reilly, Charles. *McKim, Mead & White.* London: Benn, 1924.

Rosenberg, Louis C. *The Davanzati Palace, Florence, Italy: A Restored Palace of the Fourteenth Century Measured and Drawn, Together with a Short Description.* New York: Architectural Book Publishing, 1922.

Rossiter, Stuart, ed. *Northern Italy: From the Alps to Rome.* 6th ed. Blue Guide. London: Benn, 1971.

Roth, Leland. *The Architecture of McKim, Mead & White, 1870–1920: A Building List.* New York: Garland, 1978.

———. *McKim, Mead & White, Architects.* New York: Harper & Row, 1983.

Roth, Linda H. *J. Pierpont Morgan, Collector.* Hartford, Conn.: Wadsworth Atheneum, 1987.

Saalman, Howard. *Haussmann: Paris Transformed.* New York: Braziller, 1971.

Schiaparelli, Attilio. *La Casa Fiorentina e i suoi arredi nei secoli XIV e XV.* Florence: Sansoni, 1908.

Schottmüller, Frieda. *Furniture and Interior Decoration of the Italian Renaissance.* New York: Brentano, 1921.

Seligman, Germain. *Merchants of Art: 1880–1960, Eighty Years of Professional Collecting.* New York: Appleton-Century-Crofts, 1961.

Sheldon, George William, ed. *Artistic Houses: Being a Series of Interior Views of a Number of the Most Beautiful and Celebrated Homes in the United States, with a Description of the Art Treasures Contained Therein.* 2 vols. New York: Appleton, 1883, 1884.

Sherwood, Mary Elizabeth Wilson. "Certain New York Houses." *Harper's Monthly,* September 1882, pp. 680–90.

Simmons, Edward. *From Seven to Seventy: Memories of a Painter and a Yankee.* New York: Harper, 1922.

Simpson, Colin. *Artful Partners: Bernard Berenson and Joseph Duveen.* New York: Macmillan, 1986.

Spofford, Harriet Elizabeth. *Art Decoration Applied to Furniture.* New York: Harper, 1878.

Standen, Edith A. *European Post-Medieval Tapestries . . . in the Metropolitan Museum of Art.* 2 vols. New York: Metropolitan Museum of Art, 1985.

Sturgis, Russell. "The Works of McKim, Mead & White." Great American Architects series. *Architectural Record,* May 1895, pp. 1–46.

Sullivan, Louis. *Kindergarten Chats and Other Writings.* New York: Wittenborn, Schultz, 1947.

Swanberg, W. A. *Whitney Father, Whitney Heiress.* New York: Scribner, 1980.

Thaw, Evelyn Nesbit. *The Story of My Life.* London: Long, 1914.

Towner, Wesley. *The Elegant Auctioneers.* New York: Hill and Wang, 1970.

Valentiner, W. R. "The Clarence H. Mackay Collection of Italian Renaissance Sculptures." *Art in America,* August 1925, pp. 239–65, and October 1925, pp. 315–31.

Wharton, Edith. *A Backward Glance.* New York: Appleton-Century, 1934.

——. *The House of Mirth.* New York: Scribner, 1951.

Wharton, Edith, and Ogden Codman. *The Decoration of Houses.* New York: Scribner, 1897.

Wheeler, Candace. *Principles of Home Decoration, with Practical Examples.* New York: Doubleday, Page, 1903.

——. *Yesterdays in a Busy Life.* New York: Harper, 1918.

White, Diane S. *Stanford White's Venetian Room.* Albany, N.Y.: Mount Ida Press, 1998.

White, Lawrence Grant. *Sketches and Designs by Stanford White.* New York: Architectural Book Publishing, 1920.

White, Samuel. *The Houses of McKim, Mead & White.* New York: Rizzoli, 1998.

White, Stanford. *Stanford White: Letters to His Family.* Edited by Claire Nicolas White. New York: Rizzoli, 1997.

Whitehill, Walter Muir. "The Vicissitudes of Bacchante in Boston." *New England Quarterly,* December 1954, pp. 435–54.

"William C. Whitney." *New York Times,* 20 November 1898, supplement, p. 1.

Wilson, Richard Guy. *McKim, Mead & White, Architects.* New York: Rizzoli, 1983.

Wodehouse, Lawrence. "Stanford White and the Mackays: A Case Study in Architect–Client Relationships." *Winterthur Portfolio* 11 (1976): 213–33.

——. *White of McKim, Mead and White.* New York: Garland, 1988.

Young, Mahonri Sharp. "Stanford White, the Palace and the Club." *Apollo,* March 1971, pp. 210–15.

Numbers in italics refer to pages on which illustrations appear.